Literary and
Art Theories in Japan

Michigan Classics in Japanese Studies
Number 6

Center for Japanese Studies
The University of Michigan

Makoto Ueda

Literary and Art Theories in Japan

Center for Japanese Studies
The University of Michigan
ANN ARBOR, MICHIGAN

Copyright © 1967 by The Press of Western Reserve University
All Rights Reserved
Reprinted with the permission of Makoto Ueda
Reprinted in 1991 by the Center for Japanese Studies,
108 Lane Hall, The University of Michigan,
Ann Arbor, MI 48109

Library of Congress Cataloging-in-Publication Data

Ueda, Makoto, 1931–
 Literary and art theories in Japan / Makoto Ueda.
 p. cm. — (Michigan classics in Japanese studies ; no. 6)
 Reprint. Originally published: Cleveland, Ohio : Press of Western Reserve
University, c1967.
 Includes bibliographical references and index.
 ISBN 0–939512–52–1
 1. Arts, Japanese — Philosophy. 2. Arts, Japanese — To 1868.
3. Aesthetics, Japanese. I. Title. II. Series.
BH221.J32U42 1991
700'.1—dc20 91–319
 CIP

The paper used in this publication meets the requirements
of the ANSI Standard Z39.48–1984 (Permanence of Paper).
Printed in the United States of America

TO MY WIFE

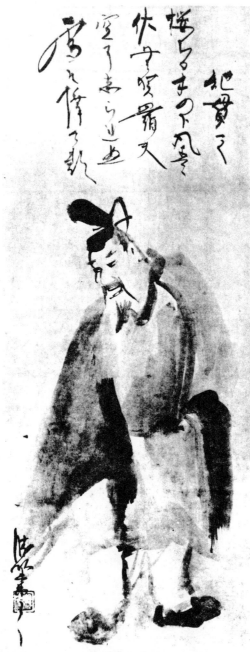

Plate 1
Tsurayuki and his poem. Portrait and
calligraphy by Iwasa Matabei (1578-1650).

Preface

A study of Japanese literary and art theories will be useful in two significant ways. First, and obviously, it will help the reader gain a deeper understanding of Japanese literature and art. By learning about the philosophies of art in Japan, he will come to know the aims and methods with which the Japanese produced paintings, music, plays, novels, and poems. As it happens, many of the major Japanese aestheticians were also great artists, so the person who carefully examines their theories of art will be rewarded with a glimpse into the secret of their creative achievements too. In this respect it is rather strange that Japanese aesthetics still remains a neglected subject in the West, where there is an increasing interest in Japanese art.

Secondly, an examination of Japanese aesthetic ideas will contribute toward an international definition of art. Since ancient times numerous attempts have been made to answer the question "What is art?" or "What is literature?"; yet in almost every case the answer has been formulated within a single cultural tradition. A definition of art that makes any claim to universality must be applicable to all arts, Oriental or Western. Japanese theories of art, which developed independently of Western culture, may provide a convenient touchstone by which to test the universal validity of a Western aesthetic concept.

This book, then, might be called the *Japanese Contributions toward a Multicultural Definition of Art*. It is not a history of Japanese aesthetics. Indeed, the aestheticians presented in it are arranged roughly in chronological order, and the reader will see an outline picture of the way in which Japanese aesthetics evolved in the course of history. That, however, is not where the emphasis lies. The book may often leave out aesthetic values that were only historically significant, for it concentrates on those values that seem intrinsically important and universally

valid. It will not discuss, for instance, the details of medieval symbolism or the mechanism of eighteenth-century rhetoric. Instead, it tries to show what the Japanese views have been on such questions as "How does art differ from life?" or "What is the use of art?" or "Can art ever become a religion?"

The same criterion has been used in choosing the thirteen major aestheticians with whom the book deals. Some of them were illustrious figures in their times and their art theories exerted tremendous influence long after their death; others were not so fortunate and their theories were discovered only in the twentieth century; but all of them had something worthwhile to say about the essential nature of literature and art. Consideration has also been given to represent views as various as possible. Thus the times of the aestheticians extend from the ninth to the nineteenth century; their fields of specialization range from lyric poetry to the novel and drama, from painting and calligraphy to the tea ceremony and flower arrangement.

Unfortunately but inevitably, some regrettable omissions had to be made in the choice of theorists. Japanese aesthetics is especially rich in lyric poetry, linked verse, painting, and the tea ceremony, and many worthy theorists in those branches of art had to be left out for the simple reason that another in the same field had already been chosen. Also, for various reasons, some major Japanese art forms are not represented in this book; I especially regret not being able to include the theories of the Kabuki, woodblock printing, and landscape gardening. Another conspicuous omission is that of all theorists after the mid-nineteenth century, but in this instance I have a more consoling justification: all aestheticians in modern Japan have been under heavy influence of the West and would better be dealt with in a separate book. The history of traditional Japanese aesthetics ends in the mid-nineteenth century.

I am indebted to a number of persons and institutions in writing this book. The origin of it goes back to my days at the University of Washington, where I picked up a number of hints while working with Professors Richard N. McKinnon and Leon Hurvitz; they were kind enough to read what was later to become part of the book. My present colleagues at the Department of

East Asian Studies, University of Toronto, have been of help to me in various ways at the later stages. I also received a generous grant from the University's Humanities Research Fund. Chapters on Toraaki and Chikamatsu have appeared in somewhat different versions in the *Journal of Aesthetics and Art Criticism* and the *Educational Theatre Journal* respectively; I am grateful to their editors for granting me permission to incorporate those essays here. My thanks are also due to those who kindly permitted me to reproduce their materials for illustrations in this book. I hereby express my deep gratitude to the Kokkasha for Plates 1, 2, 9, and 11, which were all reproduced from the *Kokka*; to the Shōgakukan for Plates 3 and 8, both reproduced from the *Zusetsu Nihon Bunkashi Taikei;* to the Kadokawa Shoten for Plates 6 and 7, of which the former was reproduced from the *Zusetsu Chadō Taikei*; to the Ikenobō Ikebana Society for Plate 5, which was reproduced from the *Ikenobō Kadō Geijutsu Zushi*; to the Heibonsha for Plate 12, which was reproduced from the *Shodō Zenshū*; to the Orion Press for Plate 13; and to Professor Henry Trubner of the Royal Ontario Museum, University of Toronto, for Plate 14. In selecting and obtaining these illustrations, I received valuable help from the Royal Ontario Museum and the East Asian Library, both of the University of Toronto.

Last but not least, I am grateful to numerous Japanese scholars who have with meticulous care edited (and in some cases annotated and interpreted) the writings of the thirteen aestheticians chosen. Their textual studies on the works of Tsurayuki, Lady Murasaki, Zeami, Bashō, and Norinaga are especially abundant and illuminating; without those I would have been at a loss a number of times during my research. On the other hand, little work has been done on the writings of Sennō, Jigū, Mitsuoki, and Yūshō beyond the publication of the texts. I hope that scholarship will soon make more progress in this area and correct whatever inadequacies my work may contain. This book does not aim to give conclusions; I will be fully satisfied if it provides a bit of stimulation to the study of literary and art theories in Japan.

Toronto, 1966 M.U.

Contents

Illustrations

1

Tsurayuki
on the Art of Lyric Poetry

Poetry as Emotional Expression

"Poetry is the spontaneous overflow of powerful feelings," declared Wordsworth in 1800, heralding the coming of a new age in poetry. This points toward a curious fact in the history of Western poetics. Prior to Wordsworth's time, Western theories of poetry had seldom been focused upon the relationship between the poet and the poem. Since Plato, Aristotle, and Horace, poetry had always been discussed in relation to nature, to truth, or to the norms and ideals of society. For one thing, the Classical tradition did not assign a high place to emotion, whether in life or in poetry. Thus the main literary modes the West cultivated were dramatic rather than lyric; the important theorizers of poetry it produced were scholars and philosophers rather than lyric poets. The fact that Western poetics originated in Greek civilization predestined, as it were, a long delay in the emergence of an expressive theory. It was natural that Wordsworth, seeking his poetic model in the utterance of unsophisticated men, should

look back beyond the Classical heritage and say, "The earliest poets of all nations generally wrote from passions excited by real events; they wrote naturally, and as men; feeling powerfully as they did, their language was daring and figurative." The earliest poets left no theory of poetry; it was for Wordsworth to formulate it for them.

A certain degree of rational thinking is essential to the formulation of a poetic theory, and the earliest poets in Japan left no poetics, either. But they did leave something that their Western counterparts did not—a lyric form powerful enough to dominate all the literary modes for several succeeding centuries. Japanese poetics as a consequence began with quite a different note, with an expressive theory. Poetry, the primitive Japanese thought, was the language of passion and emotion: people spoke in poetry at moments of intense joy, grief, longing, or indignation. Indeed, such expressionism was partly an inheritance from early Chinese poetics; Mao's Preface to *The Book of Songs* ("Shih Ching"),[1] widely read among ancient Japanese intellectuals, plainly explained the motive of verse-writing to that effect. Literary criticism in early China, however, was heavily tinted with Confucian moralism; it was often more concerned with the use of poetry than with the nature of poetry. In ancient Japanese poetics didacticism played only a minor part; as will be seen later, it was a by-product of an expressive theory. This was perhaps due to an historical factor: when rational thinking developed just enough to formulate a theory of poetry, the Japanese knew only one form of verse—the Tanka, or lyric poetry in thirty-one syllables. The theory they developed for this form had necessarily to be an expressive theory.

Ki no Tsurayuki (868–946?) was perhaps the earliest theorizer of poetry along this line. He was a courtier-scholar born in a prosperous upper-class family and was well educated in Chinese and Japanese classics. Like everyone else of his class he was also a

1. The Preface to *The Book of Songs* is one of the earliest pieces of literary criticism in China. It is traditionally attributed to Confucius' disciple Pu Shang (507–400 B.C.). It begins: "Poetry is the product of earnest thought. Thought cherished in the mind becomes earnest; exhibited in words, it becomes poetry." It is translated by James Legge in his *Chinese Classics* (London, 1865–95), IV, Part I, 34–36.

poet, and a good one; his poetic talent was so highly acclaimed that he was appointed, at the age of thirty-seven, a compiler of the first imperial anthology of poetry, called *The Collection of Ancient and Modern Poems* ("Kokin Waka Shū"). While there were three other appointed compilers, Tsurayuki seems to have been the leader of the group, for he was the one who wrote its preface in Japanese. It was here that he eloquently expounded his expressive theory of poetry. The famous opening paragraph reads: "Japanese poetry has the hearts of men for its seeds, which grow into numerous leaves of words. People, as they experience various events in life, speak out their hearts in terms of what they see and hear." Tsurayuki is here making fundamental distinctions in poetics. There are, as he implies, three elements in the making of the poem. First there is human emotion, the seed of the poem. Secondly there is the actual poem, a plant grown from the seed, the internal transformed to the external. Thirdly there is an external event that evokes emotion in the poet, the water and sunshine that wake up the seed. Tsurayuki's argument begins and ends with the first element. The poet, his emotion prompted by an event in the outside world, expresses it in the words of poetry.

Thus the crucial questions determining the nature of Tsurayuki's poetics cluster around the way in which he conceived poetic emotion. Can any emotion be made into a poem? Does the quality of the poet's emotion determine the merit of the poem? If so, what particular emotions would make a good poem? What is the process through which emotion is transformed into the substance of the poem? Does the poet's emotion differ in any way from the emotion in the poem? Why is it, in the first place, that the poet wants to express his emotion?

Tsurayuki would have found the last question easiest to answer, or probably he would not have expected the question at all since it was such an obvious fact to him. It is therefore with a matter-of-course tone that he gives his answer in a sentence immediately following the passage quoted above: "On hearing a warbler chirp in plum blossoms or a kajika frog[2] sing on the water, what living thing is not moved to sing out a poem?" In

2. *Polypedates buergeri*, a small frog noted for its beautiful singing.

3

other words, to produce a poem is a human instinct, or rather, an instinct inherent in all things that live. A man, when overcome with emotion, instinctively wants to give vent to it. Overwhelming emotion may be evoked as he faces various events in life, whether natural or human. Later in the preface Tsurayuki enumerates instances of such events. Events in nature that awaken one's poetic emotion occur most often with the cycle of the seasons: plum blossoms in spring, cuckoos in summer, tinted leaves in autumn, and the snow in winter are among those emotive objects. One is moved to sing out a poem particularly when one hears a warbler among the plum blossoms or a kajika frog on the water, or when one sees cherry blossoms fluttering down on a spring morning or hears tree leaves falling on an autumn evening. Then there are human events that can become motives for verse-writing, too. Poetic emotion would be aroused when a man wishes a long life for the emperor, when he thanks the emperor for his benevolent reign, when he is filled with joy and happiness, when he pines for someone with burning love, when he thinks of a friend of long ago, when he recalls his young, happy days, or when he mourns over the mutability of life. Tsurayuki goes on for another long passage to list many more motives for writing a poem, and it looks as if he believed that any emotion, if it is an emotion at all, could be made into a poem. This is a conclusion natural enough, since he presumes an expressive instinct in every human being.

The question now is what makes poetry differ from ordinary speech. Tsurayuki's answer seems to be suggested in some concrete instances of verse-writing that he cites in *The Tosa Diary* ("Tosa Nikki"), a travel journal he wrote some thirty years after the preface to *The Collection of Ancient and Modern Poems*. The diary includes so many instances of people composing poems on various occasions that one is almost tempted to think Tsurayuki wrote it partly for the purpose of substantiating his theory of poetry. One of those instances occurs when a certain man is deeply impressed by the beauty of nature:

> Soon our boat passed by the pine forest of Uta. Along the coast were a great number of pine trees, all some hundred

years of age. Their roots were washed by the waves, while many cranes flitted about the branches. The scene was so fascinating that a man on board could not help composing a poem:

> Those cranes, who make
> Their home on top of the pines,
> Look as if they knew
> That they and the trees were friends
> For thousands of years.[3]

The poem by no means did justice to the beauty of the scene.

The incident eloquently speaks for Tsurayuki's expressive theory. "A man on board" (who appears to be Tsurayuki himself) was so fascinated by the beauty of the view that he "could not help composing a poem." Verse-writing is a spontaneous act, spontaneous because the emotion that causes the act is intense. An ordinary emotion, since it can be controlled by reason and will, comes out in regulated speech, but an intense emotion spontaneously gushes out in verse. A good poem, therefore, should be able to reproduce in itself the original emotion as the poet felt it. Tsurayuki thought that the crane poem did not do this, so he condemned it. One of the criteria of judgment in an expressive theory of poetry is the degree to which the feeling contained in the poem is true to the original emotion of the poet.

There is another such instance in *The Tosa Diary,* this time a case in which a human event prompts a person to write a poem. The incident took place when Tsurayuki and his group were all in great delight as their boat arrived safely at the port of Naniwa, only a short distance away from the Capital and their home:

> That aged woman from Awaji Island, who had been miserably seasick all this time, was overjoyed to hear that the Capital was near. She lifted her head from the bottom of the boat and sang out a poem:
>> "When will it be?"
>> We wondered time and again
>> Waiting for this day

3. Both a pine tree and a crane were popularly believed to live for thousands of years. They were, in fact, the emblems of long life.

When our boat proceeds
Through the reeds of Naniwa.

People were all surprised, since it was such an unlikely person who produced this. Among them the lord of the boat, who had also been seasick, praised the poem very highly. "I can't say you looked charming when you were seasick," he joked, "but your poem is charming indeed."

The episode reiterates the two points just observed: the spontaneity of poetic expression and the genuineness of the poet's emotion are the prime factors in verse-writing. The old woman, coming from rustic Awaji Island, was not at all trained in the art of poetry; no one, indeed, had ever seen her composing a poem before. Nevertheless she felt such an intense joy at that moment that she composed a poem, and a good one. The lord of the boat (Tsurayuki himself) had also been unwell and was in a position to feel the genuineness of her joy.

Thus in Tsurayuki's theory the genuineness of feeling becomes one of the most important principles of critical judgment. Apparently the crucial question is not how great or deep the feeling in the poem is, but how true it is to what the poet felt. In a sense the question is that of poetic technique: any poem which fails to give an adequate expression to the poet's emotion has failed in technique. This is, however, not precisely Tsurayuki's thinking because, the sentiment in the poet and that in the poem being the same to him, an impure poem would mean impurity in the emotion of the poet. This becomes clearer in a concrete example in which Tsurayuki applies the principle to the criticism of an actual poet: "Among the famed poets of modern times, Priest Henjō[4] created a unique poetic style, but was lacking in true feeling. To take a comparison, his poetry gives the impression of looking at the portrait of a woman. The onlooker's heart is only superficially stirred." According to Tsurayuki, the weakness of Henjō's poetry is the lack of true feeling. And Henjō's poems lack it not because his poetic technique has failed (his

4. Priest Henjō (*c.* 816–90) was a grandson of Emperor Kammu and served as an official at the court until 895, when he entered the priesthood. Seventeen of his poems appear in *The Collection of Ancient and Modern Poems.*

6

technique is so good as to establish an individual style); it is because the poet does not have true feeling to begin with. In other words, the main fault lies in an insufficient motivation: the poet's feeling was not intense enough to be made into a good poem. It is as if he were composing a poem on a woman's portrait when he wants the poem to be on a woman. The poem is twice removed from reality.

Tsurayuki's criticism of Henjō seems to be generally fair. Here are a couple of samples from Henjō's poetry:

> Why does a lotus leaf
> With a heart so pure as to remain
> Untouched by its muddy
> Surroundings, deceive us into thinking
> A dewdrop on it is a jewel?

> Attracted by your name
> I, though a monk, have plucked you,
> A Lady Flower.[5]
> Please tell no one
> Of my infatuation.

The poems, both taking a motif in the beauty of nature, distinctly show an individual style, a style characterized by wit and impersonation. A clever display of intellect has made those poems amusing. But the poems show no impassioned feeling, no trace of the poet's being overwhelmed by the beauty of nature. In Tsurayuki's way of thinking, this is because Henjō had composed the poems from merely trite emotions. The poet was not capable of feeling deeply and intensely.

Tsurayuki further pursues the principle of "true feeling" and applies it to literary history. The result is typical of a romantic theory, with the idea of the beautiful past and the ugly present. He writes, "Our present age is attached to colorful surface, and our men have flowery hearts. All they have nowadays are truthless poems and hollow words. Poetry, like a piece of wood buried in the dirt, is now hidden in amorous men's houses. It is no

5. The flower is *patrinia scabiosaefolia*. For its graceful shape the Japanese called it *ominaeshi*, or a Lady Flower.

longer presentable at any serious occasion." The reason for the decline of poetry in recent times is, according to Tsurayuki, the people's "flowery hearts," which are capable of perceiving "colorful surface" alone. Even love, one of the most intense human passions, is now no more than a pastime of amorous men. A degradation of sensibility has inevitably resulted in the degeneration of poetry, since poetry is dependent on the poet's capacity to feel. And, when poetry came to express trivial emotions alone, its social status tumbled down too. The passage is permeated by the lament of the romanticist Tsurayuki.

Tsurayuki, however, did not condemn the modern age as all bad. He was aware that modern poetry, though in want of profundity of feeling, had one virtue—a refined form. The idea is most clearly seen in his preface to *The Collection of Newly Selected Poems* ("Shinsen Waka Shū"): "In the poems of ancient times, feelings are most profound while expression is still crude. The works produced in modern times are skillful in expression but shallow in meaning. Accordingly I have selected in this anthology the works of poets from Kōnin to Enchō years [810–931]. All the selected poems have both blossoms and fruit, the two essential elements of good poetry." Vegetation images, Tsurayuki's favorite, appear again. A good poem must have two elements, blossoms and fruit. The idea of blossoms would roughly correspond to what we call form or style today; it is the formal part of the poem recognizable through the eye and the ear. Fruit is the substance of the poem; it is what blossoms are for, and it has in itself something nourishing to give. The latter we have already seen: it is true feeling. Ancient poetry is full of it, since poets in those days were capable of feeling deeply and genuinely. Priest Henjō, a modern poet, was criticized for his lack of it.

The former concept, blossoms, is more complex than it may at first seem. It is discussed in greater detail in the preface to *The Collection of Ancient and Modern Poems.* Here Tsurayuki adopts a more abstract term, form, and uses it on at least three different levels. On the most elementary level, it seems to mean "verse form," as the term is used in English poetry to designate blank verse, sonnet, heroic couplet, and so on. Here is a passage

that appears early in Tsurayuki's preface: "The origin of poetry goes back to the time when heaven and earth were created. But the actual poetry we have today began with a verse by Princess Shitateru in heaven, and by Lord Susanoo on earth. In the Age of the Gods there was no fixed poetic form; the poems were crude and it was not easy to grasp the meaning. When it became the Age of Man, and after Lord Susanoo, people began to compose in thirty-one syllables."[6] Tsurayuki had a great respect for ancient poets but could not unconditionally accept the earliest poems because they were too crude in form. In his opinion, this is because the ancient Japanese had no definite verse form to channel their emotions through. The consequence of imperfect form is imperfect communication; the reader does not fully understand what the poem means. Tsurayuki thought of a fixed verse form as a filter that refines crude emotion into an organism of clearly intelligible words.

On the next level, Tsurayuki uses the term "form" for classifying poems into six categories: "Generally speaking, there are six forms of poetry. This seems to be so in Chinese verse as well. The first of the six is allegorical poetry; the second, enumerative poetry; the third, metaphorical poetry; the fourth, allusive poetry; the fifth, plain poetry; and the sixth, congratulatory poetry." The passage is the least satisfactory part of the preface, perhaps because Tsurayuki has tried, as it is generally thought, to follow too closely Mao's Preface to *The Book of Songs*. The classification is not quite convincing as it stands; one can point out, for example, that the last category is thematic while all the others deal with poetic technique. But the idea of form, vague as it is, emerges from the passage. One can think of a metaphorical poem as having a form different from a descriptive poem, even when they are both composed in the same verse form. The latter poem looks flat, while the former somehow stands up and has

6. This is the early history of Japanese poetry as popularly believed in Tsurayuki's time. Shitateru is a mythological princess who composed a dirge for her husband when he revolted against the gods and was promptly punished by death. Lord Susanoo is a younger brother of the Great Sun Goddess in Japanese mythology, who was sent down to earth and married a human princess. Happy with the completion of a new palace for himself and his bride, he composed a poem in thirty-one syllables.

thickness, so to speak. The form, thus conceived, is the inner structure of the poem, the way the poem is internally built. One might call it "structural form." Congratulatory poetry may be fitted into the idea if we assume that a poem of congratulation is most effective when it has a certain inner structure.

The form on the third and final level of meaning has to do with the over-all impression of the poem, which could be called "impressional form." Whereas the first two forms deal with formal and structural elements of poetry, the third one is concerned with its affective function and is therefore most important as a principle of criticism. Tsurayuki constantly refers to it, directly or indirectly, when he comments on the most famous of modern poets in his preface to *The Collection of Ancient and Modern Poems*. For instance, he says: "The poetry of Arihara no Narihira[7] is too rich in emotion and is insufficient in words. It is like a withered flower which has lost its colors but which still retains its fragrance." The second sentence sounds much like some medieval Japanese aestheticians (whom we shall discuss later), but unlike them Tsurayuki used the simile for a derogatory purpose. The contrast he has in mind is between emotion and words. Narihira, like most of the ancient poets, had plenty of intense emotion, but his poems do not fully express it. Burning passions and insufficient words have created an unbalance in the constitution of the poem, and this has caused a failure in impressional form. Tsurayuki does not cite any specific poem by Narihira for illustration, but we may suppose he had in mind a poem like this:

> Could there be no such thing
> As inevitable parting
> In this life!
> For the son wishes his mother
> To live as long as a thousand years.

The poem, addressed by Narihira to his aging mother, is quite simple both in emotion and in technique. It expresses one of the

7. Arihara no Narihira (*c.* 825–80), a grandson of Emperor Heijō, rose quite high as an official at the court. *The Tales of Ise* ("Ise Monogatari") narrates the story of his life. Thirty of his poems are included in *The Collection of Ancient and Modern Poems*.

most genuine feelings, the child's love for his mother, in an artless, almost naïve way. Equally simple and moving is what is believed to be Narihira's deathbed poem:

> I had heard, often enough,
> This was the road every one of us
> Must eventually take,
> But I had never thought
> It was a matter of yesterday or today.

The poem plainly describes what a man would feel in the face of death. The feeling is common, but genuine and forceful. In Tsurayuki's opinion, however, Narihira's style seemed too artless, too prose-like, and showed too little sprightly wit, polished metaphor, or colorful imagery. His art did not match the intensity of his emotion.

In advocating a balanced impressional form, Tsurayuki presents a contrasting case of failure as he criticizes another modern poet: "Funya no Yasuhide[8] is skilled in the use of words, so skilled that he tends to upset his poetic form. His poetry is like a merchant dressed in fine silks." This is the case of a poet who, unlike Narihira, has a masterful skill in the technique of poetry but who, for that very reason, fails to achieve a well-balanced poetic form. His rhetoric is too conspicuous to keep the balance between words and emotion. Tsurayuki was probably thinking of a poem by Yasuhide such as this:

> All the tree and grass leaves
> Have begun to be tinted,
> But no autumn
> Has come upon the flowers
> Of waves in the ocean.

One might say that the theme is the permanence of the universe as against all that changes. To state the theme, however, the poet has relied too heavily upon a trivial, commonplace comparison

8. Little is known of Yasuhide's life. According to extant records he served at the Court of Justice in 860, at the provincial government of Yamashiro in 877, and at the Costume Department of the Central Government in 879. Five poems by him appear in *The Collection of Ancient and Modern Poems.*

of the sea waves to flowers. All flowers fade in autumn; only the flowers of waves do not. The contrast, which should be only a means by which to present the theme, looms too prominently in the foreground of the poem. Yasuhide has so forcefully played on structural form that his impressional form has slanted to one side, as it were.

Tsurayuki further makes clear what the ideal impressional form is like. Commenting on three more modern poets, he says:

> The poetry of Kisen,[9] the priest of Mt. Uji, is ambiguous in words; his poem is vague at the beginning and at the end. It is like looking at the autumn moon through the clouds of dawn. Since only a few of his poems have remained to our day, we cannot well acquaint ourselves with his poetry. Ono no Komachi[10] is in the line of poetesses that started with Princess Sotoori[11] of antiquity. Her poetry has pathos and is not forceful. It can be compared to a lovely lady in grief. It is not forceful probably because it is the poetry of a woman. Ōtomo no Kuronushi's[12] poetry is lowly in form. It is like a woodcutter with firewood on his back resting under blossoms.

First, the ideal poetic form as conceived by Tsurayuki must not be ambiguous. Kisen's poetry has this weakness. Today we have only one poem by him:

9. Nothing is known about Kisen's life. He must have been one of the low-ranking priests who were good at poetry. Today there remains only one poem by him, the one cited here.

10. There are a number of anecdotes on Komachi's life, all presenting her as a woman of rare beauty and accomplishment. She seems to have been active at the court during the quarter century beginning in 850. Eighteen poems by her are found in *The Collection of Ancient and Modern Poems.*

11. Sotoori was a consort of Emperor Ingyō (reign, *c.* 418–51). Perhaps the legends of the time had it that she was a lovely lady and talented poet. *The Collection of Ancient and Modern Poems* contains a poem attributed to her.

12. Ōtomo no Kuronushi lived in a rural area not far from Kyoto and later became the magistrate of that county. He contributed poems to court rites during the last quarter of the ninth century. Three of his poems appear in *The Collection of Ancient and Modern Poems.*

My hut is here
To the southeast of the Capital,
A happy abode as you see,
Although people call the place
Mt. Uji, or the Mountain of Sorrow.

The poem is more complex than it may first appear. Its subject is the poet's home, which can be described in two ways in reference to its location. People refer to it as being located on Mt. Uji, which literally means the Mountain of Sorrow; they would think that the man who lives there must be full of sorrow, that the priest's life must be a lonely one. But the resident, Kisen himself, does not think of his hut in that way; he would rather say that it is situated "to the southeast of the Capital," just at the edge of the great metropolis. Moreover, he is not sorrowful; he is living there happily. But why is he happy? Is it because he is so close to the Capital? Because he is not *in* the Capital? Because an isolated life of a priest is a greater pleasure than city life? Because his spiritual life is undisturbed in spite of his geographical closeness to the earthly Capital? What ultimately is the poem trying to say? The poem plainly describes the serene state of the poet's mind but does not particularize it. This causes ambiguity.

The second element of Tsurayuki's ideal poetic form inferred from the last-quoted passage is gentleness. Tsurayuki's term for it is pathos, a kind of form with undertones of gloom, delicacy, and dreaminess that melts quietly into the reader's heart. It does not accompany a strong, vehement passion; unlike grief, pathos can never be vigorous. Therefore, when Tsurayuki speaks of Komachi's poetry as lacking in forcefulness, he is not really pointing out a weakness; rather, he is describing a quality inherent in pathos. Komachi, indeed, is the only modern poet spared of Tsurayuki's censure. Here are two examples from her poetry:

Thinking of my lover
I went to sleep, whereupon
He appeared before me.
If only I had known it was a dream
I would never have awakened.

13

> Since that drowse
> In which I met a man
> I dearly love,
> I began to depend
> On what they call a dream.

These are love poems, but they have no torrid, overwhelming passion. The poetess, longing for her lover, is too passive to take a resolute step forward; she simply escapes into dreaming. One will also note that the poems have no sparkling wit or intellectual metaphor; they do not rely on discursive reason. Komachi has no such vigor as ancient poets had, but since she does not try to conceal it by rhetoric or wit she has achieved a well-balanced impressional form.

Another instance of ill-balanced form, however, is seen in the poetry of Kuronushi. The unbalance in his case is between motif and form: though his motif is interesting, it is presented in a lowly form. But judging from the three poems by Kuronushi remaining today, Tsurayuki's criticism seems a bit too harsh. One of the poems is:

> The spring rain—
> Could that be people's tears,
> Since there is no one
> Who does not grieve
> Over the falling blossoms?

Perhaps to Tsurayuki's taste people's tears were too familiar objects to compare with spring rain, for the latter image, traditionally associated with falling blossoms, evokes an elegantly beautiful vision.

All in all, Tsurayuki's impressional form stands on a series of balance and harmony—words and emotion, technique and subject matter, clarity and ambiguity, forcefulness and gentleness, interesting motif and graceful expression. A poem having a harmonious balance in each of these pairs is considered as having a perfect impressional form. The beauty coming out of such a poem will be that of equilibrium, and not of the baroque. Tsurayuki, however, says very little on the nature of poetic

beauty. He always looks at a poem from the maker's point of view: whether the poet has successfully expressed the emotion, and not whether the poem has successfully created beauty, is a matter of concern to him.

To sum up, then, the ideal poet Tsurayuki had in mind would have to fulfill two basic requirements. First, he must be capable of conceiving a genuine emotion, and secondly, he must be capable of expressing it in a well-balanced form. To put it in another way, Tsurayuki's ideal poem must first be motivated by a true, deep feeling, and must secondly have a perfect form to contain it.

Did Tsurayuki as a poet live up to those principles himself? Here we shall glance at his actual work, which will also throw some light on his notion of true feeling and impressional form. The following is his poem called "On the First Day of Spring":

> Will the breeze
> Of today, the first spring day,
> Melt the ice
> Of the water that often soaked
> My sleeves last summer?

The emotion embodied in the poem is the joy at the coming of spring. It is expressed through a nature image, the image of the spring breeze melting the winter ice. Both the emotion and the image are quite conventional, and Tsurayuki, fully aware of it himself, tries to overcome the triteness by his technical skill. He tries to do it by expanding the scope of the poem—first by weaving into the poem the whole cycle of the seasons, and secondly by bringing in a personal experience in the form of a memory. The result is that although the poem has a well-polished surface and well-devised structure, it has lost something in the power of lyrical expression. Here is another poem by Tsurayuki, this time trying to express a deep grief:

> To the end of my life
> Flows this river, the stream
> Of my tears.
> Gushing and foaming,
> It never freezes in winter.

15

Again the poem fails to arouse an intense emotion, because it depends upon a metaphor intellectually contrived. The failure is more disastrous in this poem, insomuch as the emotion the poet is trying to depict is presumably more intense. The basic weakness lies in the fact that the grief is not specified, that it is conceived as an abstract idea. The poem, however, has a small redeeming feature—a flowing rhythm like that of a river.

Those two poems, which may not be among Tsurayuki's best but which would nevertheless be among his most characteristic, seem to suggest a revealing fact. In the preface to *The Collection of Ancient and Modern Poems* Tsurayuki appeared to place equal emphasis on true feeling and impressional form. In his actual practice, however, the latter distinctly outweighs the former. This is not because Tsurayuki failed to put his theory into practice, but because his theory was partially deficient in itself. For, in the final analysis, Tsurayuki's true feeling is not part of the poem; it is, rather, part of the creative process. Here we must carefully distinguish between three different elements in the creative process: the poet's emotion, the poem's emotion, and the poem's form. The poet's emotion is only an outer cause for the making of a poem; it may be completely expressed in the poem, or it may not be. On the other hand, the poem's emotion is *within* the poem and is controlled by the form of the poem. It follows, then, that the principle of form has a stronger grip on the actual poem than the genuineness of the poet's feeling. In other words, impressional form is an internal principle vitally working inside the poem, while true feeling is a factor that disappears as soon as the poem is completed, leaving only a shadow in the poem. Tsurayuki made no distinction between the poet's emotion and the poem's emotion; his theory failed because it insisted on the genuineness of the poet's feeling, when it should have stressed the greatness of the poem's emotion.

Tsurayuki, without knowing it, tries to correct himself by emphasizing the importance of poetic technique. The poet's emotion and the poem's emotion will come very close when a poet who is equipped with perfect technique of composition transforms the former into the latter. Tsurayuki is much concerned with poetic technique, so much, in fact, that he has made

16

it the basis of classifying poetry. As has been seen, his poetic categories, all except the last, have direct bearing on the technique of composition: plain poetry, enumerative poetry, allusive poetry, allegorical poetry, and metaphorical poetry. "Plain poetry" refers to poems in which the poet plainly states his emotion; it is poetry in the method of prose. "Enumerative poetry," on which later scholars' interpretations differ, seems to point toward those poems in which the poet enumerates the objects he proposes to depict; it is, more or less, descriptive poetry. "Allusive poetry," "allegorical poetry," and "metaphorical poetry" are self-explanatory; they comprise all poems in which allusion, allegory, and metaphor are used as principal technique.

One question concerning plain and enumerative poetry is the question of what distinguishes them from prose, for admittedly they employ the technique of prose. Tsurayuki's answer is simple: it is the thirty-one syllable form. Although he was so broad-minded as to approve poems of unfixed length in ancient times, he was, in theory and practice, all for the latter tradition that had established the short lyric form as the only verse form. His poetic sensibility, in fact, was so accustomed to this form that anything which differed from it seemed ridiculous to him. *The Tosa Diary* records an amusing incident in this connection. It happened when passengers on Tsurayuki's boat, weary of waiting for better weather in a port, composed poems to divert themselves: "People made various comments on those poems. Listening to them, a certain person also produced a poem. The poem, however, consisted of thirty-seven syllables, and people burst into laughter as they heard it recited. The author of the poem was very unhappy and indignant. I cannot even imitate the way he recited the poem; even if I wrote it down here no one would be able to read it. This is so even this very day when the poem was made; what would become of it in the future?" This is an outright insult to that "certain person," and the only reason for it, as we gather from the passage, is that his poem had six syllables more than an ordinary poem. But we should perhaps note that Tsurayuki says he could not recite the poem himself. The tradition of oral literature was still strong in those days; poems were usually read aloud by poets and readers alike. In this

instance, Tsurayuki was opposing not so much the extra syllables as the recitability of the poem in question. The man's poem did not have a poetic rhythm, and so Tsurayuki, as well as other people who were there, laughed at it.

It may not be conclusively proved that a verse of thirty-seven syllables cannot have a poetic rhythm. It is a fact, however, that poets in Japan began writing in free style only in the twentieth century. In all prior ages poetry, as well as rhythmical prose, made use of alternating five- and seven-syllable lines, or some variations of that form. It was, and still is, the basic rhythm of the Japanese language in which the most common phrase units consist of five or seven syllables. One might generally say that a passage of thirty-one syllables, with a 5-7-5-7-7 syllabic pattern, has more natural smoothness than that of thirty-seven.

As a poet Tsurayuki was particularly sensitive to poetic rhythm. Again *The Tosa Diary* records an episode substantiating this:

> "Pull the boat harder," the lord urged. "This is such a fine day." The steersman thereupon called out to his crew: *"Mifune yori, ohose-tabu nari, asagita no, ide konu saki ni, tsunade haya hike."* ["The lord is urging us. Pull your ropes harder, before the rough morning wind comes from the north."] The words had a poem-like rhythm, though they spontaneously came from the steersman. He had no intention to say anything like a poem. But since it sounded so much like a poem, I wrote it down. Indeed, it had thirty-one syllables.

The steersman's words are prosaic enough in content, but still Tsurayuki felt them poetic when he heard them spoken, because they had the basic rhythm of Japanese verse. This supports one of Tsurayuki's views that primitive men spoke in rhythmical language, which eventually developed into poetry.

It should be noted here, however, that Tsurayuki said the steersman's words "sounded like a poem"; he did not say it was a poem. After all, rhythm is an attribute of poetry, and not the prime element. A poem without rhythm would sound comical, but a speech with rhythm does not necessarily qualify as a poem.

18

As has been seen earlier, poetry needs an intense overflowing passion for its material.

Another characteristic of poetic language as important as rhythm is metaphor. Tsurayuki fully recognizes its importance: we have seen that he heavily depended upon it in his own poetry; we have also observed that he had metaphorical poetry in his classification of verse, along with allusive and allegorical poetry, which would also make use of figurative language. Above all, we recall that in the very first passage of his preface to *The Collection of Ancient and Modern Poems* he said that people, as they meet various events in life, speak out their hearts "in terms of what they see and hear"—that is, through visual and auditory images. External nature functions as a means of expression. A poet expresses his emotion in poetry, and in doing so he can make effective use of the evocative capacity of images. Moreover, in Tsurayuki's time man's view of the world was predominantly animistic. Human life was an inseparable part of the life of the universe, as the life of everything else was. Naturally there had developed public similes and metaphors, a system of correspondence between man and nature that every member of society accepted. The poet's task was only to elaborate on it or expand it in his own way. As we have seen, Tsurayuki made frequent use of metaphor even in his prose writing.

The existence of harmony between man and nature did not require the poet to be an idealist who would create his own private world of dreams. He could complacently accept external reality as it was. Hence in Tsurayuki's theory of poetry there is no place for imagination, no debate on reality and illusion. Metaphor is to him a means of evoking a feeling in the reader, a feeling available in ordinary human life; it never develops into a mystical symbol that conjures up ghosts from the "other world." Poetic experience and ordinary experience do not qualitatively differ; truth in poetry and that in ordinary life are the same. Poetry must imitate feelings as they are in actual life.

Not recognizing the concept of dual reality, Tsurayuki never poses the question of poetic reality versus ordinary reality. However, insofar as truth in poetry is not verifiable truth, some thoughts touching on the subject are bound to occur in any

writing on the nature of poetry. In this connection an episode recorded in *The Tosa Diary* is very revealing. Tsurayuki's boat was in a port where there were many beautiful pebbles and seashells on the beach. Looking at them, one of the men on board sang out a poem:

> You, the surging waves,
> Bring ashore a Seashell
> Of Forgetfulness.[13]
> I will come down and get it
> To forget the lost little one I dearly loved.

On hearing this the father who had lost his little daughter in the Province produced this one:

> I will never pick up
> The Shell of Forgetfulness.
> I would rather get
> A pure white pearl, and keep it
> As a memento of the child I lost.

Whenever the matter of his late daughter came up, the father became like a fretful child. People might say: "That girl was far from being like a pearl." But there is an old saying, too: "A lost child has a lovely appearance."

In this instance poetic reality and ordinary reality differ. The child as beautiful as a pearl in the poet's mind is just an ordinary-looking girl to an objective onlooker. Yet Tsurayuki does not try to defend poetic reality by putting it on a level different from ordinary reality. Instead, he defends his view by leaning back on ordinary reality—by citing a time-honored saying that sanctions his felt reality. The poem has failed, not in technique, but in sentimental exaggeration, as Tsurayuki feels. At the same time he defends himself: "After all, that is the sentimental exaggeration shared by all parents in the world, is it not?"

We now come to our final topic: the use of poetry. Like many other theorizers of poetry, Tsurayuki recognizes two main uses,

13. The shellfish is *sunetta menstrualis*, which was believed to make people forgetful.

hedonistic and didactic, both originating in the idea that the poem expresses the poet's true feeling.

Poetry gives pleasure to men. In Tsurayuki's idea, it is in the process of composing a poem, as well as of reading it, that people get pleasure; poetry affords an opportunity to release their feelings. Instinctively human beings want to vent their emotions and feel pleasure when that instinct is gratified. In the preface to *The Collection of Ancient and Modern Poems* Tsurayuki writes that all those people who grieved over their old age, who longed for their friends or lovers, and who suffered many other sorrows of life in the past "consoled themselves only by composing poems." In *The Tosa Diary* there are plenty of examples:

> The Eighteenth Day. We were still in the same harbor. We could not embark again, as the sea was rough. The place was quite scenic, whether viewed from afar or from nearby. But we were all too weary to enjoy the view. Men recited Chinese poems to divert themselves. To kill time a certain person produced a Japanese poem:
> > On this rugged shore
> > Where turbulent waves surge
> > White snowflakes
> > Fall, the snow of waves
> > That falls all the year round.
> This was by a man who seldom composed a poem.

The passage reveals Tsurayuki's idea that, while reciting a poem is a pleasure, to compose one is an even better diversion. Even a person far from being a professional poet can console himself by writing a verse, for the composition of a poem is an act of purgation on the part of the poet. The purgatory function of verse-writing is frequently manifest when the emotion to be vented is of a painful kind, such as grief. For this reason *The Tosa Diary* has numerous instances in which the parents who have lost their daughter compose a poem to let out their grief. One example has already been cited; here is another:

> All those people, now happily on their way home, had no child with them when they left the Capital several years before. Some of them, however, were now with the little

21

ones born to them during their service in the Province. Whenever the boat arrived at a harbor these new parents would get on and off board with their dear ones in their arms. Watching a scene like this, that mother who lost her little daughter in the Province could no longer contain herself:

> While there are some
> Who, coming with none, now return
> With their little ones,
> Here I must, coming with one,
> Sadly go home with none.

She wept as she recited the poem. On hearing this, how sad the father must have felt, too! It is not for mere fun that people make poems. Whether in China or in Japan, they compose poems when they cannot restrain their emotion.

The pleasure of composing a poem is not "mere fun," as Tsurayuki emphasizes here. It is a higher kind of pleasure that emerges when the poet is relieved of his pain by having it expressed. It is somewhat like weeping, which also serves to restore one's equilibrium at a time of intense mental tension. But, unlike weeping, the writing of a poem is a deliberate effort, and it makes specific the nature of the agony: the consequence is that the sufferer's feelings are better understood and shared by other men. It is a purgation that could relieve a deeper, more complex grief.

The second use of poetry Tsurayuki recognizes is public and social rather than personal. Poetry helps to create a peaceful, well-governed state, for it promotes a better understanding among various members of the society. In its communicative function the language of poetry is more powerful than ordinary speech, since it is more intensified and evocative. "It is poetry," Tsurayuki affirms, "which can without exerting physical strength move heaven and earth, touch invisible souls of the dead, harmonize the relationship between men and women, and soften the fiercest hearts of warriors." Poetry has even a supernatural power. The power, however, is not inherent within poetry; it springs out of the true feeling of living men. When all men and

women express their genuine, honest feelings in poetry, this world will know no unheard prayers, no grief in love, no barbaric warfare. Thirty years later Tsurayuki repeats the same belief: "Poetry not only depicts in words the beauty of the spring haze and the charm of the autumn moon, or the colors of blossoms and the songs of birds. It moves heaven and earth, touches divine beings, strengthens men's moral sense, and helps to create order in this world. Rulers educate their people by means of poetry, and people advise their rulers by means of poetry. Its appearance is colorful, yet it is impregnated with moral lessons." Here Tsurayuki has gone further in asserting the social function of poetry, for he plainly declares that poetry helps create a well-governed state. He is perhaps pushing the point a bit too far here, because the poetry anthology to which he wrote this preface hardly includes what we would call didactic or satirical poems. Part of the reason may be that Tsurayuki, writing in Chinese this time, was more keenly aware of his classical model, Mao's Preface to *The Book of Songs,* which strongly emphasized the political and social usefulness of poetry. At any rate, Tsurayuki's belief in the didactic function of poetry has remained unchanged throughout the years, if not strengthened.

In conclusion, it may be said that Tsurayuki's idea of poetry distinctly points toward an expressive theory, though naïve and incomplete in some ways. For one thing, he conceived the theory for the only Japanese verse form existing at the time, the thirty-one syllable lyric, a form best fitted to express emotion. For another thing, he had a model theory in Mao's Preface, which had defined poetry as emotional expression. Accordingly one of Tsurayuki's two main principles of poetic composition is true feeling: the poet must be capable of conceiving a deep, genuine emotion. Lacking a philosophical, religious, or moral system by which to measure the value of emotion, however, his true feeling becomes a bit too subjective and obscure a term. To correct the weakness he devised the second principle, impressional form: a good poem, he insists, must have a good harmony between style and content, words and feelings, technique and ingredients. He naturally depends more heavily on the second principle as a criterion of criticsm, and his own poetry follows it, too.

23

Tsurayuki's theory of poetry, as characteristic of any expressive theory, has little to say about truth or ultimate reality. Poetry, in his opinion, expresses emotion; it imitates reality only to the extent of, and in accordance with, what the poet perceives through his senses. This does not imply relativism because, according to Tsurayuki, there is not much difference between subjective and objective reality. Poetry is the diary of a heart, not a romantic heart that fancies and dreams, but the plain heart of an ordinary man with joy and grief, love and hatred, pity and anger—with all the emotions of ordinary life. Here is the democratic nature of poetry as conceived by Tsurayuki; everyone composed poems in his day. Hence Tsurayuki's belief in the personal and social usefulness of poetry: the poem, personally used, can be an effective means of purgation, while socially used, it can help communication between the ruler and the ruled, between men and women, between any two individuals in society.

2

Lady Murasaki
on the Art of the Novel

Truth and Falsehood in Fiction

The nature of poetic truth has always been a topic of lively controversy in Western poetics from its very beginning. The debate started when Plato declared that the artist imitates things twice removed from ultimate reality. Aristotle countered Plato's argument by suggesting that the artist may imitate things not only as they are, but also as they ought to be; poetic reality, he said, may be truer than ordinary reality. Religious artists further cultivated this idea and believed the artist to be an angel carrying a divine message to man's world. Romantic poets pushed the argument to an extreme: in their opinion the poet is a seer, a prophet, a medium, a gifted elect who is able to glimpse the splendors beyond the tomb. The controversy was carried even into the twentieth century. Freud once called the poet a daydreamer socially validated, while Jung thought that the poet visualizes the collective unconscious of the human race, past and present. Ezra Pound is quite impatient about the whole question; he says that the idea of the artist's being insane "has been carefully fostered by the inferiority complex of the public."

25

In ancient Japan there was no such controversy. As we have seen, Japanese poets before and during Tsurayuki's time did not in general seem to hold a dual view of reality; ordinary reality and the reality presented in the poem were the same to them, for any reality other than the ordinary did not exist. This naïve and harmonious world-view, however, was bound to break down sooner or later, and indeed it did soon after Tsurayuki's time. We have already noted that Tsurayuki was no believer in historical progress; we have also observed that his poetry was bent toward over-intellectualization. Already in his day the dissociation of the harmonious personality had started beneath the surface. Socially the institutions inaugurated by the laws of the mid-seventh century had grown obsolete and begun to show the signs of decay; civil uprisings, beginning in the early tenth century, were becoming more frequent. The dissatisfaction with the given self and the given world inevitably led to the creation of an imaginary self and an imaginary world. In due course it gave rise to a new literary genre, the novel, in which one could most freely command one's imagination to create fictitious characters and events. *The Tale of a Bamboo Cutter* ("Taketori Monogatari"),[1] the earliest work of this kind, narrates the story of a little baby girl who is found in a bamboo forest, grows into a lovely lady, is wooed by many suitors in vain, and eventually goes back to the moon, which is her home. *The Tales of Ise* ("Ise Monogatari"),[2] another work of early Japanese fiction, has the phrase "years ago" at the beginning of almost every tale, thereby setting the scene in the remote past. A number of other tales depicting handsome princes and lovely princesses followed, gradually developing into more mature works of fiction. Before long there appeared the greatest harvest along this line, the celebrated

1. A work of unknown authorship, written sometime in the late ninth century. A translation by F. V. Dickins is in his *Primitive and Medieval Japanese Texts* (Oxford, 1906). Another, by Donald Keene, is in *Monumenta Nipponica*, XI (1956).

2. The tales center upon the life of Arihara no Narihira, a poet mentioned in Chapter 1. Some of the tales, translated by Richard Lane and F. Vos, are included in Donald Keene (ed.), *Anthology of Japanese Literature* (New York, 1955).

26

The Tale of Genji ("Genji Monogatari") by Lady Murasaki (978–1016).

Fictionalization, then, constitutes the very basis of the novel. Plausibly enough, this soon brought out a charge against the novelist of telling "falsehoods"—that is, writing of an event that had no place in history. A sensitive noblewoman of tenth-century Japan, for example, said: "As I take a look at those old tales widely read nowadays, I find them filled with false things that abound in this world"—and she herself went on to record the facts of her life in the form of a diary. The first person who tried a defense of fiction, and who did it brilliantly, was Lady Murasaki in a scene of *The Tale of Genji.*

The scene in question is part of a chapter called "The Glow-Worm," where Prince Genji, the hero of the novel, talks to Tamakazura on the nature of fiction. At this time the prince is thirty-five years old; his keen intellect, delicate sensibility, broad learning, and varied experiences are now combined to make him an ideal nobleman in full maturity. Tamakazura, now twenty-one, is a girl for whom Genji is acting as protector; she was introduced into the court only recently. Naturally the situation is almost like that of a tutor giving a rambling talk to his pupil on literature. In fact some of Genji's comments are modeled after Tsurayuki's preface to *The Collection of Ancient and Modern Poems,* which had by this time become a classic in Japanese literary criticism. We may safely assume, then, that here Lady Murasaki is pronouncing her own ideas through Genji's mouth.

First, the setting is described:

> That year the rains of early summer were more frequent than usual, and the sky was seldom clear. The ladies at the court, all bored, entertained themselves with pictorial novels all day long. Lady Akashi, showing her talent in this instance also, gracefully copied out story books and sent them to the Princess, her daughter. Tamakazura, who had never seen a pictorial novel before, was all the more fascinated with it; from morning till night she devoted herself to reading and copying. The novels were full of interesting

27

young people. Yet, among all those persons true or fictional who went through various kinds of adventures in the novels, Tamakazura still felt herself to be the heroine of the most strange fate. The protagonist of *The Tale of Sumiyoshi*,[3] who behaved most fittingly at the time of crisis and gained the respect of both past and present readers, seemed a rare sort of lady, indeed; but Tamakazura could not but be reminded of her own horrible experience with Tsukushi when she read how nearly Lady Sumiyoshi fell into wicked Kazoe's trap.

Literature, Lady Murasaki thought, was a product of man's effort to overcome the boredom of life. The life lived by those court ladies of tenth-century Japan was as monotonous, gloomy, and boring as the rain of early summer. For one thing, they were living in an extremely small circle, cut off from fresh, new experiences. Dissatisfied with actual life, they tried to enter the world of fiction, a world of fantasy and strangeness. But in order to read a tale they had to copy it out by themselves. Soon a good skill in copying a tale became an important qualification of a court lady, and an accomplished lady like Akashi had to have good taste in selecting and copying a tale, too. Copying a novel was an art, as were so many of the things in their daily life.

The novel they read had accompanying pictures. Yet it was neither a novel with illustrations nor a picture scroll with captions. It was a pictorial novel, a novel in which the picture and the narrative were combined in one art. The diary Prince Genji wrote during his exile in Suma was a pictorial diary, too; he looked at his own life through a scroll-maker's eye. This seems to suggest the general pattern in which the novelists of those days, including Lady Murasaki herself, viewed real or imaginary life. The progression of one's life was like the unfolding of a picture scroll. When a writer wrote an account of someone's life, he always adopted the method of picture scroll writing, not merely because the pictorial novel was very fashionable in his day but

3. *The Tale of Sumiyoshi* ("Sumiyoshi Monogatari") tells of various misfortunes that befell Lady Sumiyoshi after her mother's death. Once she was nearly kidnapped by an old man named Kazoe.

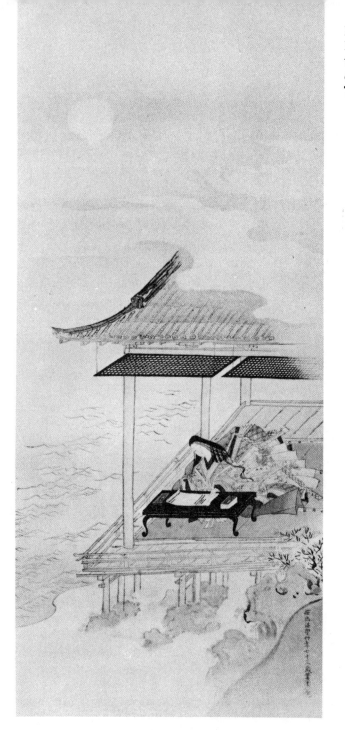

Plate 2
Lady Murasaki
writing *The Tale
of Genji*. By Kanō
Tan'yū (1602–74).

because the mode of his thinking was molded in that way. *The Tale of Genji* is no exception: structurally it is a collection of numerous episodes, with picturesque descriptions, colorful images, and minute outward details. It has no plot in the modern sense.

Many of those pictorial novels depicted fantastic happenings because the more fanciful they were the more amused the readers would be. Lady Murasaki, however, here chose Tamakazura for the lone listener to Prince Genji's talk on the novel. Among hundreds of persons who appear in *The Tale of Genji*, probably no one has had more varied experiences than Tamakazura. Daughter of Lady Yūgao, who died a mysterious death, Tamakazura does not even know who her father is. At the age of four she left the Capital to live in a remote area; at ten her last guardian died; at twenty she was rudely approached by Kazoe-no-kami, her ill-mannered suitor of seventy years of age. Selecting this girl for Genji's lone listener in this scene, Lady Murasaki seems to be suggesting that the world of fantastic stories is not so far away from real life as it may at first appear.

The truth-falsehood controversy is then brought out. Lady Murasaki continues:

> Wherever he went, Prince Genji saw those pictorial novels lying scattered about in the room. Since they kept appearing in his sight so persistently, he exclaimed: "What a nuisance! It looks as if ladies were born into this world only to be deceived by others, and willingly too! They surely know there is very little truth in those stories, and yet they allow their minds to wander into fantasies and deceits as they read them in the hot, humid weather, even forgetting that their hair is in tangles." He said this to Tamakazura and laughed.

This is a rather sarcastic remark on a temperament traditionally held to be characteristic of women. Women are fully aware that the world of fiction is built on imaginary matters while their own world consists of cold facts, yet when they read a work of fiction they forget to distinguish between the two. Genji takes this to be a confusion of truth and falsehood that arises, not

because those novel readers are foolish, but because they are women. Unable to endure life's boredom, tenth-century court ladies brought fiction into their daily lives; what they knew to be fictional gradually came to assume realness in their minds. Then, they tried to transform their daily lives into a world of fiction, too, as that was the only way of realizing their dreams. One result of this was the appearance of a number of diaries, fictional to various degrees, written by court ladies of this time. Those women lived in a "world of feeling," a world in which there was little difference between an imaginary and a factual matter as long as that matter was capable of being emotionally experienced.

Prince Genji looks at the issue from a male point of view, and laughs. Men, generally less emotional, are not lost in a fictional world to the extent women often are. Yet Genji is not unaware of a certain power in the novel, which, though fictional, still affects the factual world of men. He observes:

> "Indeed, without those old tales we would have no way by which to kill our hopelessly tedious hours. Yet among such make-believe things there are some which, having truly convincing pathos, unfold themselves with natural smoothness. We know they are not real, but still we cannot help being moved when we read them. Reading about a lovely princess buried in gloomy thoughts, we unknowingly sympathize with her. Also there are other stories which seem too fantastic to be true, yet which are so well dramatized and so dazzling that we are momentarily drawn in, even though we may not like them when we calmly read them again afterwards. Recently I had the chance to listen to some attendants reading stories to my little daughter, and I realized what good storytellers this world had. Those stories must have come from the mouths of people well accustomed to telling falsehoods. Don't you think so, too?"

Genji, while holding that all novels deal with nonfactual matters, argues that there are two different types of novels, one type ranking higher than the other.

The essential quality of the first type of novels is the feeling

30

of realness. The reader, while knowing that the details presented in the story are unreal, finds himself moved; he is emotionally involved in it as he sees the illusion of life therein. To create this illusion, the story must unfold itself with natural smoothness; the rhythm of the narrative must be identical with the rhythm of actual life. The source of this real-life feeling is truly convincing pathos. Neither a minute description of scenes alone nor a dramatic presentation of character alone would produce the feeling of real life. What truly yields the feeling of realness is pathos. A novelist may distort historical facts or tell lies, but so long as he succeeds in creating the feeling of pathos—and truly convincing pathos—his story will appeal to the reader with more realness than, say, a faithful record of historical facts.

It is not easy to define this pathos in precise terms, but it seems to denote a combined feeling of melancholy, elegance, and resignation. It is deeper and more universal than Tsurayuki's pathos; while in Tsurayuki's time it was a personal quality attributed to the poetry of someone like Komachi, it was now the dominant life-feeling of those who created the culture of that unique age known as the Heian period. It was the feeling which the people of that period experienced as they noticed the passing of a season: the spring was gone, the blossoms fell, and they felt pathos. It was the emotion they had in love affairs, too: their lovers were dead, or had deserted them, and they felt pathos. Men were sensitive to the outside world only in a passive way; they were losing the positive, headstrong energy their ancestors had. The ultimate of nature and of human life was grasped in their fading moments rather than in their creativity. Pathos, in this sense, is bent toward a tragic feeling because it arises when life is contemplated as a constant movement toward death.

The second type of novels Genji conceives are characterized by their fantastic, mysterious, and dazzling nature. They do not yield the feeling of real life; hence, when the reader calmly reflects on them afterwards, he does not like them. It is only because everyone has curiosity, an instinct to search into the unknown, that he is momentarily absorbed in the reading of fanciful happenings. Like a bad Gothic novel, such stories exert

31

no lasting impression upon the reader. There had been many novels of this kind before and during Lady Murasaki's time, and it is quite conceivable that she is here expressing her negative attitude toward them. Elsewhere in *The Tale of Genji* she has a novel of far-fetched fancy defeated by a less fantastic tale in a pictorial novel contest. In another contest Prince Genji's pictorial diary wins an overwhelming victory.

Genji, who has pursued the argument to this point, suddenly drops it and shifts his point of view. He now looks at the novel from a realist's point of view and says that all novelists are liars. Apparently he is a little embarrassed, now having realized that he has unknowingly got into a serious discussion of literature before a young girl, and this after laughing at the silliness of women assiduously copying story books. His shift of view, therefore, is only a means to smile away his seriousness; in no sense does it nullify his preceding statements. But his innocent listener, young Tamakazura, takes his joke seriously. She answers: " 'Yes. But perhaps only those who are accustomed to falsehood can see through various lies in the novels. I always thought those stories were true.' So saying, she pushed away her inkwell." Here Tamakazura is made to return to the factual world. As usual she is obedient to her guardian (at this point she still believes that Genji is her real father) and ready to accept what he has said. Her act of pushing away the inkwell is symbolic of her move from the world of fiction to the actual world. But Genji, now realizing what effect his joke has had on his young listener, must correct the statement at once: " 'That was a tasteless slander I made! Novels are the records of the things that have happened since the Age of the Gods. What *The Chronicles of Japan* ["Nihon Shoki"][4] and other history books say is but a fraction of the whole. It is in novels that we find true happenings written in detail,' he said, laughing." He now becomes quite serious, perhaps a bit over-serious, and then laughs to smooth it over. Indeed, Genji has made a daring comment. He has said

4. *The Chronicles of Japan* (720) is one of the most valuable historical writings of early Japan. Compiled under imperial auspices, it narrates the history of Japan from mythological times to 696 A.D. It has been translated into English by W. G. Aston—*Nihongi* (2 vols., London, 1896).

that novels are truer to reality than avowed historical writings.

Genji's statement is in part a development of his preceding argument concerning the two types of novels. He has showed his disrespect for fanciful tales because they describe things remote from facts. Now he turns in the opposite direction: he attacks history books because they record external facts alone. *The Chronicles of Japan* and other books of history describe only a fraction of what things have really been, since they deal with political issues in the main. They do not enter into a personal life of an individual; they have little to do with internal soul-life; they present only factual information of social events. Compared with them, novels are truer, that is, "containing more of the serious matters of truth," as the original Japanese term seems to imply. A novel treats the life of an individual, the matters of the soul, the laws that rule the inmost nature of man. It aims to present the habits of the human mind, the universal motives of various human actions, and in doing so it illuminates the history of mankind since the Age of the Gods. Literature deals with the universal, while history always remains within the realm of the particular.

Genji now feels obliged to explain his idea of the novel further. So he goes on:

> "The novel does not describe a man's life as it is. People began writing the novel when they were captivated by something good or bad in human life, something that seemed too fascinating to keep to themselves and let disappear with their deaths. A novelist, therefore, would write all kinds of good things when he wants to present someone in a favorable light. Or he might gather unusually ugly facts if needed to impress the reader in that way. Yet, good or evil, all these are not outside of this world. There are some Chinese novels little different from ours in the way they are made up, while in Japan the tales of ancient times do differ from those of modern periods. Some works may be profound, and others shallow, but it would not be right to condemn all tales as falsehood. Even in the teachings of pure-hearted Buddha there is the so-called Adopted

33

Truth, and some uninspired readers may be perplexed to find apparent contradictions in various parts of the holy texts. The contradictions occur most frequently in the Mahayana Scriptures. And yet, in the final analysis, they all serve a single purpose. The distance between the Awakening and the Sinful Desires in Buddhism is the same as that between Good and Evil in human life. Nothing in this world is useless if one takes it in good part." He thus explained the purpose of writing a tale.

Prince Genji has elaborated on his idea of the novel here, referring to its origin, method, and use.

The contrast between the novel and history is still in Genji's mind. A novelist, like an historian, takes up the pen when he sees or hears about a heart-moving event, an event that stirs in him an urge to record it for the sake of posterity. The novel, like history, is motivated by and based on actual happenings in life. However, it does not describe facts in the way a history book does; it does not record the particular—historical names, dates, and places—with impartiality. It deliberately chooses certain facts over others. The criterion of choice lies in the writer's purpose in each individual case. When he wants to describe something only in its good aspects, he would choose to write only of good things; when he wishes to emphasize the distinction among different individuals, he may have to say only bad things about certain people. Those good things that appear in the novel, as well as the bad things, are all true to reality; it is only that they are elevated to the sphere of art through the screening of the writer's mind. Each of them is an empirical fact, but as they are gathered and arranged deliberately by the novelist they constitute an experience that is not historical. An event described in the novel may not be factually true but will be felt as emotionally true, as long as it is based on universal human nature. It is for this reason that some happenings that take place in the tales of remote China seem quite close to us, even closer than some of the things that actually happened early in our own country. The difference of time and place does not much matter in the realm

34

of fiction, for it treats the universal rather than the particular, an imaginative truth rather than factual truth.

What people think as falsehood in the novel, then, is imaginative truth. Historical truth and imaginative truth may seem different at first sight, but they are ultimately the same. The relation of the one to the other is compared to that of Factual Truth to Adopted Truth in Buddhism. Factual Truth is based on the actual experiences of the Sages; Adopted Truth is purely fictional; yet both have ultimately the same aim—to teach the Law. Likewise, historical truth and imaginative truth differ only in the mode of grasping reality; they are the same in the ultimate reality they both try to represent. The novel, in its own sphere, pursues the problems of human life to the farthest point it can go, where it confronts the ultimate issue of man—the issue of Good and Evil. The issue corresponds to the ultimate issue of religion: the opposition between the Awakening and the Sinful Desires. Literature and religion alike aim at a resolution of this ultimate duality in life. The duality is the very basis of imaginative literature as it is of religion; it is also what creates truth out of falsehood in the novel.

The terms Good and Evil, we must note here, should be interpreted in their broadest senses, and not merely as ethical good and evil. In the language of tenth-century courtiers, those words also implied beauty and ugliness, or culture and vulgarity. In Lady Murasaki's *Diary* ("Murasaki Shikibu Nikki") as well as in *The Tale of Genji,* a good person is the one who possesses beauty in appearance, in manners, and in the mind. The judgment of Good and Evil was made, not merely in terms of moral qualities, but on the basis of more inclusive ethico-aesthetic elements that constituted the person or incident. The idea of Good covered as wide an area as goodness, truth, and beauty all combined.

According to Lady Murasaki's view, then, an ideal novelist will do two things: first he will take for his theme the greatest issue of human life and pursue it to the ultimate; secondly, he will do that in such a way that the feeling of real life will emerge in the process. Lady Murasaki further specifies what the greatest

issue of man is, and what the feeling of real life is like: the former is the question of Good and Evil, and the latter, truly convincing pathos. A wide search into the nature of Good on the one hand, and a deep feeling of pathos on the other, are the two essentials of a good novel.

The nucleus of Lady Murasaki's view of literature lies in this combination of an ethico-aesthetic search into the nature of Good and a religious passivity of pathos. Her ideal beauty rests on a perilous balance between the human and the unearthly; her poetics point toward a theory of tragedy. Prince Genji, the hero of her great novel, indeed rises to the stature of a tragic hero in the early episodes when he tirelessly pursues the ultimate of beauty and goodness on earth, defying, where necessary, both human and divine laws. Lady Murasaki and her age, however, were too feminine to let the hero stand against Fate throughout the whole novel: the prince gradually yields to the passivity of religion as he advances in age, changing his goal from earthly to unearthly beauty. In the early history of Japanese literature *The Tale of Genji* is the last but most significant sign of man's resistance against Fate before his complete surrender to religion. Lady Murasaki's idea of the novel, expounded in that work, has similar implications, too.

3

Yoshimoto
on the Art of Linked Verse

Verse-Writing as a Game

Japanese linked verse is a rare verse form in which a poem is the product of a combined effort by a team of poets. Most commonly, the poem consists of one hundred stanzas with, alternately, seventeen (5–7–5) and fourteen (7–7) syllables each. A small number of poets, directed by a leader, compose one hundred stanzas usually at one sitting; they may take turns to contribute a stanza, or they may wait for a volunteer, stanza by stanza. It is much like a group game; in fact it was a game in the early stages of its development, and lyric poets played it in their more relaxed moments. Slowly, however, linked verse came to take on a more sober color, and eventually in the fifteenth and sixteenth centuries it occupied the most prominent place in all the genres of Japanese literature. The poet who helped most in elevating linked verse to the level of a serious art form was Nijō Yoshimoto (1320–88), an eminent courtier and statesman who compiled the earliest anthology of linked verse in history. He also wrote a number of essays on the art of linked verse, thereby providing its theoretical basis for the first time. Many of the ideas

37

presented in the essays had been known before him, but he was responsible for collecting, refining, and codifying them in definitive terms.

The poetics of linked verse is a unique one, for it requires, as it must, an extreme of pragmatic theories. The poet and the reader are nowhere more closely related than in linked verse, because here the reader of one stanza may become the poet of the stanza immediately following. To compose a stanza for linked verse the poet must first try to become a perfect reader of all the stanzas preceding his; he has to put himself in the positions of all his fellow poets sitting around him. One obvious consequence of this is a demand for the poet to suppress his individuality: the poet must work within the framework set by other poets as well as by the contemporary rules of poetic composition. In this respect the theory of linked verse stands directly opposite from that of lyric poetry; instead of speaking out his personal emotion, the poet must dissolve it for the sake of the team of which he is a member.

Yoshimoto's poetics is built around such pragmatism. He repeatedly emphasizes "an appeal to the people present" as the primary principle of composition. "In the final analysis," he says, "the aim of linked verse is to delight the people present." "In lyric poetry," he explains elsewhere, "there are secrets of composition handed down from antiquity. But linked verse has no such ancient model; its main concern is to entertain the people present. The participants should never use a crabbed, ceremonious, or quaint expression in the name of an expert poet." "Since linked verse is for the entertainment of the party," he reiterates, "a good poet would compose a verse which delights the people present. Any verse which sounds uninteresting to the audience should be considered mediocre, however insistently the poet may claim to know the secrets of composition." The basic assumption is that the poem exists not in the poet's mind nor in the text but in "an appeal to the people present," in the excited mind of each participant in the game. Yoshimoto is quite clear about this: he goes so far as to suggest that the poet needs to have no thought of future readers in composing linked verse since his work will disappear when the game is over.

38

However, it would be dangerous indeed to pass an evaluative judgment on a verse by such an elusive standard as "an appeal to the people present." Each individual has a different taste and responds differently to the same work of art. Yoshimoto is well aware of the subjective nature of literary criticism, particularly when he holds a pragmatic view of poetry as he does. He says: "In linked verse it is difficult to talk of good and bad lines in decisive terms, even for one who is an expert in that art. It frequently happens that a stanza which a poet thinks is mediocre receives a high mark from a critic with a different taste. It is not that the critic is at fault, nor that the poet has no critical ability. It is only that one feels different from moment to moment." This leads him to the affirmation that to be a good critic is more difficult than to be a good poet. But Yoshimoto does not subscribe to relativism. Keenly aware of the subjective nature of an individual's judgment, he goes on to set up the standard of evaluation outside of the individual. It is not a personal feeling but the opinion of the majority that finally counts. He says: "You can safely assume that a verse is good if it is widely acclaimed in the world. Opinions of two or three men amount to nothing. Mencius, too, has taught us: 'That which makes all men follow is good.' You will eventually attain your goal, whatever it may be, only when you follow the way in which all men do it. Lone deviation will lead you nowhere." The merit of a poem is conceived as something objective, something agreed upon and sanctioned by many. Indeed, there would be no linked verse at all if one did not presume certain standard norms commonly accepted by poets; without accepted norms, the poets would lose the way to unify their efforts.

What, then, are those norms? They differ considerably from society to society, from age to age, just as ethical and moral norms do. "It seems that the style of linked verse has changed as many as four or five times during the last fifty years," Yoshimoto himself has observed. "In this respect linked verse is different from lyric poetry. Follow the style favored by your contemporaries." In Yoshimoto's time and the prime days of linked verse, there seem to have been two principal norms. The one is *yūgen*, and the other is unity in variety.

39

Yūgen is a term frequently used in medieval Japanese aesthetics, although it meant somewhat different things to different ages and people. In Yoshimoto's usage the term seems to designate a certain idea roughly equivalent to elegance, gracefulness, or polished beauty. Important here is the fact that *yūgen* is conceived not as a personal, human emotion like joy or grief, but as a mood or atmosphere, as an objective feeling generated from an external object. "There is nothing more pitiful," says Yoshimoto, "than to see an elegant object destroyed by a poet who uses crude words to describe it." An elegant object yields the mood of *yūgen* around itself; the poet should carefully preserve and reproduce it in his verse. The poet's personal emotion should be suppressed, so that the mood of the object of nature on which his mind focuses will reveal itself most clearly. "Essential to linked verse are the word and the style," one of Yoshimoto's disciples said. "Do not search for emotion. A verse written in crude words and in an unrefined style must be considered mediocre, no matter how interesting the poet's emotion may be." Three factors, then, are necessary to create the mood of *yūgen* in a verse: elegant objects, elegant words, and an elegant style.

As for elegant objects, here is Yoshimoto's remark: "Scenes such as the spring haze thinly covering the blossoms and a warbler singing in the blossoms are celebrated in lyric poetry. They should be treated in the same way in linked verse, too." Inevitably he has chosen seasonal objects in nature, universally accepted as lovely and graceful, for his examples of elegant objects. Elsewhere he enumerates objects that he believes can be recommended for themes of linked verse. For instance, the objects he suggests for themes of the opening stanza are:

> In the First Month: the lingering winter, the unmelted snow, plum blossoms, warblers.
> In the Second Month: plum blossoms, cherry blossoms. Cherry blossoms can become a theme as soon as one begins to wait for them, and should be made the most favored topic throughout the Third Month. They remain an important theme until they fall.

40

In the Fourth Month: cuckoos, deutzia flowers, trees with fresh green buds, thick grass.

In the Fifth Month: cuckoos, early summer rain, orange blossoms, irises.

In the Sixth Month: the summer shower, fans, summer grass, cicadas, glow-worms, the evening cool.

In the Seventh Month: scenes of early autumn, bush clovers, the Festival of the Stars (on the Seventh Day only), the moon.

In the Eighth Month: the moon, various kinds of flowers, wild ducks.

In the Ninth Month: the moon, tinted leaves, scenes of late autumn.

In the Tenth Month: the frost (through the Twelfth Month), the early winter rain, fallen leaves, anticipation of the first snowfall, winter grass (through the Eleventh Month), the chilly gust (through the Twelfth Month).

In the Eleventh Month: the snow, the hail.

In the Twelfth Month: the snow, the year-end, early plum blossoms.

The list sufficiently shows what sort of objects were considered elegant.

Elegant objects should be depicted in elegant words; it would be pitiful otherwise. "In choosing words," Yoshimoto says emphatically, "search for the flower among flowers, the jewel among jewels." He continues: "Ancient and old-fashioned works of linked verse seldom have a pleasant rhythm or a delightful line, because the poets were so intent on the clarity of meaning that they neglected to polish their words. Works produced by the people of rural areas sound lowly and coarse, too, because those poets are too absorbed in the technique of linking and pay little attention to the words they use." Crude words can be distinguished from elegant ones by the way they sound. The former sound lowly, rough, fat, and untidy, while the latter are fluent and smooth. Neither the words of peasants nor the clichés of pedantics will do. What specific words are elegant is difficult to

41

say: all one can do is to study standard classics and try to "memo-rize elegant words that great poets constantly use." Yoshimoto suggests that a beginning poet study *The Collection of Ancient and Modern Poems, The Tale of Genji,* and several other classics of Japanese court literature. One can rest assured that words which appear in those books are all elegant.

However, it is not that words are elegant in themselves. Any elegant word can be made coarse by improper use. In this respect the poet can be compared to a carpenter:

> A word can be appropriate or inappropriate, depending on the way you use it in your verse. An unskilled artisan can produce only poor handiwork, no matter what good lumber he may use for his material. A work of a master artist is always superb, even though the lumber used may not be of the highest quality. In linked verse, too, you should try to make your expression elegant, slender, and smooth. Avoid a gnarled, rough expression. You must first plane and polish your words. A poem that still shows the trace of your hatchet is not a good one.

Just as a desk, and not the lumber used to make the desk, is what finally matters, it is the poem, and not the words which make up the poem, that is at stake. The gracefulness of poetic style super-sedes that of words or of milieu. Yoshimoto illustrates the same point by another comparison: "In linked verse the style is of the foremost importance. Whatever interesting thing you may say in it will not impress the reader if it is said in a tasteless style. Such a poem can be compared to a lovely lady in a hemp dress. Make your verse elegant and graceful. A poem written in a coarse style is always mediocre, even when it is on an elegant theme such as the snow, the moon, or the blossoms." Neither poetic vocabulary nor poetic subject matter is enough to make a good poem. It needs the poet's art—a style that would properly control both words and material. And what underlies a proper style is the spirit.

Yoshimoto repeatedly refers to the importance of the spirit in linked verse. The spirit is inseparable from words. Without an

elegant spirit, there could not be an elegant word or style. "Drive away," says Yoshimoto, quoting from a Sung writer, "a crude spirit, a crude word, and a crude style from your verse." "Words can be hurt by the spirit," he says elsewhere, "and the spirit can be hurt by words." "There is often a poet," he continues, "who composes a poem with no elegant spirit and who tries to make it look elegant by the use of elegant words. He would constantly refer to 'the spring dawn' and 'the autumn dusk' and claim to be fashionable. Such a poet is always among the beginners." Indeed, some great poets in the past made frequent use of such words as the spring dawn or the autumn dusk, and there is no harm in knowing such words and others like them. But more important is to know the spirit in which to use those words. "Learn the spirit above all else," says Yoshimoto. "Wording is a superficial matter. Imitate the way in which great poets used the spirit."

If one possesses the elegant spirit, one does not have to mind even the principle of elegant words. "In the use of words," Yoshimoto says, "the poet should not as a rule go beyond the vocabulary of the imperial poetry anthologies. However, newly created words and colloquial words are also permissible in linked verse." Even the principle of *yūgen* should not be a restricting factor here. "A poet who composes only elegant pieces without a fresh, striking feature should at times try a new style," says Yoshimoto. "One cannot go wrong with *yūgen*, but sometimes one's verse may look trite and stagnant. Be very careful." A poet who possesses an elegant spirit will not be restricted by precedents or by traditional and contemporary rules; he will go beyond them.

The idea that the poet should first follow the rules and then transcend them is also observed in the second of two main principles of linked verse, unity in variety. This principle is characteristic of and essential to the nature of linked verse as a literary genre. In fact, the core of this unique verse form with multiple authorship lies where variety is stretched to a point not accessible to a single poet. The linked-verse poet must risk unity for the sake of variety, but he can hope for a great variety within unity.

The poet's individuality must be suppressed to serve the unity of the whole poem, but he would at the same time be required to contribute his uniqueness to help create variation.

Unity in linked verse is achieved on four levels primarily. First, there is the unity of verse form: the participating poets must each compose a stanza with either a 5–7–5 or a 7–7 syllabic pattern, whichever is required of him at the moment. Secondly, there is the unity of progression: each poet is obliged to compose a stanza that is in some way related to the preceding stanza contributed by one of his fellow poets. Thirdly, there is the unity of tone: all the participants must take care so that the whole poem, when finished, will have an unbroken tone throughout its one hundred stanzas. And finally there is the unity of mood: all the poets are expected to compose stanzas that will produce the mood of *yūgen* for its tonal impact.

Within those restrictions each poet must do his best to make a contribution unique to his poetic talent. Obviously he can do nothing about the syllabic patterns, which are predetermined. But as for the other three, he may be able to do a great deal.

We have already noted Yoshimoto's remark that the poet can and should exercise a considerable amount of liberty as to the principle of *yūgen*. Provided that he knows the essential spirit of linked verse, the poet is even permitted to use some unrefined colloquial words that, under ordinary circumstances, would sound too vulgar. In fact he should at times try to break away from the principle of elegance and experiment with a fresh new style. Yoshimoto advocates "freshness" as an element counterbalancing *yūgen*. Of course, "one should not indiscriminately select the new"; a beginner, therefore, ought to avoid a rare expression or a quaint word. But the ideal is to express an old, familiar truth in a new, refreshing way. "In the final analysis," Yoshimoto concludes, "the aim of linked verse is to make ordinary facts appear new." The poet's inspiration in this respect is not to be suppressed; it should be crystallized as it comes upon him, and with no intervention of the convention. "If you are a beginner," Yoshimoto teaches, "don't indulge in unnecessary speculation. In all artistic creation there is the so-called 'first flash of inspiration'; you should speak out your inspiration in

that very instant, without being disturbed by your speculative thinking." Classical learning, while necessary, may do harm to those who do not know how to handle it, for it may interfere with their fresh, individual feelings. If the poet decides to base his verse on a Classical model, he should do it lightly; otherwise his verse would look like an antique object. All in all, a linked-verse poem of one hundred stanzas would show a considerable amount of variation in mood if each stanza were the result of each poet's effort toward freshness in word, expression, and motif.

Likewise, a successful piece of linked verse will never be monotonous in tone. Its syllabic pattern is the same throughout, but its tone is different at the beginning, in the middle, and at the end. Here are Yoshimoto's words:

> In an ordinary work of linked verse, which has one hundred stanzas, the first twenty-two stanzas should be made to have a placid mood. Even in such little things as the choice of grammatical particles, be cautious so that the lines will not look flamboyant. In the next twenty-eight stanzas, compose more light-hearted lines. Then, finally, make the remaining fifty stanzas especially exciting. Every work of music has an introduction, an elaboration, and a finale. In a work of linked verse, too, the first twenty-two stanzas make up an introductory part, the middle twenty-eight an elaboration, and the last fifty a finale. Experts in Japanese football say this is the same in their sport, too.

A piece of traditional Japanese music has three parts: the first part with a quiet tone and a slow tempo (*jo*), the second part with a lighter mood and leisurely changes of pace (*ha*), and the third part with a heightened rhythm and a forceful impact (*kyū*), somewhat like the three movements in contrasted rhythms of a Western sonata—exposition, development, and recapitulation. The football played in the early Japanese court also had such changes of rhythm: in the early part of a game the player would be quite orderly in his play, making each kick a long, carefully aimed one; but as the game proceeds he would step forward and make a shorter, and often curved, kick; in the last part of the game he would enjoy a freer, more irregular play, uttering cries

and making the game lively and exciting. This principle in music and in sports is taken into linked verse, too. To overcome the monotony of the repeated syllabic patterns, the poets would compose slow-paced, somber lines in the early stage; they would become more casual and free in the next stage; and finally they would cast away all restraints, creating a mood full of change, gaiety, and excitement. Thus the entire poem, as the product of such a practice, will show a great variety of tones and rhythms within its coherent whole.

The poem is safeguarded against monotony by yet another scheme: the rules prohibiting a repetition of certain words. For instance, such words as the morning sun, the evening moon, the winter gust, the summer shower, a glow-worm, a cicada, a nightingale, a deer, a wistaria, or an iris can be used only once in a hundred-stanza poem; the poet cannot use any of these words if it has appeared in any of the preceding stanzas, whether composed by himself or by someone else in the team. Words like the spring moon, the autumn wind, the native village, or a wild duck can be used twice, provided that they occur at different parts of the poem. In no case can the same word be used twice within a span of five stanzas, and this is true of two different words designating two things of the same category, whether they may be trees, beasts, birds, or insects. There are many other rules like these, helping to ensure a certain degree of variety in any work of linked verse.

The idea of variety within unity, however, is revealed most clearly in the ways in which a poem is made to progress from one stanza to another, for it is here that the participating poets can most freely display their individual talents. Yoshimoto, drawing on the contemporary practice, lists a number of ways in which one stanza can be integrated with another. Among them the method closest to the common Western practice is "linking through meaning," which roughly corresponds to logical progression. For example, when the preceding stanza is:

> Although I have a horse here
> I would rather go out on foot.

one might compose a stanza like:

> For, at daybreak
> I had a glimpse of the snow
> Piled during the night.

But one could ignore the logical meaning of the foregoing stanza and pick out a single word in it as a connecting link. This is called "linking through word." For instance, to a stanza like:

> By trying to hate her
> I consoled myself a little.

one may add a stanza:

> The spring haze hangs
> Over the pine trees along the coast
> Ahead of my way.

The first stanza deals with love, and the second with travel; apparently the only connecting link is a Japanese word *urami*, which happens to mean either "to hate" or "to see a coast." But if one ponders on the second stanza awhile one will note that it does develop a feeling embodied in the first stanza—a mixed feeling of hatred and consolation. The second stanza is saying: "I do not like the spring haze hiding my way, but I am consoled by the lovely spring scene that the haze has created." "Linking through word" could be subtle.

One may not even need a linking word; one may connect two stanzas through a mood alone. There is, for instance, "linking through a mood of nature":

> An old path, almost hidden,
> Extends on the desolate heath.

> Tilting the leaves
> Of a bamboo bush, plum blossoms
> Are in bloom.

It is neither logical progression nor a linking word that binds the second stanza to the first; it is a mood of nature, rustic and lonely, which prevails over both. The poet of the second stanza caught the desolate feeling of the foregoing couplet and made

47

it the dominant mood of his own lines, with plum blossoms lonesomely blooming in the shade of bamboos. Linking, however, does not always have to be through a similar mood. For instance:

> The beauty of springtime
> Is felt in the sky of daybreak.

> The sorrowful autumn
> Forever has the feeling
> Of the evening dusk.

Whereas the first stanza has a mood of loveliness characteristic of spring, the second has that of loneliness found only in autumn. Such a method of linking is called "linking by contrast."

Yoshimoto lists many more ways of joining one stanza to another, such as flat linking, mosaic linking, comic linking, linking through a buried word, linking through an aftereffect, or linking by an allusion to a poem, to a legend, or to a famous place of interest. Since so many ways of linking are permitted, it almost seems that each poet can compose practically any kind of verse he likes if it has the slightest relationship to the foregoing stanza. And, in fact, the way of linking highly favored by expert poets is of such a kind as to bring out the poet's individuality to the fullest extent possible. Yoshimoto calls it "linking through an unusual association." He is referring to a case such as when "one longs for the rain in a moonlight night or desires a gust at a cherry-blossom time." For instance:

> My memory of her face
> Has dimmed into a dream
> Of that night.

> After seeing the blossoms
> I long for clouds over the moon.

The couplet is quite unconventional, for no one who can appreciate the beauty of the moon would wish for a cloudy sky. The poet has dared to break the convention, and for a good reason. He has just returned from blossom-viewing; now looking at the

moon, he recalls the lovely clouds of blossoms and wants them over the moon in the sky. Innumerable cherry blossoms spreading all over the sky in a moonlit night is indeed a lovely dream image. His feeling is somewhat related to that of the maker of the first stanza who finds the lovely face of his lover slowly dimming in his memory now that the rendezvous is over. Both stanzas present an imaginary world of beauty, in which one is not sure where the reality ends and where the dream begins.

Time and again Yoshimoto stresses the importance of the unusual and the unconventional in the making of linked verse. "The success of linking depends on the poet's individual style and individual talent," he says. "There cannot be any fixed rule." Even the most unconventional sentiment could be made use of by a master poet; this, indeed, is what distinguishes a good poet from a poor one. To use Yoshimoto's comparison, a verse composed by a mediocre poet is like handiwork made by patching wooden pieces together; it has "no power of its own and is therefore not interesting at all." Such a work will neither look fresh nor create any appeal to the people present. Yoshimoto explains why this happens:

> A stanza composed by an expert poet is integrated with its preceding stanza through an interesting turn of a spirit, though at first sight it may not seem to be linked at all. It may be said that a good stanza ignores conventional ways of linking and yet is linked through a spirit nevertheless. A stanza composed by an inexpert poet turns away from the foregoing stanza, so to speak, despite its appearance of being technically well linked. This is what I mean when I say: "Rules are to be transcended, and not to be followed, whether they are the rules of linked verse or of this grief-laden world."

Elsewhere he observed: "An expert's verse rides on the preceding stanza without the appearance of doing so. A nonexpert's stanza turns away in spirit, with all its appearance of being closely linked." In the end, the question is that of the spirit. It is this spirit which creates *yūgen*, which produces freshness, and which

49

links one stanza to another in a delightful way. Yoshimoto advocates unconventionality in linked-verse writing because the conventional rules often destroy the spirit.

This explains why Yoshimoto, who does not recognize any poetic principle unchanged through the ages, believes in the permanence of the poet's spirit. Outward principles may change, but the poet's inner spirit does not. "When I advised you to abandon your teacher," Yoshimoto explains, "I meant that you should stop imitating your teacher's style. You should retain his spirit, which is the same with all poets. A good poem always has a truthful, undistorted, and elegant spirit, whether the poet is that great Zenna[1] or anyone else. It is words and styles that should change." All great poems have something in common—the spirit.

As for what this spirit means, Yoshimoto says very little; one can only guess its nature from his casual comments touching on it, most of which have been cited already. One may safely assume, however, that it is distinctly different from Tsurayuki's emotion, for, though it lies within the poet, it is not impulsive and does not manifest itself except at the time of poetic creation. In this sense it is something like creative imagination. But it is creative imagination of a specific kind: it is especially gifted in visualizing elegant beauty and hearing a subtle change of tones. If *yūgen* and unity in variety are principles existing outside of the individual poet, the spirit remains within and sensitively responds to them. It is, one may say, a spirit in search of elegant tonal beauty.

The spirit of linked verse, therefore, does not concern itself directly with a philosophical truth, religious insight, or moral idea. It aims neither to reproduce life as it is, nor to build a world of transcendental reality; it only endeavors to create a series of lovely scenes with changing tones. External reality comes into the world of linked verse primarily as the ingredients for elegant, graceful beauty. "Work day and night on the given scene," Yoshimoto advises, "so that your product out of it would move

1. Zenna, a Buddhist monk, was one of the earliest pioneers in linked verse. Some of the best poets of the time studied linked verse under him. He lived in the early fourteenth century.

the reader to exclaim 'Indeed!' " The selection of a site for a verse-writing party becomes important. Yoshimoto says: "When you plan a verse-writing party, first of all select a good time and a good location. Looking at the snow and the moon, the blossoms and the trees, and all the other things of nature which change with time, the poets will feel something moving in their hearts and trying to express itself in words. Choose a lovely spot if you choose at all. Good poems are most likely to come out when the poets admire a lovely view of the mountains and waters." The writer of linked verse probes into nature for its beauty, and not for its mysterious hidden truth or for its metaphysical implications. Knowledge, similarly, would not be of prime importance to him. Yoshimoto observes: "The poets of today often equate learning, discussion, witticism, or epigram to linked verse. But any of these is not an essential element of poetry; it is just a piece of logical argument." Argument would better be presented in a work of prose.

The human experience embodied in a work of linked verse is in quality no different from that of ordinary life. It is only that the poet presents it in a new, refreshing way. We have already heard Yoshimoto say that an expert poet makes ordinary things look new. He says elsewhere: "The essence of linked verse lies in making everyday things look fresh." He observes, too: "Linked-verse poets, even more than lyric poets, should not go counter to the ways of the world." The writer of linked verse would neither probe an unusual, extraordinary aspect of human life nor search for a message from some strange superhuman world; such things are to be carried out by some other art form in which the artist can indulge in his personal idiosyncrasy to his heart's content. Linked verse deals with human experiences shared by every individual, with the kind of truths known to an average man. But it presents those common experiences and known truths in a wider perspective and on a firmer ground than an individual can; it has broadness of scope and depth of feeling provided only by the wisdom of many. A truth sanctioned by many may be a commonplace truth but has so much firmer reliability and broader application; the kind of beauty approved by many may be too ordinary but has so much less subjectivity

51

involved in the judgment. This is an advantage of a pragmatic theory in any field.

Linked verse, then, has its social usefulness in that it contains truths widely tested and universally accepted. It shows the norms of the society, whether good or bad; when the verse is corrupt, the society is corrupt, too. Where linked verse has a truthful spirit and straightforward expression, there is a well-governed state; it is the mirror of the society, and political leaders should make use of the fact. In this respect linked verse is even more useful than lyric poetry, as it reflects the feelings of many rather than of one.

Linked verse, furthermore, has personal usefulness. It helps man to attain a state of religious enlightenment. This is a function lyric poetry cannot well manage, for it is inherent in the very form of linked verse. Yoshimoto says:

> If one carefully studies the form of linked verse, one will note that it has little continuity of thought from one stanza to the next. A great variety of things, some thriving and others declining, some joyful and others grievous, are set side by side and move onward together; this is precisely the way of this world. The past becomes the present, spring turns to autumn, blossoms are replaced by tinted leaves, all in an instant of time; the feeling of ever-flowing change naturally emerges therefrom. Lyric poets are so much attached to their art that there have been cases in which the poet sacrificed his life for the sake of a poem, or died an untimely death as his poem was criticized.[2] There is no such thing in linked verse. Since it aims at nothing beyond the entertainment of the people present, linked verse causes no strong attachment in the poet's mind. Moreover, no person can think of other things while he participates in the mak-

2. It is likely that Yoshimoto had actual cases in mind here. Minamoto Yorizane, an eleventh-century poet, is said to have died young when a god responded to his prayer that he would give up his life if he could compose one good poem. Fujiwara Nagatō, another eleventh-century poet, became ill and finally died when one of his poems received sharp criticism from a distinguished critic of the day.

52

ing of linked verse; no malignant thought, consequently, has a chance to enter into his mind.

Linked verse helps man to attain the Buddhist way of salvation. Its form has the rhythm of actual human life, with its swiftly changing pace, its totally unpredictable turn, and its apparently chaotic arrangement of events. This life is in reality as changeful and unpredictable as linked-verse lines, so each man should try to find happiness beyond all that. To do this, he will have to purge all his worldly attachments, and linked verse will help him in this matter, too. Unlike lyric poetry, which could be an attachment in itself, linked verse is primarily a pastime with little bearing on the prestige of individual poets. It is an enjoyable game, after all, in which the participants forget all the worries of the world awhile. It helps men to transcend this mire, to look at it from a distance, even for a brief period of time.

All in all, Yoshimoto's theory of poetry is a consistent, well-founded one. If it seems to lack weight and impressiveness compared with some other poetics, it is because Yoshimoto's is a pragmatic theory that claims no extraordinary value for the poet or poetry. In his view poetry fits perfectly into the scheme of things in actual life. Verse-writing is a pastime, no more and no less. People gain pleasure out of poetry, through the process of both composing it and reading it, and these two can be done simultaneously in linked verse. Linked verse is not obliged to embody a profound truth or to present an impassioned emotion; it is asked only to be pleasurable. However, since something as subjective and elusive as the pleasure of the moment cannot be made into the criterion of poetry, Yoshimoto introduces an affective value, beauty, as the source of pleasure and makes it the standard of evaluation. Of many types of beauty the two he places above all are the beauty of elegance and the beauty of unity in variety. These are conceived largely as tonal qualities created by a subtle interplay of images and rhythms. Through words and images linked verse tries to do what music does through sound. But, unlike some Western poets of the late nineteenth century, Yoshimoto never attempts to escape from

the moral implications of words; on the contrary he believes that poetry teaches universally accepted truths in a fresh, new way. This is partly due to the fact that both the beauty of elegance and that of unity in variety are not purely tonal qualities but possess moral implications in themselves. Yoshimoto is partly aware of this when he says the variety of linked-verse lines is suggestive of the rhythm of life. He says nothing about the implications of *yūgen*, but, as will be seen in the next chapter, *yūgen* does involve a distinct attitude toward life. Yoshimoto's writings on the nature of linked verse include those and other ideas that would, if he had pursued them further, have thrown more instructive light on the essence of poetry. But we should not blame him for not probing the issues further, for he had his own doctrine, pragmatism, which could conveniently resolve them for him. After all, he was writing his theory for a single art form with its own laws, and he was most successful in doing so.

4

Zeami
on the Art of the Nō Drama

Imitation, Yūgen, and Sublimity

The aesthetics of Japanese theater reached a peak in its history with the writings of Zeami Motokiyo (1363–1443), a great actor, writer, and theorizer of the Nō drama. For one thing, the Nō was a highly refined, sophisticated art form, accepting no immature theory for itself. It had absorbed many heterogeneous elements from the outside, such as Chinese operatic drama and Japanese folk dance, Shinto rituals and Buddhist ceremonies, and popular mimetic shows and aristocratic court music, eventually integrating them all into a single, harmoniously unified art. This composite nature of the Nō placed a heavy burden on its performer, for he had to be a competent actor, singer, and dancer at the same time. Inborn gift, intensive training, and above all a never-failing passion for self-improvement were required of anyone intending to learn this art. "A man's life has an end," Zeami has said in a typical remark, "but there is no end to the pursuit of the Nō." Zeami's some twenty essays, written at various times during his long theatrical career, discuss a wide variety of topics concerning the Nō drama, but they are all permeated with his passionate concern for the perfection of his art. That is why, despite all their abstruse vocabulary and idioms, they have

a powerful appeal even to those who know little about the technical details of the medieval Japanese stage.

The most basic principle in Zeami's art theory seems to lie in the idea of imitation. "Objects to imitate are too many to enumerate here," Zeami teaches to beginning actors, "but you should study them thoroughly, because imitation is the essence of our art." Then he adds, "In principle, the aim is to imitate all objects, whatever they may be." An actor cast in a woman's role (as the Nō permitted no actress to perform on its stage) should carefully study the way in which women speak and behave in daily life. An actor who is to impersonate a high-ranking court lady has a more difficult task, because such a lady is seldom seen out of her palace. In a case like this, the actor should seek accurate information from experts on the subject. "In wearing a coat, in putting on a skirt,—in all such and similar cases," says Zeami, "do not decide by yourself. Ask the people who know." If the actor finds a noble courtier in his audience and has a chance to talk with him after the performance, this is a good opportunity to have his imitation scrutinized. "Ask him," Zeami advises, "what he thought of your performance."

Zeami goes on to explain what would happen if an actor did not follow the principle of imitation. The case in question occurs most frequently when the actor is too intent on producing some specific emotional impact upon the spectators. He might be over-anxious to create an impression of elegant beauty, for instance, which was very popular at the time. The result, as Zeami points out, is often a complete theatrical failure, for the actor has neglected the principle of imitation. The actor too anxious to produce an elegant effect often acts out his role elegantly, even in cases where the role requires him to be vigorous and forceful. In such a case, the actual effect produced will not be elegant; it will be weak instead. His performance is weak because his imitation involves a degree of falsehood. "In all acts of imitation," Zeami warns, "if there is a false element, the performance will become rough or weak." Thus, often an actor trying to create elegant beauty produces a weak effect instead; intending to bring out forcefulness from his performance, he ends up with roughness. "An actor makes such a mistake," Zeami explains,

"because he thinks that a quality like elegance or forcefulness exists independently of the object. Actually, it lies within the object itself." The beauty of elegance or forcefulness automatically emerges when the actor faithfully imitates an elegant or forceful object. If he successfully imitates a court lady, a beautiful woman, a handsome man, or various kinds of flowers, his performance will naturally become elegant, because the quality of elegance is inherent in those persons and objects. Likewise, a performance will be forceful when the actor faithfully imitates a warrior, a rustic, a demon, a deity, a pine tree, or a cedar tree, all of which have the quality of forcefulness.

Ideally, then, to imitate an object would mean that the actor becomes identical with that thing, that he dissolves himself into nothing so that the qualities inherent in the object would be naturally manifested. Zeami's way of saying this is that the actor "grows into the object." "In performing an act of imitation, of whatever object it may be," he says, "the actor should first learn how to grow into the object." "If he genuinely grows into the object," he says elsewhere, too, "his performance will be neither rough nor weak." The actor's self, in other words, should be completely absorbed by the object of his imitation. If this is successfully done, the actor will have no awareness that he is imitating an object outside of himself, for he is at one with it. The term "imitation" will no longer apply here in its ordinary sense. Zeami calls this "a realm of nonimitation." "In the art of imitation," he says, "there is a realm called 'nonimitation.' When the actor pursues the art to its ultimate and truly grows into the object, he will not be aware of his act of imitation." Identification is the ultimate form of imitation.

But how could an actor identify himself with something which he is not? By knowing the true intent of that thing, Zeami would answer. He explains this in a passage where he teaches how to act a frenzied person's role:

> To impersonate a mentally deranged person is the most interesting of all roles. Since there are so many kinds of mental derangement, an actor competent in this role would be an expert in all other roles as well. That is why this

role should be thoroughly studied. In general, a person possessed by various spirits—by, for instance, a deity, a Buddha, a wraith, or a departed soul—could be easily imitated if one knows what it is that has possessed the person. More difficult is to imitate a man who has become frenzied from having lost his parent, child, or spouse. Even a fairly good actor does not make a distinction between different kinds of frenzy but acts them all in the same manner; as a consequence the spectators are not moved. In portraying a man who is deranged because of an obsession, the actor should make the obsession the "true intent," and the derangement the "flower." An actor who performs the role with this in mind will never fail to create a glowing climax in his performance.

The "true intent," then, is that which makes the person what he is. In acting out the role of a man possessed by a deity, for instance, the actor should imitate such actions as characteristic not of any possessed person but of that specific deity, for the deity is what lies in the innermost heart of the man and what controls every one of his actions. Likewise, in imitating a person who has become frenzied the actor should first of all learn the cause of his frenzy, that specific obsession which has driven the man out of his mind. The "true intent" is the inmost nature of the man or the thing. The actor, by learning that inmost nature, can grow into that person or object.

Zeami has emphasized the importance of this throughout his essays on the art of the Nō. As he writes in one of his earliest essays, an actor performing the role of a Buddhist monk should fully express deep devotion to religion because that is what is essential to a monk. As Zeami says in one of his later essays, an actor impersonating a woman should make her heart his and then throw away all his masculine strength; he must feel as if he were born a woman. "One who mimics a woman," Zeami says, "is not a woman." Zeami cites a contemporary proverb to describe such an incomplete act of imitation: "It looks similar, but does not look right." It is an imitation of the outward only; it has failed to catch the true intent.

58

Imitation, in this special sense, is the most basic principle of Nō acting. But there are some cases in which that principle must be somewhat modified. One typical instance of this is when the actor is cast in the role of a demon. Zeami writes: "By its very nature, imitating a demon involves great difficulty, for the more faithfully the actor imitates the demon, the less entertaining his performance will be. The 'true intent' of the demon lies in its horrifying quality. But horror differs from entertainment as black differs from white. Therefore, if there is an actor who entertains the audience by performing a demon's role, he should be considered a truly accomplished artist." Another such special case is when the actor portrays a man of low social status. Zeami remarks: "The actor can imitate in detail the poetic figure of a woodcutter, a grass mower, a charcoal burner, or a saltwater drawer, but not the people of meaner occupations than those. These unsightly appearances should not be shown to gentlemen and ladies of the nobility. They would be too lowly to be of delight to the noble audience. You should fully understand this. Imitation should be carried out to a greater or lesser extent, depending upon what it is that you are imitating." In imitating an object, the actor must take into consideration what effect his imitation will produce on the spectators. If the imitation is such that it would horrify or offend the spectators, that performance would be said to be theatrically unsuccessful, no matter how faithfully the principle of imitation may have been followed. The actor, therefore, must know the proper degree to which each object should be imitated. What determines the degree is the nature of the affective response that the performance creates. It is beauty, or what Zeami calls the flower.

The type of beauty that was most welcomed in the Nō can be easily imagined. It was *yūgen*, that elegant, delicate, graceful beauty which was the ideal of linked verse and of medieval Japanese culture at large. Zeami has an apt image to suggest the beauty: "a swan with a flower in its bill." The Nō actor should imitate his object in proportion to the degree to which it has the *yūgen* quality. Flowers and birds, the breeze and the moon, noble courtiers and graceful ladies, for instance, have plenty of *yūgen* in them; the actor, therefore, may imitate these to the

fullest extent on the stage. But people of lower status and occupations have less of that beauty; accordingly the actor should take less from what they are in actual life; he should get less from the outside and create more from the inside, from what Zeami calls the spirit. One might assume that this spirit is roughly equivalent to the same term as used by Yoshimoto in linked verse; it is a spirit in pursuit of elegant beauty. The Nō actor can imitate a graceful court lady without reservation, for she has that spirit in herself. But he will have to supply it from himself when he imitates a peasant, for instance, who has little of it. Therefore, when an expert actor is on the stage the beauty of *yūgen* is always there; this is so no matter how many different roles he may perform. Zeami has an apt simile: "This would be like looking at court ladies of high and low ranks, men and women, monks and rustics, even beggars and outcasts, all adorned with a spray of blossoms." Then comes Zeami's explanation: "This spray of blossoms is the beauty of form. What creates a good form is the spirit." When an actor who has this spirit performs a demon's role, even the horrifying demon comes to assume some strange beauty; Zeami describes it as "blossoms on a crag." Even a withered old man can be made beautiful by an actor who has this spirit; Zeami describes the beauty as "blossoms on a dead tree." Kannami, Zeami's father and a celebrated Nō actor, had this spirit: his performance in his old age is compared to an aged tree that has very few branches and leaves but still retains its most beautiful blossoms.

Yūgen, then, is the beauty not merely of appearance but of the spirit; it is inner beauty manifesting itself outwards. The emphasis on inner beauty, as against the beauty of the outward appearance, is inevitable so long as the imitation in the Nō is of the inward spirit, of the true intent. It is the beauty of the innermost nature of things, the beauty of hidden truth. If the term *yūgen* is etymologically analyzed, it will be found that *yū* means deep, dim, or difficult to see, and that *gen*, originally describing the dark, profound, tranquil color of the universe, refers to the Taoist concept of truth. Zeami's idea of *yūgen* seems to combine its conventional meaning of elegant beauty with its original

meaning of profound, mysterious truth of the universe. Zeami perceived mysterious beauty in cosmic truth; beauty was the color of truth, so to speak.

If *yūgen* contains cosmic truth underneath, it must necessarily have pessimistic implications, for the truth of the universe always points toward the sad destiny of man. When man is set against the great cosmic power, the vision is always a sad, melancholy one; it is all the more so when conceived in medieval Japanese terms. Thus *yūgen*, in its broader sense, has the implication of universal sadness. Zeami has examples to explain this. After pointing out that elegant court ladies in Classical times, such as Lady Aoi, Lady Yūgao, and Lady Ukifune of *The Tale of Genji*, make excellent heroines in the Nō drama, he goes on to say: "There are even better materials which produce the jewel among jewels in this respect. These rare examples are seen in such cases as Lady Aoi haunted by Lady Rokujō's spirit, Lady Yūgao taken away by a ghost, or Lady Ukifune possessed by a supernatural being, all of which provide the seed for superb *yūgen* flowers." Noble court ladies are gracefully beautiful in themselves, but they would be even more lovely when they suffer under some strange power beyond their control, under some mysterious force hidden in the universe. Aoi, Yūgao, and Ukifune have to suffer (and die in the first two instances) from causes for which they are not responsible. That is the sad fate of mankind. Even the most beautiful and accomplished person cannot escape from the sufferings common to all men. *Yūgen* is the beauty of seeing such an ideal person go through an intense suffering as a result of being human. Thus one definition of *yūgen*, attributed to Zeami, reads: "elegance, calm, profundity, mixed with the feeling of mutability."

Of the two principal elements of *yūgen*, elegant beauty and sadness of human life, Zeami emphasized the first in his early essays but steadily shifted the emphasis to the second as he grew older. The difference in emphasis is most clearly seen when he classifies Nō singings in terms of their emotive effects. Of the five categories he sets up, elegant singing comes second. Its beauty is described as that of "looking at both a morning and an evening

scene of blossoms and the moon in one view." In another meta-
phor, it is compared to a cherry tree. In a third comparison, it is
likened to the effect of this poem:

> Shall I ever see again
> Such a beautiful blossom hunting
> On the field of Katano,[1]
> Where white flakes fall
> Like the snow at spring dawn?

One is reminded of the image of "a swan with a flower in its bill."
Cherry blossoms, beautiful in pure white, are dimly seen in the
serene darkness of the spring dawn. They are elegantly, ex-
quisitely beautiful. Moreover, those lovely petals are falling as
quietly as snow—and as if to symbolize the mutability of life.

Next comes a type called love singing. It is as gentle and beau-
tiful as elegant singing, but it has an added element—pathos.
The pathos is that of longing for someone dear missing. The fol-
lowing poem has been cited by Zeami as producing a comparable
effect:

> Tinted leaves begin to fall
> From one side of the forest
> As it rains in the evening
> And drenches a deer
> Lonesomely calling for its mate.

Now the season has changed from spring to autumn, and nature
from cherry blossoms to maple leaves. With approaching winter
in the background, a deer is lonesomely calling for its missing
mate in the cold rain. The image certainly suggests a degree of
pathos.

Sadness increases even more in the next type of singing, called
sorrowful singing. The season is now winter, and all trees are
bare. "Flowery spring and tinted autumn are both over," writes
Zeami. "Nipped by frost and buried in snow, trees in winter

1. Katano, located near present Osaka, was the Imperial Hunting
Ground and was famous for its cherry blossoms, too. As hunting is a winter
sport, the comparison of cherry blossoms to snowflakes in the poem is es-
pecially fitting.

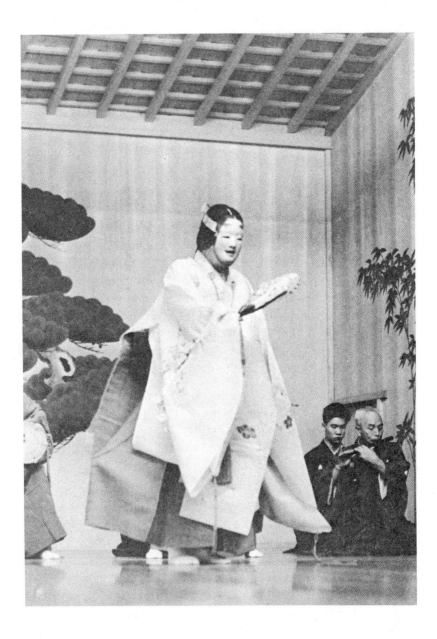

Plate 3
In this scene from the Nō play, *Hajitomi*, the lovely heroine,
apparently Lady Yūgao's ghost, tells how she put
a white flower on her fan and had it presented to Prince Genji.

stand with bare branches, as if mournfully recalling the men and things that have passed away." The poem which exemplifies the mood is:

> Even on a mountain
> Devoid of feelings, there grow
> The Trees of Sorrow.[2]
> How much more so
> In the heart of a deserted lover!

What has been expressed only indirectly in elegant and love singings now becomes more intense, so much so that it turns into a direct outcry of sorrow. The nature of sorrow, however, remains unchanged; it is the sadness over the impermanence of things in this world. The year must sooner or later come to cold winter, and love must eventually end in grief.

Thus we see elegant beauty gradually yielding its place to sadness of life as we move from the second to the third and then to the fourth type of Nō singing as categorized by Zeami. Sadness, indeed, is the dominating mood in the fourth type. Zeami, however, did not stop here: he had the fifth and final type called "sublime" singing, and he rated it above all others. "Sublime singing is the result of consummate artistry," Zeami observes. "This rank can be attained only after the singer learns the ultimate of all other singings, transcends both the good and evil of music, and arrives at the kind of singing that is like others and yet is not." Zeami's metaphor for sublime singing is a cedar tree, and the following poem is cited for illustration:

> With the years that have passed by
> It has grown austere and holy
> On Mount Kagu:[3]
> The cedar tree, upright like a spear,
> Already has a layer of moss at the root.

Impermanence, which imprisons all men and things in this world, has now been transcended. The cedar, being an evergreen

2. Firewood. It is called a Tree of Sorrow because the Japanese word for firewood, *nageki,* also has the meaning of "sorrow."

3. Mount Kagu is located near Nara. It was considered a holy mountain, as it was believed to have descended from heaven.

tree, symbolizes permanence in nature. Being a holy tree in Shintoism, it also stands for a man who has attained divine immortality. Sadness is no longer there, because death has been overcome. There is neither the graceful beauty of elegant singing nor the cold beauty of sorrowful singing; the beauty here is that of austerity, deep, tranquil, and awesome. And that is the effect produced by sublime singing.

The meaning of Zeami's sublimity will be further clarified when it is seen in the context of an elaborate scheme he devised in order to define and evaluate the emotional impacts of various Nō performances. Zeami has classified all theatrical effects into nine categories and given each a name and a rank. These are, from the lower to the higher, (1) Roughness and Aberrance, (2) Strength and Roughness, (3) Strength and Delicacy, (4) Shallowness and Loveliness, (5) Broadness and Minuteness, (6) a Right Flower, (7) a Calm Flower, (8) a Profound Flower, and (9) a Mysterious Flower. The element of *yūgen* is latent in all styles except the first three. The quality of sublimity lies only in the final three styles.

The Style of Roughness and Aberrance is the lowest of all styles. As the name shows, this style has no delicacy and it has deviated from the orthodox manners of Nō performance. Zeami compares the style to a flying squirrel. In the Confucian tradition, a flying squirrel is an animal with five talents—climbing, swimming, digging, flying, and running—but they are all commonplace talents. Likewise, when a Nō actor of mediocre talents performs a play, he will produce a crude, uninspiring effect even though he follows the technical details of the theater. The performance will be rough and unrefined, far below the desired standard.

The Style of Strength and Roughness is a little better, because it is at any rate forceful. Zeami quotes an old saying to describe it: "A three-day-old tiger cub already has a temper fiery enough to devour an ox." Again the Nō performance of this category has no grace or refinement, but it has a vital force that moves the audience.

The Style of Strength and Delicacy supersedes the two previous styles, obviously because of its added element of delicacy.

Zeami's way of suggesting the effect of this style is: "As the metal hammer moves, the precious sword emits a cold gleam." The element of strength is symbolized in the heavy metal hammer held in the muscular hand of a swordsmith. But that strength is used, not to devour an ox, but to create a delicate work of art, a precious sword. The sword, in fact, is emitting a serene gleam from its blade. A Nō performance belonging to this category will have a similar emotive effect.

The Style of Roughness and Aberrance, the Style of Strength and Roughness, and the Style of Strength and Delicacy are the lowest three, because they lack the quality of *yūgen*. A beginning student in the Nō, therefore, should avoid those styles; he should begin with the fourth style, Shallowness and Loveliness, and work upward from there. After attaining the ninth and highest style, he can then come down and perform in the lowest three styles. Those three styles can be made interesting only when played by a most competent performer, an actor who fully knows what *yūgen* is.

So the beginner's style, Shallowness and Loveliness, has a bit of *yūgen*—Loveliness implies *yūgen*, although it is yet of a shallow kind. To explain the style Zeami cites the very opening line of the *Lao Tzu*: "The Way of ways is not an ordinary way." As it seems, Zeami is giving a warning to his beginning students, as Lao Tzu is doing the same to his. There are various ways in the art of the Nō, but they all begin with and return to the Way, *yūgen*, just as in Taoism all ways derive from and lead to the Way, Tao. "Advance along the ways, and learn what the Way is like," Zeami advises. "Loveliness could manifest itself even at an early stage of apprenticeship." A Nō performance in this style may show the actor's artistic immaturity as yet, but it will nevertheless have a bit of loveliness if the actor has begun to understand what *yūgen* is.

The performer's art widens and deepens in the next higher rank, the Style of Broadness and Minuteness. As the name shows, the actor now has both depth and versatility. Zeami tries to illustrate it through a Zen saying: "The hearts of mountains, clouds, seas, and the moon are all told." The student has mastered the art of imitation and knows the true intent of all things

in the universe; accordingly, when he performs a role on the stage, he can tell through his performance all about the heart of the object he is impersonating. Of course *yūgen* is there: mountains, clouds, seas, and the moon are elegant objects, and even when he portrays something not elegant in itself, he will make it look so out of his artistry.

The highest of the middle three ranks is called the Style of a Right Flower. The term "flower," which indicates an impressive theatrical effect, appears here for the first time. The actor has attained the flower because he has been making progress along the right road. Zeami illustrates the Right Flower by a colorful line: "The spring haze brightens in the setting sun. All mountains in sight are gleaming in crimson." This is natural beauty at its most colorful. The effect is somewhat like the beauty of myriad cherry blossoms in full bloom on the field of Katano, as described in a poem quoted by Zeami elsewhere. *Yūgen* has now blossomed into a most lovely flower.

In Zeami's view, however, a performance producing such dazzling beauty is not quite the ultimate of the Nō, for there are still three more ranks remaining at the top of the scheme. These would be the ones that fall in the category of the sublime singing, although Zeami nowhere says so in plain terms. Common to the highest three ranks is the quality of quiet, subdued beauty, which is, as we recall, the main characteristic of sublimity.

The Style of a Calm Flower occupies the lowest of the top three ranks. The essence of this style is explained by a citation from Zen: "Snow is piled in a silver bowl." If the Style of a Right Flower is the ultimate of the colorful, this style is the ultimate of colorless beauty, the beauty of pure whiteness as symbolized by snow and the silver bowl. Furthermore, the snow, that wonder of nature, is contained in the silver bowl, that wonder of artistry. Art is the vessel containing the purest beauty of nature; art and nature are harmoniously united in the beauty of whiteness.

One rank higher than the Style of a Calm Flower is the Style of a Profound Flower. To describe this style Zeami again relies on a Zen saying: "Snow has covered thousands of mountains. Why is it that a solitary mountain towers unwhitened among them?" Again the setting is of natural beauty and of pure white-

ness, this time on a larger scale. But there is an irrational ele-
ment in that beautiful picture: a black peak towering among
snow-covered mountains. The other world has now begun to
invade the world of the ordinary senses. Natural beauty is not
enough; there must be the beauty of the supernatural, a strange
kind of beauty perceptible to only those supreme artists who are
endowed with extraordinary sensitivity. A Nō actor able to per-
form the Style of a Profound Flower leads his spectators to a state
of trance, in which they can appreciate the beauty of the strange
and wondrous.

Beauty of the supernatural exists only in part in the Style of a
Profound Flower. It thoroughly pervades the Style of a Mys-
terious Flower, the highest of all nine ranks. Zeami, while con-
ceding that this style is beyond description, attempts to illustrate
it by another Zen epigram: "In Silla the sun shines brightly at
midnight." The statement is apparently a flat contradiction.
But it may not be a contradiction to those who can transcend the
limitations of time and space. Silla, part of present Korea, is lo-
cated to the east of China; the sun shines brightly there when it
is still night in China. A person in China would be able to see
the bright sun at midnight, if only he could overcome the limita-
tion of space and see the sky of Korea. We see contradictions in
the universe only because we are confined within space and time.
Once we transcend our limited senses, what we have hitherto
seen as contradictions may not be contradictions. A superb Nō
actor, through the Style of a Mysterious Flower, makes us visual-
ize such a transcendental world, a world of higher reality lying
beyond our ordinary senses. It is a realm of permanence, of im-
mortal souls. At its sight we are struck with the feeling of auster-
ity. Such is the impact of a sublime performance.

According to Zeami's idea, then, the Nō is a symbolic drama.
The idea seems to be valid when applied to actual Nō plays
remaining today. The protagonist of the Nō is usually some
strange being from the other world: a deity, a spirit, the departed
soul of a man, and the like. The core of the play consists of an ac-
count of life narrated by such a protagonist, a transcendental be-
ing who has been to the other world as well as to our world. We
cannot directly see him or hear him talk; we can do that only

through a medium, the deuteragonist of the play, who, aptly, is a Buddhist monk. The protagonist appears in the monk's dream, and we, together with the monk, come to know what the world of dreams is like. That world, of course, is expressed in terms of the things of this world, for this is the only way we can perceive it. In short, the things that appear in the play are symbols. The artist is a manipulator of symbols.

The view that art is magic thus lies in the center of Zeami's aesthetics. This is not a unique view in itself, but Zeami has expressed it in such a beautifully metaphorical language. The following is one of those passages in which Zeami explains the nature of art and the artist:

> If we explain this by comparing it to the notion of Being and Non-Being in Buddhism, Being corresponds to the appearance and Non-Being to the vessel. It is a Non-Being which engenders Being. This is like a crystal, which is transparent and devoid of color or design, yet produces fire and water out of itself. Why is it that two heterogeneous matters like fire and water emerge from a single transparent object? There is a poem saying:
>
>> Smash a cherry tree
>> And you will find no flower
>> In the splinters.
>> It is in the sky of spring
>> That cherry blossoms bloom.
>
> The seed of the flower that blossoms out in all works of art lies in the artist's soul. Just as a transparent crystal produces fire and water, or a colorless cherry tree bears blossoms and fruit, a superb artist creates a moving work of art out of a landscape within his soul. It is such a person that can be called a vessel. Works of art are many and various, some singing of the moon and the breeze on the occasion of a festival, others admiring the blossoms and the birds at an outdoor excursion. The universe is a vessel containing all things—flowers and leaves, the snow and the moon, mountains and seas, trees and grass, the animate and the inanimate—according to the season of the year. Make those

numerous things the material of your art, let your soul be
the vessel of the universe, and set it in the spacious, tranquil
way of the void. You will then be able to attain the ultimate
of art, the Mysterious Flower.

Running through the passage is a contrast between two sets
of reality, ordinary and higher, as symbolized by a series of dif-
ferent images. Ordinary reality is perceptible through our senses,
like cherry blossoms, fire, and water; it is appearance, or Being.
But ordinary reality is in truth a manifestation of higher reality,
the reality whose essence is hidden and remains unnoticed in
ordinary human life. In its colorlessness and intangibility, higher
reality may be compared to a crystal or a cherry tree without
blossoms. The artist, endowed with extra sensitivity, can see a
glimpse of it and come to conceive a strange landscape within
his soul. When he expresses the landscape by means of art, there
emerges a moving work. The work of art is the expression of a
microcosm formed inside the artist's soul. In the sense that each
artist contains this microcosm within himself, he can be said to
be a vessel. It is for this reason that he is creative, that he can
create everything out of nothing. Thus the artist can be com-
pared to the universe, which produces thousands of things out
of itself. The mysteries of the universe are the mysteries of art,
which eventually bloom into the Mysterious Flower.

Having such symbolic nature, the Nō, as conceived by Zeami,
inevitably approaches close to music on one hand and to religion
on the other. The Nō must rely on the instantaneous emotive
power of music inasmuch as it aims not to analyze social problems
but to represent ultimate reality lying beyond the realm of the
intellect. Music, the most sensuous among the means of com-
munication, is least controlled by reason and is most appealing
to the imagination. Thus the Nō play has no dramatic structure
in the Western sense; it has little plot and less characterization.
Instead it has ample music; all the actor's lines are recited in
rhythmical speech, with the accompaniment of orchestral music.
Zeami has declared: "Music is the soul of the Nō." The structure
of the Nō is musically conceived: it has *jo, ha,* and *kyū*, like tra-
ditional Japanese music. The rhythm of the Nō play is suggestive

of the great hidden law of the universe; it is, in fact, the universal rhythm of life. "All things in the universe, good or evil, large or small, animate or inanimate, have each the rhythm of *jo, ha,* and *kyū,*" Zeami says. "It is observed even in such things as a bird's singing or an insect's chirping." "Everything has *jo, ha,* and *kyū,*" he says elsewhere. "The Nō follows that, too." In the Nō a segment of life is presented, not as an accumulation of different parts, but as an integral entity animated with a living rhythm. As the universe gives each object of nature a rhythm of life, so does the artist pour life into his work through the rhythm of nature. It follows that the language of the Nō must be rhythmical, too; it must be poetry. Zeami, who has advised his students to sacrifice all other pursuits for the sake of the Nō, makes an exception for poetry. A Nō writer is required to be a good poet, too.

The musical quality of the Nō is well described by Zeami through the metaphor of a flowing stream. Water flows slowly and peacefully on a spacious plain. It rushes on, whirling and bubbling, as it comes to the rapids. A landscape gardener imitates all this in making a garden; he creates a beautiful stream, with falls, rapids, curves, deep pools, sunken rocks, and many other things at proper places along its course. The Nō writer should be such a gardener in composing his work, too. He will put forth the "landscape within his soul" by manipulating the varying rhythm of nature. He will use auditory symbols suggestive of intangible reality.

If the Nō intends to present the mysteries of the cosmos by means of visual and auditory symbols, its relationship to religion is obvious, for religion tries to teach the mysterious truths of pre- and after-life through a symbolic or metaphysical system, too. The Nō is a religious drama; it is a ritual. The implications of the Nō are predominantly Buddhist; they point toward a Buddhist scheme of salvation. In many Nō plays the protagonist is a sinner, a sinner not because he has committed a crime against society, but because he has suffered from the limitations of humanity, because he was born a human being. Thus he cannot be saved by human means. In his lifetime, however, he was not even aware of his sin; it is only after death that he discovers what life really is and how sinful it is. The awakening, coupled with

70

the prayer of the deuteragonist (who is a monk), redeems him at the end of the play. The spectators, while they watch the protagonist's spiritual metamorphosis enacted on the stage, come to feel their souls purified and elevated. Such is the purging effect of the Nō.

No doubt Zeami believed in the oneness of art and religion. In one of his last essays he quotes a famous Zen saying: "All laws return to the Law. Where does the Law return to? It returns to all laws." This must have been one of his lifelong mottoes in both art and religion. We have already seen his many quotations from religious texts in describing the ultimate of art, too. Zeami, well disciplined in religious classics in his young days, later entered the priesthood. There is even a record of miracles coming upon him. Did he indeed attain the ultimate of religion, that calm, enlightened state of mind, through art? Sadly, the answer seems to be in the negative. Testifying to it is his mournful confession in the last of his essays on the Nō, which he wrote when met by the untimely death of Motomasa, his eldest son and a talented actor who had seemed to promise a bright future for the Nō drama after Zeami's time. It reads: "I had bequeathed all the secrets of our art to Motomasa and had been calmly waiting for death's call. Then all of a sudden Motomasa died, ending the line of our art and bringing our theater to a close. My grandsons are yet small, and there is no one else who will inherit our art. When I think of this my aged heart feels so much sinful attachment as to disturb my readiness for death." As Zeami had always thought, art would eventually lead the artist to the calm, to a serenity of mind. Imitation was a way to penetrate the surface and reach for hidden reality. *Yūgen* was a way to resign oneself to the sadness of that hidden reality. Sublimity was a way to accept that reality with calm of mind. Yet Zeami had to discover, near the end of his life, that art was not religion after all. Religion, emphasizing the world beyond, preached the abandonment of all things in this life, including art itself. Art, even the impersonal art of the Nō, had to be of this world as long as it was written by human playwrights, performed by human actors, and appreciated by human spectators. Zeami could not attain Nirvana as long as he remained an artist.

71

5

Sennō
on the Art of Flower Arrangement

Art and
Vegetable Life

The aesthetics of flower arrangement is interesting partly because it treats an art that depends upon the beauty of nature to an unusually large degree. Flowers are beautiful in themselves, demanding no special orientation on the part of those who see and appreciate them. In this respect flower arrangement can be said to be an art far less sophisticated than, say, linked verse or the Nō drama. In point of fact it is no elaborate art in many areas of the world; people can and do enjoy a flower as it is, or as they casually put it in a vase, without ever bothering about the rules of arranging it. In Japan, however, flower arrangement has become a fully developed, mature art, with a number of fixed rules, technical disciplines, and underlying philosophical ideas. Not only was it popular in medieval times, but it is still thriving today with some two thousand specialized schools teaching that art. The largest of the schools, called Ikenobō, boasts of having more than one million students all over the country.

Unfortunately, despite its long history Japanese floral art has not had a great theorist to give it a solid theoretical basis, as did Tsurayuki in poetry or Zeami in drama. We are, however, not without a few documents written by some masters in the past which, though in a fragmentary way, explain the basic prin-

ciples of flower arrangement. One of the best known is a short essay written in 1542 by Sennō (d. 1555?), the twenty-eighth headmaster of the Ikenobō school. To be exact, Sennō was not wholly responsible for its contents because, as the postscript says, he merely copied from a secret book of his family. Be that as it may, the piece has remained as one of the most important writings on Japanese floral art throughout the centuries.

Sennō begins the essay with a reference to the history of Japanese flower arrangement, thereby clarifying the identity of his school:

> The practice of putting flowers in a vase goes back to ancient times. But in those days people adored beautiful flowers only; they arranged flowers without really knowing the profound meaning of nature. In contrast, the basic aim of our school is to bring a scene of nature into a man's home, a scene of various plants naturally growing on the fields, hills, and waters, where flowers and leaves take on a most beautiful form. This art was initiated by our ancestors with this aim in mind, and it is now practiced as an amusement by all people in urban and rural areas.

The earliest document in Japan that refers to flowers set in a vase is *The Collection of Ten Thousand Leaves* ("Manyō Shū"),[1] an anthology of poems composed in the eighth century and earlier. Various books written in the subsequent centuries show that the people of those days enjoyed putting in vases such flowers and plants as lotus, cherry, willow, iris, plum, wistaria, and pine. The famous *Pillow Book* ("Makura no Sōshi")[2] of Sei Shōnagon has this description: "By the railing on the veranda stood a huge celadon vase with many branches of cherry blossoms, all about five feet long, beautifully blooming over the

1. The earliest anthology of Japanese poetry, completed some time in the eighth century. It contains some 4,500 poems composed by all classes of people in that century and earlier. Its complete English translation, undertaken by J. L. Pierson, is now in progress (Leiden, 1929–).

2. A collection of witty essays by a lady who served at the Imperial Court in the last years of the tenth century. Written in a superbly polished style, it presents a vivid picture of the contemporary court life. Several English translations are available.

rails." The latter half of the fourteenth century witnessed the beginning of "flower contests," in which contestants brought flowers to be judged for their beauty. In the early fifteenth century flower exhibits much like the ones today were begun. But in those days, as Sennō notes, people enjoyed lovely flowers only, or else they appreciated all kinds of beautiful vases in which the flowers were arranged. The Ikenobō school, as Sennō insists, is different from this tradition in that it emphasizes the beauty of plants naturally growing on the land and water, rather than the beauty of flowers *per se*. A most colorful flower might prove unattractive if it is arranged against the laws of nature. The imitation of nature is the basis of floral art.

How can the floral artist imitate nature according to its laws, then? At the most elementary level, he will carefully observe the ways in which plants grow in nature and will faithfully reproduce them in his work. Another secret book of the Ikenobō school, called *The Selections from a Recluse's Teaching* ("Senden Shō")[3] and apparently written somewhat earlier than Sennō's essay, is quite clear about this. "Whether you use a flower or a tree," it says, "you should make a tall plant tall and a low-growing plant low." Sennō is more specific: he enumerates the names of the plants which should not be made tall when arranged in a vase. They are: common marigold, hare's foot fern, osmund, butterbur flower, mountain anise, lobelia, gardenia, azalea, nut grass, plantain lily, candock, gentian, broom plant, swamp lettuce, serissa. If any of these plants should stand high above the vase, a law of nature would be breached and a poor work of art would result.

Likewise, other things that seldom or never take place in nature should be carefully avoided in floral art. Sennō lists a number of things prohibited in flower arrangement on this account: "Do not use a flower without the leaves. Insert nothing between a flower and its leaves. Do not wrap up a tree with grass, or *vice versa*. Branches and leaves should not touch the water. Branches

3. Also called *How to Arrange Ten Thousand Flowers*, it is a collection of various rules of flower arrangement existent at the time. One theory has it that Sennō himself was the author.

should not intersect one another; twigs on the same branch, however, can cross each other. No branch or leaf should droop lower than the top of the vase. The stem of a large flower should not be cut too short." Behind these rules lies the idea that one should imitate the norms, and not the exceptions, of natural scenes and phenomena.

Most plants in nature rely on sunshine for healthy existence, and their growth is conditioned by the sun in numerous ways. The floral artist should carefully observe these facts and do nothing contradictory to them. Sennō writes, for example, "No branch should point backward to the wall"; no tree in nature has a branch growing toward a wall or a large rock. Again he teaches: "If you are going to put a plant under an overhanging branch of another plant, you should allow about two inches of space between them"; under a wide branch of a tree nothing grows tall. These and other rules pertaining to the relationship between the sun and the flower should be carefully observed in arranging flowers.

The relationship between the sun and the plant, however, goes much further into the heart of floral art and forms a basic principle of form. In general, three kinds of branches will grow from a plant, depending upon their relation to the sun. The first kind of branch will come out when the sunshine falls from straight above; the branch will grow upright toward the sky. The second kind is a branch on the shady side of the plant; it will grow high and parallel to the trunk. The third is a branch on the sunny side; it will spread low and away from the trunk. Floral art observes this rule and applies it to the three main branches that constitute the basic structure of a work of flower arrangement. The center branch, called *shin* or the "true branch," is the tallest and points straight upward. The one in the back, called *soe* or the "accompanying branch," is the next longer and grows close to the true branch. The one in front, named *nagashi* or the "flowing branch," is the shortest and grows away from the central branch. As shown in Plate 4, this is as if two objects, *B* and *C*, were keeping a perfect balance on the fulcrum *A*, lighter *C* being placed farther from *A* than heavier

B. No matter how many branches or plants one may use in a vase, one must always observe this principle of balance that controls the three main branches.

The Rikka or Standing Flowers, the most formal and stylized of Japanese flower arrangement prevalent in the sixteenth century and for which Sennō wrote his essay, is an elaboration of this three-branch form. In addition to *shin, soe,* and *nagashi,* it has four more basic branches: *soe-uke, mikoshi, shō-shin,* and *maeoki. Soe-uke* means the "branch that receives *soe*"; it is a short branch extending sideways on the other side of *soe,* thus providing a force that counterbalances the strength of long, upward-growing *shin* and *soe. Mikoshi,* or the "overlooking branch," goes over and above *soe-uke* and gives the sense of distance and dimension. *Shō-shin,* or the "small *shin,*" is a short branch located in the center; in contrast to the long, upright *shin* it produces the feeling of weight and stability. *Maeoki,* which means the "front-laid," is some small plant placed at the front bottom in order to cover the roots of other plants just above the water. Around those seven branches some other subsidiary branches are put in to complete a work of the Rikka, but they are all well proportioned and spaced so that none of them will disturb the sense of balance the whole arrangement produces.

This feeling of balance, which controls the length and position of every branch in the vase, rules numerous other aspects of floral art also. In every phase of floral art one should aim at balance, but not symmetry, because it is the way plants grow in nature. One should therefore try to harmonize two disparate, often opposing, elements of form and color rather than to combine two homogeneous equals. Some of the most frequently used pairs of contrast in floral art are the strong and the weak, the dense and the sparse, the long and the short, the thick and the thin, the broad and the narrow, the round and the angular, the growing and the shrunken, the straight and the crooked. A good work of flower arrangement is a neatly balanced combination of some or all of those contrasts.

Many of Sennō's concrete teachings are along this line. He says, for instance, "If you have a plant with long branches or leaves on one side, complement it with a short plant which has

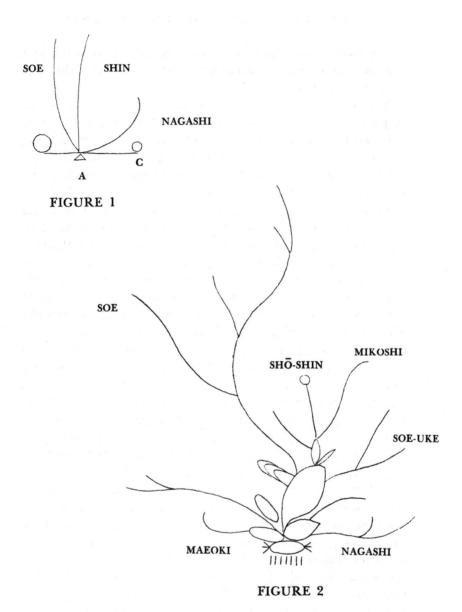

SOE SHIN

NAGASHI

C

A

FIGURE 1

SOE

SHŌ-SHIN MIKOSHI

SOE-UKE

MAEOKI NAGASHI

FIGURE 2

Plate 4
The basic branches of the Rikka, the oldest and most formal of the
styles of Japanese flower arrangement.

thick branches or leaves on the other side. If the one has open branches, the other should have closed ones. If the one is tall, the other must be low; if the one is broad, the other must be pointed; if the one goes up, the other must come down. Use a delicate plant beside a stout one, and a slender plant beside a thick one." Or: "As for the branches near the water, the one must be higher and the other lower. They should not be too sparse, but should not give the impression of being tightly forced in, either. You should unite them close together without making them look so." Sennō's principle of avoiding symmetry is even more clear in some of his other teachings:

> Do not use two plants of the same kind in one vase. You may, however, use them if the color of one flower is different from that of the other.

> There are "shade" leaves and "light" leaves. If there are some leaves facing the sun, there must be others growing in the shade.

> If you have a branch with three blossoms, avoid letting a lone blossom face the front. If your branch has five blossoms, turn three of them toward the front; if it has three, let the two open toward the front.

Sometimes three vases are used as one set. The principle of contrast must be applied in this case, too: "When a set of three vases is used, pay close attention to the choice of *maeoki* in the two accompanying vases. If you use some flowers or grass in the one, put some tree branches in the other. If you have a plant with broad leaves in one vase, you must choose something with small leaves for the other. Use plants of different shape and color so that the one vase will not look similar to the other." As may be imagined, harmony should be observed not only among the plants in the vase but also between the plants and the vase: "If you have a vase with a large mouth, let your flower open high above. If the vase has a medium-size mouth, let the flower open at the medium height. In the case of a vase with a small mouth, let the flower open near the water." Furthermore, the position of the vase in the room demands serious thinking. One must

77

arrange flowers in such a way that they make perfect harmony with the rest of the room: "If you are arranging flowers for a vase put under the shelf, let your *shin* extend a little sideways while keeping its normal length. Do not make it high. No branch or leaf should extend outside the alcove." The room itself must have an atmosphere suitable for flower arrangement. Among the concrete instructions Sennō gives are these:

> Spread out a rug, a Chinese mat, a leopard's or a tiger's skin on the veranda. Set out a bamboo chair, or other kind of simple chair, as well as shoes. Also prepare a fan, a broom, a cane, a straw hat, or a scroll table, as would fit the occasion.

> As for the back compartment, place a long sword on the left and a halberd on the right. Place a set of armour in the center, with a helmet on it. Hang a drape in front of them and roll it up a foot or so.

> From the end of spring through early autumn, hang a wind-bell above the wide veranda or at the edge of the study. From late autumn to early spring let it hang from the ceiling of the room.

> Place a brazier in the room for the six months of winter and spring. There is a series of instructions as to the manner of putting charcoal in it.

Here we see floral art determining almost every detail of interior decoration. It is as if every piece of furniture were selected and arranged for the proper appreciation of the flowers placed in the room. One could almost say that floral art provided a center of daily life.

How close the art of flower arrangement was to the heart of medieval Japanese life is amply illustrated by the fact that it was an indispensable part of various observances and festivities, religious or secular. Flower arrangement played a part at a Buddhist ceremony, at a Shinto ritual, at a poetry contest, at a wedding, at a seasonal rite, at a war camp, and so forth. As usual Sennō sets down the details:

For prayer and dedication, use for *shin* a straight plant with thick branches and leaves. The next tallest plant should be erected on the side of the deity. For a verse-writing party, set the flowers on the right-hand side of the holy image. Similar care should be taken on other similar occasions.

At a wedding ceremony, do not use a crooked plant, a dead branch, or a branch with torn leaves. Make use of a pair of straight plants with fresh leaves, or young branches, or "light" and "shade" leaves, or branches said to harmonize heaven and earth.

There are certain ways in which flowers are arranged at a war camp. A crooked plant, a branch with torn leaves, or a dead branch should be avoided. No camellia or hollyhock flower should be used at a castle. Use "victory" plants.

Do not use a red flower at a housewarming party. Nor should one use a flower that plays on names. On a congratulatory occasion one may use a flower blooming out of season, but not a flower blooming late in season.

Sennō goes further to list the kind of plants that can be used on a happy occasion. They are: pine, bamboo, plum, camellia, willow, aronia, pink, cockscomb, azalea, stone leek, broad bellflower, chrysanthemum, peach, pomegranate, lychnis, peony, common marigold, mountain mandarin, white pine, rose mallow, Chinese rose, daffodil, lily, ginger, iris, evergreens. And there are some plants, and some ways of arrangement, which should be avoided on a day of rejoicing: copse, weed, four flowers, four leaves, four plants, four tree branches, six flowers or six leaves in a vase, a flower blooming late in season, poppy, miscanthus, gardenia, lotus, purple bamboo, aster, candock, pieris japonica, black pine, rock willow, prickly ash, rice willow, milkwort, melon, tea, cedar, azedarac, gentian, the rose of Sharon, white stone leek. This is a rather arbitrary classification of "lucky" and "unlucky" plants. The basis of classification, largely conventional, is not easy to see today. A pine tree is a lucky plant no doubt because it is evergreen and represents permanence in nature and long life in man. A bamboo plant belongs to the

same category since it grows fast and upright. A plum tree is also lucky presumably because it is the first blossoming tree of the year; it blooms even in the snow. It is easy to see why copse and weed cannot be used at a happy event. A red flower cannot be arranged at a housewarming party, since the color resembles fire. A combination of four flowers, leaves, plants, or branches must be avoided, because the Japanese word *shi*, signifying "four," also implies "death." Poppy seeds are poisonous, and so is a pieris japonica plant.

Such a categorization of flowers on the basis of their symbolic meanings evidently indicates that already in Sennō's time there was a well-established tradition of flower symbolism. One arranged flowers not just to appreciate their beauty, but to express one's feelings, such as piety, happiness, wish for long life or for victory in a war. It is not exactly the case of empathy, because the floral artist seldom expressed his *personal* feelings by his unique choice and arrangement of flowers. By and large he expressed *universalized* feelings, as it were, by means of established conventions. The underlying idea is not that one's feelings are personal and unique, but that they are universal and shared by flowers and plants in nature as well.

This idea is clearly manifested in another aspect of imitation in floral art—the season in nature. Time shows its effects on vegetation just as it does on human life. Again the masters of flower arrangement start with an elementary principle here: plants in nature are sensitive to the change of the seasons, so one must follow it carefully as one arranges flowers in a vase. For instance, as a rule one should not use a flower out of season. "It is not a good thing," says the author of *The Selection from a Recluse's Teaching*, "to leave out a flower of the season in favor of something else. The basic rule is to use the flowers of the time." As usual Sennō is more particular and gives examples of the plants that can be used in each month of the year:

In the First Month: pine, plum.
In the Second Month: willow, camellia.
In the Third Month: peach, iris.
In the Fourth Month: deutia crenata, herbaceous peony.

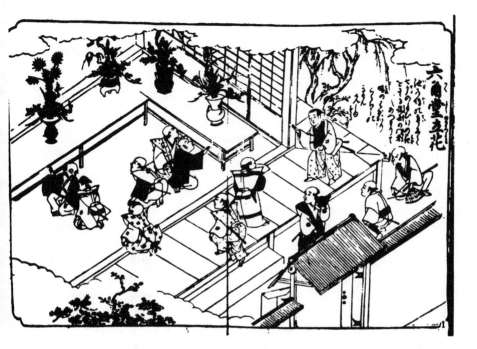

Plate 5
A floral art show in the late seventeenth century.
Held at the Rokkaku Temple in Kyoto, the show displayed the works
of flower arrangement by the contemporary Ikenobō artists.
Reprinted from *A Detailed View of the Flowering Capital*
("Karaku Saiken").

In the Fifth Month: bamboo, sweet flag.
In the Sixth Month: lily, lotus.
In the Seventh Month: broad bellflower, lychnis.
In the Eighth Month: cypress, white pine.
In the Ninth Month: chrysanthemum, cockscomb.
In the Tenth Month: Chinese cornel tree, nandin.
In the Eleventh Month: daffodil, winter chrysanthemum.
In the Twelfth Month: loquat, early plum blossom.

Sennō has other general rules concerning the season in floral art:

From late spring through early autumn, let flowers dominate your work. From late autumn through early spring, let trees take over.

When spring blossoms are fallen and when such flowers as wistaria and mountain roses begin to bloom, start using peonies, herbaceous peonies, irises, broad bellflowers, asters, lychnises, and the like. Arrange them in such a way that they stand upright and high above the water. When there comes the season for autumn flowers like chrysanthemums and gentians, your work must suggest the desolation of a withered winter moor. Perhaps it would be better to use a bit of low plants to cover the water.

Sennō's last point is quite characteristic of medieval Japanese art: one arranges flowers of winter not for their loveliness but for their mood of desolation, for their suggestion of a withered winter moor. Like Zeami's sublimity, it is not colorful beauty but subdued, austere beauty that the floral artist is here aiming at. Wintry desolation can be beautiful, because it is the way the cycle of the seasons has it. By looking at a desolate wilderness, or at a work of flower arrangement representing a winter scene, one may learn a truth of nature and of human life.

Sennō elaborates on this idea in one of the most beautiful and suggestive passages ever written on flower arrangement:

I have so many leisurely hours here at my hermitage I entertain myself by gathering some old tree branches and by

putting them in a cracked jar. As I sit watching them, various thoughts come to my mind. Mount Lu[4] and Lake Hsiang[5] are said to be scenic, but we cannot enjoy the beauty unless we go there. The jade trees and fairy pond in the Kunlung Mountains are famous, but they are rarely to be seen. Even Wang Wei's[6] painting of the Wang River cannot produce a cool breeze of summer; even Ch'ien Hsüan's[7] scroll depicting flowers cannot yield the fragrance of autumn. We shall have to labor ourselves a good deal to build a rock garden or a water fountain in our frontyard. In contrast, floral art can represent a vast scene of mountains and rivers with just a little water and small twigs; it can give a great variety of amusement within a brief period of time. It may rightly be called a miracle-worker's art. A certain poet of antiquity had his lover sleep on the seven parts of a mat, himself lying on the remaining three. Likewise I put my flower vase on the seven and myself on the three, whereupon the alcove becomes so fascinating that I am never tired of looking at it. I feel as if I were not far away from the jewelry trees and treasure ponds of Paradise, as I smell above the vase a breeze from a divine world. Buddha himself, from his earliest teachings to his most mature, has consistently taught in terms of flowers. Don't the colors blue, yellow, red, white, and black represent the Five Faculties and the Five Parts? The death of numerous flowers in winter reveals the law of change and mutability in life, too, and if in that desolate scene there is a patch of land with pine and cedar trees, that would symbolize the eternal truth of the cosmos. When Buddha was asked to give a sermon on Vulture Peak, he simply showed a flower to the audience as he turned it in his fingers. Among the

4. A famous mountain located in Chianghsi Province.
5. A scenic lake in Hunan Province.
6. Wang Wei (699–759) was a famous poet and painter in Tang times. He had a cottage along the Wang River and frequently made it the setting of his poems and paintings.
7. Ch'ien Hsüan, also called Ch'ien Shun-chü, was a Chinese painter who lived at the end of the thirteenth and beginning of the fourteenth century. He excelled in flower painting.

people who watched, Kāshyapa alone understood the meaning and smiled. Buddha's intuitive experience of the Right Law and Enlightenment, not expressible in words, was thus transmitted from one heart to another, and Buddha praised the disciple's high attainment. Hsieh Ling-yün[8] reached the stage of enlightenment as he watched peach blossoms; so did Huang Shan-ku[9] as he smelled the fragrance of Asian olive blossoms. A person who arranges flowers can not only entertain himself amid the plants of nature that change with the seasons; he might, as he watches flowers and leaves falling, hit upon an invaluable clue to enlightenment, too.

This passage, in the course of summing up the philosophy of floral art, raises some revealing points.

As has been seen, Sennō believed that the beauty of a work of flower arrangement lay not in lovely flowers but in plants naturally growing on the fields and hills. The beauty of floral art was qualitatively the same as the beauty of natural scenery. Apparently Sennō starts out with the same assumption here: ideal beauty can be found only in natural landscapes, in such places of superb beauty as Mount Lu, Lake Hsiang, and the Kunlung Mountains. He has one reservation however: one cannot enjoy the beauty of landscapes unless one actually goes there. It is significant that all the famous scenes he mentions in the passage are in remote China, and none in Japan. Significant also is his reference to jewelry trees and treasure ponds in the same breath as other actual places in China. The implication seems to be that the ideal beauty of nature does not actually exist—it can be found only in the land of dreams.

Next, Sennō takes up landscape painting and gardening. Landscape painting faithfully reproduces nature, and especially when it is done by such a master painter as Wang Wei or Ch'ien Hsüan, it achieves superb beauty. Still, as Sennō points out, a

8. Hsieh Ling-yün (384–433) was a poet of Chin in the Six dynasties. He was fond of Buddhist speculations, and some of his poems have distinctly Buddhist overtones.

9. Huang Shan-ku (1045–1105), whose real name was Huang T'ing-chien, lived toward the end of Northern Sung times. Though a Confucian in public life, he also had a solid knowledge of Buddhist philosophy.

work of painting cannot "produce a cool breeze of summer" nor "yield the fragrance of autumn." It is somehow removed from nature and does not do exactly what nature does. In this respect landscape gardening comes closer to nature, for it uses exactly what nature has for its ingredients. But landscape gardening needs a great deal of time and manpower; it is a rich man's art.

Floral art can do what those three cannot. It can produce a landscape of ideal beauty within a humble hut; it can bring forth a cool breeze in summer or a fragrance of autumn; it needs no elaborate garden in front of a palace. A work of flower arrangement, as Sennō believes, can "represent a vast scene of mountains and rivers with just a little water and small twigs," and this within a brief period of time. How can it do this? By "a miracle-worker's art," Sennō answers. We would call it symbolism.

Sennō explains the nature of symbolic representation in floral art by alluding to a love poem by an anonymous poet:

> This modest mat
> Of the rural northeast
> Consists of ten parts.
> You, my love, sleep over the seven
> While I rest on the remaining three.

Northeast Japan was an underdeveloped area, where inhabitants were poor. The poet and his wife had nothing to sleep on at night, except for a shabby mat made of ten parts. But in sharing the small mat the husband wanted his wife to sleep on seven parts of it, keeping only three for himself. Sennō compares the floral artist to the husband, and a vase of flowers to the wife. The artist will handle his material with the loving care of a devoted husband. He will suppress his ego and give plenty of room for the flowers—70 per cent for the flowers, 30 per cent for the artist. Nevertheless the man and the flowers will be harmoniously united in one in the work of floral art, just as a man and a woman are united in happy wedlock. The artist, by becoming part of the flowers and of nature, will touch on the ultimate cosmic truth and present it in his work of flower arrangement.

84

What is this ultimate truth, then? It is the same as that of religion. In fact Buddha himself used a flower for the symbol of truth, and this from the Avatamska Sutra, which collects his earliest teachings, through the Saddharma-pundarika Sutra, the most profound of all the Mahayana scriptures. The flower represents the Great Law in its various aspects. It may assume various colors—blue, yellow, red, white, and black; but the essential "flower-ness" remains unchanged. The Five Colors of flowers correspond to the Five Faculties—the eye, the ear, the nose, the tongue, and the skin—and to the Five Parts—the head, the neck, the chest, the hand, and the foot. These are located at different parts of a human body and function in different ways, but all serve for one cause as controlled by the soul. Likewise, there are the Five Powers in Buddhism: Faith, Energy, Mindfulness, Concentration, and Full Knowledge. These may at first seem to be different powers, but a person who disciplines himself in them will soon discover that all of them resort ultimately to Buddha, just as the River Ganges flows eastward into the ocean, gathering a number of streams on the way. There is, therefore, a close correspondence between the flower and the ultimate truth of the universe. Thus, according to a legend, when Buddha was asked to preach the Law on Vulture Peak, he did not say a word; he simply showed a flower to the audience, turning it in his fingers. Among eighty thousand people who saw the symbol, only Kāshyapa understood the meaning and smiled. What this disciple saw in his master's wordless teaching was the supreme experience of Buddha, an intuitive perception of the Right Law and the Way to Nirvana. In later ages there were also some who attained enlightenment by meditating on flowers. Among them Hsieh Ling-yün, a poet of the Six dynasties, received the secret message as he watched peach blossoms, and Huang Shan-ku, a poet of Northern Sung, did the same by smelling Asian olive blossoms.

Floral art, therefore, is much more than a mere diversion; when it is pursued with utmost seriousness and devotion, it serves as a means of gaining access to the world of the enlightened. Flowers, as part of nature, reveal the laws of nature and of Buddha. To take the most obvious examples, by watching

flowers fall one would perceive the brevity and mutability of life, or by finding an evergreen tree among bare trees in winter one would sense the eternity of the cosmos and of Buddha's Law. The floral artist, living amid the flowers, may gradually enter into a realm where no worldly passion troubles him. Detaching himself from intricate human relationships, he would come to live in a hermitage among the mountains and to enjoy ample hours of leisure and tranquility. He might amuse himself at times by arranging flowers in a vase, but even then his state of mind is such that he would prefer old tree branches to lovely flowers, and a cracked jar to a gorgeous vase. Simple, austere beauty would be his aesthetic ideal.

Again in Sennō's view art approaches religion. For the artist his work is important, but equally important is the process of producing the work, because it is in this process that his mind is disciplined. In fact the merit of the resultant work has more to do with the artist's devotion than with his skill or talent. In his concluding passage Sennō makes this clear: "In any art no one lacking in devotion is able to attain its ultimate. Even a person of no inborn talent may produce a moving work of art as a result of his strenuous self-discipline." Sennō has laid down a number of rules on the art of flower arrangement, but, as he warns at the end of his essay, those are merely basic principles indicating a general direction. "Learn the ways in which plants grow in nature," he says. "There is no definite rule by which you accept or repudiate certain things in flower arrangement. A similar thing can be said of any art." The beauty of a work of flower arrangement derives more from the creator's soul than from the material he has used or from the traditional rules he has adhered to. The ultimate aim of floral art is to represent nature in its inmost essence; in the process of pursuing this goal the artist disciplines his mind, perfects his personality, and becomes at one with the universe.

6

Rikyū
on the Art of the Tea Ceremony

Life as Art

The Japanese tea ceremony presents an interesting case in which art comes very close to life. Drinking tea is a matter of ordinary life, primarily related to man's physical, and not aesthetic, faculty. In point of fact it had been no art for many years in Japan until late in the medieval age, when a few great masters, including Rikyū (1522–91), laid down a series of rules and developed them into a ceremony. But, of course, a ceremony is by itself part of life; mere ceremonial rules do not create an art. In any civilized society the drinking of tea requires certain proper etiquette on the participants' part, but this is not necessarily an art. The Japanese tea ceremony, if it claims to be an art, has to justify the claim on some other ground. It has to show itself distinctly different from an ordinary tea party.

A Japanese tea master's answer would be that the tea ceremony creates an atmosphere that provides the participant with a kind of pleasure not obtainable in ordinary life. As dramatic or literary art presents an illusion of life at a level different from actual life, the tea ceremony creates a world where man is pleasurably freed from the fetters of society. There in the tea room all men become actors on the stage—temporary inhabitants of a different world. Anyone who treads the garden path to a tea room should be prepared to purify himself to enter this other world. Rikyū is reported to have said, "The first thing the host of a tea cere-

mony should do is to bring out water for the guest. The first thing the guest should do is to wash his hands with the water. In this act lies the basic meaning of the whole setting. Both the host and the guest, facing each other on the garden path, cleanse themselves of the stains of earthly life. The water basin is there for that purpose." The garden path is a row of stepping stones leading to the tea room; it is so called because it goes through a small garden with rocks and shrubs. At the symbolic level it represents a path from the ordinary world to the other world. Here the guest must cleanse himself of the impurities of ordinary life; the washing of the hands is a ritual signifying that. Having completed the ritual, he is removed from the hustle and bustle of daily life.

Obviously, then, the first rule of the tea ceremony must be that the participant bring no earthly matter into the tea room. The tea room must not be a salon where people entertain themselves in social conversation. Rikyū seems to have been particularly emphatic on this. "Do not ever bring in social gossip," he said, and then cited a poem itemizing the topics of conversation prohibited in the tea room:

> Your religion,
> Your neighbors' treasures,
> Your in-laws,
> The wars in the country,
> Virtues and vices of men.

The inclusion of religion is interesting; it shows the level at which religion was discussed in daily conversation among the people of the time. Another interesting line is "virtues and vices of men"; ethics also is barred from the tea room, insofar as it is the decorum of the ordinary, utilitarian world. Consequently all the political, military, religious, ethical, and social gossip is shut out of the tea room. This is "the dust of the soul" as Rikyū calls it in another of his didactic poems:

> The garden path
> Is a way out of this
> Grief-laden world.

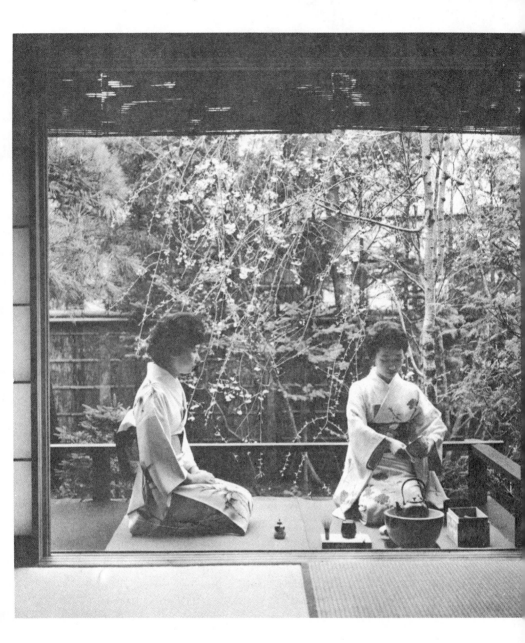

Plate 6
A tea ceremony under the blossoms.
Photo by K. Saito.

Why should you scatter there
The dust of your soul?

Stressed again is the fact that the tea room is a world completely cut off from everyday life.

It would naturally follow that social class distinction should disappear in the tea room. This is exactly the case, and it is all the more remarkable because class distinctions were far more rigid in the formative days of the tea ceremony. One of Rikyū's disciples, Nanbō Sōkei,[1] has recorded Rikyū's words on this point:

"In the tea ceremony the guest of honor always takes the head seat, no matter how high-born or lowly he may be. The seating order does not depend upon the social status of the guests. However high they may socially rank, all the guests except the main one are expected to concede the head seat. The guest of honor, on his part, should not hesitate to take the head seat when the host asks him so. This creates an enjoyable occasion well removed from ordinary life. But in recent years it is not practiced; the guests sit in the order of social ranks, often leaving the supposed guest of honor in a lower seat. The host, anticipating this, often takes precaution and invites only those who rank lower than the guest he intends to honor. A regrettable trend, indeed!" Rikyū said, sadly.

Sōkei goes on to cite an actual example in which Rikyū did what he taught. Rikyū once held a tea ceremony in honor of his friend, a person from the merchant class. A high-ranking warrior, not knowing of the event, dropped in for a visit. Rikyū welcomed him into the tea room but asked him to sit in one of the lower

1. Though mysteries surround his life, Nanbō Sōkei has been famous as the supposed author of a seven-volume book popularly known as *Nanbō's Records* ("Nanbō Roku"). It claims to be faithful records of Rikyū's teachings, and the first six volumes indeed bear Rikyū's postscripts certifying his inspection. Some recent scholars, however, have argued that the book includes a good deal of interpolations by later editors. While the question is yet to be solved, the book has no doubt much to offer to those who study the tea ceremony of Rikyū's time.

seats. The general readily complied, saying it was a matter of course.

Pursuing the same spirit, one of Rikyū's leading disciples has made a revealing comment. Yamanoue Sōji,[2] himself a renowned tea master, once taught: "Treat your guest unceremoniously if he is of an upper class. Treat him with scrupulous care if he is of a lower class." In actual life a person is always courteous to his superior, sometimes to an unnecessary extent, while daring to be rude to those below him; he is apt to carry this habit into the tea room, too. Sōji, in his usual ironical words, is warning against this practice. Treat all guests with equal courtesy, he is saying, for social status should never invade the tea room. The guests have cast off all their worldly possessions as they came along the garden path.

The tea ceremony cleanses men not only of what they possess but also of what they yearn after in their trivial daily existence. If in ordinary life they crave for wealth and luxury, in the tea room they long for a life of poverty and modesty. This idea pervades all the details of the tea ceremony. Interior decoration should be kept to the minimum in the tea room. "In most cases," says Sōkei, "the room looks better when it is not decorated with unused utensils." "Utensils in the tea room," he reiterates elsewhere, "would better be sparse." The way of arranging the utensils should be simple and plain as well. Sōkei observes: "Important is to arrange the few things in a simple way." In arranging flowers in the tea room, it is better not to use many flowers. "In a small tea room," says Sōkei, "it is always advisable to use only one kind of flower, and only one branch or two. Also the manner of arranging would better be light." Flowers with gaudy colors should not be used in the tea room. Likewise, the participants' clothes should be of a modest kind and of a subdued color. Rikyū is said to have composed the following poem to teach how to dress for the tea ceremony:

2. Yamanoue Sōji (1554–90), another great tea master from Sakai, is well known as the author of *Yamanoue Sōji's Writings* ("Yamanoue Sōji Ki"), a valuable document describing the history, rules, and ideals of the tea ceremony as conceived by one of Rikyū's leading disciples.

Change your neckband;
Wear a garment of gray cotton
 With a sash,
Socks, and a fan,
All newly cleaned.

The poem is said to have established gray as a fashionable color
among Rikyū's contemporaries. As for the dishes to be served at
the tea room, modesty is again the keynote. "In general," Sōkei
says, "serve an especially light meal. A bowl of soup and a dish
of vegetable or two should be the most. Tea cake does not have
to be served." In brief, the tea ceremony is trying to set up an
antithesis to ordinary life, to the kind of life whose aim is mate-
rial gratification. The principle is well summarized in a passage
attributed to Rikyū: "It is in earthly life that luxurious living
and dainty food are considered the source of comfort. If a person
has a shelter just sufficient to protect him from rain, and a sup-
ply of food just enough to keep him from hunger, that is all he
needs. This is the essence of the tea ceremony, as well as of
Buddha's teaching."

The idea is carried further—in the tea ceremony one should
not mind using a broken utensil. "There are some people who
loathe the slightest flaw on the utensil they use," says Sōkei.
"They do not know the spirit of the tea ceremony." They do not
know, Sōkei means to say, that poverty and modesty are the
ideal of the tea ceremony. Rikyū seems to have gone even further;
at least in one episode he preferred the imperfect to the perfect.
One day Rikyū and Jōō,[3] another great sixteenth-century tea
master under whom Rikyū himself studied tea as a youth, were
invited to a tea ceremony together with a couple of others. On
the way to the host's residence they saw a vase for sale. Jōō liked
it very much, but as he had company he said nothing at the time
and sent for it the next morning. To his disappointment, he

3. Takeno Jōō (1502–55) was one of the most influential tea masters
before Rikyū. He was the founder of the so-called Sakai school of the
tea ceremony. A wealthy merchant, he had a large collection of *objets
d'art*. He was also skilled in poetry, linked verse, flower arrangement, cal-
ligraphy, and Japanese chess.

found the vase had already been sold. Then an invitation to tea came from Rikyū, who said that he would like to show a vase he had just bought. Jōō went, now realizing that Rikyū was the one who had beaten him to the vase. Indeed there the vase was, with two camellia flowers neatly arranged in it, but, strangely enough, one of the ears of the vase had been broken off. While other guests sat wondering, Jōō said to Rikyū: "It is strange that you have chipped an ear off that vase. From the moment I saw the vase yesterday, I have been fascinated by it and kept thinking I would use it at my tea ceremony, but only after breaking off an ear. So, before I came here this morning I had planned to carry out a scheme. Thinking that it wouldn't be very interesting to chip off an ear after discussing the matter with you at the end of the ceremony, I had planned to break off an ear myself at the recess or some such time." So saying, Jōō took out a hammer from his pocket.

In this episode the idea of poverty is transformed into an aesthetic principle. To be scant and imperfect is desirable, not only because it is a morally satisfying experience, but also because it creates a certain kind of beauty. The medieval Japanese gave a name to this beauty of poverty, or beautiful poverty, and called it *wabi*. Morally interpreted, the tea ceremony presents a world free of earthly luxuries. Aesthetically viewed, it aims to produce the beauty of *wabi*.

It is difficult to describe *wabi* in expository terms, as it is a sensory effect. Medieval Japanese artists once again tried to elucidate it by quoting classical Japanese poems which they thought produced a similar effect. One of the most famous examples is a poem cited by Jōō:

> As I look ahead,
> I see neither cherry blossoms
> Nor tinted leaves:
> Only a modest hut on the coast
> In the dusk of autumn evening.

Rikyū is said to have liked to quote another poem as well as the one just cited:

> To those who await
> Only the cherry blossoms,
> How I wish to show
> Small buds sprouting out of the snow
> At a mountain village as spring comes!

Rikyū himself composed the following poem to show the essence of the tea ceremony:

> Though few passers-by
> Stop and look with attentive eyes,
> The field in spring
> Is dotted with miscellaneous flowers
> Blooming amongst the weeds.

Set side by side, those poems make fairly clear the implications of *wabi.*

Conspicuous in those poems is a contrast between two types of beauty. The one is a traditional type—gorgeous, colorful beauty like that of cherry blossoms or maple leaves. It is more obvious, lucid beauty admired by all men alike. Yet the three poems unanimously reject it in favor of the second type of beauty. This beauty is somber, subdued, and inornate, so much so that many people do not even recognize it. This does not mean that it is rarely seen; on the contrary it is everywhere—the lonesome seacoast with a fisherman's modest hut, small buds coming out of the snow at a mountain village, or miscellaneous flowers blooming amid the weeds on the roadside. It is the beauty of the rustic as against the courtly, of the common as against the luxurious, of the stout as against the fragile—of refreshing simplicity as against earthly extravagance. In the tea ceremony this type of beauty is preferred because it is more lasting; it is more lasting because it does not depend upon the senses; the beauty of a fisherman's shack, of the little buds, or of the flowering weeds is spiritual rather than sensory. It is beauty without a gleaming color. The beauty which the tea ceremony aims at must be *wabi,* so long as it tries to escape from the world of the colorful and the sensuous.

Wabi, then, is distinctly different from *yūgen*, though in their basic moral implications both try to overcome the world of colors. The beauty of *yūgen* emerges when one mournfully observes the immovable fact of life: even the most elegant and beautiful must fade with the passing of time. But *wabi* is the beauty arising out of vigorous life hidden beneath the rustic surface. It is the colorless in contrast with the colorful, but that absence of color conceals potential energy underneath, like the snow hiding a sprouting bud, or the desolate seacoast nurturing a fisherman. If it is the beauty of poverty, that poverty must contain sustained life-force in it. The tea ceremony is an escape from earthly life, but it does not escape from life. Its beauty is that of simple life quietly following its natural course.

Here *wabi* may seem to be approaching Zeami's idea of sublimity. Yet *wabi* differs from sublimity in that it presumes no transcendental force of the universe. While sublimity conquered and transcended the earthly, *wabi* merely withdraws from it. The relationship between *wabi* and the earthly is antithetical, and not dialectical. Therefore, whereas sublimity is the beauty of a supernatural and superhuman world, *wabi* is the beauty of a natural and human world, though the world is of a very specific kind. Thus while the beauty of sublimity is austere and chilly, that of *wabi* has a touch of warmth and geniality in it. It must be so, for, as against the Nō drama, which visualizes the destiny of a soul, the tea ceremony entertains living men with a cup of tea. As a matter of fact, some tea masters have defined *wabi* in purely human terms. Jōō once said, "The modern implication of *wabi* is to be honest, reserved, and modest." Kobori Enshū,[4] another of Rikyū's disciples, went to an extreme. "There is nothing special about the art of the tea ceremony," he said. "Be loyal to your lord and father; be diligent in your family duties; and be careful not to lose your friends."

One might say, then, that the discipline in *wabi* takes man out of his ordinary life, but unlike the Nō it does not lead him

4. Kobori Enshū (1579–1647) was a daimio and all-round artist who taught the tea ceremony to a large number of people, including the third Shogun himself. He, too, founded a new branch of the tea ceremony, called the Enshū school.

to a realm as distant as beyond the grave. In the tea ceremony
man remains within a human world, and in that sense it is not
religious. Here the tea ceremony, at least in Rikyū's school, marks
a distinct departure from medieval Japanese Buddhism, such
as the Pure Land sect, which strongly stressed the life beyond
death. But, in the sense that it aims to create a self-contained
world where a human soul is left free to pursue its own perfec-
tion, the tea ceremony is like Buddhism, especially like Zen
Buddhism, which advocates liberty and all-inclusiveness of the
soul. The closeness of the tea ceremony to Zen is often exag-
gerated, but insofar as Zen emphasizes the human means to at-
tain the Buddhahood, and not the nature of the Buddhahood it-
self, the two seem to meet on a common ground. In Zen Buddhism
man is expected to purge all his worldly desires, including even his
wish to attain the Buddhahood; it is in this process that the tea
ceremony approaches Zen. In fact, with the help of Zen the
participant in the tea ceremony will find it easier to discard the
earthly world at the entrance of the garden path. Thus one classic
in the tea ceremony advises that a scroll of a Zen master's cal-
ligraphy be hung in the tea room. "Looking at the scroll one will
feel a liberated heart which, by detaching itself from the world
of the flesh, has purged all things impure," it teaches. Likewise,
when Sōkei talks of Buddha's domain being represented in the
tea ceremony, that domain is not of esoteric or Pure Land Bud-
dhism but of Zen. "The ultimate aim of *wabi*," says Sōkei, "is to
represent Buddha's domain pure and uncontaminated. This is
why the host and the guests, once they enter the modest tea
room, should cleanse themselves of earthly dust and talk heart
to heart. Therefore, do not be over-concerned about rules and
manners. Simply make fire, boil water, and drink tea. The tea
ceremony is nothing other than that."

Again like Zen, the tea ceremony tries not to be restricted by
rules and manners—even by its own rules and manners. *Wabi* is
the beauty not of the formalities but of the spirit underlying
the formalities, just as Zen Buddhists attach importance not to
the holy scriptures but to the spirit that produced the scriptures.
If one could attain *wabi* without the formalities, that would be
fine, or even better. This point has been mentioned by various

tea masters again and again. Rikyū, for instance, has a didactic poem:

> Be sure you know
> That the tea ceremony, in essence,
> Is nothing
> But to boil water,
> Make tea, and drink it.

There is also an episode in this connection. Someone once asked Rikyū about the secret of the art of the tea ceremony. Rikyū answered: "Entertain your guests so that they feel warm in winter and cool in summer. Set charcoal so that it will boil the water, and prepare tea so that it will taste good. There is no other secret." The man who asked was not at all satisfied and said: "I know all that." Thereupon Rikyū replied: "Then you try to do just that. I will be your guest; in fact, I will become your pupil if you can do it." To do with perfect freedom what the mind knows it wants is extremely difficult, for one has to abandon the very will to do it, too. The host is expected to entertain the guest by inviting him into a world different from the ordinary, but his conscious effort to do so will spoil the whole event, for any effort done consciously is contrived. The host and the guest are expected to talk heart to heart, but again an effort to do so will defeat the purpose. "The two hearts perfectly communicating with one another—this is fine," says Sōkei. "But the two hearts striving toward perfect communication—this is bad. If the host and the guest had enlightened hearts, the atmosphere would become congenial by itself." Sōkei says the same thing elsewhere when he refers to the tea ceremony as "the manifestation of an enlightened heart" and "not the art of the formalities."

What the "enlightened heart" means would be gathered from what has already been said. It is a heart free of all earthly wishes and desires, of all worldly rules and manners. It is freed even from the rules of the tea ceremony itself; Rikyū is said to have broken the rules at will, often to the extent of "making a mountain into a valley, and changing the West into the East." The heart follows its natural course; it accepts whatever nature may offer. "It is

96

enjoyable to have a tea ceremony when it is raining, or when it is
extremely cold," says Rikyū. "The tea ceremony would lose its
very meaning if one did not enjoy rain and snow." A person with
an enlightened heart can be recognized even through the sound
of his footsteps. The sound of his clogs is "neither noisy nor
stealthy"; it is "gentle and with no impure thought." He would
have a penetrating eye in distinguishing beauty from ugliness,
the true from the false. He would readily distinguish good from
evil, not only in things connected with the tea ceremony but in
all things that come into his sight. He would be a good art critic,
because the beauty of *wabi* is ultimately moral. Rikyū's idea
of the relationship between art and morality is suggested in this
meaningful remark of his: "If your body is slanted, you do not
notice a scroll hanging slanted."

At this point one might wonder how the tea ceremony would
actually look when a great tea master with an enlightened heart
conducts it. Only those who have been so privileged as to witness
it could answer that question. We have no way of restoring the
tea ceremonies hosted by Rikyū and other noted tea masters of
the past, but we can at least have a glimpse of them through de-
tailed descriptions where they are available. The following pas-
sage by Sōkei, for instance, beautifully depicts the way in which
Rikyū entertained his fellow tea master, Sōkyū,[5] one winter
morning:

> It was a beautiful dawn, with snow on the ground. Sōkyū,
> on the spur of the moment, decided to visit Rikyū and went
> to his house. As if anticipating a visitor, the door to the
> garden path was slightly open. Sōkyū walked into the wait-
> ing arbor, had his visit announced, and waited. An exquisite
> fragrance of incense floated from a distance, where a light
> was dimly flickering. Sōkyū, a fine connoisseur of incense,

5. Tsuda Sōkyū, or sometimes called Sōgyū (d. 1591), was another
tea master from Sakai and enjoyed a fame almost equaling Rikyū's in his
lifetime. He also had many interests: fencing, football, flower arrangement,
poetry, and incense burning. His *Tea Diary* ("Chanoyu Nikki") is a valu-
able document recording the details of the tea ceremonies hosted by him-
self and his father, another eminent tea master.

immediately knew that it was the celebrated "orchid-musk incense." Presently there appeared Rikyū, with a tea master's robe over his paper garment, welcoming the guest. As they sat in the tea room, Sōkyū asked for the lingering fragrance of the incense. Rikyū readily brought out the burner. The host and the guest had exchanged a few words, when they heard the sound of the kitchen door open. As Rikyū explained, a servant he had sent to Samegai for its noted water had just come back. Saying he would now get that fresh water, Rikyū lifted up the kettle and went into the kitchen. Sōkyū drew near the fire and looked at it, now that the kettle was gone. The charcoal, so arranged as to fit the time of the dawn, was beautiful beyond words. Looking up, Sōkyū noticed reserve charcoal neatly kept in a container on the shelf. He brought some down, added it to the fire, and cleaned the fireside with a feather brush. When the aged host reappeared from the kitchen with the kettle in his hand, Sōkyū explained that he had added more charcoal to the fire as he thought it would be needed for boiling the fresh water, even though he was sorry to impair the beautiful arrangement the host had originally made. Rikyū was deeply moved and complimented Sōkyū, saying that he was delighted to entertain such a thoughtful guest. As the winter night was long, there was still a bit of time until daylight. Rikyū, saying that he would like to serve tea while the fire lasted, brought out a light meal. As they sat eating, the morning bloomed out.

The passage conveys some of the atmosphere in which Rikyū conducted a tea ceremony in his later years. In this instance the word "ceremony" sounds almost out of place, for the whole scene is permeated with the warmth of informal hospitality; it is, indeed, a scene of one friend casually visiting another without ceremonies. The scene is not lacking in the properties of the usual tea ceremony, with the garden path, the waiting arbor, the tea room, the incense, the priestly garment, the charcoal arrangement, and so forth; nevertheless the whole atmosphere is deeply

tinted with the congenial hearts of the two participating men.

In conclusion, then, it may be said that the tea ceremony is an art lying in a slender margin between the human and the non-human. It differs from ordinary life for it tries to escape from the trivialities of day-to-day living and to create its own world where man is left free to pursue his heart's desire in peace and calm. Here the pleasure of the tea ceremony becomes identical with the pleasure of any creative art: through an artistic creation of the other world man is liberated from social restrictions limiting the free expansion of his faculties. The tea ceremony is a moment of life arbitrarily transformed into a world of art. But, in the final analysis, it seems that life cannot be completely made into art so long as those who inhabit the world of art are human beings. In that world of art a person may cast off his social self, but not his private, biological self; he would die if he were to do so. For this reason the tea ceremony can never overcome death; it has never transcended death. It tries to find peace and serenity of mind beyond earthly life, and yet on this side of death. This is why the tea ceremony, while preaching the philosophy of the void, always has a touch of warmth in it; this is why *wabi*, the beauty of the somber and the colorless, has a streak of vigorous life underneath. The tea ceremony, by its very nature, must remain in the realm of the human.

But, could one really find absolute peace of mind in the tea ceremony? Is it actually possible to find a realm of perfect calm beyond earthly life and still on this side of death? In brief, could life be lived as art? Sadly, evidence seems to point toward a negative answer. Rikyū died a tragic death when he was ordered to commit suicide by the mighty ruler of Japan, who was once his ardent admirer. Sōji died an even more pathetic death; he was executed, after having his ears and nose cut off. Many conjectures have been made as to the reason for their extraordinary punishments, but there seems to be no doubt that their violent deaths stemmed from their deep involvements in human affairs, political, commercial, and domestic. Tea masters cannot denounce life in favor of art, because their art is part of life. But, as long as they remain in the realm of life—however remote the realm

may be from ordinary life—they cannot completely escape from the conditions of life. Their dilemma is acutely reflected in a poem by Rikyū:

> I was sure I knew
> The difficulties of living
> In this sorrowful world,
> And yet, in spite of myself,
> I am lost in the clouds of doubt.

The dilemma is perhaps the one universal among serious artists of any kind, or, for that matter, among all sensitive men who suffer from the disparity between the ideal and reality, between their aspirations after the things beyond humanity and their awareness of their limitations as human beings. One of Rikyū's favorite poems, a poem by a Buddhist monk which Rikyū is said to have frequently hummed to himself, reads:

> How sad it is!
> With all my endeavor
> Not to tarnish it,
> The Holy Law tends to become
> Nothing more than my means of living.

With all his accomplishments, there were times when Rikyū found his tea not completely free of impurity, his heart not completely cleansed of earthly mire.

7

Toraaki
on the Art of Comedy

The Making of the Comic

A number of the characteristics of comedy have been pointed out many times before. Comedy, as is commonly believed, is a drama with a happy ending. Its hero, confronted with various obstacles, overcomes them one by one and eventually reaches his goal. Defined in terms of its effect upon the audience, comedy is a drama that evokes laughter. The laughter, as some would insist, must be thoughtful laughter or delight addressed to the intellect and emphasizing judgment. Seen from a moral point of view, comedy works on "some defect or ugliness that is not painful or destructive." Its function is to enter rightly into the ridiculous aspects of mankind and to represent people's defects agreeably on the stage. Its implications refer to social and moral norms, and hence it frequently concerns a social group rather than the fate of an individual. Theories of comedy have been formulated by emphasizing one or another of those characteristic features, and the choice is largely determined, as it seems, by the type of comedy for which the theory is written. Comedy is itself a very general term encompassing the plays of Aristophanes, Plautus, Molière, Chekhov, and Shaw, to mention only a few.

The idea of comedy conceived by Ōkura Toraaki (1597–1662)

101

has also been conditioned by the nature of the particular type of drama for which he was a professional actor. The Kyōgen, or the Comic Interlude, is closely related to the Nō drama. Though self-contained and suitable to be performed by itself, it is primarily an interlude inserted between two Nō plays, functioning as a kind of comic relief for the somber ritualistic stage. Toraaki has aptly described the close relationship in this remark, "A Nō play and a Comic Interlude complement each other to make a single performance." Naturally a meaningful antithesis for Toraaki is not between tragedy and comedy, but between the Nō and the Comic Interlude.

We are therefore not surprised to see Toraaki following Zeami and making imitation the most elementary principle of the art of the Comic Interlude. "More than anything else," he says, "the Comic Interlude is an art of imitation." "It imitates," he says again, "all kinds of things existing in this world." The actor should carefully observe and imitate the manners and speech of men in actual life; this is more so in the Comic Interlude than in the Nō because the former, unlike the latter, always treats the contemporary world and takes its material from the lives of ordinary men and women. In the Comic Interlude the actor would use the same level of speech as common people would use and would act in the same manner in which they would behave in daily life. When he is cast in the role of a drunkard, he would follow a real-life drunkard in everything he says or does, with staggering steps, hollow eyes, and thick voice. "Drunkenness is something one can easily witness in actual life," Toraaki says. "Observe it in detail." This is true of all other roles as well.

The actor, however, should not imitate persons and things indiscriminately, because some of them would look ugly when imitated on the stage. Just as the *yūgen* mood of the Nō would be shattered if the actor performing a beggar's role should appear on the stage with dirty rags on his body, so would the stage effect of the Comic Interlude become crude if the actor in a peasant's role should act in the shabby clothes of a real peasant. "The actor would look filthy," Toraaki says, "if he should, in imitating a lowly man, wear a tattered garment on the stage." The actor cast in an insane man's role should imitate the words

102

and behavior of an actual madman, but in doing so he ought to select only the proper. The distinction between the proper and the improper is made by the standard of *yūgen* as in the Nō, for the Comic Interlude is primarily a part of the Nō performance and should do nothing to break its harmony in mood. Toraaki records an example of his fellow professional who failed to observe this rule. Once a certain actor of the Comic Interlude mimicked in an exaggerated gesture a man dozing off and falling to the ground. The audience burst into laughter. The elegant mood of the Nō, however, was so irrevocably destroyed that the chief Nō actor hated this comedian forever thereafter.

The actor for the Comic Interlude ought to be especially attentive to the words he uses. Unlike the Nō, the Comic Interlude can use a wide range of vocabulary, including colloquialisms and dialects; it is all the more apt to become rustic, vulgar, and indecent. "It is essential," Toraaki writes, "that one closely scrutinize one's words and make sure that none will sound lowly and offensive when spoken on the stage." Sometimes a vulgar word slips out of the actor's mouth unawares if he constantly uses it in his daily life. For this reason the actor should be very careful about the use of words in his personal life as well.

Imitation and *yūgen*, as seen this far, are really two basic dramatic principles common to both the Nō and the Comic Interlude. The actor of the Comic Interlude should go beyond these principles, for his art has a realm distinctly its own. The essential difference of the Comic Interlude from the Nō is well summarized in Toraaki's epigram: "The Nō transforms the unreal into the real; the Comic Interlude, the real into the unreal." The Nō brings the world of dreams into the tangible world; it visualizes a realm of superhuman reality where gods, demons, and departed souls appear and disappear according to transcendental laws. In contrast, the Comic Interlude treats a world vividly real and downright human, with fun-loving husbands, tyrannical wives, slow-witted masters, and shrewd servants. It is not without superhuman elements, for there are some plays with gods, demons, and animals for their protagonists. But even in these instances nonhuman characters behave exactly like men: in one play the Thunder God is bruised on the hip when

103

he falls from heaven; in another a devil vainly sings love songs to a woman; and in a third a clever badger cheats a hunter and disarms him. The Thunder God, the devil, and the badger are from a world of the unreal, but they speak and act according to the laws of humanity as they are put on the comic stage. Men and women who appear in the Comic Interlude are also unreal in the sense that they are depicted as more stupid and laughable than ordinary people, yet they are all character-types modeled after the men in real life. The Comic Interlude draws upon the characters and behavior of actual men, upon the social and moral codes of the contemporary age, and then it presents them humorously in the guise of stereotyped characters and in a fairytale world. Toraaki's way of saying this is that the Comic Interlude transforms the real into the unreal.

Toraaki's epigram may not seem to explain why the elements of laughter should enter into the process of metamorphosis from the real into the unreal. The explanation is implied in some of the numerous thirty-one syllable poems that Toraaki composed for the benefit of his young disciples. To cite a few of these didactic poems:

> You try and try
> To escape from this world—
> The result is worse.
> Your mind will be at ease, only
> When you accept things as they are.

> Things in this world
> Can be, because they are
> As they are.
> If you try to be,
> You can never be.

> Would any good
> Be brought out, by becoming
> Gravely serious?
> Try to ignore trivialities
> As you live in this world.

> An angular object
> Is difficult to handle
> As it often catches.
> Always endeavor to round off
> The angles of your soul.

Human nature being what it is, this life is filled with contradictions and irrationalities, and if one should face it with all seriousness one would soon be disillusioned, disappointed, and depressed. To become happy to any degree, one should learn to ignore trivial matters and to look at grave matters with indifferent eyes. Only when one does this successfully is it possible to laugh in this grief-laden world. In other words, there is always dry detachment when things in real life are made into the ingredients of the Comic Interlude. And this detachment is what makes laughter possible.

The Comic Interlude, therefore, is not a satirical drama in which *dramatis personae* are criticized or laughed at against a set of ethical norms. As a rule, it has little or no moral idealism in its intent. The play about the Thunder God who fell from heaven and hurt his hip[1] is not a satire on God or on the popular belief in God; the playwright is warm toward the poor deity to the extent that he gets first-aid treatment from a human doctor. The source of laughter in this particular instance lies, among other things, in the god's fear of the mountebank's needle—a fear shared by all men alike. In this life there are many things as painful as the doctor's needle, but we cannot avoid them as long as we remain human beings. If that is human reality, why don't we endure the pain with a smile?—after all, even the dreadful Thunder God is terribly afraid of the needle. This is the basic attitude underlying many a Comic Interlude.

Toraaki seems to be stressing the same point when he says, "The Comic Interlude makes true things funny and funny things true." Without the true or the real there would be nothing truly comic; Toraaki is quite insistent on this. "Any Comic

1. The play, called "Thunder God" ("Kaminari"), is included in Sakanishi's *Kyogen*.

105

Interlude without the true," he says, "is not a Comic Interlude."
He explains it further: " 'Playful words are the product of a
thinking mind,' said Chang Tzu-hou.[2] 'Playful words' are the
words said for fun or in sport. Untrue as they may sound, they
too arise from what the mind thinks; that is why Chang spoke
of playful words as being the product of a thinking mind. Holy
men and wise men utter playful words, too. This fact points to
the core of the Comic Interlude." The passage is intended to
correct the common misunderstanding that playful words are all
silly, nonsensical, and without serious meaning. Some of the
words said in jest are deeply rooted in man's thoughts; they may
contain a profound truth about life, though they do not look so
at first. Men of high religious attainment or of deep wisdom
may say playful things, too, but lying beneath their playfulness
is their thorough understanding of human reality. The true
Comic Interlude must be as such also; it must observe the
truths of life through a playful eye or must discover them in
things that appear amusing on the surface. The true must be al-
ways latent in the comic.

As the Comic Interlude is not satirical, the truth it embodies
seldom has idealistic or transcendental implications. It is, rather,
a practical, commonsense truth familiar to all classes of people.
The Thunder God's fear of the doctor's needle is a truth uni-
versal and common enough: everyone is afraid of physical pain.
The secret of success in the Comic Interlude lies in working up
such an old commonplace truth into a fresh, new insight. "It is
essential," says Toraaki, "that one use the old and make it new."
"Since a good writer has a creative mind," he reiterates later,
"the old material he uses does not look old. This is like a magician
in fairyland concocting gold out of iron. In the Comic Interlude,
too, it is essential to transform the old into the new." The audi-
ence feels amused when it discovers that a character in the play,
with all his new guise, suddenly stumbles on one of the age-old
foibles of common men. The quick recognition of a familiar

2. Chang Tzu-hou (1027–77), better known as Chang Tsai, was an offi-
cial in Sung times and one of the earliest neo-Confucianists. His philosoph-
ical works, notably *The Correct Disciplines for Beginners* ("Cheng Meng"),
were well known to the Japanese in Toraaki's time.

truth on the part of the audience is a necessity for a successful comic performance.

For this reason, the comic without the true supporting it should be sternly rejected. As Toraaki maintains, there are three grades of laughter—"the high, the middle, and the low." Unfortunately the low type receives favorable response from the audience most easily and is therefore most apt to spread quickly and widely in theatrical circles. Toraaki writes: "The Comic Interlude now popular in the world is unprincipled, confused, and wild. The actor would speak vulgar words, twist his body, make faces, distort his eyes and mouth, show mean gestures, and do anything else to make the spectators laugh. Those things may amuse the lowly, but any thoughtful person would feel embarrassed at the sight. Such an actor should be called a clown for the Kabuki show now popular among the people." The passage is trying to distinguish comedy from farce, burlesque, and horseplay. Funny faces, vulgar words, and exaggerated gestures make people laugh, indeed; but, as they arise in and appeal to men's superficial and lower faculties alone, thoughtful men would feel embarrassed to watch them; the laughter they evoke is of the same kind as that of the Kabuki, which was little more than a burlesque show in Toraaki's time. To do this sort of thing, therefore, is a "disease of comedy." The actor who acts in this manner is a clown who is, in Toraaki's definition, "a man cast off from the road." What he performs is not a Comic Interlude but a comic face, something far below dramatic art.

Laughter caused by an awkward face, a base gesture, or a vulgar talk is of the low kind because these do not properly represent the true nature of things. They are abnormal—"diseased" and "crippled," in Toraaki's words. Toraaki wrote a didactic poem to explain this point:

> Making an odd gesture
> To catch the spectators' eyes
> Is an ugly act, indeed.
> It is like a normal man's
> Temporarily becoming a cripple.

A crippled man is ugly, and people may laugh at his ugliness. A

clown who makes funny faces can be compared to a cripple in the nature of laughter he causes in the audience. Such is a pitiless, unhealthy, superficial laughter. Toraaki has another metaphor to push the point further. "Some people with a hobby in gardening," he says, "often amuse themselves by bending a straight pine tree or by straightening a crooked one. Such is a deformation of nature; it is artifice. True amusement lies in looking at a tree that has an inborn charm and has become austere with age." The amusement of the high type of comedy is here so elevated that the term amusement in its ordinary usage does not apply. Certainly the amusement of looking at an old tree is different from that of watching a funny face or gesture. The highest type of comedy is austere in its outlook. Theoretically, to be funny is not the ultimate aim of comedy.

If this conclusion surprises us, Toraaki has anticipated our surprise, for he says, "Some actors and spectators take it for granted that the Comic Interlude is something funny. Accordingly, these actors try to look funny, and the spectators are discontent if the acting is not funny. But such is not the proper attitude." Along the same line is Toraaki's famous comment on laughter. "To be delightful is better than to be funny," he says. "To be superb and moving is even better. This is the most fundamental principle." He is of course talking about the Comic Interlude, and laughter in its ordinary sense is not part of its fundamental principle. At one point Toraaki goes even further and maintains that pathos, apparently an opposite of laughter, is the final goal. "All the arts," he says, "repudiate an attempt to amuse. Everything ends in pathos." This is perhaps the point Toraaki must eventually reach so long as he pursues the true as more important than the comic. There is a room for laughter so long as the true remains within the sphere of practical truths of human life, but if one goes beyond it and begins to pursue the eternal truth of the cosmos, one will sooner or later face the sad fact of human imperfectibility, whereupon there emerges pathos. Toraaki, who preached a realist's approach to life, has now broken that code himself.

Thus the Comic Interlude approaches the Nō once again. For, performed on the stage with such an aim in mind, it will in-

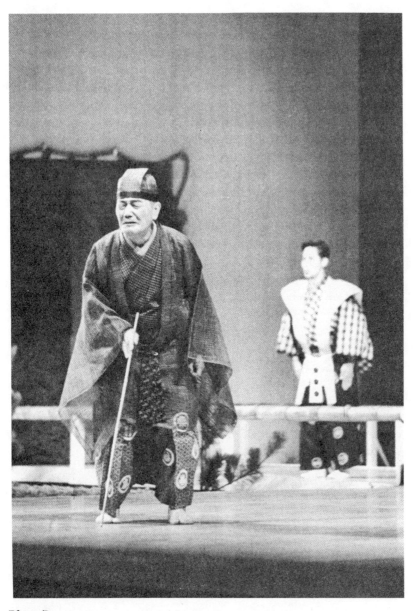

Plate 7
A scene from the comic interlude, *A Blind Man Enjoying the Moonlight.*
Here the blind man, standing at the edge of a moor, listens to the chirp of autumn insects.
Photo by T. Yoshikoshi.

evitably produce an effect not dissimilar to the Nō. As a matter of fact, Toraaki's metaphor of an old tree for the ideal comic performance is strikingly close to Zeami's metaphor of an aged cedar tree for the sublime Nō performance. Toraaki, while insisting on the identity of the Comic Interlude, never hesitates to come close to the Nō on this account. In one instance he records a complaint from a spectator who said that his performance was too serious and too much like the Nō. Toraaki's reply reveals how firmly he believed in his ideal. He answers that his performance follows in every way what has been prescribed by the founders of the Comic Interlude. Then he continues: "It is not that my Comic Interlude has approached the Nō. It is rather that the Nō performed by most of the contemporary actors has become like the popular Kabuki and has deviated far from the kind of performance I do."

Ideally speaking, then, the Comic Interlude is very close to the Nō in its pursuit of the true nature of things. Its imitation, specializing in the social aspect of life and in the realistic side of human nature, should be ultimately such that it would reveal the basic constituents of reality so often hidden under the surface of life. It must imitate not merely the visible appearance but the invisible essence of the object. Toraaki explains this idea by citing an old Chinese anecdote. Hsi Shih, a woman of Chou times who was noted for her beauty, once suffered a chest ailment. The sight of her, with her hands pressing her chest and with her eyebrows bent in pain, was more beautiful than ever before. A certain woman, trying to imitate her, pretended an illness in the chest: she pressed her bosom with her hands and knitted her eyebrows. As it turned out, she looked uglier than ever before. Such is, as Toraaki says, "an imitation of the surface only—a laughable act." "If you want to imitate an attractive woman," he continues, "learn what lies inside her heart rather than what appears on the outside. If you come to know her heart well, your appearance and manners will automatically come to resemble hers, however different yours may be from hers on the outside."

The ideal type of imitation would be a union of the imitator with the soul of the object he imitates. The actor of the highest order will have no conscious will to imitate nor any awareness

109

of imitation as he performs his role on the stage. Toraaki explains this type of imitation by a series of apt metaphors. "Our eyes can see thousands of things," he says in one instance, "but is this because our eyes go and catch the things, or because the things come and enter into our eyes? The moon is reflected on the water; but is this because the water rises and soaks the moon, or because the moon falls and sinks into the water?" To phrase it in Toraaki's idiom, an ideal type of imitation would be such that one does not know whether the man is imitating the thing, or the thing has entered into the man. The actor and his object are united; he grows into the object. "An actor expert in this art," Toraaki observes, "enters into the object smoothly and effortlessly." In order to do this, the actor will have to dissolve his own soul into nothing; only then will he be able to penetrate into any external object with no feeling of resistance. The artist's soul should be like water, which has no shape of its own and which can therefore take on any shape its container gives it:

> Let your soul be
> As shapeless as water.
> Whether round
> Or square, leave to your container
> The forming of its shape.

If water is a Buddhist metaphor, Toraaki can offer a more Western metaphor, too. "Let your soul be a mirror," he says, "which reflects all the laws of the universe." Once the artist becomes a clear mirror, he can imitate all things in the universe with no conscious effort. "No matter how spacious the universe may be," Toraaki affirms, "it will be contained in your soul." Such is ultimately what the art of the Comic Interlude aims at. Toraaki phrases it in another way: "The Comic Interlude is an art based upon the principle of a thousand hands and a thousand eyes." The actor with a mirror-like soul is omniscient like a Boddhisattva who has a thousand hands and a thousand eyes. He can see through the whole of the universe.

In Toraaki's conception of the Comic Interlude, then, the ideal actor is a man perfect in religious and moral terms, too.

No unscrupulous man can become a great actor. Toraaki care-
fully distinguishes between a skilled actor and a great actor. A
skilled actor is the one who was born gifted in the art, who has
studied the art of acting extensively, and who has become a suc-
cessful, well-known actor with the support of many patrons. A
great actor, however, goes beyond this: he is not only "skilled in
the art and conversant with all its fundamentals" but "knows
the nature of things, has broad learning and the qualities of a
master, looks after his sons and grandsons, and trains his pupils
well." For this reason great actors are very rare, while the skilled
are not too rare. Every student of the Comic Interlude should
try to improve not merely his art but more basically his moral
character, aiming to become a great, rather than a skilled, actor.
Again Toraaki has a didactic poem on this:

> To lead a virtuous
> Life, to keep the self upright,
> To dissolve the soul
> And to pursue the nature of things—
> These make up the basis of our art.

Throughout his writings on the Comic Interlude, Toraaki is
most insistent on the importance of the actor's moral integrity
as the foundation for artistic accomplishment. He enlists the
help of all kinds of moral precepts lying near at hand, whether of
Buddhist, Confucian, or Shinto origin, so that many of his
passages look more like part of an ethical or religious tract. At
one time he would talk on a general moral principle, like "a
struggle with the self"—"One who has a mortal enemy trains
oneself hard in order to beat him, but one who has no foe is apt
to become lazy and negligent of self-discipline. In such a case
one should consider oneself an enemy to conquer. The self is
a formidable foe." At another time he would advise on a spe-
cific practical matter—"There are certain rules you must observe
in your dressing room. Refrain from excessive eating and drink-
ing, from quarreling, from talking aloud and laughing aloud."
Toraaki went through a number of disciplines himself. Five
religious masters of the time, one in Shintoism and four in dif-

111

ferent sects of Buddhism, have testified to his attainment under their guidance.

It comes as no surprise to know that the Comic Interlude, requiring so much discipline on the performer's part, should have an edifying effect on the audience as well. Toraaki suggests the usefulness of the Comic Interlude when he narrates the origin and history of the theater. The origin of the Comic Interlude goes back to the time of the founding of the Japanese nation, when the grandson of the Great Sun Goddess, preparing for his descent from heaven, first sent down a certain deity to the earth as a forerunner. The earthly sovereigns, however, were overawed by the august appearance of the deity and did not dare to come close. Thereupon the heavenly gods commissioned a beautiful and sagacious goddess to moderate the situation. The goddess, showing her feminine charm to the maximum, walked to the sovereigns and asked them, smiling, why they had not welcomed the heavenly messenger. The earthly lords, now relieved of their awe and tension, all promised their loyal service. "From the spirit of this goddess," Toraaki explains, "arose the Comic Interlude." The Comic Interlude contains a divine message from heaven which nevertheless has a form considered approachable by common men, having even some elements of laughter. The comic, enfolding the true, rounds off its sharp edges. Herein lies the use of the Comic Interlude.

All in all, it can be said that Toraaki touches on a number of points made about the nature of comedy in the West. The Comic Interlude imitates actions of men, and usually in such a way that it causes the spectators to laugh. The laughter should not be of the type commonly found in farce or burlesque; it should not laugh at the crippled, the obvious deformities of the unfortunate few, but should deal with the common foibles of the many. The Comic Interlude changes the real into the unreal; that is, the fictitious world of the comic must be ruled by the laws of the real. The laws are usually not of a transcendental world as in the Nō, but of this mundane world and of this earthly life. The laughter is rooted in the distance from which one looks at the laws that may, under normal circumstances, bind and torture one. The laughter, therefore, is not always a heartfelt optimistic one but at times

112

borders on pathos. This is inevitable as long as the Comic Interlude pursues the real and the true. The strong didactic tone underlying Toraaki's book stems from his heavier emphasis on the true than on the comic. On one hand Toraaki saw the contemporary comedy degraded to burlesque; on the other he had behind him the medieval Japanese tradition that often identified art with religion.

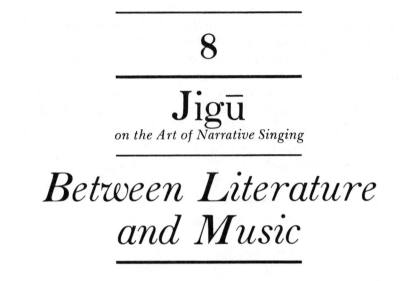

8

Jigū

on the Art of Narrative Singing

Between Literature and Music

Narrative singing is an interesting art form encompassing both literature and music. Its text can be read as a work of literature —as an epic, a novel, or a poem narrating an account of wars, adventures, and romances. It has produced what we now know as masterpieces of literature: the *Iliad*, the *Odyssey*, the *Nibelungenlied*, the *Chanson de Roland,* and so forth. Naturally those works have certain common features, the features of oral literature; they were created for dramatic narration or singing, often with the accompaniment of a lyre, a lute, or a similar instrument. People who professionally sang them were usually blind bards who could not read; they memorized the stories and the tunes and thus vocally passed them from generation to generation. This is why narrative singing was the oldest form of literature in many cultures; it could flourish without the benefit of a writing system. But that also accounts for the rarity of the books theorizing about this art; narrative singing was an art performed predominantly by the blind and often for the illiterate. Jigū's *The Remnants from the Western Sea* ("Saikai Yoteki Shū"), written in the early seventeenth century, is one of those few books that expound this ancient but fast-dying art.

The type of narrative for which the *Remnants* was written

constitutes the main stream of oral literature in Japan. It is called the Heikyoku, or Heike music, because it sings of the decline and fall of the great Heike clan, which enjoyed unmatched prosperity in the early twelfth century. Its text, called *The Tale of the Heike* ("Heike Monogatari"),[1] now remains as a monument of medieval Japanese literature, but it was initially a narrative for singing. During its prime days in the twelfth and thirteenth centuries it was an exclusive property of blind bards who wandered through the country and sang it for the entertainment of local people and soldiers in camp. It was divided into some two hundred verses, each telling an episode related to the sad fate of the Heike clan. The bard would sing several verses of his or his audience's choice in one evening and would go on singing some more the following evening if there were sufficient demand. As for its internal structure, each verse was divided into phrases, and each phrase was assigned a fixed melody. Nine such melodies are mentioned by Jigū in the *Remnants*. The singing was accompanied by the music of *biwa*, a string instrument somewhat resembling the Western guitar. As a rule, however, vocal and instrumental music were not simultaneous: the *biwa* melody was inserted between two vocal phrases, either to set the tone of singing for the phrase to follow or to recapture the mood of the foregoing phrase. The combination of sung phrases and *biwa* patterns, involving the elements of both literature and music, made the Heikyoku a fairly sophisticated art.

In analyzing this art form, a good starting point is provided by Jigū in a passage of the *Remnants* where he neatly sums up the various elements of the Heikyoku and their interrelationship. Here a work of narrative singing is compared to a bamboo blind and is dissolved into its separate components. Jigū writes:

> The words of the Heikyoku would correspond to the bamboo matchsticks; the voice, to the thread; the modulation, to the color; the tongue, to the hand; the Heike legend, to

1. *The Tale of the Heike* is a Japanese epic, which took its present form sometime between 1190 and 1220. In a melodious lyric style and with the undertones of Buddhistic fatalism, it describes the fall of the old world of court nobles and the rise of the new class of warriors. There are several partial translations in English.

115

the artisan; and the *biwa,* to the tool. Just as the artisan gathers a number of bamboo matchsticks, cuts them all to a uniform length, and weaves them into a blind, so does the singer weave a multitude of words with his tongue, using the *biwa* for his tool, the modulation for the color, and the Heike legend for the artisan. This is an important point. It will not do if there are matchsticks but no string, nor will it work if there are matchsticks and strings but no tool for weaving. Again, no blind could be woven if there are matchsticks, strings, and tools but no artisan to work on them. Even if all those four are provided, they still would not make a good blind unless the strings are colored. We call a person a good singer only when he dyes his thread with the color of modulation, has a good command over the tool of *biwa* as well as over the artisan of the legend, and weaves the matchsticks of words with the thread of voice, manipulating his tongue like a hand.

With a comprehensive metaphor the passage points out the essentials of narrative singing. The Heikyoku is basically a literary art that depicts human life by means of language. But oral elements play a vital role in it; they determine the internal structure of the work, providing its unifying principle. They ultimately go into the area of music and directly appeal to the listener's emotive faculty. The instrumental music, accompanying the work, sets the tone of singing on one hand and enhances the emotional impact on the other. Important, however, is that all this must be done within a prescribed framework, for the Heikyoku is a performing, and not creative, art. The artist cannot invent a new story or an original melody, yet he is expected to display his individual talent in his performance.

The aspect of the Heikyoku as literature is of basic importance, for obviously the purpose of narrative singing is to tell a story. The oral and musical elements are secondary to the literary; after all, they are there as the means of narrating an account effectively. Thus Jigū, at the very beginning of the *Remnants,* declares: "If you want to narrate the Heike story, you should above all know the Heike well." In the same paragraph he points

out the five most essential elements of Heike singing: rhythm, melody, style, modulation, and *biwa* accompaniment. But he quickly comes back to the Heike legend and puts it above all five. He writes:

> Even if the singer appears to be competent in all these five and seems worthy of the name of an expert, we cannot call him an expert unless he knows the Heike. What I call "the Heike" does not lie in the voice, nor depend on the words, nor consist in the melodies, nor rest on the style, nor mingle with *biwa* music, nor derive from the singer's artistry. It is too profound to be taught. It is empty and transparent, yet colorful, graceful, and shapely. No teacher can teach the Heike; there is no teacher other than the Heike itself.

The second half of the passage has a mystifying overtone characteristic of medieval Japanese writings, but what it is trying to say seems to be that the ultimate of the Heike music falls outside of musical elements. The musical elements, though important, are in the final analysis subsidiary to this mysterious core of the work which lies in the legend and which is intelligible only to those who know the legend intimately. Jigū elsewhere calls this essence of the legend the "spirit" and makes it the basis of classifying all the Heike verses. "The Heike lies in the spirit," he says. "Its classification should not be based on the words of the text." Every Heikyoku singer must master all the techniques of singing, but with all his technical attainments he would still need to grasp this spirit of the legend, for, after all, his singing techniques are merely the means of bringing about the spirit before the audience. If he succeeds in capturing the spirit all the listeners will be drawn into a state of trance, forgetting the external reality in which they live. They will see the snow and frost in summer, hear a cuckoo's song through the winter trees, and live the life of a recluse in the center of a metropolis.

The spirit of the Heike legend, being profound, empty, and colorless, refuses a clear-cut definition. It can be observed only in its different manifestations in different types of verses. According to Jigū there are seven such manifestations, and every Heike verse embodies one of the seven. These are named

117

divinity, celebration, longing, fighting, righteousness, grief, and devotion. A verse of divinity prays to Buddha and the gods for the peace of the world and of personal life. A celebration piece rejoices at the happiness of men and wishes for its perpetual continuance. Longing is a mood arising out of a number in which a person feels the pain of unrequited love, or worries over the safety of his master, or waits for his dear one who does not arrive. Fighting, as the word shows, is the spirit of a person valiantly battling in a war for his chivalrous honor. Righteousness is chiefly manifest in the verses in which truth and justice are the themes, but it also includes a wide variety of pieces dealing with such materials as the four seasons, travel, the arts, and some comic incidents. Devotion signifies the mood pervading the pieces that feature a person who has given up this transient world and who finds his consolation in a religious life. Though somewhat arbitrarily classified, those seven manifestations of the Heike spirit seem to cover all the main aspects of human life and all the principal phases of human mentality. Together they form the representative qualities of man's inner experience, and the spirit is the root of them all. The heroes of the Heike legend, highly accomplished as men of culture yet living in an age of war and turmoil, displayed these qualities to an extent far greater than an average man; or, at least, that is what the legend says. To show those ancient men with great humanity living their spirited lives and fulfilling their destiny—that is the core of the Heike legend, and its spirit lies in that, too. Every Heikyoku singer must know this well; this is what Jigū means when he teaches "know the Heike well." When the singer sings a number belonging to the fighting category, he should do it in such a way that the fighter's fierce manly spirit, perhaps tinted with the feeling of pity or of futility, will clearly come out. When he recites an episode of longing, he should show the mutability of love, or, more generally, the changefulness of all events in human life. The spirit of the Heike legend is the spirit underlying the various phases of human life, because the legend is life—life lived more freely than that of an average man.

The reproduction of this spirit, then, should be the paramount concern for the Heikyoku singer all during his perform-

ance, whether he is reciting the narrative part or singing the lyric part—the two elements that constitute every Heikyoku verse. He should keep this in mind especially when he is performing the narrative, because it is here that he can least depend upon the instantaneous evocative power of music. In the narrative sections his voice is deprived of all its colors, as it were; in fact it is called the White Voice in the terminology of the Heikyoku. Since in those sections the language is used more in its denotative function, the performer is expected to make his voice "white" so that the content of his narrative directly reaches the audience. Jigū's metaphor for that is a mirror: just as a mirror reflects the shape of all things, the singer's narration should reflect the spirit of the Heike and let the audience see it. "If you are reciting an account of people fighting and killing, you should do it in such a way as to make the audience witness the war," says Jigū. "If you are describing a love affair, let your listener's heart enliven. If you are telling a comic story, make him burst into laughter. If your account is about a person mourning over the dead, falling from fame to oblivion, or retiring into the secluded life of a monk in the mountains, induce your listener to pity and sorrow. In any case perform your verse in such a way that it befits the theme." In short, the singer's art throughout the narrative part amounts to the art of skillful storytelling. It is easy to learn, but difficult to polish to perfection. Jigū cites the words of an expert singer who once said that the White Voice is at once the easiest and the most difficult of all the Heikyoku singings on the performer's part.

The remaining portion of the Heikyoku verse is melodiously sung, and it is here that the performance depends more on the elements of music for its emotive effect. Here the singer recreates the spirit of the Heike legend not only through his story but through the melodious way in which he tells it. His voice is now tinged with various colors, and they change from phrase to phrase. According to Jigū there are eight such colors or melodies. In the nomenclature of the Heikyoku they are called the Chant, the First Fold, the Middle Sound, the Third Fold, the Broken Voice, the Chest Voice, the Picking, and the Pointing Voice. These are all stereotyped melodies conventionally assigned to

119

the phrases of the sung portion of Heikyoku verse. Each phrase, by being sung with one of those melodies, is expected to convey its message more forcefully to the audience.

An interesting fact is that those melodies carried certain emotional overtones in themselves, apart from the literary meaning of the phrases they accompanied. Jigū, as usual, describes them by vivid metaphors. The Chant, which is the simplest of the eight melodies and the closest to the White Voice, is compared to a broken lotus stem. A lotus stalk, when broken to pieces, is still connected by its thin white fiber; likewise in the Chant phrase the voice is broken into different units of words and yet somehow retains its continuity. The First Fold, which is a relatively slow-paced, low-pitched melody, is likened to a mountain stream. It is like the feeling of a poet who sitting at home quietly recalls to mind a little stream he saw in the mountains: the stream carried a spray of lovely blossoms blown down by a mountain gust, but no sooner had the poet looked than the blossoms were gone, leaving only the pure, clear water ceaselessly flowing down through the rocks. The Third Fold, a melody with a high pitch and a slow pace, is explained by the metaphor of a large crane soaring. It is as if a crane were flying up from the reed plain into the clouds: as the *biwa* sounds like a breeze blowing over the reeds that grow near a swift stream, the voice now leisurely rises like a large crane flying upward, now wavers as gracefully as the crane flapping its wings, and now slowly comes down like the bird returning to the ground. The Middle Sound, a melody somewhat higher than the First Fold but lower than the Third Fold in its pitch, produces an effect similar to that of looking at a tall iris flower. The sound should be "tall, cool, and clear"; it should give an impression of a five-foot iris just sprayed with water. The Broken Voice, with a slow tempo and a grievous undertone, is so called perhaps because it produces an effect of the voice being broken word by word. Jigū compares it to a tall bamboo plant with nodes here and there on its stem; the plant, moreover, has thick leaves on top, over which thin snow has settled like beautiful blossoms. The Chest Voice is explained by analogy to the shower of summer. It is like the cool air under the clear sky in summer, that refreshing air people heartily enjoy

Plate 8
A blind bard playing a biwa and singing the Heikyoku.
Reprinted from the *Artisans' Poetry Contest in Seventy-One Rounds*
("Shichijū-Ichiban Shokunin Utaawase").

after a sudden shower on a hot, humid day. The Picking, a quick-paced melody often used in describing an heroic battle scene, resembles lovely beads strung together in a disorderly manner. Its effect is like that of the following three poems:

> The chain of the beads
> That adorns the Goddess of Autumn
> Seems to have weakened:
> Scattered all over, without order,
> Are the white drops of dew.

> The wind blows
> Ceaselessly over the plain
> Wet with dew,
> Scattering about the white beads
> The autumn grass has strung together.

> With the coming of spring
> Doesn't a willow tree create
> Many a chain of beads
> As its yarns of fresh green leaves
> String together the white drops of dew?

Lastly there is the Pointing Voice, a melody with a quick tempo, a flowing rhythm, and a light-hearted mood. Jigū mentions the name but somehow does not bother to give it a metaphor.

The musical quality of the Heikyoku is also obvious in its *biwa* accompaniment. The accompaniment, in itself the sound devoid of moral content, enhances the effect of narrative singing when it is combined with the verses. On the singer's part, it also functions as the indicator of the fundamental tone for each phrase. Normally, if a melody of *biwa* accompaniment ends with A, for instance, it would mean that the initial fundamental tone for the following phrase is A. So far as the tonal qualities are concerned, the *biwa* music leads the vocal part; instrumental music prepares the way for vocal music. This relationship is explained by Jigū with the metaphor of a man clearing his way with a hatchet. "Even when the road is good, a person cannot advance if it is blocked with obstacles," Jigū says. "But he will be able to pass easily if he clears away the obstacles with an ax

121

or a hatchet. This is true of Heikyoku singing as well." Instrumental music, being more sensuously striking, has a more immediate effect on the audience than vocal music. Some drunken, noisy members of the audience will quiet down if the singer first sounds his *biwa*. He then can begin his singing.

Now turning to the aspects of the Heike music as a performing art, we immediately face the vital question of tradition versus individual talent. The words and melodies of the Heikyoku were fixed in its formative years; theoretically, no Heikyoku artist after the thirteenth century has been permitted to create a new verse or melody. Therefore, the first thing the performer should do is to observe the traditional rules and to perform in accordance with them. This obvious premise, however, is often neglected by the performers of later times. Some modern singers, Jigū notes, are ignorant of the traditional rules and are intent only on making a sensational impression; the result is that they scream out disorderly melodies in an angry voice, contorting their faces and shaking their heads. Their performance could be likened to the muddy water in a newly built moat as contrasted with a clear stream in a natural river. The ideal singer would be exactly the opposite: like the transparent water in a beautiful mountain stream, he would purely be a medium without his personal feeling or will while he performs. He would let the artisan weave the bamboo blind instead of weaving it by himself. Elsewhere Jigū remarks, "Your performance will not reach its perfection until you are determined to forget all things, to forget even your own existence." Like Zeami before him, Jigū here seems to be advocating the identification of the performer with the performed. He also made this epigrammatic remark: "The man manipulates the Heikyoku, and the Heikyoku manipulates the man." It means, as Jigū explains, that the singer is so totally immersed in his performance that his soul is at one with that of the Heikyoku.

On the other hand, the scrupulous adherence to traditional rules does not necessarily guarantee a successful performance. If a singer has no individuality, his performance will create nothing more than a mechanical production of stereotyped music. Some singers of early times, being more conservative and often over-

122

scrupulous, fell into this pitfall. Jigū compares them to a stubborn priest who insists on completing a rite when the temple is on fire. By Buddha's miraculous power the fire might eventually subside before the praying priest, but no one else would be there to hear his prayer anyway. The Heikyoku is an art performed by living men for living men; the performer, while following the rules, must not be enslaved by them.

The subtle relationship between the tradition of the art and the individuality of the artist is skillfully explained by Jigū through a series of metaphors. The first of the metaphors compares the narrative singer to a carpenter making a round wooden pillar. The carpenter, working on a piece of natural timber, would first make it square, then octagonal, then roundish, and then round, step by step carving off the angles. The Heikyoku artist must strictly observe the prescribed rules in his early stages of apprenticeship, but as his learning advances he should make them flexible and eventually integrate them into his own talent. Jigū's second metaphor is that of a flowing stream. The river remains unchanged from old, but the water that flows in it is never the same. Likewise, the artistic tradition remains the same, but the individuality of the artist which animates it is fresh and new. Jigū's third metaphor is that of a human face. All faces have eyes, ears, a nose, a mouth, yet some faces are more beautiful than others. Similarly, while the ingredients that make up the traditional Heikyoku are the same, the way they are mixed and arranged in its performance depends upon the individual artist. An expert artist, while narrating an age-old story exactly to the word, still manages to give a fresh impression to the audience. Jigū's fourth and final metaphor, taking a comparison from a skylark, presents a case where the artist gives freshness to his performance by breaking the fixed rules. Just as a lark nestled in the bush flies up as high as the clouds and enjoys its freedom in the vast sky, so can an expert singer freely depart from the rules if the occasion is fitting; he could sing a Middle Sound phrase by the Third Fold melody, or a Pointing Voice phrase by the First Fold melody; or, if he feels his voice wearing out, he could resort to the White Voice any time. The only thing he should be careful of is that he must in all cases "return and

settle down in the traditional Heikyoku," as a lark always comes back to its nest. The expert's freedom is always well disciplined. He would be like Confucius, who once said: "At seventy, I could follow my heart's desire without transgressing what was right." The whole point is summed up in a poem:

> Different paths
> Are chosen by different men
> To climb the mountain,
> But they all look up
> To the same moon high above the peak.

Although there are many different methods prescribed by tradition and modified by the individual, they all aim at the same goal: the beauty of performance as the effect of singing.

What, then, would the beauty of a Heikyoku performance be like? It differs according to the performer's talent. Jigū grades acceptable Heikyoku performances into three ranks and describes the impact of each. The three ranks are called, from the lower to the higher, the Spirited Performance, the Excellent Performance, and the Consummate Performance. The Spirited Performance is rendered by an artist who has mastered all the rules of Heikyoku art; it is a performance fulfilling all that is traditionally required of that art. The Excellent Performance adds to it the individuality of the artist; the artist now makes discriminating use of what he has learned. The performance is like a dish of food well seasoned with salt; it has an immediate, distinguishing appeal to the audience. To take another comparison, it is like eating a cucumber or an eggplant far ahead of the season; going beyond the routine performance, it gives the audience a pleasant surprise. The Consummate Performance is in a way an antithesis to the Excellent Performance: the voice sounds ordinary, the melodies are sung according to the score, and the performance has no spectacular effect as a whole. But somehow it never bores the audience; when it is over the listeners unanimously hope to have another such occasion. The Consummate Performance is like rice; it has no dainty taste, but all people eat it three times every day and are never tired of it. It has a more lasting effect than the Excellent Performance.

As for the sources of such an artistic effect, Jigū mentions two. The impact of a Heikyoku performance originates partly in the music itself, and partly in the performer's artistry. The success of narrative singing is a joint responsibility of the composer and the singer. But in actuality there are some performances that are beautiful chiefly because of the words and music, and others that are appealing mainly because of the way the performer handles the words and music. Jigū distinguishes between these two types of beauty, calling the former the Flower of the Music and the latter the Flower of the Moment. The Flower of the Music is natural beauty like that of spring blossoms; it blooms without effort on the part of the performer if he is a competent artist. The Flower of the Moment is like cherry blossoms blooming in autumn; it blossoms only when the expert performer adds something new that is suitable for the occasion. Here we are tempted to identify the Flower of the Moment with the effect of the so-called Excellent Performance. The identification is not quite justified, because when he talks of the flower Jigū is stressing the harmony between the singer and the audience. The singer, whether he is a competent, excellent, or consummate performer, would not succeed in his singing unless he had a firm grasp of the situation and established a relationship with his audience. Jigū compares this to a person using a Japanese fan. If the day is hot, the person will open the fan as wide as possible. If the day is cool, he will open it only halfway, or three-quarters of the way, or to whatever extent he might wish to create a breeze. Likewise, the Heikyoku artist ought to adjust his performance according to the type of audience he has. In some cases he has an audience genuinely fond of listening to the Heikyoku *per se*. In other instances the audience wants merely an entertainment.

The Heikyoku artist, then, must have good showmanship as well. While he is on the stage he should constantly think in terms of his audience, doing his best to make his performance pleasurable to their eyes and ears. This would be like a water bird floating on the surface of deep water: at a glance the bird looks casually afloat, but its feet are incessantly moving under the water. To enrich his art the singer must be as avaricious as a beggar. Just as a beggar throws into his bag everything he can

lay his hand on, the Heikyoku artist should take in every bit and piece from other performing arts and make use of whatever he can. He must have a never-failing passion for his art. In the course of his career he might come across his fellow artists' jealousy or hatred; still worse, he may have times when he is not sure of his teacher's opinion of him. But with all these difficulties he must persist in his art, like the weed growing on the hard ground that people constantly trample.

This praise of passion sets Jigū's art theory distinctly apart from medieval theories, in spite of its heavy borrowing from them in aesthetic concepts and nomenclature. As we have seen in previous chapters, medieval Japanese theorists consistently renounced passions, the passion for art included, in favor of a transparent soul reflecting the spirit of the universe. With them, the perfection as a man superseded the perfection as an artist. But in Jigū's theory this is not so. *The Remnants from the Western Sea* is markedly free of moral didacticism. Indeed, it does mention fine personality as an asset for the Heikyoku artist; for instance, the book lists the Five Vices to be shunned by anyone learning the art of the Heikyoku—Obstinacy, Heartlessness, Hatred, Anger, and Pride. Yet it was for a practical reason that Jigū rejected these vices: a student who has them will find it difficult to get along with his teacher and will eventually be cast out by him. Similarly Jigū says that the artist must be modest—"until he learns the ultimate of the art from his teacher." He also remarks that the artist must not be quarrelsome—"until he enters a good school, gains substantial training, and perfects his artistry." Moral attainment is needed, not because the art demands it, but because it smoothes the teacher-student relationship. Morality is recommended for a utilitarian, rather than artistic, reason.

On the whole, it may be said that the uniqueness of Jigū's theory lies in the uniqueness of the art form for which he wrote his theory. The Heikyoku is basically a literary art that tries to represent human life as it was lived by the heroes of the past. That life may not be historically true, but it presents a panoramic view of men and women who, living in a highly cultured and yet unusually stormy age, displayed the ways of humanity

126

to an extent far greater than the average man. Here the Heik-yoku artist becomes a medium without his own personality, a storyteller who sacrifices his individuality for the sake of his story. The story would be more effectively told if the narrator were also a musician, so the storyteller becomes a singer as well. While the narrative visualizes the details of the legendary Heike world, the music powerfully conveys the mood of each incident narrated, sometimes heroic and manly, sometimes delicate and feminine, and sometimes sorrowful and Buddhistic. If the artist is successful, his performance will bloom into a beautiful flower, regardless of the mood he is creating. This impact is not necessarily a spectacular one: ideally, it should be one that would fascinate the listeners in a quiet, unnoticeable manner, deeply moving them without letting them know why. The Heikyoku artist should be a shrewd performer. Here religious and moral attainments have comparatively little to do with artistic perfection. The Heikyoku, being a performing art, does not demand expression of the thoughts and feelings of the artist as a man.

9

Mitsuoki
on the Art of Painting

In Search of the Lifelike

The Japanese made a late start in formulating their theories of painting. Indeed, some principles of art criticism are suggested in *The Tale of Genji*, which has a chapter on a painting contest,[1] or in *The Collection of Famous Stories, Ancient and Modern* ("Kokon Chomon Jū"),[2] which has a section concerning various controversies among artists and critics. But those are casual, fragmentary remarks, with little intent of guiding either painters or art critics. The early Japanese never bothered to write a theory of painting, for, as it seems, they were completely satisfied with what they had received from the Chinese. Thus, even after the Japanese finally began to write books on the art of painting in the early seventeenth century, they closely followed the teachings of Chinese masters in the Six dynasty, T'ang and Sung periods. Hsieh Ho's Six canons,[3] Hsia Wen-yen's Three Ranks,[4] Jao Tsu-

1. The chapter translated by Waley as "The Picture Competition" in his volume called *The Sacred Tree*.
2. A collection of some seven hundred tales compiled by Tachibana Narisue in 1254. The tales are grouped under thirty headings, such as "Poetry," "Music and Dance," "Calligraphy," "Filial Piety," "Love," "Painting."
3. Hsieh Ho (*c.* 500) was a painter of the Southern Ch'i dynasty and was

jan's Twelve Things to Avoid,[5] and many other principles of traditional Chinese painting were time and again quoted and insisted upon as a set of absolute rules. It was not until the last years of the seventeenth century that any effort was made toward the formulation of a Japanese theory of painting. One of the earliest who attempted this was a renowned court painter, Tosa Mitsuoki (1617–91). The title of his book, *The Authoritative Summary of the Rules of Japanese Painting* ("Honchō Gahō Taiden"), itself suggests his conception of Japanese painting as independent of Chinese art.

Mitsuoki had several motives in emphasizing the identity of Japanese painting. He was the head of the Tosa family, the oldest dynasty of artists in Japan specializing in secular painting with national themes. As professional painters, however, the Tosas had been at the lowest point of their decline for quite some time, even losing, amid the social disorders of the sixteenth century, the post in the studio of the imperial court, which they had long held. Talented, ambitious, and energetic, Mitsuoki vigorously endeavored to restore his family's previous eminence. In this he succeeded remarkably: he soon became a reputed painter in the Capital and in 1654 he had himself appointed head of the Imperial Painting Office. During all those days his immediate rivals were the Kanōs, a powerful family of painters particularly skilled in handling Chinese themes and techniques. As a consequence, despite his due respect for Chinese painters, he took every chance to attack the Kanō school. Thus his family tradition, his official position at the Japanese court, and his keen awareness of the rival Kanō style, all led Mitsuoki to stress the identity of Japanese painting when he wrote the *Summary*.

Mitsuoki wrote the compendium a year before his death, with

especially good at portrait painting. His famous Six Canons appear in his *Notes on the Classification of Ancient Paintings* ("Ku Hua P'in Lu").

4. Hsia Wen-yen was an art historian of the Yuan dynasty and the author of *The Precious Mirror of Paintings* ("T'u Hui Pao Chien"), in which the Three Ranks are defined. It is likely, however, that the idea of the Three Ranks had been expressed earlier, especially in critical writings on calligraphy.

5. Jao Tsu-jan, of the Yuan dynasty, is known as the editor of *The Twelve Primary Things to Avoid in Painting* ("Hui Tsung Shih Erh Chi").

the purpose of transmitting the secrets of the Tosa school of painting to his descendants. It consists of some fifty short sections, each with a heading, and several of them with illustrations. At first sight these sections seem to be loosely arranged, but a closer examination shows that they fall into three main categories—theory, practice, and criticism. The first part, comprising such sections as "The Six Canons," "The Three Ranks," and "The Essentials of the Theory of Painting," persuasively expound the fundamental ideas on the art of painting. Some of the sections make profuse use of Chinese aesthetic ideas and terms, but in interpreting them Mitsuoki often shows his originality. "The Essentials of the Theory of Painting," which constitutes the nucleus of the book, is unmistakably his own. The middle part of the *Summary* touches on some technical details of painting in a practical manner. A section called "The Methods of Making Pigment," for instance, describes the material for and the process of making all kinds of colors. A section entitled "The Human Body" teaches how to represent eyes, eyebrows, lips, hair, beard, and so forth in painting a portrait. The section "How to Place a Seal" shows, with a fitting illustration, the best spot for putting the painter's seal on his painting. Then the final part of the book criticizes paintings and painters, ancient and modern. As may be expected, the painters of the Kanō school receive the sharpest attack. Mitsuoki's attack, however, does make a point consistent with his general line of argument, as will be seen later.

What type of art theory emerges through these sections? Its central thesis seems to be summarized by Mitsuoki in a passage that appears in "The Essentials of the Theory of Painting": "Among works of painting that delineate various kinds of objects, some are mediocre because they are exceedingly lifelike, and others are mediocre because they are not lifelike. If there is a painting which is lifelike and which is good for that reason, that work has followed the laws of life. If there is a painting which is not lifelike and which is good for that reason, that work has followed the laws of painting. Herein lies the essence of my precepts." Mitsuoki is here clarifying the relationship between nature and art in a fourfold argument. Art should imitate

130

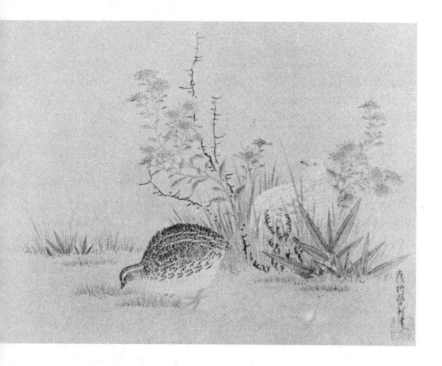

Plate 9
"Quails." By Tosa Mitsuoki.

nature, but a mere duplication of an object of nature does not necessarily produce a good work of art. The artist must at some point depart from, or even distort, nature. But of course a casual distortion of nature would not bring forth a good work of art, either; such a work, being not lifelike, would be lifeless. All good works of art are lifelike, not so much in the sense that they copy all the outward details of real life, as in the sense that they observe all the inward laws of nature. The painter may omit some external particulars in order to stress a certain invisible law of nature, thereby making his work more lifelike in effect. A superb artist might go even further; his painting may not appear lifelike but has a forceful effect for that very reason. He has gone beyond the laws of life; he has entered a sphere governed solely by the laws of art. According to Mitsuoki, such is the ultimate of the art of painting.

It should be noted that Mitsuoki here conceives the laws of nature and of art not as mutually exclusive or contradictory, but as complementary. The artist must first observe the laws of nature before he comes to cope with the laws of art; otherwise his work would not resemble life but become lifeless. To observe the laws of nature and to follow them faithfully are, in fact, the two most elementary laws of art. Details of an object of nature should never be overlooked. A student in painting should start his training by learning how to depict the way things are in real life. Mitsuoki's advice to beginners is very revealing: "Anyone who wishes to learn the art of painting should first study the way of things in nature. He should then proceed to learn how to use the brush in outline-drawing. Finally he should come to have a good grip of the spirit. On the last point there is a good deal that cannot be said in words." The study of nature comes even before learning how to handle the brush. Without thoroughly knowing how things are in real life, one cannot draw their outlines. A careful observation of objects in actual life is an absolutely necessary preliminary for anyone who wishes to learn drawing, and eventually, the spirit of painting.

Throughout the sections of his book where he criticizes the works of other painters, Mitsuoki vigorously attacks those artists who failed to observe the rules of nature or of human life. Dis-

crepancy between nature and the work of art is, as he terms it, "a disease of painting." The harshness of his criticism of other painters on this account is perhaps partly justified by his declared premise that a careful observation of nature is the most basic of the principles of painting. Here is one of those passages:

> One of the painters of former days, Kanō Motonobu,[6] has painted a flying bird with its neck and legs stretched. As a rule, however, flying birds draw in their legs when they stretch their necks, and they duck their heads when they stretch their legs. In no case do they stretch their necks and legs at the same time. Motonobu seems to have painted the picture without knowing this fact. Also, in painting a flock of cranes, he has depicted a young one still with reddish brown feathers pecking at something on the ground. I must say this is the painter's error. As a rule a crane keeps its young ones close to the nest by tieing ivy to their legs, until their reddish brown feathers drop off. They are allowed to leave the nest only after they get white feathers on them. For this reason no one could paint a young brown-feathered crane on the ground. It seems Motonobu did not realize this.

In the same tone Mitsuoki goes on to warn against contradicting other rules of the animal and vegetable worlds. One should not, he says, paint a cuckoo from the back side, for a cuckoo is a high-flying bird and no one is able to see its back. Birds like cuckoos, woodpeckers, and orioles have four toes on each leg, two directed forward and two backward; one should never paint a bird's leg with six toes, as some painters have done. Chinese animals and Japanese plants, or Japanese animals and Chinese plants, should never be painted together. One should not paint a Japanese peony alongside a lion, nor should one put a Japanese cherry tree alongside a myna, a parrot, or a parakeet. Mitsuoki's insistence on lifelikeness is so steadfast as to prohibit painting any bird or animal larger than the life-size.

6. Kanō Motonobu (1476–1559) was a noted painter of the Kanō school and was influential at the court in his lifetime. He painted a number of screen pictures at temples and mansions.

Similarly, close attention should be paid when painting a man or a scene from human life. A conscientious preliminary study is particularly needed in working on historical themes. Mitsuoki writes:

> Factual errors are frequently found in works portraying historical figures. Painters in our family have been making every effort to correct them. You should be well aware of this. If a painting has a factual error in it, it must be said to be diseased, however skillfully the work may have been executed and whatever an expert the painter may be known to be. Keep this well in mind. Scholarship is a prerequisite of a painter. There is always something worthwhile to see in a work of a well-educated painter, even if he may not be an expert craftsman. A painter with no learning is apt to make a factual mistake, even if he is an experienced artisan.

Mitsuoki offers plenty of examples. In depicting a war of the old days, some have painted soldiers with their forelocks shaven off, but that hair style began only in the Muromachi period. There are a number of paintings with a courtier carrying a lacquered bow, yet such a bow was used only once a year, at a ceremony on the seventeenth day of the First Month. There are numerous portraits of ancient noblemen with black robes, but in those days a black robe was a mourning costume and was not worn in daily life otherwise. All those errors could have been avoided if the painters had taken the trouble to study a bit of history. The most preliminary element of the painter's work is to examine the object carefully; this comes before all the techniques of painting needed for representing an object.

The student, after thoroughly studying the proposed object, will then go on to reproduce its shape and color. This has been universally recognized as a fundamental of painting, and Hsieh Ho, for example, put it in his Six Canons. The Third Canon said, "According to the object depict its form." After citing the canon Mitsuoki adds, "There are thousands of objects and thousands of forms. Every one of them is to be depicted individually." Hsieh Ho's Fourth Canon stated, "According to species apply color"; Mitsuoki explains, "This means that you should use

appropriate pigment according to the type of object you are depicting." This is sound advice for a beginner, emphasizing accurate visual representation as basic to the art of painting. The painter should not choose a shape or color; let the object choose it. The painter's task is to re-create the shape and color of the object on his canvas as they are in nature. A good painter always has a master skill in delineating the object.

The painter who carefully observes his object and who faithfully reproduces its shape and color is a good painter, but by no means an ideal one. He has only fulfilled a couple of the most elementary requirements of a painter. In fact, such a painter's work would fit into the lowest of three ranks that Mitsuoki uses in grading works of painting. Closely following Hsia Wen-yen, Mitsuoki classifies into three categories all the works of painting above the acceptable level: the Competent Work, the Marvelous Work, and the Divine Work. On the first of the three Mitsuoki remarks: "A painting which succeeds in reproducing the original figure and which follows all the technical rules of painting may be called a Competent Work. The painter has well observed the disciplines and mastered an established style. Such is commonly called a skillful artist. One can reach this stage through training. No ordinary painter can attain the ranks of the Divine Work and the Marvelous Work." In other words, a painter who has learned all the rules and techniques of painting necessary for an exact reproduction of color and shape can produce a Competent Work, which, although itself a fine accomplishment, still leaves much to be desired.

The next higher in rank is the Marvelous Work. Mitsuoki explains: "A painting in which the brushwork is superb, the coloring is perfect, and the meaning overflows, may be called a Marvelous Work. The painter has transcended established styles, for his art is now fully mature; even though he paints independently of the rules, he never breaks the rules. This is because he paints the meaning rather than the shape." The student of painting, as he advances in his training, must try to go beyond the rules after completely mastering them. He will go beyond the mere copying of color and shape, beyond a faithful reproduction of the external appearance. If he successfully does this, his

work will show a charm not so much through its outward life-likeness as through its meaning, for the meaning of a painting lies not in the shape or color of the object but in the way in which the painter delineates it. There are therefore cases where the artist departs from ordinary rules and does not copy the exact shape or color. An advanced painter can do this because he, thoroughly knowing the objective of his work, paints the meaning rather than the shape.

As for what this meaning exactly is, Mitsuoki gives no clear-cut definition, but it can be gathered from several passages scattered in his writing. For instance, after teaching that one must depict the shape according to the object, he explains: "For example, an emperor must be painted as befitting his high rank, a wise Confucianist as having a pious, compassionate heart, a tree as being hard, grass as being soft, spring scenery as being pervaded with warmth, and an autumn landscape as wrapped in a desolate atmosphere." Along the same line Mitsuoki produces a longer list of examples elsewhere: a warrior must be made brave, a nobleman elegant, a recluse idealistic, a lady charming, a country house rustic, the water rushing in torrents, the mountains stately and calm, and so forth. The meaning of an object, then, is its distinguishing characteristic, an innermost element that gives the object its *raison d'être*. It is not dissimilar to Zeami's true intent. The painter must try to paint an object in such a way that its inmost nature may manifest itself. When he succeeds in doing so, his painting will have a meaning that overshadows the shape; the meaning will prevail over the painting and will, in Mitsuoki's term, overflow.

When the painter pursues this principle to the ultimate, he will reach the realm of the Divine Work, the highest of the three ranks. Mitsuoki, again quoting from Hsieh, writes: "This is a work which has 'the spirit's circulation—life's motion.' It springs from heavenly nature and surpasses any ordinary man's skill. It is therefore called the Divine Work." The painting of the highest order is a product of inborn nature given by heaven, something even a painter of the most meticulous craftsmanship cannot attain. For this reason it cannot be learned by training: there is some superhuman quality accessible only to a limited number

of geniuses. Mitsuoki tries to explain this mysterious quality by referring to a well-known Chinese aesthetic term, Hsieh Ho's "the spirit's circulation—life's motion." The term has aroused a great deal of controversy as to its precise meaning, and painters and critics in China and Japan have given scores of different interpretations. Mitsuoki felt it imperative to explain the term in his own words and to clarify what he meant by it. This he does in the very first paragraph of the *Summary*. He writes:

"The spirit's circulation" means that the painter, as he sets out to work, lets the spirit of his soul circulate through his body. When his soul is small and his spirit insufficient, his brushwork will be stunted, feeble, and always unsatisfactory. The painter's brushwork should become gentle and soft upon grief, coarse and strong upon anger, mellow and carefree upon joy; it is essential that the painter choose the precise emotion. He should first enter into a calm frame of mind, a mind devoid of nervousness or excitement; he should let the spirit expand through his body, with his soul filling up heaven and earth; in such a mindless state he will begin a work of painting. "Life's motion" means that a painting, whether of a god or a devil or a man, whether of a beast or a bird or a tree, contains the spirit of the object and thereby makes the spectator feel as if the object were standing before his eyes. A warrior should show his martial glory, a court lady her elegant charm, a Buddhist priest an appearance of his holy mission. A bird should have the force of soaring and singing, a beast the vigor of howling and scampering. A pine or cypress tree should show the mysteriously venerable shape with which it stands through the snow and frost; a dragon or a tiger should display the force by which it catches the spirit of the wind and the clouds, moving even heaven and earth. Spring flowers, ready to burst open, have the air of warmth and resourcefulness; summer trees, with their cool verdure, have the potentiality of powerful growth; autumn grass, with wilted dryness in the atmosphere, has an appearance of harsh desolation; and winter flowers, with the snow and frost, have

the color of withstanding the cold. The foremost principle in the art of painting lies in a successful rendering of the spirit each object has. Particularly important is the case of painting men and human life. Unless the painting successfully transmits the spirit of the object, it will have nothing divine in it, and, if that is the case, the work is like a shrine with no god in it. No ordinary artist can transmit such a spirit into his work; but, unless the student strives with this aim in mind from the first day of his training, how could he expect to attain the ultimate of the art of painting eventually? The same is true of all other paintings. There would be no need for talking about principles of painting, if painting were no more than an art of copying the shape. The ultimate aim of painting is to represent the spirit of the object. In every work of painting, whether it is of human life, a bird, a beast, an insect, or a fish, the spirit of a living object can be represented only by putting eyes into the painting. A portrait, whatever fine complexion or shapely figure it may have, will suffer from the lack of a living spirit if it is dead in the eyes.

Mitsuoki has given the age-old Chinese term an interpretation typical of medieval Japanese aesthetics.

In essence the so-called Divine Work is a further development of the Marvelous Work. The meaning, which was essential to the Marvelous Work, is now replaced by the spirit. But the spirit is really the source of the meaning; each object has its meaning, its *raison d'être,* because of its spirit given by nature. The spirit is the life-force of the object. It is not an attribute but a potential power. An artist who paints a bird should do it in such a way as not merely to copy all the attributes of a bird but to transmit the "bird-ness" of it; otherwise his bird will neither fly nor sing, it will be devoid of spirit and of life. One who paints the portrait of a man should of course reproduce his complexion and appearance with precision, yet far more important is the making of the eyes, for it is the eyes that reflect the spirit of the man. Without the spirit the portrait is soulless and lifeless; the man is a corpse. That painting, in other words, would have no "life's motion."

137

How, then, could the artist put life into his work? Through "the spirit's circulation," Mitsuoki would answer. The painter can give spirit to his painting only by growing into the object of the painting himself—that is to say, by identifying his spirit with the spirit of the object in his painting. In order to do this, he would first have to unite himself in one spirit; his whole being, and not his intellect alone or his emotion alone, should be inspired. However, this does not mean that his mind is all in excitement; on the contrary, he will be in a most tranquil state of mind, with no interference of his ego. His body, fully pervaded with the spirit, is empty of the spirit; the maximum of fullness is void. The mind of the artist in such a state can fill up the whole of heaven and earth; it can transform itself to any outside object with ease. Himself a bird, the painter can paint a bird that has its true spirit, a bird ready to fly or sing at any moment. Himself liberated from his personal grief, he can paint a grieving man with life and spirit, for the grief he paints is not his own but that of the particular man he is painting. The artist must paint a precise emotion, Mitsuoki has said; in painting an emotion, the artist ought to exclude all emotions of his own. Only then will the painting have an emotion of its own, a life of its own; it will have "life's motion." "The spirit's circulation" is the creative process, and "life's motion" its resulting product.

Every artist, then, should strive toward creating "life's motion" through "the spirit's circulation." But what should he do in more concrete terms? Mitsuoki has already suggested an answer: concentrate on the eyes. Every object has the eyes, or a point that most vitally reflects its innermost nature. The painter should try to illuminate that point at all cost; the remaining parts of his painting should be made subordinate to it, or, as frequently is the case, would better be omitted altogether. Mitsuoki explains this principle by a pair of comparisons: first, poetry and prose, and secondly, poetry in China and in Japan. He writes:

> In all types of painting, whether monochrome or color, make simplicity your guiding principle. The patterns would better be left incomplete. It would be more effective

to represent only one-third of the background objects. If you are handling a poetic theme, do not describe it in detail, but leave its meaning unsaid. A blank space is also part of the picture; leave white space and fill it with unspoken meaning. Foreign painting is like prose; Japanese painting is like poetry. Or, as another saying goes, painting is visual poetry, and poetry is verbal painting. Japanese painters have developed a technique of depicting the inside of a house by not painting the roof. In this technique Tosa Mitsunobu[7] was extremely skilled and surpassed all Chinese painters; it is said that he was respected even in China. This is one of the examples in which the painting is not lifelike and is good nonetheless. As is commonly observed, Japanese painting is flexible, unique, imaginative, informal, and flower-like. Chinese painting is orthodox, permanent, realistic, and fruit-like. In point of truthfulness to the original object, even the best of ancient Japanese works are inferior to Chinese paintings.

The comparison of poetry and prose is an apt one. Poetry can leave out all the minute details of actual life if it so chooses; emancipated from the restrictions of factual reality, it can to a great degree escape the dictates of logic and intellect; but with all those omissions the poem expands its meaning, as it leaves more room for the reader's imagination. According to Mitsuoki, a work of painting should do that, too. Painting should not describe; it should suggest. It should not explain the meaning to the spectator; it should rather inspire the spectator to reach for the meaning himself. The painter, therefore, only needs to paint the "eyes," making the rest as simple as possible. Just as a sensitive person can read someone's mind by looking into his eyes, a real connoisseur of painting can grasp the inmost meaning of the work by watching its "eyes." By watching them he will be filled with a mysterious spirit, which the painter has poured into the

7. Tosa Mitsunobu was another illustrious painter of the Tosa school. He headed the Imperial Painting Office from around 1469 to 1523. He was mainly responsible for the earlier prosperity of the Tosa family in the Capital.

work. Even a white blank space, if properly set in a painting, can contribute to this cause; or, sometimes, a blank area is the best method of suggestion as it leaves everything to the spectator's direct personal experience.

Mitsuoki makes the same point by comparing this method to the general practice of Chinese painting. If Japanese painting aims at being good poetry, Chinese painting endeavors to become good prose. The latter is more orthodox; that is, it tries to reproduce life by describing it in detail, just as prose does. In this respect Japanese painting is less orthodox, for it keeps a greater distance from factual reality. Japanese painters, for instance, have invented a technique by which a house is painted without its roof. This method, often employed in a picture scroll narrating a story, does have its justification: the house is there in order to set a stage for the characters of the story; the characters are the "eyes" of that particular painting, while the roof of the house is a subsidiary detail in it. In this sense Japanese painting has more flexibility; it allows more room for the individual painter to display his uniqueness. To take a comparison in calligraphy, Japanese painting is like the informal Cursive Style, in which each calligrapher can command utmost freedom from the set form. To take a comparison in vegetable life, it is like a flower that, while retaining its energy to bear a fruit, does not hesitate to display its beauty in full bloom. Important, of course, is that the painting has the sense of realness in its core, however deeply it may be hidden underneath, just as the Cursive Style is based on the formal Square Style, or a flower is a manifestation of the energy that eventually produces fruit. Simplicity, which Mitsuoki sees as the essence of Japanese painting, is as such; it is the kind of simplicity that nourishes a deep meaning in its heart.

Simplicity being too general a word perhaps, Mitsuoki more often uses a specific term to express the same idea: lightness. "The essence of painting can be described in one word, 'lightness,'" he says. "Even when you are doing color paintings in the formal style, never forget the principle of lightness." In color painting this principle requires, for one thing, the use of light color. "Do your coloring with reservation," he advises. "This

140

follows the principle of lightness. . . . A beginner's coloring tends to be too deep from the outset. When made too deep, the color will become heavy, lowly, and dead. . . . We find that all the masterworks of the past purport to be light. Simplicity is an important principle." The principle requires, for another thing, the light touch of the brush. "There is a secret in this," Mitsuoki confides. "Don't touch the paper with force. Move your brush in such a manner that you don't feel its hair touching the paper." "The best way to draw a stroke with the brush is to be natural and straight," he says elsewhere. "Don't let your brush stagnate. Handle your brush unlaboredly, letting it neither float nor sink, with no effort to express your intent. In all cases, be lenient in using the brush." Lightness is the opposite of artifice. "Painting would better be simple and modest," Mitsuoki says. "This means that you should leave your work as it is, once it is completed. If you retouch your work with the hope of improving it, the work will become stagnant, ugly, spiritless, and dead." The artist should paint naturally and leave the work naturally. Too much effort to make it beautiful will bring forth only an adverse result. "A painting which is too beautiful," says Mitsuoki, "is weak."

The idea of lightness prevails through other parts of the *Summary* as well. In a section called "Moss," for example, Mitsuoki writes: "To draw many mosses in one painting is extremely lowly, although to be too sparse may result in a loose composition." In a section entitled "Undergrowth," he writes: "Do not paint underbrush in too great detail, although this depends upon the style of painting." Teaching how to draw a bamboo plant, he remarks: "Do not let branches grow at every joint. Nor let leaves grow on every branch." Mitsuoki does not like the method of Ukiyoe painters for the same reason. "They only think of exact resemblance to the actual object," he says. "They paint too much detail. The result is a lowly style." All this is summarized in another of Mitsuoki's instructive paragraphs:

In painting trees and grass, insert branches, leaves, and flowers only where they are absolutely necessary. And even in these cases, put down a bit fewer than what seems needed.

It is lowly to have branches and leaves where not needed. In painting patterns and wrinkles on a dress, it is better to depict them with just a few strokes. In painting anything, do not describe it in full detail. The best way is to express the full meaning with few descriptions. A poor painter does not know how to bring out the meaning; consequently his work, with all its detailed descriptions, has the look of being lacking in something. A work by a master painter has only a few details and yet lets the meaning abundantly manifest itself.

Mitsuoki never forgets to remind us of the primary purpose of simplification. Simplicity is for the sake of suggestion; the painter must make his work simple, but only in such a way as to suggest the meaning of the work. A work of true lightness is loaded with meaning.

Mitsuoki's conception of fine painting is largely exhausted by the ideas of imitation and lightness. The remainder of the *Summary* contains only more derivative, practical points that may help the painter to come closer to the ideal. For instance, presumably following Hsieh Ho's Second Canon, Mitsuoki teaches the proper way of holding the brush. He says that one should hold the brush "not tightly nor feebly" but "lightly and strongly" in one's fingers. "Lightly and strongly" corresponds well to the idea of lightness: it is the way of holding the brush so as to create lightness in the work. As to what "lightly and strongly" means in more concrete terms, Mitsuoki has little to say. According to him, such belongs to "the mysterious art of finger tips," far beyond description. The student must learn it through the finger tips, and not through the brain. One thing that may help him is to see how ancient masters did it. He may borrow some old masterpieces from his teacher and copy them himself. Mitsuoki interprets Hsieh Ho's Sixth Canon in this sense. "The best way to learn painting is by copying the model," he writes. "Unless you have a copy of an old masterpiece for your model, you can neither learn nor criticize painting. You learn various techniques of drawing and coloring automatically in the course of copying the model."

142

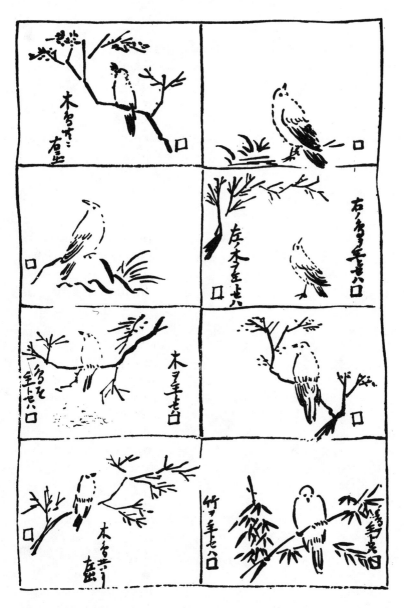

Plate 10

An illustration in Mitsuoki's *Authoritative Summary* showing where
to place a seal.

In three of the instances the painter has a choice. In the picture
at the bottom right, for example, he will put a seal on the lower
left corner ("the host's side") if he considers bamboo the main
subject, or on the lower right if he regards the bird as the chief topic.

Another practical bit of advice Mitsuoki gives concerns the balance and harmony of designs within a work of painting. Quoting Hsieh Ho's Fifth Canon on the importance of balanced composition, he teaches that the painter must plan, before setting out to work, how much of human life he is to put in, or in what way he is to do it, in view of the rest of his canvas. Among some concrete details he gives as examples, typical of Mitsuoki, is his remark: "In all types of painting, whether large or small in size, it is always undesirable to draw things in the middle. Leave the foreground blank and paint toward the back." Mitsuoki is especially emphatic on the fact that each work of painting has the front and the back, the "host's side" and the "guest's side," and the painter is advised to keep this in mind all during his work. The position of the seal should be carefully calculated, too; the seal, as Mitsuoki says, "gives balance to the painting." It should be put on the "host's side." Mitsuoki has himself drawn some illustrations to show this (see Plate 10, facing p. 142). His minute sense of detail extends even to the matter of the density of ink on the seal. "Too much ink produces a lowly impression," he warns. "The fine way of putting a seal is to make it look thin on the painting, like thin frost"; here is another instance of lightness manifesting itself in a tiny detail.

On the whole, then, Mitsuoki's theory of painting follows the line of medieval Japanese aesthetics. It has borrowed quite a few ideas and terms from early Chinese art theories, but in interpreting them Mitsuoki makes some points that are unmistakably Japanese. Of the two ideas that constitute the base of his theory, imitation is much like its counterpart in the aesthetics of medieval Japanese drama. At the elementary level it means literal lifelikeness, the rejection of any distortion of facts in nature and in human life. At a more advanced level, for which every student painter must strive to reach, it means a representation not of shape but of internal essence. The painter should try to suggest rather than to delineate. The idea inevitably leads to the other of Mitsuoki's twin principles, lightness. One should paint lightly, for the indescribable mystery of nature can only be suggested by a few natural strokes of the brush. To create a blank space pregnant with meaning is far more desirable than to describe every-

thing in detail. As Mitsuoki himself points out, the principle of lightness has much in common with the technique of poetry, particularly of Japanese poetry. Indeed, the idea is to be pursued further and given a very important place in the poetics of the Haiku. This we shall see in the next chapter.

10

Bashō

on the Art of the Haiku

Impersonality in Poetry

Japanese poetics reached another high point in its history with the appearance of Matsuo Bashō (1644–94) in the seventeenth century. Bashō is chiefly known as a great writer of the Haiku, one of the world's shortest verse forms that consists of only three lines with a total of seventeen syllables. Yet his immense influence over contemporary and later poets is due in no small measure to his poetic ideas as well as to his poetic works. Besides being a talented poet, Bashō was also an excellent teacher of verse-writing who had numerous disciples all over Japan. He and his disciples followed certain poetic principles of their own and clearly distinguished themselves from other poets, so their contemporaries called them the poets of *shōmon*, or the Bashō school. As is well known, it was this school that came to form the main current of the Haiku through succeeding centuries. To examine Bashō's poetics, then, is to study the poetics of the Haiku in its most orthodox form.

Bashō, however, never wrote a theory of poetry himself. He seems to have thought that fixed rules would be too binding and too restrictive on each poet's creative imagination. There is plenty of evidence to show that he tried to encourage his disciples' individual talents instead of imposing his own rules upon

145

them. Yet he did have a series of poetic ideas with which he could have formulated a set of rules consistent within itself, if only he had been inclined to do so. "Those disciples of mine who are so inclined," Bashō once said, "can talk with me personally, write down what they understand from me, and use it privately as the teaching of our school." Fortunately for us, many of Bashō's disciples were so inclined and left us with a considerable number of essays and miscellaneous pieces expounding the poetic ideas of Bashō and his school. Of those writings, Kyorai's and Dohō's are most valuable, since these poets were not only Bashō's leading disciples but themselves tried to be as faithful as possible to their master's teaching.[1] The writings of Shikō, Kyoroku, Rogan, and others are generally less reliable, whether because of their dogmatic tendency, lack of understanding, or plain misinformation; but within these limits they still throw light on Bashō's teaching.[2] Those pieces, together with Bashō's own essays, journals, letters, and other miscellaneous reminiscences, provide more than ample material to study his ideas on the art of the Haiku. These ideas were many and various, and some were so elusive that modern scholars differ widely in their interpreta-

1. Mukai Kyorai (1651–1704) was a leading poet among Bashō's disciples and was close to him throughout his later years. Kyorai's writings on the Haiku, published as *Kyorai's Writings* ("Kyorai Shō") in 1775, show his good understanding of Bashō's poetics. Part of this book has been translated by Donald Keene and is included in his *Anthology of Japanese Literature*.

Hattori Dohō (1657–1730) was born and lived in Ueno, so he had the advantage of seeing Bashō whenever the master visited his native town. A less original poet than Kyorai, Dohō was perhaps even more faithful in recording Bashō's teachings. In this respect his *Three Books on the Art of the Haiku* ("Sanzōshi"), published in 1776, is invaluable.

2. Kagami Shikō (1665–1731) was probably the most systematic theorizer of poetry in the Bashō school. His ideas on the Haiku, however, became increasingly dogmatic after Bashō's death.

Morikawa Kyoroku (1656–1715) was especially close to Bashō in the latter's last years. *Dialogues on the Art of the Haiku* ("Haikai Mondō," 1698) is an interesting book documenting a lively controversy between him and Kyorai on various aspects of Haiku writing.

Zushi Rogan (d. 1693) was a promising student of Bashō's but died before the age of forty. In 1693 he welcomed his traveling teacher to his home at a town in northeast Japan, and what he heard from Bashō during those seven days resulted in *The Record of the Seven Days* ("Kikigaki Nanukagusa"), the earliest known document of Bashō's poetics.

146

tions. But at all events they should include such concepts as the poetic spirit, *sabi, shiori,* slenderness, inspiration, fragrance, reverberation, reflection, plainness, and lightness, all of which appear frequently in the writings of the *shōmon* poets.

Of those ideas the poetic spirit occupies the central position; one might almost say that all other ideas are different aspects of it. "Of the Haiku there is a style that remains unchanged for thousands of years," says Kyorai. "There is also a style that prospers only for a time. These are the two poles of the late Master's teaching, and they are really the same in essence. They are the same, because they both resort to a single source, the poetic spirit." "Of the Master's Haiku, there is a style that remains unchanged for thousands of years," Dohō reiterates. "There is also a style that changes with time. All other styles are ultimately reduced to these two, which in turn can be traced back to a single origin. That single origin is the poetic spirit." Two of Bashō's most faithful pupils are here making the point in almost the same vocabulary; Bashō must have been quite emphatic on it. According to Bashō, then, all the styles of the Haiku fall into two large categories: the one that has qualities transcending time and place, and the other that is rooted in the taste of the time. Both styles are good, the former because of its universal appeal, the latter because of its freshness in expression. Bashō, however, thinks that the two are ultimately one—the poetic spirit. All good Haiku, whatever style they may show, spring from this common source.

In truth, the poetic spirit was conceived by Bashō on an even grander scale. He believed that this spirit went far beyond the realm of the Haiku, that, indeed, it pervaded all areas of creative arts. Bashō says this in his own writing:

> There is a common element permeating Saigyō's lyric poetry, Sōgi's linked verse, Sesshū's painting, and Rikyū's tea ceremony.[3] It is the poetic spirit, the spirit that leads one

3. Priest Saigyō (1118–90) was one of the finest lyric poets after Tsura-yuki's time. As indicated by the title of his book of poetry, *The Collection of Poems at a Mountain Hut* ("Sanka Shū"), he loved the life of a recluse and spent most of his life wandering all over Japan.

Iio Sōgi (1421–1502) was one of the most influential writers of linked

147

to follow the ways of the universe and to become a friend
with things of the seasons. For a person who has the spirit,
everything he sees becomes a flower, and everything he
imagines turns into a moon. Those who do not see the
flower are no different from barbarians, and those who do
not imagine the flower are akin to beasts. Leave barbarians
and beasts behind; follow the ways of the universe and re-
turn to nature.

Somewhat metaphysically Bashō has here conceived a spirit that
underlies all creative activities. It is a spirit that produces all
works of art, and ultimately it goes back to the creative power
of the universe. The universe creates beautiful flowers and the
lovely moon, and so does the artist; they are both creative, and
appreciative, of things beautiful. The creation and appreciation
of beauty is essentially what distinguishes civilized men from
barbarians and beasts; it is the prime factor of culture. Thus
Bashō's poetic spirit comes to assume a form of cultured prim-
itivism; his concluding words are, fittingly enough, "return to
nature."

Yet Bashō's primitivism was necessarily of a specific kind, as
it was based on his poetic spirit. In this respect a remark by
Bashō, recorded by Dohō, is revealing: "Attain a high stage of
enlightenment," he said, "and return to the world of common
men." The poetic spirit has two aspects: a high spiritual attain-
ment and a life of the laity. The former, with its Buddhist over-
tone, would presume those serene, quiet, ascetic qualities that
were the concerns of medieval Japanese artists. The latter, with
its emphasis on the mundane, points toward that gay, pleasure-
loving world of newly emerging Japan, often called the "floating
world." The two sets of values are inevitably in conflict with one
another at times. Bashō himself was well aware of the conflict: he

verse following Yoshimoto's time. He was the central figure in composing
the celebrated *Minase Sangin Hyakuin,* referred to on page 240. He also
liked to travel.

Sesshū (1420–1506) was a Zen monk and an expert in brush painting.
He studied in China for a while and mastered the art of landscape painting,
and after returning to Japan he created a style of his own. The orthodox
school of black ink painting in Japan can be said to have started with him.

often criticized himself for being neither a priest nor a layman. But certainly Bashō's ideal must have been to overcome that conflict, to reach a realm where those two sets of values are not antithetical but dialectical. Before we proceed to see whether and how this could be done, we need to examine one by one the values that make up the two aspects of the poetic spirit. The first set of values, which are to help the poet to attain a high stage of enlightenment, would include *sabi, shiori,* slenderness, inspiration, and so on. The second set of qualities, which form the world of common men, would contain such ideas as plainness and lightness. Each of those values is interesting in itself, as it reveals some phase of Bashō's poetics as well as the poetics of the Haiku.

Sabi is perhaps the best known of all these ideas pertaining to Bashō's poetics. Bashō, however, seldom used that term himself, although he often used the word *sabishi* from which it was derived. *Sabishi* primarily means solitary or lonely, referring to a man's state of mind when he is in want of company. But Bashō seems to have used that word in a more limited sense. Here is, for instance, Bashō's Haiku using the word *sabishi*:

> Loneliness—.
> Standing amid the blossoms,
> A cypress tree.

It is spring, and cherry blossoms are in full bloom. But in the middle of them there is something that does not harmonize with the loveliness and gaiety of the scene: a green cypress tree. Because of that cypress, the scene somehow yields the atmosphere of loneliness. In this poem, then, loneliness is not referring to a man's personal emotion; it is describing an impersonal atmosphere, a mood created by a natural landscape.

Sabi, derived from *sabishi,* seems to connote this sort of objective, nonemotional loneliness. There is only one poem remaining today that Bashō reportedly said had *sabi,* and this quality of loneliness is manifest in that poem, too. In fact, that poem is strikingly close to the cypress poem just cited:

> Under the blossoms
> Two aged watchmen,
> With their white heads together—.

149

This is not purely a nature poem; there are two men placed in the heart of a landscape. Yet the Haiku says nothing about the men's inner feelings. They are part of the natural scene, just as a cypress tree was in the previous poem. And again like the cypress tree, the image of the aged watchmen provides a sharp contrast to the colorful cherry blossoms, thereby creating an atmosphere of loneliness. Lovely as the blossoms are, they must eventually fall with the passing of time, as suggested by the white hair of the watchmen. Important is the fact that these old men are not grieving over the impending fall of the blossoms or over the anticipated end of their lives. They are there simply to fulfill their place in nature, together with the blossoms; they are part of impersonal nature. Such seems to be the implication of *sabi,* the lonely mood latent in this sort of natural scenery.

Bashō conceived loneliness as an impersonal atmosphere, in contrast with grief or sorrow, which is a personal emotion. The contrast cannot be over-emphasized, because loneliness thus conceived lay at the bottom of Bashō's view of life, pointing toward a way in which his plea "return to nature" can be fulfilled. For Bashō, sorrow was the word to describe life and the world at large; in his view this life was "a demoniac world of the lusts" and mankind was "drowning in a filthy ditch." Life is filled with sorrow because men, each pursuing his own desires, hurt one another. There is no escape for men from sorrow, since it is inherent in humanity. If there should be an escape, it would be only through a denial of humanity, through men's dehumanizing themselves. They can escape from sorrow only when they transform it into an impersonal atmosphere, loneliness.

This metamorphosis of sorrow into loneliness is the theme of one of Bashō's most famous poems. Bashō composed the Haiku while staying alone at a temple in the mountains:

> My sorrowful soul—.
> Make it feel lonesome,
> You, a cuckoo.

The poet, as he set out to compose the poem, was still in the world of humanity, with a personal feeling like sorrow. The cuckoo, on the other hand, seemed to have already transcended

sorrow, as it was closer to the heart of nature. Thereupon the poet wished that the bird's cry might enlighten his soul and eventually lead him into the realm of impersonal loneliness, where he would no longer feel sorrow.

Bashō makes a similar point on another occasion, this time in his diary. It was a rainy morning, and Bashō, trying to kill time, did some idle scribbling:

> A person in mourning makes Grief his master, and a person who drinks wine makes Pleasure his master. When Priest Saigyō sang:
> "Even casual visitors
> Ceased to think about
> This mountain village.
> It would be sorrowful, indeed,
> If here were no loneliness to live with."
> he made Loneliness his master.

Again sorrow and loneliness are clearly distinguished. While sorrow is something hard to live with, loneliness is something enjoyable to have around; in fact, loneliness is what gives solace to a sorrowful life. Though the poem is Saigyō's, Bashō, in quoting it in his diary, must have felt exactly the same way; Saigyō had long been his model both in life and in poetry.

Such a dissolution of personal emotion into an impersonal atmosphere constitutes the core of Bashō's attitude toward life. It was the way in which Bashō tried to bear the sorrows inherent in human life. Bashō was quite determined in keeping this attitude, so much so that he at times looked cold-hearted, or even inhuman. One striking instance of this appears in one of his journals. One day on his journey he came across a little infant abandoned on the roadside and crying bitterly. His remark, addressed to the infant, was a very calm one: "Are you hated by your father, or are you neglected by your mother? No, it is not that your father hates you, nor that your mother neglects you. It is merely fate. Grieve over your adverse fate." A similar attitude prevails in all of his poems produced on grievous occasions, for example, this poem composed by Bashō at the death of his beloved disciple:

151

> In the autumn gust
> It is sorrowfully broken:
> A mulberry stick.

As a self-contained entity, the poem does not much differ in mood from another Haiku by Bashō that simply describes a scene of nature:

> All flowers are dead.
> Sprinkling sorrows
> Are the grass seeds.

Bashō's poems on death, even on the death of those dearest to him, do not show the intensity of grief that is the merit of a dirge or elegy. It was not that Bashō was inhuman; rather, he was *un*human. He tried to overcome his grief by transforming it into something impersonal.

This attitude toward life held by Bashō was his attitude toward poetry, too, especially in his later years when he established a style distinctly his own. A poem containing a personal emotion was inferior to a poem presenting an impersonal atmosphere. Here are two contesting Haiku for which Bashō was the judge:

> The town where they pound cloth—.
> A dog is howling for his mate
> Piteously.

> A garden of taros outside—.
> I listen to the gusty rain
> From inside the hut.

Bashō judged the second poem to be the winner. One of the reasons for that verdict was, as he tells us, that the scene of the rain falling on the large leaves of taros at night was "truly desolate and lonesome." Compared with it, the image of a dog barking for his mate was too human, too abundant in personal sentiments.

Indeed the finest of Bashō's poems seem to be devoid of ordinary human emotions. Here, for instance, are three of his poems universally acknowledged as among his best:

> Quietness—
> The cicada's cry
> Penetrates the rocks.

> The rough sea—
> Far over Sado Isle,[4] extends
> The Milky Way.

> Gathering the rains
> Of June, how swiftly flows
> The Mogami River![5]

These poems contain no personal emotion: no joy, sorrow, love, hatred, anger, jealousy. All there is is the atmosphere of the quiet, the vast, or the swift. It is the atmosphere of impersonal nature, and not an emotion of human life.

Sabi is such an atmosphere. It is loneliness, not the loneliness of a man who has lost his dear one, but the loneliness of the rain falling on large taro leaves at night, or the loneliness emerging out of a cicada's cry amid the white, dry rocks, or the Milky Way extending over the rough sea, or a huge river torrentially rushing in the rainy season. Nature has no emotion, but it has life, through which it creates an atmosphere. This impersonal atmosphere, with an overtone of loneliness, is the core of *sabi*. In this respect it comes close to Rikyū's *wabi*. But *sabi* seems to differ from *wabi* in that it dissolves, rather than withdraws from, ordinary human emotions. Here *sabi* is more like Zeami's sublimity. Yet it differs from sublimity in one significant way. While sublimity transcends ordinary life and enters the world of the supernatural, *sabi* does not attempt to go into the other world. The beauty of sublimity is symbolic; that of *sabi* is not. For Zeami a cedar tree is beautiful because an eternal god is behind it. For Bashō a cypress tree is beautiful because it is a cypress tree, because it is part of impersonal nature.

4. Sado is an island on the Sea of Japan, some fifty miles off the mainland coast. Some eminent people, including Zeami, led a sorrowful life here after being banished from the Capital.
5. The Mogami River is one of the largest rivers in northeastern Japan. Flowing through the mountains, it has many falls and rapids along its way. June is the rainy season in the area.

While *sabi* derives its connotation of loneliness from the poet's attitude toward life, *shiori* seems to produce loneliness out of the structure of the poem. The former is related to the poet's philosophy, and the latter to his poetic technique, both bringing out a poem with the same overtone of loneliness. Etymologically, *shiori* stems from a verb *shioru,* which means "to bend" or "to be flexible." Originally, therefore, *shiori* described a poem flexible in meaning, a poem ambiguous enough to allow several different interpretations. But it so happened that there was another verb, *shioru,* written differently and declined differently but pronounced the same, which meant "to wither," "to droop," or "to wilt." This meaning seems to have found its way into the other meaning of *shiori,* too. Thus, when the poets of the Bashō school use it, *shiori* appears to refer to a poem containing several levels of meaning and yet altogether yielding the mood of loneliness, an atmosphere created by the image of a withering flower.

Let us take an example. Here is a Haiku that Bashō said had the quality of *shiori*:

> The Ten Dumplings
> Have become smaller, too—
> The autumn wind.

The Ten Dumplings, so called because they were strung together in a unit of ten, were the special product of a certain mountain village in central Japan, where they were sold to travelers on the roadside. But it is now autumn, and travelers have become fewer. As the sales drop, the villagers now make their dumplings smaller and get more profit from each sale. The general mood arising out of the poem is sadness, but what is that sadness directed toward? Toward the poor villagers who have to depend on the sale of dumplings for their livelihood? Toward the villagers who miss the traveling season? Or toward the poet, a lonely traveler? Toward the poet mourning over the passing of summer? Or toward both nature and human life, which must change with time? The word "too" and the verbless last line make the meaning ambiguous. But through that ambiguity the feeling of sadness is universalized, as it were. The sadness is no longer the petty feeling of the villagers grieving over diminished sale. It is "loneli-

ness" shared by the villagers, by the traveling poet, and by the autumn wind. Sadness has been dissolved into that impersonal loneliness.

The concepts of *sabi* and *shiori* explain two of the techniques peculiar to the Haiku: *kireji* or the "cutting-word," and *kigo* or the "season-word." The cutting-word is a word or a part of a word used in a Haiku poem to cut the structure into two parts. It may or may not have its own meaning; its main function is to show that the flow of the meaning is interrupted there. It often follows the subject of the sentence, interrupting the sentence at that juncture and leaving out the predicate verb altogether. The result is of course ambiguity; the reader must supply the verb in his own imagination. In the cicada poem quoted earlier, for instance, a cutting-word follows "Quietness—," in the place of whatever verb there might have been. In the Ten Dumplings poem there is a cutting-word after the second line, thereby leaving the last line hanging in the air. All this creates ambiguity, but that ambiguity changes the particular into the universal and transforms a specific personal emotion into a vague, impersonal atmosphere.

Kigo or the season-word is concerned with a rule in the orthodox Haiku tradition which prescribes that every poem must contain a word suggestive of a season of the year. A rule like this would be arbitrary in other verse forms, but in the poetics of the Haiku it does make sense. Each Haiku poem, according to Bashō, must present an atmosphere of nature; it follows, then, that each Haiku must imply a season, for nature is seasonal. Even when the Haiku takes its original material from a personal emotion, it will still show a season, since that particular emotion will, by the time it is made into a poem, have been transformed into an impersonal mood of nature. We have already seen an example of this in Bashō's poem on the death of his disciple. Here are two more similar examples, both composed on intensely emotional occasions. Bashō produced the following poem when he revisited his native home, where he wept over a lock of his late mother's hair kept as a memento in a little bag:

If I take it in my hand,

155

The hair will melt with my burning tears.
The autumn frost—.

He wrote the next Haiku on hearing of the untimely death of another of his disciples:

Move the gravemound!
My tearful cry
Is the wind of autumn.

In both of these two poems an intense emotion is suggested in the first two lines but then in the third line, which contains a season-word, the poet's grief is depersonalized into an object of nature, the autumn frost or the autumn wind. Death is sad, but it is part of nature, just as winter, heralded by autumn, is part of the cycle of the seasons. Grief dissolves into the loneliness of the universe.

The main task for the Haiku poet, then, is to immerse himself into the heart of an object or an incident that he proposes to sing about, and to catch the impersonal mood it shares with the universe. In order to be able to do this, he must have a most delicate, sensitive mind. Bashō has a name for such a special working of mind: slenderness. It is as if the mind were so slender that it could go into any external object and reach its innermost life. The Haiku that Bashō thought showed slenderness is:

The water birds
Must be asleep, too,
On Lake Yogo.

Lake Yogo is a small, quiet lake among the mountains. The poet was staying at a rustic inn near the lake, and as he lay in bed at night he thought of the water birds on the lake. With a slender mind the poet entered into the life of the water birds and found therein the loneliness of a traveler like himself—or, indeed, like all men and all changing things in nature.

Another example of a poem that Bashō thought had slenderness is one composed by Bashō himself:

The salted sea bream's
Gums are chilly, too,
At the fish shop.

156

The sea bream that the poet saw at the fish shop was of course dead. But again with the slenderness of mind he entered into the fish and felt chilly. There is ambiguity as to why he felt chilly. It may be that the day was chilly. It may be that the fish shop was chilly, or chilly-looking, because it had so few fish on display due to bad fishing weather. Or perhaps the fish's white teeth somehow yielded a chilly impression. The word "too" in the second line creates that ambiguity. But the over-all impression produced by the poem is unmistakably that of loneliness.

However, no matter what a slender mind the poet may have, it is no easy matter to enter into the innermost life of an external object. It presumes the poet's complete dehumanization, the dissolution of all his emotions. But obviously a man cannot live without his emotions, for he is a biological existence who must maintain himself and his species through his physical desires. The poet could dehumanize himself, but only for a brief period of time, perhaps only for a few moments at most. For the poet those moments are precious indeed, since this is the only time when he can get a glimpse of the impersonal essence of the universe, of the innermost life energy shared by all things in nature. Here arises Bashō's concept of inspiration, which he thought was essential to the writing of the Haiku.

Understandably, in Bashō's view poetic inspiration goes through two stages, perceptual and expressive. First, there is the poet's instantaneous perception of the essence of the object; secondly, there must be the poet's spontaneity in recording that perception in the form of a poem. About the first stage Dohō has a passage:

> The Master said: "Learn about a pine tree from a pine tree, and about a bamboo plant from a bamboo plant." What he meant was that the poet should detach the mind from his own self. Nevertheless some people interpret the word "learn" in their own ways and never really "learn." "Learn" means to enter into the object, perceive its delicate life, and feel its feeling, whereupon a poem forms itself. Even a poem that lucidly describes an object could not attain a true poetic sentiment unless it contains the feelings

157

that spontaneously emerged out of the object. In such a poem the object and the poet's self would remain forever separate, for it was composed by the poet's personal self.

Here is a strong plea for objective, impersonal poetry. The poet's task is not to express his emotions, but to detach himself from them and to enter into the object of nature. A pine tree has its own life, so a poet composing a verse on it should first learn what sort of life it is by entering into the pine tree and perceiving its delicate life. The poet will become at one with the pine tree; this is the only way by which he can learn about the inner life of the pine. And, when he identifies himself with the tree, a poem will spontaneously form itself in his mind, without a conscious attempt on his part. Dohō has made a distinction between "growing" and "making" in the process in which a poem is created. "There are two ways in which a verse may be written: 'growing' and 'making,'" he says. "When a poet who has always trained his mind along the way of the Haiku applies himself to the object, the color of his mind 'grows' into a poem. In the case of a poet who lacks that training, nothing grows into a poem; as a consequence, he has to 'make' a poem out of his self." A true Haiku poet can make his mind transparent, as it were, so that an external object dyes it in its color; this color grows into a poem. A mediocre poet cannot do this, so he has to turn to his intellect, learning, conventional poetic technique, and so on; the poem thus made is inevitably artificial. Dohō calls this "a technician's disease" and cites Bashō's teaching to the same effect. "Let a little child compose the Haiku," said Bashō at one time. "Any beginner's Haiku has something promising," he said at another time.

A poet who has successfully perceived the delicate life of an object must go to the next step: to record that perception adequately. Even if the perception is attained, no good poem will emerge from it if it is distorted or lost in the process of expression. Dohō is referring to this danger when he says: "One of two things might happen to the poet who has entered into the essence of the object: he might nourish that inspiration, or he might destroy it. If he destroys that inspiration, the poem will become

158

spiritless." Then he quotes Bashō's words: "The Haiku must be composed by the force of inspiration." Bashō said the same thing again and again. "If you get a flash of insight into an object," he taught at one time, "record it before it fades away in your mind." "When you are composing a verse," he said at another time, "let there not be a hair's breadth separating your mind from what you write. Quickly say what is in your mind; never hesitate at that moment." Bashō had more colorful similes, too, in stressing the spontaneity of poetic expression. The composing of the Haiku must be done in an instant, he said, "like felling a massive tree, like leaping at a formidable enemy, like cutting a watermelon, or like biting at a pear." All this clearly points to Bashō's idea that the Haiku poet should never lose his inspired moments but write down the instantaneous perception as it is, with no impure thought intervening in the process.

The idea of inspiration explains that exreme brevity of the Haiku form, which consists of only seventeen syllables. The inspired moments never last long; they cannot, as long as they presume the poet's complete submersion in an external object. His momentary perception cannot be described; it defies a logical explanation. The Haiku needs only to present concrete images in the briefest words. The relationship between images does not have to be spelled out, for doing so would mean the imposing of logic upon a fresh, new insight. The omission of the predicate verb and the use of the cutting-word are thus justified, as we have already seen.

It naturally follows that the Haiku need not have logic in its internal structure. This is substantiated by what Bashō and his disciples have written, too. Indeed, they have said little about the methods of structure in the Haiku; but we can guess what their thoughts on the subject must have been, because we have their written comments on the principles of structure in the Renku, or linked verse in the Haiku style. Since the Renku can be said to be the linked Haiku, we can safely assume that what is valid in the Renku can be applied to the Haiku as well.

Bashō and his disciples have conceived a number of structural principles in the Renku, but chief among them seem to be fragrance, reverberation, and reflection. As these terms show,

159

none of them is logical; indeed, all are very impressionistic and elusive. Fragrance, as explained by Rogan, is "like the fragrance of a flower drifting." It is as if a faint fragrance flowed out of a stanza and quietly moved to the next stanza in the Renku. Here is an example:

> Enlivened at the top
> Is a pine tree in the shower of summer.
>
> A Zen monk
> Stark naked
> Enjoys the cool.

There is some vague connection between a pine tree in the summer shower and a naked Zen monk cooling himself. This link is termed as "fragrance." Another example of fragrance is given by Dohō:

> Many different names
> Are all too confusing:
> The spring flowers.
>
> Slapped, a butterfly
> Awakens from its sleep.

The first stanza sings of the beauty of spring flowers: various flowers are all so beautifully blooming that it is confusing to remember them each by a different name. But the expression "confusing" gives one the impression of something unsettled, as if something is fluttering at a corner of a beautiful landscape. The author of the second stanza, Bashō himself, smelled this "fragrance" and therewith created the image of a fluttering butterfly in his stanza.

"Reverberation" is explained by Rogan: "As soon as the first stanza is hit, the second stanza reverberates from it in unison." Kyorai also has a similar explanation and then cites an example:

> On the veranda
> A silver-glazed cup
> Is smashed.
>
> Look! The slender sword
> Is about to be drawn.

The first stanza suggests a fierce fight about to start between two warriors at a banquet: one of the warriors, in anger, flings his wine cup at the veranda and smashes it into pieces. The second stanza, continuing that tense atmosphere, creates an equally strained situation where a warrior, ready to fight, is about to unsheathe a long, slender sword. The relationship between the two stanzas is described as "reverberation." Here is another example:

> An orphaned crow is yet to find its bed
> Somewhere under the moon of tonight.

> The spears
> Charging at a thief
> Have the sound of the deepening night.

The natural order of the universe is disturbed in the couplet with the orphaned crow, and that is echoed in the triplet, which tells of a thief discovered by the guards in the depth of night.

"Reflection" seems to describe the relationship between two successive stanzas in which the atmosphere of the one reflects that of the other. It is sometimes called "movement," too, for the poetic atmosphere moves from one stanza to another. Here is an example:

> The brushwood is being cut down
> Along a grassy path toward the peak.

> Deep amid the pine trees
> In the forest on the left
> Is a thatch-roofed temple.

Bashō thought that the rough, coarse atmosphere of forest workers cutting down the brushwood, as presented in the couplet, is not reflected in, or does not move smoothly into, the mood of the triplet, which is peaceful and still. So he suggested that the first line of the triplet be changed to "It is hailing—," whose harsh wintry mood would well befit the mood of the couplet.

As seen in those instances, the qualities such as fragrance, reverberation, and reflection are delicate and subtle indeed. It is not easy to distinguish between them, although it has been said

161

that fragrance deals with a quiet, peaceful atmosphere while reverberation occurs when the mood is more forceful and stirring. We saw such an anti-discursive attitude in the structural principles advocated by Yoshimoto; that trend has now been further carried on by Bashō and his disciples. And that is no wonder, since the Haiku, even more than linked verse, has its roots in the poet's pre-logical mentality, in his flash of insight into the nature of things.

Here we might see a few instances in which such impressionistic qualities are used as unifying elements within the individual Haiku:

> The chrysanthemum smell—
> In the old town of Nara,
> Many ancient Buddhas.

> Exhausted,
> I look for an inn.
> The wistaria flowers—.

> Quietly, quietly,
> Yellow mountain roses fall.
> The sound of the rapids—.

> Under the crescent moon
> Dimly looms the earth.
> The buckwheat flowers—.

In each of these Haiku two disparate objects are abruptly juxtaposed, with little or no explanation. The scent of chrysanthemums and old Buddhist images, purple wistaria flowers and a tired traveler, yellow mountain roses and the sound of a torrent, the crescent moon and white buckwheat flowers—there is little logical connection between the two objects presented in each Haiku. Yet the juxtaposition of the two objects produces a strangely harmonious mood, a mood that cannot be described except by such impressionistic terms as fragrance or reverberation.

There seems to be one special case, however, in which we can define a structural method of the Haiku with a modern scientific

term. This is the case of synesthesia. In some Haiku two objects
are juxtaposed in such a way that the merging of different senses
may take place. Here are some examples:

> Their fragrance
> Is whiter than peach blossoms:
> The daffodils.

> Over the evening sea
> The wild ducks' cry
> Is faintly white.

> It is whiter
> Than the rocks of Ishiyama:[6]
> The autumn wind.

> Onions lie
> Washed in white.
> How chilly it is!

In these poems a color is used to suggest the quality of a frag-
rance, a sound, a tactile sensation, or a temperature. Such a
method is very effective for presenting an experience in its
totality, in contrast with the method of science, which dissolves
a whole into its component parts. Synesthesia presumes an atti-
tude that accepts the ultimate interrelatedness of all things and
experiences. Bashō's synesthesia, however, seems to differ sig-
nificantly from its counterpart in French Symbolist poetry.
French Symbolists used synesthesia in such a way as to create a
shocking effect and the beauty of artifice; their beauty was the
perfume of amber, musk, benjamin, and incense—violent, sen-
sual, artificial, sophisticated, often decadent and even abnormal.
But the effect of Bashō's synesthesia is like the fragrance of daffo-
dils or the wild ducks' cry over the evening sea—faint, natural,
simple, primitive, and never extravagant or shocking. This of
course stems from Bashō's basic attitude toward life—*sabi, shiori,*
and "return to nature." We might recall that all four instances

6. Ishiyama, literally meaning "a stone mountain," is a site of a large
Buddhist temple in Omi Province. The place is famous for its bleached
rocks.

of synesthesia cited above involved the color white, suggestive of that universal loneliness.

However, the ideas of *sabi, shiori,* and return to primitive nature did not constitute the whole of Bashō's philosophy or his poetics. Here we must turn to the other side of the poetic spirit, which, as we remember, urged one to "return to the world of common men" after attaining a high stage of enlightenment. This emphasis on plain, ordinary life is another essential factor in the Haiku; indeed, that is an important element distinguishing the Haiku from other forms of traditional Japanese poetry. "Chinese poetry, Japanese lyric, linked verse, and the Haiku are all poetry," observed Dohō. "But the Haiku draws upon all things of life for its material, including even those which are left out in the other three." In traditional Japanese poetry, for instance, a warbler frequently sings in the blossoms. But when the Haiku creates a scene with a warbler, it need not be such an elegant picture. Dohō cites an example from Bashō's work:

> The warbler—
> It pooped on a rice cake
> At the veranda.

The difference between traditional linked verse and the Haiku is also made clear by Bashō when he says: "A willow tree in the spring rain is wholly of the linked verse world. A crow digging up a mud-snail belongs entirely to the Haiku." The world of the Haiku includes all things in existence, elegant or not elegant; it contains warblers, blossoms, and the moon, but it does not exclude a muddy crow, a bird's droppings, or a horse's dung. These are also part of nature.

Likewise, the Haiku takes in all things of human life. The Haiku poet, while detaching himself from worldly desires, lives among them. He does not flee from the world of ordinary men; he is in the middle of it, understanding and sharing the feelings of ordinary men; he has only to be a bystander, who calmly and smilingly observes them. Bashō has a poem suggesting that the poetic spirit does not exclude the feelings of common men:

> When masked beggars
> Come round, my poetic spirit
> Is also at the year's end.

According to a custom of the day, beggars masked themselves with red cloth when they went out begging toward the end of the year, so people who saw them were once again reminded that the year's end was approaching. In this Haiku Bashō is saying that he, with his poetic spirit, shared that year-end feeling, too. Dohō proposes to contrast this poem by Bashō with the following Haiku by someone else:

> My storehouse burnt down,
> I can now enjoy
> An unobstructed view of the moon.

The poem, trying to transcend an ordinary man's feelings under such circumstances, is ludicrously pretentious. Bashō's poem, in contrast, is far from vulgar while dealing with common men's feelings.

Bashō repeatedly emphasized the importance of understanding the feelings of plain men in ordinary life. "One need not be a Haiku poet," he said to Shikō. "But if there is a person who does not harmonize with ordinary life and who does not understand ordinary sentiments, he should be called the most unpoetic person." "One need not be a Haiku poet," he told Dohō, too. "But a person cannot be considered a wholesome personality unless he harmonizes with ordinary life and understands ordinary sentiments." The implication is that the Haiku helps one adapt to ordinary life and to understand ordinary sentiments. If one attains this kind of personality, one really need not compose poetry; the poetic spirit is what counts, and not the actual poem written on paper.

The Haiku poet, therefore, takes an attitude somewhat like that of a recluse, but nevertheless lives among ordinary men and enjoys a plain way of living. Bashō, carrying this attitude further, came up with the notion of lightness in the last years of his life. In the year of his death, for instance, when one of his pupils asked him what the future style of the Haiku would be, Bashō answered: "In five or six years the present style will change completely, and will become much lighter." In the same year he wrote a letter to Dohō and another disciple of his, in which he said: "I was greatly pleased to see lightness prevailing in your verse in general." As for the nature of lightness, Bashō had a

number of metaphors. "Simply observe," he once said, "what children do." "The style I have in mind," he said at another time, "is a light one both in form and in structure, like the impression of looking at a shallow sand-bed river." On another occasion someone asked Bashō what the latest style of the Haiku was. Bashō answered: "Eat vegetable soup rather than duck stew." The man who asked was puzzled and wondered how plain vegetable soup could be compared with delicious duck stew. Bashō only smiled and did not reply. Kyorai, who had been listening, told the man: "Indeed, I can see why you are not tired of duck stew: you have never eaten it, so you crave for it day and night." Lightness, then, is the beauty of things plain and ordinary, as against colorful, gorgeous beauty. It is the beauty of naïveté rather than of sophistication; of simplicity rather than the ornate; of the shallow rather than of the deep. It goes without saying that this beauty of the shallow does not imply a total lack of depth, however: only those who have tasted duck stew can appreciate the true delicacy of vegetable soup. A person can see the beauty of lightness in the world of common men only after attaining a high stage of enlightenment.

It is unfortunate that there are few examples left today of the poems said to contain the quality of lightness. Only in one instance do we have a poem which Bashō thought had lightness:

> Under the trees
> Soup, fish salad and all
> In cherry blossoms.

This is a blossom-viewing poem, but instead of those elegant courtiers and graceful ladies, or of that hazy moon in the evening dusk, here is a down-to-earth object, food—and a plain sort of food, too. The poem depicts the scene of a family picnic, where cherry blossoms are falling on all things that are there, including the picnic dishes. The peaceful, happy mood of the family will be broken some time, as suggested by the falling blossoms, but nevertheless the picnickers are thoroughly enjoying that momentary happiness in a plain way. The implication points toward lightness.

In another instance we have a Haiku poem that Bashō thought

166

was lacking in lightness. The poem was written by Etsujin,[7] a friend of Bashō's, and the incident was recorded by Kyorai:

> Spring under His Majesty's reign—
> The color of a mosquito net
> Is light green throughout the ages.

The late Master once said to me: "A poem cannot be a true Haiku unless it settles down. Etsujin's poetry did seem to settle down, but then it began to show heaviness. In this poem of his, the words "The color of a mosquito net / Is light green throughout the ages" are good enough. Before those words he should have placed a phrase like "The moonshine—" or "The dawning day—" for the first line, thereby making the poem a Haiku on a mosquito net. But he used the unchanging color of mosquito net to suggest the eternal spring of His Majesty's reign, and thereby made the poem a Haiku celebrating the New Year. As a consequence, the poem has become heavy in meaning and does not look neat. Your poetry, too, has settled down where it should, and in that respect you need not worry. But do not stay fixed there."

A poem should be light, but it should not be flippant, frivolous, or trite. It ought to give the impression of having "settled down"; all its parts should be neatly balanced and firmly founded. But that does not mean the poem is weighty and dignified. Etsujin's Haiku is weighty and dignified; it sounds almost like a national anthem. Bashō therefore proposed to change the whole tone of the poem by replacing its first line, which is especially grandiose. The Haiku would then become a poem about a mosquito net, a subject familiar enough. It may not exactly be light, but it would be far lighter.

We have one more instance where Bashō rejected a verse for its lack of lightness. This time it was linked Haiku, and Bashō

7. Ochi Etsujin (1656–?) was especially close to Bashō in the 1680's; in 1688, for instance, he was Bashō's sole companion in the famous journey that resulted in *The Journal of a Travel to Sarashina*. After Bashō's death he was engaged in a series of lively controversies with Shikō over principles of the Haiku.

thought the stanzas were too "sweet"—that is, too heavily loaded with emotion. The stanzas read:

> Without sense or discretion
> He falls deeply in love.

> The rustic setting
> Begins to show its charm
> In the vicinity of Fushimi.

The stanzas deal with love, not courtly love, but the love of a common man, probably a young, peddling merchant. So the material is something that could have produced lightness, and the writer of the triplet (Bashō) tried to use it that way and created a rustic setting (Fushimi was located in the outskirts of Kyoto, bordering on the countryside). But the result was not lightness but sweetness; emotions of young love were not sublimated enough. This would become clearer if we contrast it with the two stanzas dealing with a similar kind of love included in *A Sack of Charcoal* ("Sumidawara"), a collection of linked Haiku containing Bashō's works in his last years:

> Without telling
> Even his next-door neighbor,
> He brought his bride home.

> In the shade of the screen,
> A tray for the cake dish.

The theme is again the sort of love found among the people of modest means. The couple, being poor, had no elaborate wedding ceremony: the bridegroom, in fact, did not mention his wedding even to his next-door neighbor, but quietly brought his bride home. Yet, without a gorgeous wedding, the occasion was a happy one to the couple just the same; they celebrated it between themselves with a small cake at the bridegroom's home. The stanzas simply describe facts as they are; the couplet, in particular, merely depicts an impersonal scene. Yet the stanzas are not lacking in deeply felt love; it is merely that that love is here looked at by a smiling bystander. Such would be a manifestation of lightness.

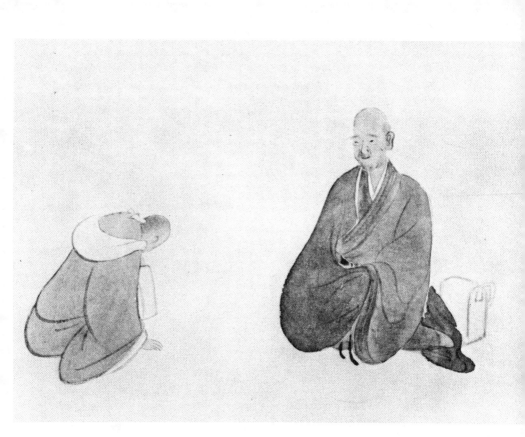

Plate 11
Bashō and his disciple Sora.
The latter, taken ill during their journey together, bids the
Master farewell at an inn.
Painting by Yosa Buson (1716-83), who was also an expert writer
of the Haiku.

If the idea of lightness were pursued further there would emerge the element of humor, for lightness is the quality that detaches a man from worldly concerns while he is immersed in the mire, and that is precisely what makes humor possible. Life is constant suffering for those who have not attained enlightenment; it is something to flee from for those who long for the life of a recluse. But those who have returned to the earthly world after attaining a high stage of enlightenment can look at life with a smile, for they are part of that life and are not so. Knowing what life ultimately is, they can take suffering with a detached, light-hearted attitude—with lightness. Bashō was one of those men, as is clearly shown in the following instance. Here Bashō is describing himself in a journal:

> My straw hat had been worn out in the rains I met on the long journey; my paper robe had been wrinkled in the storms I suffered at various places. Though I was familiar with all the sorrows of traveling, I felt sad this time. Then it occurred to me that a certain comic poet had also traveled in this area some time before, and that led me to compose a poem:
>> In the wintry gust
>> I wander, like Chikusai[8]
>> The comic poet.

The passage well describes the tired, emaciated Bashō on a rugged journey. The situation was a desperate one indeed; even Bashō says it was sad. But then he detached himself from the sadness and composed a poem with light-heartedness. The Haiku, with its allusion to a whimsical mountebank in popular fiction, has done away with sadness; there is even a suggestion of the poet's smiling at himself.

We shall take one more example of lightness verging on humor. This time it is part of the Renku, the second stanza of which was written by Bashō:

8. Chikusai is the hero of a popular fiction called *The Tale of Chikusai* ("Chikusai Monogatari," 1635 or 1636) attributed to Karasumaru Mitsuhiro. A physician by profession, he writes a number of comic verses on the incidents he meets during his travel to Edo.

> Stealthily,
> He braids a straw sandal
> In the moonlight.

> There she rushes out to shake the fleas
> Off her pajamas in the early autumn night.

The first stanza depicts a farmhouse scene where a peasant, unable to support his family with daytime work alone, is making straw sandals late at night. He is working in the moonlight outdoors to save lamp oil, but he has to be cautious not to disturb his neighbors. Bashō's couplet that follows, however, neither mourns over the sad peasant life nor protests against the existing social order; staring at the cold fact of life, he just smiles it away. In his stanza he introduces a new character, probably the peasant's wife, who comes out of the house with sleepy eyes to shake off the fleas in the open. The lines are permeated with lightness, which somewhat brightens the otherwise somber picture.

We may conclude, then, that Bashō's poetic spirit functioned not only as a poetic doctrine but also as a moral, or even religious, discipline for him. *Sabi* and *shiori* are poetic principles advocating impersonality in composition, but they also attempt to show that man could overcome life's sorrow by dissolving it into universal loneliness. Fragrance, reverberation, and reflection are poetic principles referring to the impressionistic ways in which different parts of a poem are related, but they also suggest the interrelatedness of all things in the universe, the common destiny of all things in the world. Plainness and lightness are also poetic principles advocating the Haiku's all-inclusiveness in theme and material, but going beyond they also teach how to live in this grief-laden world with a smile. Bashō was painfully aware of the sorrows of life and once even contemplated entering the priesthood. But he never became a priest, no doubt because he believed in the saving power of poetry, in the sublimating effect of the poetic spirit. "At one time I craved for a high office and a substantial estate; at another time I thought of living within the walls of a monastery," he writes, looking back on his past career. "But I kept wandering aimlessly like a cloud while singing of flowers and birds, until that became even the source

of my livelihood. With no other talent to resort to, now I can only cling to this thin string of the Haiku." Under the pose of modesty characteristic of Bashō, we can detect his single-minded devotion to the Haiku as the source of not only material, but spiritual, livelihood.

Unfortunately, the Haiku could not be a religion after all. Bashō seems to have come to that painful realization toward the end of his life. In a short prose piece believed to be written two years before his death, he speaks of his determination to stop writing poetry and says: "No sooner have I decided to give up poetry and closed my mouth than a poetic sentiment solicits my heart and something flickers in my mind. Such is the weird power of the poetic spirit." Lying in his deathbed, Bashō still thought of poetry. He fully knew that it was no occasion for verse-writing, but, as he told Shikō, he wandered through morning clouds and evening mist while asleep, and was startled at the sound of a mountain stream and the cry of wild birds when awake. "All this," he then said, "is a sinful attachment." He further continued, "I simply wish I could forget the Haiku of my lifetime." His last poem was:

> On a journey, ill—
> My dreams roam
> Over a wild moor.

The poem seems to fully substantiate Shikō's record. In the face of death, *sabi, shiori,* and lightness were to lead Bashō to a peaceful, serene state of mind. Yet actually they did not; they could not; as long as they remained poetic principles, and as long as Bashō remained a poet. Those principles of depersonalization could give the poet a moment of solace, but only for that brief, inspired period of time; the next moment he had to emerge out of that impersonal self and resume his role as a poet. A poet must necessarily be an active, vigorous personality, for his task is an act of creation; but Bashō tried to set up his poetics and religion at the extreme of passivity. Bashō's mistake lay precisely in this: he sought to attain the passivity of religion by means of poetry, despite the fact that poetry by its very nature demanded a degree of positivism on the part of the poet. This

171

degree of positivism, no matter how slight it might be in the case of the Haiku, inevitably formed an obstacle in the path of religion—a sinful attachment, as Buddhism calls it. Bashō again suffered the fate of all artists who tried the same; we have already seen the instances of Zeami and Rikyū before him.

11

Yūshō

on the Art of Calligraphy

Aesthetic Elements of the Line

Calligraphy is an art fully developed in northeastern Asia, where Chinese characters are used in writing. No doubt this is largely due to the nature of Chinese characters themselves, which are primarily pictographs derived from the forms of actual objects. While there remains little evidence today to verify the gradual process in which these characters came into being, it is not difficult to surmise that their creators, in imitating visual forms and simplifying them into pictographs, consciously or unconsciously depended upon their aesthetic sensibility to some extent. In this sense Chinese characters can be said to be the product of mimetic art; from the very beginning they had the possibility of being artistically cultivated. Indeed, once socially sanctioned, they hardened into a common property of the community not easily changed by the taste of an individual; the details of each pictograph, including even its stroke order, came to be strictly prescribed by common consent. Those traditional rules, however, were for a calligrapher what the rules of versification are for a poet; they provided a basic framework within which each artist was to display his individuality. For one thing, the calligrapher of Chinese characters used a brush for his writing instrument, which gave him a good deal of flexibility in drawing a line.

Furthermore, Chinese characters permitted a wide variety of styles, though based on the three standard ones: the most formal Square Style, the most informal Cursive Style, and the Semi-Cursive Style, which stands midway between the two. Lastly, Chinese characters were ideograms capable of expressing thoughts and emotions in themselves; even in isolation they could have a literary appeal. All those factors combined, calligraphy has become a quite complex art, synthesizing the functions of representative and expressive art, time and space art, pictorial and verbal art.

All books and essays on the art of calligraphy necessarily reflect such complexity, and this often makes them difficult to read. One of the most comprehensible among Japanese classics on the subject is *The Secrets of Calligraphy* ("Hitsudō Hiden Shō"), a book in which Ojio Yūshō, an expert Japanese calligrapher of the seventeenth century, answers a student's questions on seventy-seven items. One of the items, in which Yūshō enumerates the most important rules for students of calligraphy, is to be highly commended not only for its clarity of statement but also for its firm grasp of the principal issues involved in learning this difficult art. The rules to be observed by beginning students are:

1. Keep your body upright and your soul righteous as you take up the brush.

2. Write with a calm mind while carefully studying the forms of characters.

3. Be gentle in the use of the brush.

4. Put flesh to the characters.

5. Let the characters observe the prescribed form.

6. Pay close attention to the soul of the brush and of the characters.

7. Consider the weight of each character.

8. Pay attention to the rhythm of the brush.

9. Thoroughly understand how to handle the brush.

10. Give heed to the way of connecting one character with another.

The basic rules for advanced students in calligraphy are:

1. Write with force, while retaining gentleness in the brushwork.

2. Let the characters depart from the prescribed form.

3. Consider the momentum of the brush.

4. Consider the length of the proposed phrase in proportion to the size of your paper.

5. Do not lose the individuality of your brush.

6. Give thought to the balance of the characters.

7. Be attentive so as to allow no slackening in your brush movement.

8. Give thought to the amount of ink in your brush, so that there may be no excess or deficiency.

9. Create a harmony among the ink, the brush, and the paper.

10. Learn the Way of Calligraphy.

Those precepts, simple and often commonplace as they may appear, expand a good deal in scope and depth when considered in light of the other seventy-six articles that make up the rest of the book.

These two sets of precepts, put side by side, readily reveal one general principle, which is perhaps a truism in learning any art: a beginner must observe prescribed rules, while an advanced student must transcend them. The truism, however, has a special implication in this instance, for the precepts seem to teach that the artist, as he advances in his study of the art, could and should express more and more of his self in his work. In other words a beginner in the art of calligraphy should pay attention to its representative phase, and an advanced student to its expressive

phase. This is indicative of the basic nature of calligraphy, an expressive art superimposed on a representative art.

Yet calligraphy, seen as a representative art, is a curious one indeed. It has no object of nature to represent. Or, if one regards the Chinese ideogram as an imitation of nature, the calligrapher imitates an imitation. Therefore it often happens that a work of calligraphy, poorly executed, falls into a lifeless imitation twice removed from nature, as it were. This occurs when a beginning student tries to imitate a master calligrapher of the past without learning the fundamentals of the art. Yūshō warns against this practice: "A work produced by copying another artist's work should not really be thought of as being created by the calligrapher. It is a counterfeit, like a wild fox's transforming itself into a human being."[1] Elsewhere in the book Yūshō classes an imitator of expert calligraphers in the same category as a worthless person faking a man of virtue, a mediocre blacksmith counterfeiting a masterpiece, and a gilded work looking like gold or silver. An imitation of another artist's work, no matter how skillfully it may be done, turns out to be devoid of life and spirit.

The dilemma of not having an object of imitation in nature could be solved only by assuming something imaginatively ideal, something which does not exist in factual reality but which could be imagined as having a perfect form. This is exactly what Yūshō does. He compares a written character to the figure of a man, presumably to the harmonious figure of a perfect man. Just as the painter portraying Venus or the Virgin imagines the most beautiful figure of a woman, the calligrapher must create an ideogram in the image of an ideal human figure. "Since characters were first created in the image of a human figure," says Yūshō, "a calligrapher who writes them must use his brush in such a way that their hands and feet would move and work as if with life." Naturally enough Yūshō goes on to compare a poor work of calligraphy to a dead human body with its flesh and bones decomposed. A good calligrapher would "draw all strokes, horizontal, vertical, or diagonal, with the kind of accuracy with

1. A fox was popularly believed to have the power to turn itself into different forms at will.

176

which arms and legs are put on a human body." Characters can be alive, dead, or sick, depending on the merit of the calligrapher who creates them. Every student of calligraphy must strive to produce living characters.

How would those living characters look in more concrete details? Yūshō's reply is an elaborate one. He itemizes all the attributes of a living character:

1. The character wears a hat and shoes.

2. The Semi-Cursive character looks as if it is being seated.

3. The Cursive character looks as if it is walking.

4. The character moves.

5. The character works.

6. The character and the brushwork have a soul.

7. The character and the brushwork have individuality.

8. The character is alive.

9. The character has shape and color.

10. The character is not sick.

11. The brushwork has life.

12. The brushwork has force.

13. The character shows the calligrapher's competence.

14. The brushwork has a head.

15. The brushwork has a front and a back, as in a human body.

16. The character has flesh and bones.

17. The brushwork is untainted.

18. The brushwork is stout and delicate.

19. The brushwork has energy in reserve.

20. The character is well mannered.

21. The character has morals.

22. The brushwork has peace and harmony.

23. The character has ardor.

24. The character breathes.

25. The brushwork shows an expert's confidence.

26. The character has nobility.

27. The character has a voice.

28. The character has a spirit.

Yūshō then goes on to list the characteristics of a dead character for the sake of contrast:

1. The brushwork has no individuality.

2. The brushwork has no life.

3. The character has no flesh.

4. The brushwork and the character have no soul.

5. The character is powerless.

6. The character does not breathe.

7. The character is without shape or color.

8. The character has no energy in reserve.

9. The character is voiceless.

10. The character is spiritless.

The metaphor of a human body, which recurs throughout these items, impressionistically points toward the essence of calligraphy with all its complexity.

First of all, calligraphy is a formal art. The making of a proper form thus becomes a prime factor in the creative process. Each character in a work of calligraphy must have a balanced, harmonious form like a human figure. It has a head, backbone, arms, legs, and so on; it has flesh and bones, too. It must even be properly dressed, with a hat and a pair of shoes; it must be ready to

sit or walk as the occasion requires. The importance of the character's proper, harmonious outlook is emphasized by Yūshō elsewhere: "All classes of men, from high-ranking noblemen to lowly commoners, have proper costumes to wear on given occasions. A work of calligraphy in the Cursive Style is like a man in ordinary dress. As there is no law or inhibition for wearing clothes on informal occasions, the Cursive Style prescribes no specific rule; all it aims at is balance." An ill-balanced character must not be drawn. It would look more like a beast or a bird than like a human being. "Some contemporary calligraphers' works look like a snake," Yūshō observes. "Since their characters have eyes and mouths, I often mistake them for painting. But in truth they are neither painting nor calligraphy; no true artist in China or Japan has ever produced that kind." Calligraphy and painting, both having the elements of space art, share the same principle of visual balance and harmony. A work of pictorial art that fails to follow it would look like a snake, a deformation of nature. Nevertheless some people praise such a work, saying that it is unique, original, and imaginative. Yūshō denounces this modern trend by using the metaphor of a tree, somewhat in the same manner as Toraaki has done. There is, he says, often an old tree which has an unusual appearance but which is attractive because it has naturally grown into that form. If a natural tree should be artificially distorted, with its branches bent down and its trunk twisted, it will look no better than "a criminal with his nose and fingers shaved off." The beauty of balance is after all the beauty of nature. A character drawn by a calligrapher should in its abstract way have the balance and harmony of nature. .

As may be easily imagined, balance is not only an internal principle of calligraphic composition but is extended to rule the arrangement of characters on a given paper. No matter what a well-balanced form a character may have in itself, the work would be a failure if that character should upset the balance with other characters preceding it or following it. To integrate a character with another in an harmonious way thus becomes another important principle in the art of calligraphy. Yūshō cites examples of broken harmony: to add a heavy char-

acter to a light one, to add a Chinese character to a Japanese character (which is smaller and lighter), to set a character in isolation, and to connect the end of a phrase to the beginning of another. Another element of balance is the harmony of written characters with the paper: the size of characters and the length of lines should match well the given space. Furthermore, there should be harmony among the ink, the brush, and the paper: a certain kind of paper requires a certain kind of ink and brush, and so forth. The quality of ink determines the weight of the brush as well as the size of characters. All these are the cases of visual harmony common to all pictorial arts, and the calligrapher must observe them, too.

However, calligraphy is different from painting and other space arts in that it is basically a linear art. A form in calligraphy is created not by marking off a space but by arranging a line or lines. To put it another way, a calligraphic line is not the margin of a space but the space itself—a one-dimensional space. This is why calligraphy needs no color; a calligraphic line needs to be only visual, so that the extremes of visuality, black and white, are most effectively employed. A line, moreover, can have attributes which a space cannot have—speed, rhythm, momentum, and other attributes of time art. These, combined with the elements of visual art, provide the calligrapher with a number of tools to work with.

A calligraphic line, seen as material for visual art, has such elements as direction, length, thickness, and darkness. The direction of a line, upward or downward, straight or curving, horizontal, vertical, or diagonal, is obviously an important factor. Yūshō especially stresses the importance of a straight line: "On the whole calligraphy, as well as other arts, defies a twisted, serpentine form. Try to make a line straight, whether you are a beginner or an advanced student." The length of a line, involving the elements of time, can be quite expressive: a long line could imply slowness, leisure, ease, and freedom, while a short line or a dot would suggest abruptness, instantaneousness, rashness, and discontinuity. In determining the length of a stroke, a calligrapher must ponder its relationship to other strokes, since, needless to say, line length is relative. Thickness, observed only

in an artistic line, produces a sense of quality and density: a thick line would express abundance and softness, while a thin line would hint impermeability, inflexibility, and resolution. Yūshō thinks that thickness is partly determined by the calligrapher's natural temperament. "Some make thick strokes, and others thin ones," he says. "This can be compared to the fact that some men are fat and others slender. Such is the inborn physique; one cannot say which is better." Darkness, or density of ink, is also an element not found in a geometrical line. A rich black line, resulting from abundant ink in the brush, would suggest overflowing energy, satisfied relaxation, and carefree will, while a dry scratchy line of light tone, caused by insufficient ink, would indicate scarcity, loneliness, and desolation. Also, the even density of ink would express the calligrapher's thoughtfulness and sense of proportion, while the contrary would convey the feeling of speed, informality, and light-heartedness. For this reason one should, as Yūshō advises, use heavy ink for the Square and the Semi-Cursive Styles, and light for the Cursive Style.

A calligraphic line furthermore has attributes of time art, such as speed, rhythm, and momentum. The speed of a line is in origin the speed of the brush with which the calligrapher created it. A line drawn rapidly would somehow show this speed after the action is completed; in a work of calligraphy it will have the effects of quickness, agressiveness, directness, and simplicity. A slowly written line could mean tranquility, meditativeness, passivity, and skepticism. A calligrapher must make a line deliberately quick or slow; otherwise he would end up with a rash line instead of a speedy one, or with a sticky line instead of a tranquil one. The rhythm of a calligraphic line is created by a calculated combination of varying speeds. Since the order in which strokes are made is traditionally fixed, an experienced onlooker would be able to follow calligraphic lines with all their different speeds, thus reproducing in his mind the rhythm with which they were originally drawn. Calligraphy here becomes music of lines. This is why Yūshō advises his students to heed the rhythm of the brush. Momentum, another element of time art that Yūshō finds in calligraphy, could be thought of as a rule

controlling the change of rhythm. When a thick, heavy stroke is moving with a great speed, the next stroke to be drawn will be very much affected by its great momentum; if the calligrapher fails to show the effect in the next line, the harmony of the rhythm running through the work will be broken. Rhythm should be created by momentum rather than by the calligrapher's personal will. "A rhythm created by momentum is fine," Yūshō says. "To be avoided is a rhythm resulting from the calligrapher's strain."

Calligraphic lines will thus be able to express a number of simple or complex feelings by combining those attributes of time and space art. A stroke can have strength; for instance, a thick straight line, slowly drawn with ample ink, would be a strong one. A forceful movement of the brush does not necessarily guarantee a strong line; the strength of a line is derived from a certain combination of artistic qualities, and not from the mere physical force with which the line is drawn. One who fails to observe this fact will create a rough line instead of a strong one. Likewise a gentle line, which is produced by combining some aesthetic elements, is commendable, but if one merely draws a line gently nothing better than a weak line will result. Hence Yūshō's advice to advanced students: "Write with force, while retaining gentleness in the brushwork." Another quality of a calligraphic line is weight. There can be a weighty line and a light line, depending upon the way in which the calligrapher fuses the elements of length, thickness, speed, rhythm, and momentum. A slow movement of the brush does not necessarily produce a weighty line; a hurried movement might result in a frivolous, rather than light, line. A line can be fleshy or bony, which is not the same as thick or slender. Yūshō explains the difference by a metaphor of trees: "Pines and Chinese nettles have little flesh however thick they may be, whereas cedars and willows have plenty of flesh though they are slender. In calligraphy and painting, the works of Prince Son'en[2] and Sesshū are bony,

2. Prince Son'en (1298–1356), son of Emperor Fushimi, and the Abbot of Temple Enryaku, was a celebrated calligrapher. He founded a school of calligraphy, called Son'en school after his name, which grew so influential that all government documents came to be written in that style.

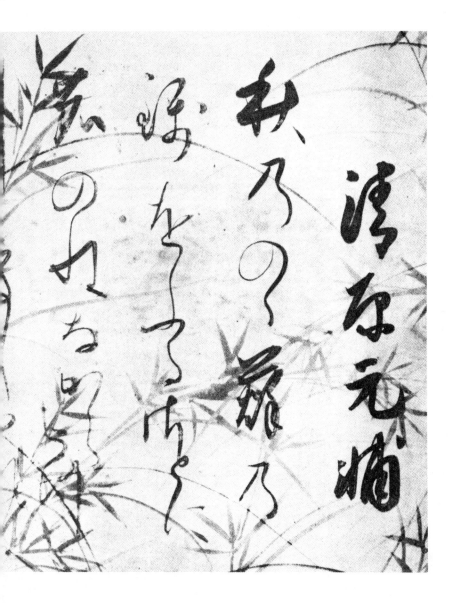

Plate 12
Kiyohara Motosuke's poem on the beauty of autumn.
Calligraphy by Shōkadō Shōjō (1584–1639). Yūshō was an admirer of
Shōjō's art and studied calligraphy under one of his leading disciples.

while those of Shōkadō and Kanō Tan'yū[3] are fleshy. One cannot say which is better." There are still a number of calligraphic qualities mentioned by Yūshō, such as righteousness, loveliness, force, abundance, virtuosity, sincerity. These are all impressionistic qualities created by combining various elements of space and time art.

The calligrapher, then, is required to show his expert skill and delicate sensitivity in every movement of his brush. The touch of the brush should be neither rough nor weak, but strong and gentle. Yūshō compares it to the shaving skill of an expert barber. "It is like a master barber shaving one's face with a razor," he says. "Do not press the paper with your brush, nor leave the brush adrift; try to take the middle of the two. There should be harmony among the brush, the ink, and the paper." The artist must have complete control over his instruments.

Those are, however, the most basic principles of the art of calligraphy. A master calligrapher would go beyond them by pouring his emotion into his work. Calligraphy is not only a representative but also an expressive art; a work of calligraphy should have not only harmony but also a soul. This is why Yūshō, who urges beginners to follow a prescribed form and to let the soul of the brush manifest itself, advises advanced students to depart from a set form and to consider the individuality of his brush. "It is commmendable for a beginner to be observant of the rules," Yūshō says. "It is bad, however, for an advanced student to be enslaved by them." A calligrapher blindly clinging to the rules may be compared to a scholar tied to obsolete words, to a physician over-dependent upon medicine, to an apprentice over-anxious for worldly success, and to a merchant abusing his trade for profit. The artist must not be a slave. He must, Yūshō says, "follow the rules and yet depart from them," and "comply with the laws and yet transgress them."

A spontaneous expression of emotion, then, is to be recom-

3. Kanō Tan'yū (1602-74) was a master painter of the Kanō school, who was appointed the Painter-in-Ordinary of the Tokugawa government at the age of fifteen. His conservatism and moralism were welcomed by the then ruling warrior class, and his school enjoyed unprecedented popularity during his lifetime. A prolific painter, he painted hundreds of works to adorn castles, mansions, and temples in both Kyoto and Edo.

mended for a calligrapher. Fixed rules are, after all, a means of helping this self-expression. A person who can naturally express his emotion may produce a good work of calligraphy, even if he does not know the technical rules. It is for this reason that a child who has not learned the rules often comes out with a good work. "Children are simple and straightforward in their way of thinking and follow their inborn nature in practicing handwriting," Yūshō says. "Therefore, they seldom produce a poor work." A teacher of calligraphy should try to help develop his student's talents rather than impose conventional disciplines without discrimination. Giving out a hundred copies of model calligraphy to a hundred students would lead to the destruction of the students' individual talents. Such a practice would be compared to that of a physician who, treating patients with various diseases, gives every one of them the same pill made by combining various pills intended for various diseases.

Yūshō repeatedly criticizes contemporary teachers of calligraphy for their emphasis on traditional rules at the expense of individual talent. Those teachers, Yūshō thinks, have forgotten the simple truth: calligraphy expresses the heart. "Handwriting truly resembles the writer's personality," he says in the best-known passage of his writing. "A quick-minded man moves the brush hurriedly. A man pretending to be a fashionable calligrapher produces a poor work because his brush becomes sticky. A dandy writes artistic-looking characters. A meticulous man writes in a scrupulous and conservative manner." Hence his conclusion: "It is only natural that handwriting should mirror the writer's personality as it follows the way of his heart." Here calligraphy comes to assume didactic nature. Only those who are pure at heart can produce a good work of calligraphy. "People of the old days were first of all honest-hearted and discreet," Yūshō observes. "They never boasted of their calligraphic skill or, for that matter, of any skill. When they made a prayer, they would do it with a true heart; so, in many cases they received a divine power. People of late are untrue at heart, lazy in their pursuit of artistic ideals, and often habitually boastful." Calligraphic disciplines are ultimately spiritual and moral. The art of calligraphy becomes a "Way," that is, a way to ethical and

religious perfection. Yūshō's teaching to advanced students aptly ends by urging them to learn the "Way of Calligraphy."

On the whole, then, it may be said that Yūshō's twenty precepts on the art of calligraphy cited at the outset of this chapter concisely sum up the complex nature of that art. Calligraphy is first of all a representative art, in which the artist imitates not an object of nature but an abstract figure pre-determined by the tradition. Hence the artist must observe traditional rules, expressing with confidence the soul of the figure he imitates. The soul of the figure, it is assumed, would automatically want to be perfect in shape, just as every man and woman yearns after a perfect human figure. Thus calligraphy becomes a pictorial art, in which the artist seeks to draw a shape ideally beautiful and harmonious. He must therefore study the shape of each ideogram carefully and create a beautiful picture out of it; he must also ponder the relationship between two ideograms, between ideograms and the paper, or between the brush, the ink, and the paper, so that the combination of all these will give the impression of a harmoniously composed painting. A calligraphic picture, however, is basically different from an ordinary painting in that it is composed of rhythmical lines, for calligraphy is also a time art, in which the artist composes music with lines. Hence the student of calligraphy must pay close attention to the speed, rhythm, and momentum of his brush. The merging of the elements of time and space art provides calligraphy with unique aesthetic qualities, such as weight, thickness, force, and tranquillity. This enlarges the room where the calligrapher can pour out his inner feelings. Calligraphy is thus an expressive art as well, in which the artist puts forth his emotions in a visual form. In fact every work of calligraphy, or a piece of handwriting for that matter, reflects the maker's personality. In order to be a perfect calligrapher, the student must first try to become a morally perfect man. We now know why Yūshō's advice to students of calligraphy begins and ends in a moral tone: the first principle, "Keep your body upright and your soul righteous as you take up the brush"; and the last one, "Learn the Way of Calligraphy."

12

Chikamatsu
on the Art of the Puppet Theater

The Sense of Honor as a Dramatic Principle

The puppet theater is another art that has shown unique development in Japan. In origin a primitive kind of entertainment performed by traveling showmen, it grew into a mature histrionic art in the seventeenth century, with performers of professional training, plays of literary merit, and stage settings artistically calculated. In a sense it was the first blossoming of Japanese drama, since the Nō was more poetry, and the Kabuki more spectacle, than drama. The puppet theater, making use of lifelike marionettes, presented lively human actions. If the play was written by a competent dramatist, it seldom failed to offer some moments of intense emotional conflict, which is the essence of drama.

The person who contributed most to the artistic development of the Japanese puppet theater was, as everyone would agree, Chikamatsu Monzaemon (1653–1725), a gifted, prolific playwright sometimes called "the Japanese Shakespeare." During his long professional career he wrote some one hundred plays for the puppet theater, most of which were immensely successful

186

with the contemporary audience. Many of his plays (historical plays) took their material from some well-known historical incidents, but some (domestic plays) treated the happenings of the day, too. In either case the drama usually centered upon a conflict between love and honor, or between passion and duty, experienced by a character in the play. In interpreting the conflict, however, later critics are sharply divided, and this has led to a variety of opinions in assessing Chikamatsu the playwright. Conservative scholars regard him as a playwright with a strong sense of decorum, as a writer who insisted on the importance of reason over passion on all occasions. Romantic critics think otherwise: in their opinion his drama presents the purest type of love, which, because of its very purity, cannot find its fulfilment in this earthly mire. And then some leftist scholars, influential among the younger generation in today's Japan, hold that Chikamatsu's plays exemplify a clash between the conservative society and the progressive individual, between the moralism of the feudal age and the expanding ego of the modern man.

An examination of Chikamatsu's aesthetic ideas would not only be interesting in itself but would throw some light on the differing interpretations of Chikamatsu, too. Chikamatsu never wrote a treatise on the art of the theater, but we have a document recording several of his informal conversations with his friends in which he suggests his views on the art of the puppet theater. The document, which is part of the Preface to *Souvenirs from Naniwa* ("Naniwa Miyage")[1] by Hozumi Ikan, reveals a good deal about the playwright when examined in the light of his plays.

The most fundamental of Chikamatsu's assumptions on art is stated in a passage where he defines art in its relation to reality. He says:

> Art is something that lies in the thin margin between truth and falsehood. Indeed, since people today are fond of life-

1. *Souvenirs from Naniwa* (1738) is a book of interpretative and critical commentaries on the texts of nine puppet plays. Naniwa is an old name for Osaka, the flourishing center of the puppet theater in its prime days. The author, Hozumi Ikan (1692–1769), was a Confucian scholar of considerable merit.

like realism, it is widely in practice that a retainer on the stage duplicates the language and manners of a real retainer. Yet, does a real retainer ever put rouge and powder on his face as an actor does? Again, would it turn out to be entertaining if an actor, insisting that a real retainer does not make up his face, should appear on the stage with his head shaven and his beard unshorn? This is what I mean by "the thin margin between truth and falsehood." It is falsehood, and yet it is not falsehood. It is truth, and yet it is not truth. Entertainment emerges from between the two.

Chikamatsu is here answering a person who has pointed out to him that the people of the time would not accept plays unless they were "realistic" like the Kabuki drama. The Kabuki, using living actors and lifelike settings, were certainly closer to actual life on the surface. But Chikamatsu defends the puppet theater by saying that closeness to the details of actuality does not necessarily guarantee entertainment. The puppet theater does not copy real life exactly as it is, but the audience is entertained for that very reason. If the play were to reproduce reality with the utmost faithfulness, the audience would not feel it amusing. Chikamatsu explains this by recounting an episode:

Concerning this subject there is a story about a certain court lady who had a lover. They loved one another passionately, but since the lady lived deep in the palace where her lover was not permitted to come, she could see him only very rarely, through the bamboo screens at the court. She pined for him so desperately that she finally had a wooden image carved of the man. The image was not at all like an ordinary doll, for it did not differ in any detail from the actual person. It reproduced everything from the complexion of his face to the pores of his skin; the ears, the nostrils, the mouth—even the number of his teeth, were faithfully duplicated. Indeed, as the image was carved with the man posing nearby, there was absolutely no difference between the model and the copy except that the former had a soul while the latter did not. Yet, when the lady looked at the image closely, she found it uninteresting, unsightly,

and even a bit frightening. Her love was thereby chilled, and as she felt it disturbing to have the doll around, she soon threw it away.

Here Chikamatsu is suggesting that an exact copy of reality evokes a disagreeable feeling in the spectator. As for the reason why this should be so, Chikamatsu gives no explicit explanation. Perhaps reality is not beautiful, so if the observer comes too close to it he sees its ugliness. Perhaps it is lifelessness that evokes horror; one feels frightened when one finds no life where it is expected. Or perhaps life itself has disagreeable elements; if it is too faithfully reproduced, the spectator is made painfully aware of them. In any case, there should be a degree of detachment between actual life and a work of art; without this aesthetic distance there emerges no pleasure, and hence no true work of art.

The puppet theater takes advantage of this necessary distance between life and art. In fact, it is only by rejecting naturalism that the doll theater can claim its existence, for on its stage lifeless marionettes must be assumed to be living men. The puppet theater has its own sphere of life with its own type of reality. One could even put onto its stage a tiger that behaves like a man; after all, a puppet in the shape of a tiger has the same degree of realness as a doll shaped like a man. Chikamatsu has made a full use of this fact as a playwright. In his historical plays he changes factual details freely as they suit his dramatic purpose, often introducing miracles and divine interventions into his plot. In his domestic plays sheer accidents occur again and again to drive the unfortunate lovers to their catastrophe. Some critics conclude from this that Chikamatsu was pious, or that he believed in fatalism. They have confused what the artist creates with what he represents; they have not asked themselves whether Chikamatsu's *dramatis personae* are real retainers or actors with rouge and powder on their faces.

The meaning of falsehood in Chikamatsu is now clear: it refers to the necessary distance between actual life and the work of art. But Chikamatsu has talked of truth, too, and of art as lying "in the thin margin between truth and falsehood." He ex-

189

plains this in another passage: "All puppet plays describe facts as they are, but they also contain things that exist only in the sphere of art. In recent plays female characters speak many things which real women could not possibly say. These belong to the domain of art; as they reveal what real women cannot say, one comes to know what their innermost feelings are." Here Chikamatsu is saying that a work of art presents things which are truer than facts. Facts of ordinary life sometimes do not fairly represent truth, because they are conditioned, influenced, and often suppressed by the strictures of society. The work of art, by creating a false domain where these restrictions are temporarily lifted, permits men to approach closer to the true. Chikamatsu's reference to female characters is especially appropriate: Japanese women, particularly in those feudal times, were greatly reserved in expressing their emotions, and frequently their words and demeanors were contrary to their inner feelings. Characters in the play are freer from social conventions; their words can be truer to their emotions than real people can. Chikamatsu reiterates the point in another passage:

> In one of the court novels I read in my youth, there was a passage describing how on a certain festival day the snow had fallen heavily and piled up on the ground.[2] A guard was ordered to remove the snow from an orange tree. When he carried out the order, a pine tree next to it, still loaded with snow, resentfully recoiled its branches. Even an inanimate object like a tree is here given a soul by a stroke of the pen. For, are we not struck with the feeling of real life when we visualize a pine tree resentfully recoiling its branches to shake off the snow as soon as it saw its neighboring tree cleared of the snow? From this model I came to learn how to put life into my puppet plays.

The passage is suggestive of Chikamatsu's belief that the representation of an internal motive, rather than the faithful copy of an external action, is what gives life to a drama as well as to

2. *The Tale of Genji.* The passage referred to appears in a chapter called "The Saffron-Flower." The occasion, however, was not at the time of a festival.

a story. Neither a precise imitation of outward appearance nor a melodramatic presentation of life affords lasting pleasure to the audience. Only an action resulting from an internal motive will serve for true entertainment on the stage; the playwright should concern himself only with those actions in life that represent inmost human nature. One might recall here Aristotle's idea of imitation, as expounded by S. H. Butcher: "The πρᾶξις that art seeks to reproduce is mainly an inward process, a psychical energy working outwards; deeds, incidents, events, situations, being included under it so far as these spring from an inward act of will, or elicit some activity of thought or feeling." External actions show reality only at the superficial level; hidden reality lies behind what things seem to be—it may be hidden in the heart of a woman who is too reserved to speak the truth, or in the spirit of a pine tree that is unable to speak. The artist's task is to see through to the buried truth and to create a "falsehood" that would give full expression to it.

At this point one might note that in Chikamatsu's view, as in Aristotle's, a work of art is a likeness to or a reproduction of the original, and not a symbolic representation of it. While urging the detachment of art from reality, Chikamatsu never forgets to insist on the resemblance of a copy to the original. He has spoken of art as lying in the thin margin between truth and falsehood; he has also stated that a puppet play describes facts as they are. The spectacle of a pine tree resentfully shaking off the snow is an imitation, and not a symbolization, of a human action. Herein lies one of the essential differences between the Nō and the puppet theater.

Another point worthy of note here is that in Chikamatsu's idea the hidden truth that art seeks to represent lies in the sphere of humanity, and not in a nonhuman world of essences. The puppet theater presents men and women speaking and behaving according to the laws of this world and of this life. It expresses, and does not suppress, human emotions; it can express the emotions of a most bashful woman who could not ordinarily speak out her feelings. In the world of art even a pine tree has emotions and gives vent to them. An evergreen tree, as we recall, was a favorite metaphor of medieval and medievalist

aestheticians in Japan, but in their hands it was used for quite a different purpose. The tree used to be a symbol of an ideal man who has attained perfect peace of mind after purging all his personal emotions; all men were to imitate a tree. Now, in Chikamatsu's view, it is the tree that imitates a man. Emotions are not to be suppressed but to be expanded; they even invade the nonhuman world. Here lies another point of difference between the Nō and the puppet theater.

It is of course natural that Chikamatsu's concept of art should be in perfect accord with the nature of the puppet theater. The puppet theater essentially differs both from the realistic Kabuki and from the symbolic Nō. Using dolls in place of human actors, it refuses to reproduce life as it is. Allowing the dolls to imitate human actions, it also avoids falling into the slow ritual of symbolic drama. In brief, the puppet stage claims a position between the two poles of dramatic art, the naturalistic and the poetic. Indeed, it is an art lying "in the thin margin between truth and falsehood."

This middle position, however, puts the writer of a puppet play in a difficult position, for it means that he cannot fully exploit the advantages of either a dramatic or a poetic art. How could he present human emotions effectively, using neither the physical expressiveness of a living actor nor the emotive language of poetry? In imitating a human action, how could a lifeless puppet be made more convincing than a living actor? Chikamatsu's answer seems to be implied in the following passage:

> Essential to the puppet theater is pathos. However, I do not approve of those playwrights who frequently use such words as "it is pitiful," nor of those performers who chant in a voice as tearful as the *bunyabushi*.[3] Pathos, in the sense in which I use it, springs entirely from the sense of honor. A play will be moving if its various characters are put under the pressure of honor. And if the play is as such, it will prove that the more restrained the melody and words are, the

3. One of the singing styles of the puppet theater that had especially pathetic melodies. It was so called because it was begun by a singer named Okamoto Bunya. The style was very popular in Osaka in the last years of the seventeenth century.

Plate 13
Jihei and his wife, Osan, in Chikamatsu's puppet play, *The Love Suicides at Amijima.*
Jihei, crouching over a quilt-covered foot warmer, tells Osan how coolly he was treated by Koharu, his paramour for the last two years. Osan suddenly realizes that Koharu is determined to commit suicide.
Photo by K. Mimura.

> deeper the resulting pathos will be. If something pitiful is described by saying "it is pitiful," there is no room for imagination and, all in all, the feeling of pathos will be slight, too. It is essential that one make a thing pitiful by itself, without ever saying "it is pitiful."

Here, while rejecting the use of melodramatic and sentimental words, Chikamatsu argues that real pathos in a play should come out of a dramatic situation, and that the dramatic situation is built around the sense of honor in the characters of the play. Human nature, as he sees it, is potentially dramatic; it contains feelings, passions, and wills that often run counter to each other. There is the sense of honor in each man, however, which pressures him into resisting and controlling the conflicts as much as he can. The feeling of pathos is deeply stirred when we see a person in the play facing two alternative actions in the course of his life and anticipating a disaster whether he chooses the one or the other. It would be even more pathetic if his sense of honor is split in two, like social and personal obligations, and whichever choice he may make will eventually lead him to lose his face, fortune, love, or life itself.

In Chikamatsu's view, the sense of honor thus occupies the central position at once in ethics and in aesthetics. Theatricality is closely connected with morality. To achieve high theatricality, the playwright should create a character with a great sense of honor. The dramatist's task is to bring forth on the stage a series of situations in which the sense of honor in the play's characters would be most powerfully revealed. Drama consists essentially in the interplay of elemental forces in human nature—intellect, passion, will—ruled, successfully or unsuccessfully, by the sense of honor. Lifeless puppets present the conflict in a simpler, more primal form than living actors, because they are further removed from the details of actuality, because they are less involved in the complexity of real life. The dramatic moment comes when two puppets, representing two antithetical forces in human nature, meet and clash in a fraction of a second.

The use of puppets, however, has its limitations, and they are the limitations of Chikamatsu, too. Puppets are far more likely

193

than living actors to give the impression that the men they represent are mentally static and do not grow. In Chikamatsu's works, indeed, almost all the characters are flat and seldom show psychological development in the course of the play. Often the protagonist recedes to the background while another character displays a great sense of honor. The plot is subordinate to the character and the character is an imitation, or a variation at best, of the stock-type in which it has originated. In an historical play the protagonist is always a warrior of heroic stature, accompanied by a self-sacrificing wife, most loyal retainers, and often a concubine who has a great sense of honor. In a domestic play there are ordinarily four main characters: a middle-class merchant, his faithful wife, his honorable courtesan-mistress, and his villainous rival for the mistress. Chikamatsu's greatness lies neither in his plot construction nor in his characterization, but in his ability and skill to create a moment of high dramatic impact where, forced by honor, two opposing elements in human nature fight a duel.

This is the essential point where "the Japanese Shakespeare" differs from the real Shakespeare. A Shakespearian tragedy presents a microcosm in which the protagonist suffers and grows until he exhausts all the possibilities of growth. In Chikamatsu's world the hero indeed completes his life-cycle at the end of the play, but his deathward movement is constructed on a series of accidents and misfortunes. In each of those misfortunes he reveals admirable nobleness of heart, but he does so simply because that is his nature. He does not mentally and morally grow because he, unlike Shakespeare's tragic heroes, is not awakened to the sense of mortality, to the seriousness of human life. In this respect Chikamatsu is nearer to Corneille and Racine, in whose plays human nobility is set against the power of unpredictable fate. But again he differs from them because, while in a classical French drama there is always a single controlling idea that unifies all the parts of the work into a coherent whole, Chikamatsu's play shows the quality of an epic in which noble characters reveal their great sense of honor in a series of loosely connected incidents. And probably this is part of the explanation for the present state of confusion among the critics of Chikamatsu. Chika-

matsu's main effort lay not so much in expressing a consistent moral view through the structure of his drama, as in creating individual scenes animated with intensely emotional conflicts. Since his play lacks a single prevailing view that controls its structure as a whole, his critics, whether conservative, romantic, or Marxist, are left free to see their own shadows in Chikamatsu's world.

13

Norinaga
on the Art of Writing

Shintoism and the Theory of Literature

What would a Shintoist theory of literature be like? Beyond doubt Motoori Norinaga (1730–1801) was the best qualified person to answer the question, for he was not only a great philosopher whose work marked the peak of the Shinto revival in the eighteenth century, but also a devoted scholar in literature who wrote a number of textual and critical studies on Japanese classics. A literary theory formulated by a philosopher-scholar, rather than by a poet, novelist, or playwright, is rare in Japan, too. Gifted with sharp intellect, Norinaga consciously made an effort to construct a theory of literature consistent within itself and with the whole system of his philosophy. The result is a remarkably methodical poetics covering all aspects of literary writing and giving them a center of reference. He was indeed the first major literary *theorist* in Japan, in the stricter sense of the word.

With all his keen intellect, however, Norinaga's philosophy is characterized by its rigorous anti-intellectualism. Perhaps precisely because he had such a logical, penetrating mind he became so painfully aware of the limitations of that mind. "A mind is limited, however wise the man may be," he writes in a typical passage. "The mind is such a tiny thing and can know nothing

196

that lies beyond its borders." One often meditates, for instance, on the wonders of heaven and earth—whether the earth is hanging in the sky, or is placed on something else. Any attempt to explain it in rational terms would be an act of haughty arrogance as well as of pitiful ignorance. The universe is full of mysteries, man's life abounds in irrationalities, and one would better accept all this as lying beyond the realm of human knowledge. Norinaga criticizes Buddhist and Confucian philosophers for that reason; they pretend to know the unknowable, they try to rationalize the irrational.

Norinaga's distrust of discursive reason has another basis: intellect cannot create. Intellect is a dissecting power, not a creative energy. The limitations of human knowledge arise partly from that fact; a mind can never completely know something it is unable to create. Norinaga tries to substantiate this contention by referring to the act of procreation. The wisest philosopher, the most enlightened scholar, or the most skillful artisan cannot concoct a living human being. But an ordinary man and woman, "with no toiling mind, with no helping tool, and with no painstaking effort," can produce a baby. The whole act, as Norinaga sees it, is "not even worthy of description; it is awkward, effeminate, and more senseless than child's play." Yet it can do what the best of human minds cannot. Man's mind is not capable of explaining the most "awkward" of his own acts; how could one expect it to explain profound mysteries that lie between heaven and earth?

Not to explain the mysteries, but to make them metaphysically comprehensible, Norinaga inevitably brings in the concept of gods, who, naturally, are omniscient, creative, and irrational from man's point of view. For a Classicist such as Norinaga, gods lay conveniently at hand—the gods in Shintoism. Shinto gods, as described in *The Record of Ancient Matters* ("Kojiki"),[1] *The*

1. *The Record of Ancient Matters* (712), the oldest of Japanese classics, narrates the history of Japan from the time of its mythological founding. Reflecting the life and thoughts of the ancient Japanese, it has provided invaluable material for scholars in history, literature, philosophy, and religion. Especially its early parts are filled with myths and legends, telling the accounts of ancient gods and heroes; Shintoists often sought their sources here in documenting their belief.

Chronicles of Japan, and other early Japanese writings, are indeed omniscient, creative, and irrational. They are the creators and manipulators of all things in nature. The gods use people, animals, and plants as men use tools. And the gods do not necessarily make good use of their mighty power, because there are evil gods as well as benevolent ones. Furthermore, evil gods may sometimes do good deeds, and good gods evil. To think of all gods as benevolent and merciful is no more than man's wishful thinking. For gods are, after all, as temperamental and irrational as human beings; they are as susceptible to wrath as human beings. In fact, gods themselves sprang from the same source as men, animals, and all other objects in the universe. This source is the Holy Spirit of the God of Creation. The gods are more powerful than men because they rank higher in the scheme of the Holy Spirit, just as men rule over animals and birds because of their higher rank in the same scheme.

The fact that Shinto gods, ranking higher in the hierarchy of things, can manipulate men, does not necessarily mean that men are devoid of free will. Men, indeed, are under the control of the gods, but they are free within their status and ability allotted by the God of Creation. Again it is like animals and birds having their own free lives, although men, more high-ranking and powerful, can catch, tame, or kill them. Each man, therefore, must repudiate determinist ethics and try to do his best within the realm where he is free. Norinaga is quite insistent on this. "If a person should think he could leave everything to divine will and become irresponsible for his conduct," he says, "he would be making a grave mistake. It is each man's responsibility to do his best within his power." The God of Creation has given each man an ability to perform good deeds out of his own free will; if he fails to do so, he fails to fulfill his god-given capacity and is inferior to birds and insects. Instances of such failure occur frequently in modern times, as man, over-confident of his rational mind, has lost sight of the God of Creation above him and of the Holy Spirit within him. To correct this deplorable modern trend is simple: man has only to break through his hard, man-made surface of rational and didactic thinking and to return to his inner true heart given by the Holy Spirit. To return to the true

heart is the very basis of ethics; in fact, that must be the purpose of life for all men, since it is the only way by which man can know the Creator.

How can one return to his inborn true heart, the heart devoid of all superficialities? Here literature comes in. A work of literature can and should penetrate through all the barriers of artificial thinking, finally reaching the innermost part of the human heart. It purifies a human soul by discarding all the impure elements that surround it; the soul is thereby liberated from man-made fetters. The *mono no aware*, Norinaga's famous term describing the essence of literature, can be understood as a principle of such self-emancipation.

In defining *mono no aware*, Norinaga begins with an etymological analysis of the word. According to Norinaga, *aware* consists of two interjections, *a* and *hare*, both of which are used when one's heart is greatly moved. One cries out, for example, "*A*, how beautiful the moon is!" or "*A*, what a pitiful thing this is!" or "*Hare*, how lovely the flowers are!" or "*Hare*, what a good child you are!" *Aware*, which combines these two interjections, is primarily a word describing a deeply moved heart, a heart filled with intense emotion. The emotion could be joy, happiness, wonder, horror, hatred, love, grief, anger, jealousy, or anything else. It may be said, however, that two of the emotions, love and grief, tend to dominate, since they are the most heart-engaging emotions. "Human feelings are deepest in love," says Norinaga. "The most profound and touching instances of *mono no aware* are therefore most frequently observed in love affairs." This is why there have been so many love poems and love stories written since ancient times. Grief, on the other hand, is an even more universal feeling than love; frequently love itself turns into grief. Man faces grief more often than happiness, because he is imperfect, weak, and easily hurt; besides, grief, being always painful, penetrates deeper into the heart. "Man feels more deeply when his wish is thwarted," Norinaga observes. "Therefore, one commonly equates *aware* with grief nowadays." In any case, the feeling of *aware* emerges when the heart is deeply and genuinely moved in the face of some external event.

How can one distinguish deep and genuine feelings from shal-

199

low and impure ones? Here our attention must be shifted to the fact that *aware* is modified by *mono* in the phrase *mono no aware* (*no* is a modifying particle). *Mono* literally means "thing (s)"; so *mono no aware* would mean "a deep feeling over things." Norinaga explains the meaning of "things": "*mono,*" he says, "is a word which is added when one speaks in broad terms." *Mono,* in other words, generalizes the meaning of *aware.* "A deep feeling" cannot be any feeling out of personal idiosyncrasy, but must be a feeling that emerges from any man under the same circumstances. A sad thing is sad to any sensitive person; if there is anyone who fails to feel sad, he is heartless, or, in Norinaga's idiom, he does not know *mono no aware.* Looking at cherry blossoms in full bloom, one is always moved by their beauty; if there is anyone who is not, he does not know *mono no aware.* Emphasizing the universality of *mono no aware,* Norinaga cites a practical example, too. Keeping a household, one would always want to cut down unnecessary expenses; if there is a housewife who would not, she is lacking in *mono no aware.* Norinaga sums up his idea of *mono no aware* in a short passage: "A person who has a heart capable of understanding things would always experience the feeling that the occasion calls for, though he does not try to do so. Those who find themselves otherwise do not know how to respond to things; they do not have a heart capable of feeling what it should." A deep, genuine feeling is something that springs spontaneously from the heart, from the pure, sensitive heart. *Mono no aware,* though a universal human feeling in origin, is an elevated, purified feeling for the modern man who has lost his natural sensibility. Herein lies an explanation for the ennobling effect of *mono no aware* on the modern man, and for the function of literature in the modern world.

Why is it that many men in modern times have lost their nature-given faculty of feeling genuinely? Because, Norinaga answers, a number of social, moral, and religious codes have besieged the human heart. The Bushidō, or Japanese chivalry, has consistently taught that a warrior should think lightly of his life; this has suppressed a free play of his genuine feelings, for what man would not value his life? Confucianism has always forced many so-called virtues upon the conduct of men, so much

so that nowadays men are the captives of didactic ideas. Buddhism rejects *mono no aware*, too; in fact, it aims at the unhuman, precisely the opposite of human feelings. It renounces grief over death, love between men and women, and anything else that is human. But here lies the weakness of Buddhism, for no man can be completely unhuman. As Norinaga says, even the most holy priest cannot but be moved at the sight of beautiful cherry blossoms, or of a lovely lady he happens to meet in the street. "If there is a priest who has no such feeling," Norinaga writes, "he is more heartless than birds and insects—he is, we should say, no better than a rock or a tree." This is a view diametrically opposed to that of the medieval Japanese. Norinaga's view is that a man, even a Buddhist priest, cannot but be a man with human feelings. Norinaga goes on to prove it by saying that so many famous priests in the past composed poems on the beauty of blossoms, or even on the beauty of women. He goes so far as to contend that priests compose more love poems than laymen because their desires are more deeply suppressed. Norinaga is in no sense criticizing the verse-writing of priests here; he is simply trying to show the purging effect of *mono no aware* in literature.

Through the idea of *mono no aware* Norinaga can also explain the motive for writing a poem or a story, which Tsurayuki disposed of as a mere expressive instinct. Norinaga takes an example of a man depressed for some personal reason. "If the man has a wife who knows *mono no aware*," he says, "'he will be consoled by talking with her. Even when he will not talk, the wife will see into his heart and treat him fittingly, sharing his grief and giving him solace." A man who is moved with a heart-rending emotion will speak it out, hoping, consciously or unconsciously, that the emotion will be shared by other men. The listeners, if they know *mono no aware*, will be able to understand his feeling and share it with him. To know that his feeling is shared by someone else is itself a great pleasure and solace to the man. One writes a poem or a story for this reason. Norinaga says: "If a person leaves his feelings unexpressed within his heart, they will get tangled more and more until they become unbearable to him. But if he writes them out in poetry or prose according to the occasion and sends it to a friend who has a similar mind, his

201

anguish will be emptied and his melancholy consoled." About the motive of reading a poem or a story, Norinaga has this to say: "When reading, for instance, of a man worried over something and buried in deep gloom, one is often struck with the feeling of realness. This is because one has understood the man's heart and knows *mono no aware*. And one has been able to understand the man's heart because one has read all about the circumstances that caused his melancholy." *Mono no aware*, primarily a feeling that can be shared deep in the heart of everyone, gives a motive to both writers and readers.

Because of this communicative function, *mono no aware* becomes an important principle both aesthetic and moral. A man lacking in genuine feeling cannot distinguish beauty from ugliness, good from evil. Imagine a man looking up at the sky. If he lacks the capacity for feeling deeply, the sky will have no meaning to him. But, as Norinaga says, "If he knows *mono no aware*, the sky will look sad or gay, depending upon his state of mind at the time." This is so even with an insentient object like the sky; his feelings will be aroused more when the object is a human being. For instance, reading the account of Kashiwagi's adultery in *The Tale of Genji*, those who cannot feel deeply will have no sympathy with Kashiwagi; those who are confined within Confucian morality will no doubt loathe the adulterer. But look at Prince Genji, who knows *mono no aware*. He takes pity on Kashiwagi, and in spite of the fact that he is the very victim of that incident. Norinaga observes: "A good person, because he knows *mono no aware*, can understand how unbearable the feeling of love could be. So he does not bitterly censure a man who has erred on this account." An evil person is the one who cannot sympathize with others because he cannot feel with others. "A person who is insistent on his own feelings alone and who vigorously attacks what other people say," Norinaga remarks, "is an egoist who does not know *mono no aware*." *Mono no aware* is an opposite of egoism; it enables one to feel with others, to understand others.

Mono no aware has now become a mode of perception. To feel is to perceive and to know—to know in the broadest sense; for to feel with a person or a thing means to know the person

or the thing thoroughly. Norinaga explains this: "Living in this world, a person sees, hears, and meets all kinds of events. If he takes them into his heart and feels the hearts of the events within it, then one may say the person knows the hearts of the events, the cores of the facts—he knows *mono no aware*." A person cannot really feel unless he knows what it is that makes him feel. Only those who know the heart of a grieving man can feel the grief with him; only those who know the cause of the joy can feel happy with the joyous person. "Therefore," Norinaga says, "when a man understands the heart of a joyous or sorrowful event, he can be said to know *mono no aware*. The man who does not know the heart will feel nothing—neither joy nor sorrow." Sometimes a man who does not understand the heart pretends to feel happy or sad. "Such is what we call a superficial feeling," Norinaga says. "In truth the man does not know *mono no aware*."

Knowing or understanding, as Norinaga uses the term, is primarily intuitive. A man who knows *mono no aware* does not have to objectively examine an event; instantaneously he takes it into his heart, feels it, and understands it. In fact, *mono no aware* is so spontaneous that the man feels it with or without his voluntary will. When a man with a capacity for feeling deeply hears or reads about a sad event, then "an uncontrollable feeling spontaneously arises in his heart, and he feels sad even if he does not want to." "Feelings," Norinaga says elsewhere, too, "cannot be controlled by the man, though they are his own." *Mono no aware* penetrates into the heart deeper than reason or will, than Confucian teachings of good and evil. This explains why a scrupulous man at times feels tempted to break a commandment, or in fact does so. *Mono no aware* is more deeply rooted in the human heart and hence more valid in its application than Confucian or Buddhist teachings. And this is why a literary work filled with ethically repugnant incidents may deeply move the reader's heart.

If, then, *mono no aware* is a mode of cognition more intuitive, far-reaching, and valid than others, what would ultimate human reality be like as seen through it? Norinaga answers that it is foolish, effeminate, and weak. "All human feelings," he says,

203

"are quite foolish in their true, natural state. People try hard to trim, modify, and improve them so that they may appear wise, but as a result they gain only some decorated feelings, and not true natural ones." The innermost human heart is as foolish and weak as a woman's or a child's. Any feeling that is manly, discreet, and righteous is not a true human feeling; it is artificial, it is made up by reading books, by conforming to social norms, by adhering to Buddhist or Confucian disciplines—in brief, by suppressing one's heart in one way or another. "The original, natural heart of man," Norinaga writes, "is most straightforward, senseless, poor, and unsightly." Such effeminate feelings are manifested more often in women than in men, because women are "poorer in controlling their emotions and hence more apt to reveal their true hearts." If her beloved child were to die, a mother would shed tears profusely and appear almost insane with grief, while the father might look calm and even indifferent, without dropping a tear. But this is so only because the father has hidden his natural feelings in fear of appearing unmanly; his heart is as grief-ridden as the mother's. To take another example, a warrior is expected to sacrifice his life for the sake of his lord and his country. Yet, when he lies dying in the battlefield, would he not wish to see once more his beloved wife and children, or his aging father and mother? Is it not true that the manliest soldier, as fearless as a devil, feels sorrow during the last moments of his life? "Such is," Norinaga concludes, "the true nature of the human heart common to millions of men, common to saints as well as to ordinary men. . . . If there should be anyone who has no such feeling, he would be inferior to beasts and birds, or to trees and rocks. Who in the world would not feel sad as he lies dying?"

Such effeminate feelings, as they are rooted in the human heart deeper than any other, are most moving when they are expressed straightforwardly. A direct expression of them is more powerfully appealing than rhetoric or logical persuasion. Norinaga illustrates this point by telling a story of a man determined to kill two captives. An onlooker, taking pity on the victims, tries to dissuade the man, lecturing to him how evil it is to kill a fellow man. The capturer, while a bit moved, is not quite convinced. Then one of the captives, like a brave soldier, speaks

out and tells how lightly he thinks of his life and how worried he is about the future of the pitiless murderer. His capturer, angered at this, immediately kills him. In contrast, the other captive is weeping, wailing, and pleading; again and again he cries out the same words: "Please spare my life." The murderer is finally moved and saves his life. A literary work is expected to do what this second captive has done—that is, to speak out the true human heart, which is foolish, effeminate, and weak. A good work of literature has a strong appeal for this reason. That, indeed, is the justification of literature. "Poetry," Norinaga declares, "has its prime aim in presenting the natural ways of the foolish human heart." And here is Norinaga's definition of literature: "Poetry or the novel does not concern itself with good or evil, wisdom or stupidity. It only describes in detail what man truly feels in his natural self, from which we learn what the innermost part of the human heart is like. It is through a work of literature that we learn what true human feelings are, that we learn *mono no aware.*"

In this connection it is interesting to observe how totally the poetic spirit, the central idea in medieval Japanese aesthetics, has been transformed by Norinaga. According to Norinaga's definition, "the poetic spirit in modern times lies in expressing the senseless, foolish feelings of the true heart in some interesting, attractive way." In contrast with medieval aestheticians and with Bashō, who insisted on the suppression of human feelings, Norinaga maintains that the poetic spirit consists in the very expression of the true human heart as it is freed from all its external restrictions. Even a human desire, that archenemy of medieval Japanese aestheticians, is admitted into the poetic spirit by Norinaga, with a proviso. "There are poems that draw on desires, too," he says, "if the desires involve feelings." If the desire is nothing more than "a heart that only wishes to possess something"—if it is nothing more than greed or avarice—then it has no place in poetry. But if the desire generates feelings, it may very well become the source for poetic creation. "Love," Norinaga observes, "springs originally out of desire, but it involves deep feelings." Thus love is frequently dealt with in a poem or a story.

A literary work, then, is an honest expression of foolish but

205

true human feelings as they naturally are in the innermost part of the heart. To use Norinaga's simile, it is like "showing the kitchen and bedrooms to the guest, rather than receiving him in the parlor." In another of his metaphors, poetry is a "tool that cleans up a dusty heart." A question here is why Norinaga did not take a liking to the contemporary novels, which were certainly more realistic than early court novels, or to the Haiku, which dealt with the life of common men more substantially than early poetry. It is a relevant question, because we know Norinaga had a broad view of poetry, so broad as to include not only linked verse and the Haiku but also the Nō, ditties, comic poetry, the puppet theater, and popular songs. His answer is that a straightforward expression of the human heart as it is does not necessarily produce a good work of literature; in fact, a realistic description of a modern man's feelings often results in a meager work. This is because man no longer has a pure heart in the modern age. Norinaga elaborates: "In discussing the nature of poetry, one would assume that the poem is an expression of natural feelings. But with the passing of time men's hearts have grown more and more false, less and less pure. In modern times, therefore, the essence of verse-writing lies in adorning words and making the poem beautiful. . . . It is not that poetry has declined in modern times. It is rather that men's hearts have deteriorated with time." According to Norinaga, some contemporary poems and novels are good works of literature in that they are faithful representations of human reality, but they are not the very best because they represent an inferior kind of human reality. This could not be helped; the fault lies not with the poet or novelist, but with the age. For this reason Norinaga encourages the student of poetry to express his true feelings as they are, and not to decorate and hence falsify his feelings. "A modern poet should express his heart as it is," he says. "One might try to compose a simple poem in an ancient fashion, thinking that contemporary poetry has swerved from what poetry should be. But this is to misinterpret the ideal of poetry." The honest expression of a degenerate heart is a lesser evil than the contrived expression of a pretentious heart.

Though extremely difficult, there is a way for a modern man

to attain a true heart, and thereby a good poem. This is by delving into good poems of ancient times and by learning the language in which they are written. A modern poet should not try to imitate the feelings of ancient masters; this would be a falsification of his feelings. Instead, he should try to learn their poetic language and make it his own. "Then his heart would be gradually transformed by ancient poetry and books," Norinaga says, "until it becomes at one with an ancient master's heart. Thereupon he can freely express his own feelings." As against the traditionally held view that one should attain a true heart in order to write a good poem, Norinaga is arguing that a true heart can be attained only through good poetry, for, according to him, no thought or feeling exists without the language. Words are the organizers of the human mind; they give form to the formless. In writing a poem, therefore, one should first seek words, and not feelings. "Feelings are not to be sought; they are something that naturally arises," Norinaga says. "To be sought are words. This is why I say the first principle of verse-writing is to arrange the words in good order."

Norinaga has repeatedly emphasized the importance of artistic expression in literary writing. About lyric poetry in particular, he once declared: "Poetry is an art of language, in which the artist expresses his feelings in an appropriate way. If one should speak out his feelings as they are, there would be no poetry at all—or, at best, the worst kind of poetry." By "an appropriate way" Norinaga means "such a way that words are neither too many nor too few, that they flow smoothly and sound pleasant." Poetry must have art, that is, "the words must be well regulated, neat, and orderly." This might seem a contradiction to Norinaga's definition of poetry as a simple, straightforward expression of true human feelings. It is no contradiction, however, because in Norinaga's opinion a direct expression of deeply felt emotion is always regulated, neat, and orderly. Norinaga illustrates this by taking an example in the way in which a man weeps on a sad occasion. When the sorrow is not deep the man only sobs spasmodically. If it is a truly deep grief he wails, with a steady voice that has certain rhythmical patterns. "When the grief is intense," Norinaga concludes, "the man's voice would

have a regulated flow without his conscious intention." Likewise, the words of a man in deep grief are naturally regulated and have artistic qualities in themselves; if a man speaks in a plain language, one can see his grief is shallow. "True poetry," Norinaga asserts, "has its essence in those words that are naturally artistic as they have spouted out of a deeply moved heart." Here is also a reason why the Classicist Norinaga preferred the poetry of Tsurayuki's time to that of more ancient times; the very earliest poems, he thought, were "so extremely simple that they often looked crude, unrefined, and shabby."

What is true of poetry is true of prose works, too. One of Norinaga's sharp perceptions was that poetry and the novel were the same in essence. "There is no art of poetry apart from the art of the novel," he once said, "nor is there any art of the novel apart from the art of poetry. Poetry and the novel have precisely the same aim." The aim is, of course, to express true human feelings as the heart is deeply moved. Norinaga defines the novel almost in the same terms as poetry. "People have various feelings at various occasions in life," he says. "The novel describes those things which stir especially deep feelings. It reveals *mono no aware* in doing so." Like the poet, the novelist is inextricably involved in various life-feelings, so much so that he cannot contain them within himself. These feelings, poured into the novel, would move anyone who reads it.

The difference between the novel and poetry is suggested by the word "describe," which Norinaga used in the above definition. Elsewhere he uses the words "describe in minute detail" in explaining the essence of the novel. He writes of the author of *The Tale of Genji:*

The novelist, with a heart exceedingly sensitive to *mono no aware*, penetrated all kinds of events and all types of people in the world as she saw or heard about them. Each time her heart readily responded, and the responses gradually accumulated in her, until she could not contain them in herself. Thereupon she set out to describe them in minute detail, making use of fictional characters she created. Things that she approved of or disagreed with, things that she

208

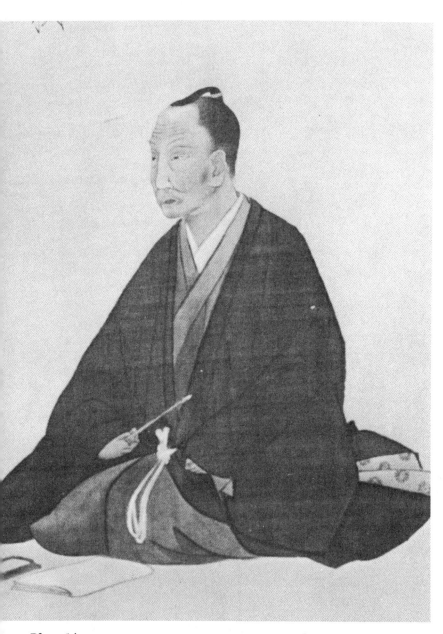

Plate 14
Norinaga.
Portrait by Gorei (1765–1849).
From a hanging scroll now in the possession of Professor Henry
Trubner of the Royal Ontario Museum, University of Toronto.

thought hateful—she put them all into the minds and words of those characters, thereby having her obsessed heart cleansed.

Whereas the poem directly presents feelings in a rhythmical language, the novel "describes them in minute detail." In this respect the novelist finds it convenient to have fictional characters into whom he can pour his feelings; even the most odious things he can say through a fictional character. Through fictional persons and fictional situations, the novelist can describe the ultimate of joy, grief, love, or anger, as well as hatred. In this way he can describe "what a good man's heart is like, what an evil man's heart is like"; in brief, he can show "the details of the innermost human heart." In depicting a good man the novelist can gather all the attributes of benevolent men in the world; in presenting a malignant person he can pile up all the world's evils in that character. The novelist can present his idea or feeling through his selective creation of fictional characters and situations. A tragic hero, said Aristotle, must be a man of high social status. Norinaga in effect says the same. "When one responds to the sight of a man suffering from a disaster," he writes, "it makes a great difference whether the victim is a noble courtier or a lowly person. One's sympathy would be especially deep upon seeing a noble person crushed under a disaster." A novelist who wishes to describe the sorrow of life would create a nobleman in deep grief; the reader would feel the sorrow more deeply that way. Fictionalization is a necessary and effective scheme for the novel, which must, unlike poetry, describe. Poetry presents feelings, but the novel describes the circumstances that have prompted the feelings.

For this reason a poet living in the modern degenerate age should learn the purer feelings of early poets by reading classics of fiction such as *The Tale of Genji*. The student of verse-writing will make a far greater progress if he reads not only Classical poetry but also the novels of Classical times, because in this way he will come to know the soil in which that poetry took its roots. To a person who has not read the novels, the titles of Classical poems would sound strange, as if coming from some remote

land. For those who are well acquainted with Classical novels, reading an ancient poem would be like listening to an intimate friend, whereas the poem would seem to be a total stranger's words to those who have not read them. In this respect poetry and the novel complement one another.

All of these arguments of Norinaga's about the nature of a literary work make sufficiently clear his view on the use of literature. It goes without saying that he rejects both a Confucian and a Buddhist view; sometimes he seems too emotionally insistent in his rejection, no doubt because the age he lived in was so overwhelmingly in favor of didactic literature. "Poetry is feelings spoken out in an appropriate way," he says in one passage. "A poet utters whatever is in his heart, good or bad. Why should he be blamed for speaking out his amorous feeling? If his poem is good, why shouldn't it deserve high praise?" "Confucianism has its own aim," he says in another passage. "Buddhism has its own aim. The novel has its own aim. If one should mix them up and build up an argument thereon, that will be a fallacious argument indeed." Confucianism and Buddhism would condemn a maiden who, taking pity on a man desperately in love with her, secretly meets him without her parents' permission. Yet literature would approve of her; in fact there are numerous literary works describing such a maiden. This is because "novels are not concerned with the moral acceptability of her deed; they simply admire her *mono no aware*." It is like admiring a beautiful lotus flower blooming in a muddy pool. The externals surrounding it may be dirty, but that does not change the quality of its beauty. A novel may describe adulterous love, but this is all for "making the flower of *mono no aware* bloom." Morally evil as it may be, it is aesthetically most beautiful. Many moralist scholars who condemned *The Tale of Genji* on ethical grounds are completely in the wrong.

According to Norinaga, then, literature is independent of all didactic purposefulness; in no case does it make usefulness its prime aim. This does not imply literature is useless; on the contrary literature can be, and usually is, greatly useful, without aiming to be so. Norinaga explains this by an apt metaphor. "Trees have no intention of helping men when they grow large,"

210

he says. "But if a tall tree stands in the forest, men may cut it down and make excellent lumber out of it. They may use the lumber for various purposes—for making a big thing or a small thing, for doing a good thing or an evil thing." A literary work grows naturally out of a man's heart; though it may be used by various men for various purposes, it is primarily not intended to be so.

After admitting that the usefulness of literature is only incidental, Norinaga goes on to explain the three ways in which literature can be useful. First, literature can give the pleasure of emotional purgation; secondly, it can nourish *mono no aware;* and thirdly, it can help attain the ultimate of Shintoism. We have already discussed all these at some length, so here we shall simply summarize them. The first use stems from Norinaga's definition of literature as emotional expression. A person can purge his obsession by expressing it in words; he feels consoled as he expects, consciously or unconsciously, his worry to be shared by others. The same can be said of a person who hears or reads about the life of someone else. "As the reader reads about someone's life resembling his own," Norinaga says, "he comes to realize that his sorrows are not only his own, whereupon he feels consoled." Literature communicates human feelings, and the communication is a solace both to the one who initiates the communication and to the one who receives it.

The communicative function of literature leads to the second use of literature: a literary work nourishes man's sensitivity to true human feelings. "Novels describe the various ways in which things happen and people feel," Norinaga says. "Therefore the reader, without special effort, comes to know how things happen in the world, and how people behave and feel on various occasions." Literature is knowledge—it is informative of true human feelings. "It records human feelings as they are," Norinaga says, "and shows to the reader what they are like." It describes, for instance, how a parent feels toward his child. A son, reading a work of literature, may realize how dear a father's love is; then he will realize, too, why he should be kind to his father. Literature, by simply describing true feelings of a father toward his son, in effect teaches the importance of filial piety. "There is

nothing better than poetry," Norinaga declares, "to make one familiar with human feelings and with the true cause of an event, or to soften a man's heart and nourish kindness in it." A work of literature is not a sermon, but it teaches the basis of ethics; it teaches *mono no aware,* how men generally feel and why one should be kind, tolerant, and sympathetic toward others. It teaches, in brief, what the universal true heart is like—the heart that has been buried underneath the contemporary social and moral norms.

Now one can easily see the third and most important use of literature as conceived by Norinaga. Through literature, and only through literature, man can return to his innermost self—the self that is energetic and creative as bestowed by the God of Creation. "Make it your habit to write poetry, to read old tales, and to learn thereby about the poetic spirit of the ancients," Norinaga advises. "This will be an immense help not only for those studying the art of poetry but also for those trying to attain the ancient ways of the gods." A person who writes good poetry or who reads good works of literature can, without knowing it, purge all modern rational thoughts that have suppressed his heart, or all medieval Buddhist ideas that have tried to reduce his humanity. Literature helps one to approach Shinto gods, who are more truly human than modern men, and Shintoism, in turn, helps one to understand a work of literature, which probes all areas of the human mind, rational and irrational, conscious and subconscious. "Unlike Confucianism or Buddhism, Shintoism does not indulge in any of the noisy debates over Good and Evil, or over Right and Wrong," Norinaga says. "It is all-inclusive, bountiful, and gracious—exactly what poetry aims at." In short, literature helps one to return to basic humanity, as Shintoism does.

All in all, it may be said that Norinaga's theory of literature is a remarkably modern, humanistic one. Ironically enough, this is so because he derived his theory from Shintoism, a religion now generally considered obsolete and dead. The truth is that Shintoism is humanistic in its basic view of the world and of man; its cosmos is ruled by anthropomorphic gods; men are derived from and can eventually become gods. In insisting that

men should know the ways of ancient gods, Norinaga is actually saying, as some romantic primitivists did, that men should return to their true unsophisticated selves so well expressed by primitive people who were unspoiled by the evils of civilization. This aim would most effectively be attained through literature, for literature is capable of expressing human feelings without the process of abstraction or generalization. Human feelings, in their original form, are all pre-moral and may look foolish or senseless in the light of modern rational and ethical ideas. By reading works of literature one comes to learn about those basic human feelings that lie deeper than rational and didactic thoughts; one comes to know *mono no aware*. Literature does not aim to teach; it simply presents or describes inmost human feelings. But in its presentation or description it shows how weak and foolish men really are, and therefore how necessary it is for them to understand, sympathize, and help each other. Through works of literature man comes to know who he really is, where he stands in the scheme of things, and what he is expected to do in his present existence.

14

Conclusion

The foregoing chapters have outlined the views on the nature of literature and the arts held by thirteen major aestheticians in Japan during her pre-Western years. It would of course be both impossible and impertinent to formulate a single Japanese aesthetics out of them. Those theorists lived in different ages, had different temperaments, and, above all, were disciplined in different branches of art. Yet, precisely because of such historical, personal, and disciplinary differences, a comprehensive study of their writings would help to bring to focus certain general issues of aesthetics common to all ages, environments, and art forms; they would illuminate many crucial problems which any serious artist, and any serious thinker on art, must eventually face. For the sake of convenience we might group the issues under eight headings: (1) nature versus art, (2) the creative process, (3) beauty, or the sensuous effect of the work of art, (4) internal structure and unity, (5) interrelationship of the arts, (6) literary and art criticism, (7) the "mode of existence" of the work of art, and (8) the use of art. By comparing, contrasting, and synthesizing our thirteen aestheticians' views on these issues, we might at least point toward the general conception of art in the Japanese tradition.

The idea that art imitates nature is shared by most Japanese aestheticians. However, as is the case in the West, the meaning of "nature" differs considerably among the theorists, thereby giving rise to a variety of mimetic theories. The least sophisticated interpretation of "nature" is given by Tsurayuki, who simply equates it with external reality as perceived through the

senses. In his view a work of art is the result of an attempt to reproduce tangible reality; a landscape poem, for instance, tries to re-create a scene of nature by means of words. In the way he looks at reality, the artist is no different from an ordinary man; artistic experience is qualitatively the same as any experience in ordinary life. Anyone capable of seeing, hearing, and feeling the beauty of nature can produce a work of art; in fact a person who has never before composed a poem might become a good poet when faced by a movingly beautiful scene of nature.

Tsurayuki's view, naïve as it is, anticipates what might be called "aesthete" theories of art when it mentions beauty of nature as a motive of artistic creation. Art does not reproduce nature indiscriminately; it selects from nature only those aspects that are felt to be beautiful. Nature now becomes "refined nature"; realism turns to "selective realism." The artist is no longer a plain, average man, but a person singularly sensitive to beauty. Yoshimoto, Zeami, and Toraaki partly subscribe to this view when they reject the coarse and the crude in favor of their ideal beauty, *yūgen,* for the material of art. Extending this view, one might maintain that art imitates nature only in those phases deliberately chosen by the artist. The artist might select not only the beautiful but also the ugly for one reason or another. The view is supported by Lady Murasaki and her ardent admirer, Norinaga.

One conspicuous feature of Japanese aesthete theories is their fondness of one particular type of beauty, the elegant. Not only the court novelist Murasaki and the court poet Yoshimoto, but also the comic actor Toraaki and the narrative singer Jigū give it a high place in their aesthetics. Perhaps we might attribute this to two main sources of Japanese civilization: the Heian culture and Buddhism. The culture of the Heian period, created by courtiers and dominated by ladies, had early cultivated a special sensibility for refined, delicate, graceful beauty, while Japanese Buddhism, advising men to resign themselves to fate rather than to fight with it, minimized the value of manly, heroic, dynamic beauty. Thus Japanese theater is lacking in an Aristotelian tragedy; Japanese literature is barren in political novels; Japanese music, even when singing of an heroic battle

215

scene, yields the effect of lovely white beads disorderly strung together.

Aesthete theories stand on a rather fragile basis in that beauty, or ugliness, is subject to the judgment of the individual onlooker. Tsurayuki was already aware of this when he doubted that other people had considered his daughter to be as lovely as he did. Men's sensibility differs from one to another; the senses cannot be wholly trusted. The disbelief in sensuous perception becomes complete with medieval Japanese aestheticians who hold a dual view of reality. In medieval Buddhist belief, the reality that the senses perceive is superficial and illusory; higher reality lies somewhere beyond the reach of men's eyes and ears. The function of art is to bring this intangible world momentarily to the sphere of the senses by such means as images, metaphors, and symbols. The artist now becomes a medium, a shaman, a magician. He is crystal or water, which, being transparent, can let all colors pass through; he is a mirror capable of reflecting all things, or a vessel capable of containing all things. Art imitates, not the shape and color of an object, but its inner spirit, its hidden meaning, its true intent. This view is shared by all medieval and medievalist aestheticians.

Unique to the medieval Japanese theories is that they propose a complete dehumanization of the artist in his creative activity. In Western theories of artistic representation, "dehumanization" means the detachment of the artist from the object of his imitation; the artist must find an objective correlative, with none of his personal feelings interfering in the process of imitation. But the Japanese advocate not only the detachment but the dissolution of the artist as a man. It is not enough that the artist learn about a bamboo from a bamboo; he must himself become a bamboo. The medieval Japanese view marks one extreme of all representative theories of art.

With the approach of the modern age, the emphasis of Japanese aestheticians gradually shifted from the unhuman to the human, from external to internal reality. The artist, seeking the object of representation, now looks into his soul. The nature he imitates is human nature, nature in himself as well as in all his fellow men. Of utmost importance to the artist is to represent

216

human nature as it is, and not as distorted by some pre-conceived ideas. Human reality thus conceived might show itself irrational and ugly, but if that is the truth the work of art must say so. Art, after all, cannot escape from humanity, so long as its creator is a human being. This view seems to underlie the arguments of Yūshō, Chikamatsu, and Norinaga.

The question as to the nature of poetic or aesthetic truth arises in all theories of representation. Which is truer, poetic truth or factual truth? With the exception of Tsurayuki, who was not yet fully aware of the issue, all Japanese aestheticians answer in favor of poetic truth. Lady Murasaki places good works of fiction higher than books of history in her scheme of things, as she sees more truth in the former. All theories under Buddhist influence repudiate factual reality as illusory and recognize higher reality lying in the sphere of art; for this reason they often try to bring art and religion together. Norinaga, who professes no liking for Buddhism, holds a dual view of reality arising from his Shinto belief; Chikamatsu, whose ideas on drama apparently owe little to Buddhism, still believes that *dramatis personae* speak more truthful words than living men. In the realm of art men are unfettered from the strictures of society and are therefore freer to speak out what lies deep in their hearts.

Seen from a different angle, those mimetic theories would turn into a variety of expressive theories. Tsurayuki's view, defining poetry as spontaneous expression of emotion, is the most elementary and orthodox of expressive theories. The naturalistic view held by Chikamatsu and by Norinaga is really a latter-day modification of Tsurayuki's notion: ancient artists, being simplehearted, could create works of art by plainly expressing their emotions, but the people of modern times, spoiled by the evils of civilization, must toil to attain the emotions truer and purer than those in their daily lives. The aesthete theories necessarily demand the cultivation of aesthetic sensibility on the part of the artist, and hence the artist must be, as Yoshimoto and Rikyū said, possessed of discriminating aesthetic taste. Also, medieval theorists' insistence on the annihilation of the self in the creative process could be restated in terms of the artist's self-expression; the medieval artist, desiring to expand his self, tries to make his

soul void so that it can embody all. We recall Zeami's comparison of the artist to a vessel that contains the whole universe, or Sennō's claim that art can represent a vast scene of mountains and rivers with a little water and a few twigs.

One characteristic of Japanese expressive theories is their conspicuous silence on the function of discursive reason in the process of artistic expression. Of course the materials of art tend to be emotions rather than ideas, but the Japanese seem to be almost excessively emphatic on this truism. Yoshimoto has excluded from poetry learning, discussion, witticism, and epigram, thereby denying most of the intellectual elements in poetry. Norinaga, by placing *mono no aware* in the nucleus of the creative process, has consistently kept rationality from becoming either the motive or the organizing principle of literature. Even Toraaki, writing in a genre of literature where wit and humor tend to dominate, has conceived *yūgen* and pathos as essential to art. Japanese aestheticians minimize the role of intellect in artistic creation. They are all intuitionists.

In contrast with logical speculation, intuition is irrational, instantaneous, and inspirational. It is "a flash of insight" in Bashō's term, "the first flash of inspiration" in Yoshimoto's words, and "a stir of feelings" as Norinaga puts it. In that moment the artist's egoism is dissolved and his self sublimated, and even the artist himself cannot restore that mental state once the moment is over. For this reason Mitsuoki and Bashō advise the arist not to retouch his work at some later date; the artist is not his ordinary self at the moment of inspiration. But the idea of the artist's being "insane" does not appear in Japanese aesthetics. Rather, a superb artist is divinely possessed; he is like the holy Kāshyapa who saw a sacred message in a flower, or like an omniscient Boddhisattva with a thousand hands and a thousand eyes.

The artist cannot through his own will produce inspiration or induce it to visit upon him, as it lies outside his ordinary self. He can, however, create a state of mind where inspiration will more easily generate itself. That mental state has been described as a mind with "no impure thought," or "a calm frame of mind, a mind devoid of nervousness or excitement." The artist could

arrive at this state by intense mental concentration; by forcing his mind on an object, he could purge all the contents of his mind that do not belong to the occasion. As to the question of what the mind should concentrate on, answers differ somewhat among aestheticians. Medieval aestheticians would of course say it should be an object of nature; the poet should submerge himself within an object, perceive its delicate life, and feel its feelings. Norinaga says it can be anything—a word, a theme, an object related to the theme, and the poet should concentrate on it with such intensity that he forgets eating and sleeping, or hears nothing if he is spoken to. Tsurayuki and Yoshimoto also point out a case when such intense concentration of mind is brought about without effort on the part of the artist; this occurs when the artist is overwhelmed by the beauty of nature.

One might note here that medieval aestheticians and Norinaga, with their stress on mental concentration, inadvertently approach the concept of the mask. Medieval aestheticians, Jigū and Bashō included, insisted on the oneness of the imitator and the imitated, the performer and the performed; this in effect means that the artist puts on the mask of whatever object he is projecting himself into. Naturally enough, actors like Zeami and Toraaki especially emphasize the point. Though from a different viewpoint, Norinaga seems to come to a similar conclusion, too: every poet, he says, has a desire to be like some ancient master poet, and he might try to put on that master's mask during his composition; this is perfectly legitimate, insofar as that desire is true and sincere. This, as Norinaga says, is the only way in which a poet could improve his art.

Another issue pertaining to artistic expression is whether aesthetic emotion, or the emotion embodied in the work of art, is qualitatively different from ordinary emotion, or the emotion in actual life. The Japanese aestheticians with humanistic bent answer it in the negative. According to Tsurayuki, any ordinary emotion becomes of itself a poetic emotion when it is highly intensified. Chikamatsu suggests that the playwright intensify ordinary emotions by manipulating man's sense of honor. In Norinaga's opinion, emotions embodied in a literary work are the same in kind as those of life—only barer, less controlled, and

219

more outspoken than in actual life. In contrast, medieval and medievalist aestheticians conceive aesthetic emotions as qualitatively different from ordinary ones. Emotions in the work of art are impersonal and unhuman; they are, in fact, not emotions but atmospheres and moods. Thus Bashō maintains that grief in actual life must turn into *sabi* in the poem. The whole point of the tea ceremony is to create an artificial atmosphere where many of the life-feelings are sublimated. Zeami's highest aim in art, sublimity, exists in a sphere beyond the reach of ordinary life. According to the medievalists, aesthetic emotion is purposeless since it is free of man's desire and will. It is useless in the sense that it offers no help toward man's material gratification.

As for the effect of emotional expression upon the expressing agent, some Japanese aestheticians explain it by the idea of catharsis. The Japanese notion of "catharsis" is perhaps a bit peculiar in that it is concerned more with the artist's creative activity than with the response of the audience. Tsurayuki is a vigorous proponent of the idea: emotional expression clears one's mind, gives one a pleasant feeling, he says. Norinaga follows it up: "All thoughts that are tangled in the mind," he writes, "are loosened and dispersed when they are spoken out or written down." For the medievalists, catharsis is not simply the letting out of emotions; it is rather a qualitative transformation of them. Thus in Zeami's aesthetics agonizing grief turns into serene sublimity, and in Bashō's it changes into unhuman *sabi*, as life is transformed into a work of art.

Though less positively, some Japanese aestheticians seem to recognize catharsis also in the effect of a literary work upon the reader. Norinaga, for instance, says: "The reason one's heart is consoled by reading a novel is because the reader, by learning about the life of someone else, realizes that he is not alone in feeling the sadness of life." The reader identifies himself with a character in the novel; so, when that character gives vent to his emotion, the reader feels his heart consoled, too. Lady Murasaki may have had a similar idea; after stating how Tamakazura loved to read novels, she points out that the young girl compared her life with their heroines'. Tsurayuki also seems to anticipate the notion when he consoles himself by recalling an ancient poem

220

on the loneliness of looking at the moon on the wide expanse of the ocean. In Tsurayuki's view, however, the purgative effect of poetry is far greater for the poet than for the reader.

To describe more generally the effect of an art work upon the reader, spectator, or listener, the Japanese of course have that all-inclusive word, beauty. The work of art is beautiful, and thereby moves the hearts of men. Japanese aestheticians have proceeded to spell out the implications of beauty and in doing so have well summed up the Japanese concept of beauty. The elements that stand out are freshness, lifelikeness, pathos, elegance, austerity, simplicity, and balance.

The beauty of freshness in the work of art has been pointed out by many Japanese aestheticians, ancient and modern alike. A person facing a good work of art is struck with the feeling of freshness. A good Haiku, said Bashō, gives the effect of looking at a shallow sand-bed river, with its water eternally fresh. A good Heikyoku performance, said Jigū, yields a feeling somewhat similar to that of eating a cucumber ahead of the season. "Art," said Toraaki, "makes common things look uncommon." "In the final analysis," said Yoshimoto, "the aim of linked verse is to make ordinary facts appear new." "A master poet," said Norinaga, "uses age-old themes and words but produces a work of novelty." The last two quotations suggest wherein the impact of freshness originates. Freshness is the feeling that emerges when one suddenly perceives an old truth in a new guise. A work of art opens the onlooker's eyes; it makes him see what has been there but what has not been noticed before.

The discovery of a hidden truth is also the basis for the beauty of lifelikeness. Lifelikeness does not mean likeness in outward appearance; a precise copy of surface reality, in fact, would be ugly, as Chikamatsu observed. To be lifelike implies to be true to inner life, to contain the buried truths of life. A person looking at a work of art feels it beautiful when he finds in it some universal law of nature manifesting itself. It is the beauty of discovering the spirit, the meaning, or the true intent of a man or a natural object in a work of art. A painting of summer trees holding the potentiality of powerful growth, or a story of a dying soldier longing for his beloved wife, is beautiful for this reason.

221

A characteristically Japanese variation of lifelikeness is pathos. The Japanese, when they pursued the truths of life to their ultimate, arrived at pathos, as all Buddhists would. Beauty is truth, and truth is pathetic—it is so, at least, in the Buddhist view of life; man is a pitiful existence, bound by passions, measured by time, and constantly fearful of death. Thus Toraaki, pursuing the true rather than the comic, must say: "All arts repudiate an attempt to amuse. Everything ends in pathos." Lady Murasaki, who regards good fiction as truer than history, believes that a fine novel yields "truly convincing pathos." Chikamatsu, teaching how to put life into puppet plays, rates the feeling of pathos as the most important element. Both Zeami and Jigū recognize pathos in so many works of art that they put them in two large categories—love or longing, and sorrow or grief. A work of art, if it embodies a profound truth of life, inevitably has undertones of sorrow, for any good artist is sadly aware of the limitations of humanity.

It is significant that the Japanese have singled out pathos from among all similar sentiments. Pathos is not grief, sadness, misery, or despair; it is gentler, calmer, more passive, and refined. Refinement, indeed, is another characteristic of Japanese beauty. Many Japanese artists, in repudiating the direct copying of crude reality, tried to avoid direct expression of strong emotions. The trend is latent even in Tsurayuki, whose very tenet was spontaneous expression of powerful emotions: as we saw, he emphasized the importance of form and stylization. The tendency grew with time, reaching its peak in medieval arts. If refinement is taken away from the tea ceremony, for instance, most of the beauty of that art would be lost; the beauty of the tea ceremony is that of refined poverty.

When refinement is combined with pathos, there emerges another peculiarly Japanese beauty—*yūgen*. It would be infinitely more pathetic and moving to see a refined court noble, rather than a lowly rustic, suffering the kind of disaster no human being can escape. There is indeed unique beauty in the sight of a handsome, intelligent prince or a lovely, accomplished court lady going through intense grief as a result of human imperfectibility; that beauty is *yūgen*. Thus Zeami, as we recall, de-

222

fined *yūgen* as "elegance, calm, profundity, mixed with the feeling of mutability."

When the element of calm grows larger in *yūgen*, there forms another type of beauty—austerity. The beauty of *yūgen* emerges when a graceful person, too sophisticated to have barbaric vigor for fighting, sadly resigns himself to fate; if the person resigns calmly and without sadness, the result would be Zeami's austere beauty, sublimity. Austerity is a sensory effect felt by one who faces the dignity of a divine being, or of a man who has approached the essence of the universe by sublimating the human elements in himself. It is also the effect of Bashō's *sabi*, which emerges when the personal is transformed into the impersonal. Both sublimity and *sabi*, being unhuman, have an over-all effect of chilliness. One might add a bit of warmth to it by allowing a minimum of humanity; if one does, there springs up the beauty of *wabi*. *Wabi* can be seen as a moderate type of austerity.

Whereas all the foregoing types of beauty are to a large extent empathic values, simplicity and balance are the kinds of beauty more heavily dependent upon the internal structure of the objective work. Of the two, simplicity is more typical of Japanese beauty. Mitsuoki, for instance, makes it the distinguishing mark of Japanese painting. Simplicity is rooted in the attitude of medieval artists who try to present the indescribable essence of the universe by means of suggestion. It is in blank space that suggestive power reaches its maximum; void is fullness. Simplicity also has the moral implication of escaping from the everyday world where material luxury is the aim of life. In this sense it is a corollary of sublimity, *sabi*, *wabi*, and above all, lightness. Lightness is the flavor of vegetable soup, but it is understood only by those who have tasted the most luxurious of all delicacies. The blank space must be full of meaning; the void must not be empty. Simplicity is the beauty of artful omission, of density and concentration.

Balance is in itself not peculiar to Japanese beauty. But the Japanese idea of balance seems to have at least one peculiar feature: it avoids symmetry. Sennō, as we recall, in various ways enforced the principle of balance in flower arrangement, yet always rejected symmetry on the ground that plants in nature

never grow symmetrically. Mitsuoki, who insisted on balance to the extent of prescribing even the position of the painter's seal on the canvas, taught that in a painting the foreground would best be left unpainted. Classical Japanese poetry, with all its indebtedness to Chinese poetry throughout the centuries, has retained its unsymmetrical 5–7–5–7–7 syllable pattern, resisting the adoption of the technique of parallelism in which Chinese verse abounds. The Haiku, which has a balanced form of 5–7–5 syllable lines, is frequently divided by a cutting-word into two syntactical units, 5–7 and 5, or 5 and 7–5, thus breaking up the symmetry of form; the two unsymmetrical units are of course harmoniously united by the principle of fragrance, reverberation, or reflection. If in time arts an *A–B–A* rhythm pattern is considered symmetrical, the Japanese tend to avoid that, too. The typical Japanese rhythm is *jo, ha, kyū*—from the slow and the regular to the quick and the irregular; this rhythm is adopted in linked verse, the Nō, and the Comic Interlude. Rikyū, using different terms—*in* (the Female Principle) and *yō* (the Male Principle), points toward the same concept; he says that the rhythm of the tea ceremony is from the *in* to the *yō*, that is, from order and calm to gaiety and excitement.

The fact that in Japan a poem or a drama is often constructed in accordance with a musical rhythm suggests a characteristic feature of the Japanese concept of structural unity. Japanese arts generally shun logic as the principle of unity and try to minimize the role of intellect in the structure of a work; this is true even of those arts that could admit into themselves a large measure of discursive reason if they wanted to. Linked verse, for example, could have relied far more on logic in connecting its different stanzas, but the majority of the methods of linking taught by Yoshimoto are illogical ones—linking through a word, a mood, an association, an allusion, and so forth. In the Haiku, all the structural methods recommended by Bashō are highly impressionistic; fragrance, reverberation, and reflection are values in which intellect has no place. When talking about the work of prose, which is supposedly more logical than poetic language, Japanese aestheticians never emphasize the importance of tight, logically coherent structure. Lady Murasaki speaks only of

224

natural smoothness, the rhythm of life, which is never logical; *The Tale of Genji*, in fact, is almost a series of short stories loosely strung together. A tragedy could certainly make effective use of a logically constructed plot, but Chikamatsu seldom does so; his plays, especially his historical plays, present a series of incidents that are in themselves dramatic but loosely connected to one another. A comedy would be quite effective, too, when it has a tight plot unfolding itself toward a single dénouement, but Toraaki teaches that there should be two or three climaxes in each work of the Comic Interlude. Perhaps beneath all this lies a view of life that Norinaga says is traditionally Japanese: human life is essentially irrational and the universe is not logically constructed. The work of art, if it aims to copy life and nature faithfully, cannot have a logical structure. Added to this is the medieval idea that ultimate reality, even if it could be uncovered through the superhuman faculty of the artist, cannot be expressed in logical terms. Thus Japanese artists prefer to depend upon the illogical, imaginative power of images, metaphors, and symbols when they set out to describe the essence of the universe. They make extensive use of images and metaphors even when they write on aesthetics. As we have seen, Japanese aesthetic writings tend to be metaphorical rather than analytical, and impressionistic rather than rationalistic.

Such similarities in artistic structure and effect among different arts have often led Japanese aestheticians to make the assertion that all arts are one in essence. Mitsuoki once described painting as visual poetry, and poetry as verbal painting. Tsurayuki in his comment on the art of poetry, and Zeami in his remark on the art of the theater, both stated that singing and dancing derived from the same spirit and motive. Jōō is reported to have taught that every student of the tea ceremony should learn the art of calligraphy and literature as well. Norinaga's definition of poetry is so broad as to include religious music, the Heikyoku, the Nō, ditties, folk songs, and others. Bashō recognized a single element permeating lyric poetry, linked verse, painting, and the tea ceremony; furthermore, he suggested that an expert in one art would find it easier to learn another art. All those men conceived their aesthetic ideas, such as *yūgen, sabi,*

225

wabi, mono no aware, to be the basis for all the arts. In fact many Japanese arts are composite arts, and in some cases they are uniquely Japanese. Literature and painting are united in the pictorial novel; painting and music are at one in calligraphy; poetry, drama, dance, and sculpture are fused in the Nō.

Japanese aesthetics, while stressing the oneness of all arts, has little to say why and how one art differs from another. Norinaga once posed to himself the question of why the Heikyoku and the puppet theater can be considered poetry. His answer was that these arts were in origin "the like of the novel," yet were different from the novel in that "they were sung with melodies." In other words, the difference between the arts lies in their milieu, in their ways of expression and communication. Life is presented through vocal and instrumental music in the case of the Heikyoku, and through written language in the case of the novel. Similarly, if an emotion is conveyed by means of words, there will emerge poetry; if in gestures, dance; if in lines and colors, painting. Zeami and Mitsuoki must have assumed this when the former defined both poetry and dance as outward expression of intense inner emotion, and when the latter described painting as visual poetry and poetry as verbal painting. Zeami furthermore seems to imply that the intensity of emotion determines the milieu: an ordinary emotion would call for prose, a more intense emotion would ask for verse, and the most intense emotion would demand bodily movements. Zeami beautifully put this into practice in his Nō plays, using prose in presenting ordinary dialogue, poetry in pouring out the impassioned emotion of the protagonist, and dance in marking the peak of that emotional utterance. Without theorizing about it, Tsurayuki in *The Tosa Diary* and Bashō in his travel journals make similarly calculated use of prose and verse.

On the question of the interrelationship of the arts, a good deal may be said from the spectator's or reader's point of view, too. Japanese aestheticians are totally silent on it, however; for that matter, they have generally very little to say about the relationship between the work and the audience, or about the nature of literary and art criticism. No doubt this is mainly because most of Japanese aestheticians were artists, and they wrote their

theories for the benefit of their disciples and followers. Nevertheless it is evident that they were constantly aware of the readers or spectators when they formulated their theories, and we can discern the critical attitudes underlying their writings. These attitudes could be conveniently summarized in six general categories, and we can perhaps see in them the genesis of six types of literary and art criticism: judicial, philosophical, impressionistic, technical, historical, and objective.

Judicial criticism, with its emphasis on evaluation, is basic to all types of criticism. Good works of art must be distinguished from bad ones in one way or another, and without some standard of evaluation one would find it difficult even to draw a line between that which is a work of art and that which is not. The necessity of appraisal was the prime motive of literary and art criticism in Japan, too, and judicial criticism was the basic concern of many Japanese aestheticians. Flower contests, picture contests, poetry contests, which prospered in early Japanese courts, developed literary and art criticism in its evaluative aspect. When Buddhism was introduced, it provided convenient tools for this type of criticism with its various classification systems. In this tradition Zeami classified Nō performances into nine ranks in the order of excellence. Jigū graded Heikyoku performances in three ranks: the Spirited Performance, the Excellent Performance, and the Consummate Performance. Mitsuoki also had three ranks of painting: the Competent Work, the Miraculous Work, and the Divine Work. Evidence shows that Bashō, while not having a hierarchical scheme, constantly made judgmental criticism on actual works of the Haiku.

Preliminary to judicial criticism is setting up the standard by which the judgment is made; but, as may be expected, Japanese aestheticians differ considerably in their opinions as to what the standard should be. One convenient criterion, it may be thought, is the greatness of ideas and feelings contained in the work of art; a work that is philosophically great is artistically great as well. Philosophical criticism, however, is conspicuously absent in Japanese aesthetics. Tsurayuki is perhaps the one who came closest to it when he envisaged true feelings as the basis of evaluation, but he insisted on the genuineness of the poet's feelings

227

rather than on the greatness of the feelings *per se*. For one thing, there was once more that Japanese disbelief in logical formulation, systematization, and abstraction. Japanese aestheticians were unphilosophical in the sense that they instinctively avoided separating ideas from the work of art.

In contrast, impressionistic criticism was widely accepted by Japanese aestheticians. A work of art was judged by the nature of the emotional impact it produced upon the reader, spectator, or listener. A tea ceremony that provided the feeling of *wabi* was better than the one that did not; a work of calligraphy that looked alive was preferable to the one that looked dead; and a puppet play whose pathos moved the audience to tears was superb. In Japanese theatrical arts this emotional impact was often called the flower; each work was evaluated according to the nature of the flower it put out. Thus, as we saw, Japanese aestheticians tried to define the various modes of artistic effect as specifically as possible, using such terms as *yūgen*, sublimity, *sabi*, and lightness.

However, impressionistic criticism, more than any other type of artistic appreciation, is exposed to the danger of subjectivism. Emotional response to the work of art differs inevitably from one person to another. As Yoshimoto rightly observed, the same verse can be praised or condemned by different readers. There may be no clear-cut solution to this problem, but at least two ways of safeguarding against critical subjectivism are suggested by Japanese aestheticians. One, proposed by Yoshimoto, is to heed only the majority opinion; subjective impressions, when accumulated in number, assume more objectivity. Hence Yoshimoto's remark: "You can safely assume that a verse is good if it is widely acclaimed in the world." The other corrective, suggested by Zeami, is to discern the taste of the audience; people who are better oriented in the arts are better qualified to be critics. The people in the Capital made a better audience for the Nō than those in the rural areas, so the actors who performed in the Capital could automatically improve their art.

As opposed to impressionistic criticism, which relies on the audience-work relationship, technical criticism explores the author-work relationship. It evaluates a work of art by observing

how successfully the artist has realized his aim in his work. The success or failure of artistic expression is a matter of technique; the artist who has failed to express himself adequately in his work has failed in his technique. The poem composed by a grieving man must give full expression to his grief; the painting of a Confucianist must properly express the painter's idea of a Confucianist. Tsurayuki often employed technical criticism successfully when he criticized the works of ancient and modern poets: Narihira's poetry, for instance, was criticized for its poor technique in expressing a genuine emotion. Mitsuoki also endorsed technical criticism when he said a poor painter did not know how to bring out the meaning; a painting of a bird that does not produce the force of singing and soaring is a technical failure.

Technical criticism makes it necessary for the critic to discern what the artist's intention was in producing a specific work of art. This will require the critic to delve into the artist's biography and other circumstantial factors conditioning his creative process. The result of such an attempt is historical criticism. Among Japanese aestheticians the foremost exponent of this type of criticism is naturally Norinaga, an eminent scholar in Classics. We have already heard him say that a student learning the art of Classical poetry must read ancient novels, too, so that he may come to know the soil in which that poetry took its roots. Norinaga's idea of a literary critic is also revealed in the following passage: "Suppose you are looking at a high mountain from a far-off place. You can see the mountain only vaguely and cannot recognize the trees on it. But, if you ask a villager who lives near the mountain and who goes there every day to get firewood, he could tell you what the trees are and how they look on the top or at the bottom." The distance between the mountain and the onlooker can be interpreted in terms of either time or space. The point is that the critic is closer to the object in question, that he has intimate knowledge of the circumstances surrounding the object as well as of the object itself. Norinaga tried to be like the villager himself; he has written voluminous commentaries on a number of Japanese classics, painstakingly investigating the language and culture of the people in Classical times.

Lastly, there is a critical attitude that might be called objec-

229

tive criticism. Different from technical and historical criticism, which seek evaluative criteria in the author-work relationship, and unlike impressionistic criticism, which ultimately depends on the emotional impact of the work, objective criticism sets out to interpret and judge the work of art by its intrinsic laws. The standard of criticism lies in each individual work, and not in the author nor in the reader. The Japanese critic who took this attitude without declaring it was Bashō, though he resorted to other types of criticism as well. We have already seen him criticize his disciple's verse on a thatch-roofed temple and change the original line "Deep amid the pine trees" to a new line "It is hailing—." Bashō's reason for the change was that the new line was more suitable to that particular context, that it reflected the mood of the context better than the original line. Here Bashō is neither resorting to the external circumstances in which the original line was composed, nor is he judging the line by the standard of *sabi* or lightness; he is saying that the line "It is hailing—" fits better with the mood created by that particular context of the poem. In a like manner Bashō proposed changes in a number of poems written by his disciples. Here is another instance:

> In the autumn wind
> New *sake* is being brewed.
> The mountain road . . .

Bashō suggested that the last line be changed to "The cold of the night . . ." The original poem takes its setting in the daytime; with Bashō's "correction" the scene changes to night. Probably Bashō thought that the loneliness of autumn night would be more fitting to the mood of *sake* being quietly fermented. But does one really have a right to propose such a far-reaching change, especially when one knows how important the poet's original inspiration is? Should we not say that Bashō in this instance has composed a poem of his own and is imposing it upon his poor disciple?

This brings us to a crucial question in literary and art criticism: the mode of existence of the work of art. Where does the real work lie—in the author's mind, in the spectator's mind, in

the physical work itself, or elsewhere? The impressionistic critics would answer that it lies in the spectator's mind. Such values as *yūgen, sabi,* and *wabi* are sensuous impressions stirred in the mind of the participant; the work of art comes to exist only when the audience psychically responds to it. Thus Zeami and Toraaki, analyzing the elements of theatrical success, put enormous emphasis on the actor's part while speaking lightly of the playwright's role by comparison. Jigū, referring to a good performance in narrative singing, recognizes such an artistic effect as the Flower of the Moment, which, not written down in the musical score, nevertheless emerges when the performer sings the number. According to these aestheticians, then, the real work of art is the original created work plus all its emotional impact pressed upon the mind of the audience, regardless of whether the impact arises from the actual body of the work, or from the performer's artistry, or from the external conditions in which the performance takes place. In short, the real work of art lies in the experience of each reader, spectator, or listener. Yoshimoto once pushed this idea to the extreme and seemed to infer that the work of art disappears when the situation for which it is created is gone.

In contrast with this view, technical and historical critics would say that the real work of art lies in the mind of the original author. The actual physical work is the internal made external, the emotion transformed into words, images, sounds, lines, planes, or gestures. Because the means of expression is never perfect, the actual work always remains an imperfect replica of the original emotion. Tsurayuki gives a silent agreement to this view when he compares Priest Henjō's poetry to the portrait of a woman: the portrait, being an imperfect copy of a real woman, never comes to life. Himself a poet, Tsurayuki was ever sensitive to the limitations of language as a means of expression: he often stated, apologetically, that his grief was more intense than is expressed in his poem, or that a scene of nature was more beautiful than what appears in his poem. A real work of art, then, is the actual physical work plus all other elements that remain unexpressed in the artist's mind on that occasion. In brief, it is equivalent to the experience of the artist.

231

This view contains in itself the danger of falling into the so-called genetic fallacy. Often the author's intention is sought outside of the work, and the work is judged by some standard exterior to literature. Norinaga, largely a technical and historical critic, is aware of the danger. "Of all works of poetry since the earliest times, love poems occupy the largest proportion," he writes. "Some of the love poems could be considered lustful and immoral. But this is not the fault of the poems; it is the fault of the men who composed the poems." A poem should be evaluated by its poetic values, and not by the moral integrity of the person who produced the poem. A work of art lies in the experience of the artist, but it is the experience as contained or suggested in the actual work.

As might be expected, the independence of the actual work both from the author and from the audience is most strongly insisted on by objective critics. In their opinion the work of art is a self-contained entity, permitting no element exterior to itself to enter into the critical procedure. It is independent even of its author once it is completed. Taking this stand, Bashō freely changed his students' poems, as we have seen. He has an even more striking example. One of his disciples composed a moon-viewing poem:

> On the rocky cliff—
> Here, too, is a guest
> Of the moon.

Bashō asked the disciple who the guest was. The disciple answered that he was a stranger. Bashō then remarked: "How much more interesting the poem would be if you make yourself the guest of the moon!" This episode would puzzle many a technical and historical critic. Here the original author, who has all the circumstantial facts on the making of the poem, is explaining its meaning. Bashō nevertheless makes up his own interpretation and even imposes it upon the original author. Implied, of course, is Bashō's assumption that the poem, once it is finished, is open to any interpretation pertinent to itself, regardless of the original circumstances under which it was made. The real poem, then, lies in the work itself—the work which is the result of the

author's experience but which is nonetheless independent of it, the work which is the cause of the audience's response but which is not the response itself.

Lastly, about the use of art. As may be expected, all Japanese aestheticians believe that art is useful. Yet, the idea that art has a unique use of its own, that art can do something which cannot be done by any other human activity, is not so widely recognized. Norinaga, in fact, was probably the only Japanese aesthetician who was clearly aware of the problem and who resolutely refused to submit to any form of didacticism. As we recall, he explained the use of literature by the metaphor of a tree: a tree grows in nature with no intention of helping men, although men might cut it down and use it for lumber; the didactic use of literature is only incidental. Vigorously opposing the "didactic heresy," he said elsewhere: "Confucianism has its own aim. Buddhism has its own aim. The novel has its own aim." Rikyū was perhaps moving in the same direction when he said: "There are many Buddhist paintings produced by the priests in Tang times. Some people do not hang them in their tea room, saying that such paintings would make the room look like a temple. I utterly disagree. By all means hang them in your tea room and appreciate them. Devotion to Buddhism is another matter." Also, when Bashō emphasized the uselessness of poetry by comparing it to a fireplace in summer and a fan in winter, he was in his modest way pointing out the usefulness of poetry not found in other human activities.

The use of art could be viewed in two general aspects: social and personal. Of the two, Japanese aestheticians put a far greater emphasis on the latter. This is in sharp contrast to the Chinese, who from the earliest times recognized the political and moral function of literature and the arts. Indeed, Tsurayuki is influenced by the Confucian view and refers to the social usefulness of poetry, but his stand seems almost out of place in view of the nonpolitical nature of the overwhelming majority of Japanese poetry, including his own. Norinaga also points out the social function of literature when he says: "Since poetry speaks out the feelings of all classes of people, by reading poems the rulers can know in detail how the ruled feel at heart." Yet, as usual, Nori-

naga says this only after reasserting that "poetry does not make it its prime aim to help rule the state; it simply speaks out men's feelings in an appropriate way."

The views on the personal use of art range between the two poles of hedonism and didacticism. Men gain pleasure or instruction, or pleasure and instruction, from the work of art. But, if art claims to be useful in a unique way, the pleasure or instruction which art provides must be of a kind all its own.

Of the nature of the pleasure of art, Japanese aestheticians mention three main characteristics. The first is that the pleasure of art is cathartic. As we have seen time and again, composing poetry is a sophisticated way of giving vent to one's emotion; one feels pleasure when the emotion is emptied or sublimated through art. One might get a similar effect by weeping, but, as has been pointed out by Norinaga, the pleasure of poetry is higher in the sense that poetic purgation specifies the nature of emotion, thereby making it sharable by a larger number of men.

Secondly, there is a view that art liberates man from the pettiness and boredom of his everyday life. The pleasure of art is that of being able to pursue one's dream in a sphere where the restrictions of social and moral decorum cannot reach; it is the pleasure of wish-fulfillment. It was for this pleasure that court ladies read stories of fanciful events, as described by Lady Murasaki. The pleasure of participating in the tea ceremony lies precisely in that the participant is thereby freed of worldly concerns, as explained by Rikyū. The work of art, of course, differs from a dream in that it is artificially made; the artist deliberately makes up a dream world and keeps complete control over it.

Thirdly, there is a view that the pleasure of art is connected with its informative function. Art imparts truth, or some equivalent of truth, and new knowledge is a source of pleasure for man. Toraaki seemed to say something to that effect when he observed that the Comic Interlude should be made pleasurable through the presentation of the real and the true. Yoshimoto, who maintained that the aim of linked verse lies in the pleasure of the moment, believed that the poet makes old truths look new. The work of art functions as an eye-opener; the participant, introduced to a new scene he has never seen before, wanders in it in sheer delight.

234

This third view immediately leads us to the question of the instructive function of art. Art is informative; it is a form of knowledge. As to the question of how that knowledge differs from other types of knowledge, Japanese aestheticians answer from several different angles. For instance there is Lady Murasaki's view that the knowledge embodied in the work of art is not factual in the narrow sense of the word. It is not historical or scientific knowledge in that it need not have a verifiable fact for its center of reference. The work of art presents imaginative, rather than factual, truth. Another point is made by Tsurayuki, Chikamatsu, and Norinaga: art imparts knowledge at a level more primigenial than philosophy, ethics, or any other type of systematic knowledge. As art is expressive of the innermost heart of man, it presents a state of human mentality before it is generalized and hardened by discursive intellect. In this sense the knowledge contained in the work of art is pre-philosophical and pre-ethical; it is intuitive knowledge.

Finally there is the medieval Japanese view maintaining that the knowledge conveyed through the work of art is esoteric. The artist is a seer; through his superhuman faculties he can reach for the hidden truth of nature and present it in his work. In medieval Japanese terminology, art is a way to enlightenment. It has the same goal as religion. Indeed, for many Japanese artists art functioned as religion, not only in their art theories but also in their actual life. Art was the center of their life, the ultimate principle by which they united the chaos of life into a coherent vision. Sennō devoted himself to the art of flower arrangement, believing that it would give him "an invaluable clue to enlightenment." Lady Murasaki, who compared the novel to the holy scripture in its revelational function, wrote a massive work presenting a hero who searches for a way to salvation all through his life. Bashō thought that those who were troubled with sinful desires often became experts in some art or another; he became a devoted poet himself.

Ironically, however, it seems that great artists, just when they thought they had attained the ultimate of their arts, had to realize that art was not religion afer all. We have seen the examples of this in Zeami, Rikyū, and Bashō. Religion, because of its emphasis on the life beyond death, always demands a measure

of sacrifice from the life in this world; this was particularly true of medieval Japanese Buddhism, which denied all human desires as sinful. But art by its very nature needs humanity, even if that art is the Nō or the Haiku, which aims at the creation of the non-human, for without a desire for creation on the part of the artist there would be no work of art at all. The dilemma of Zeami, Rikyū, and Bashō lay in that they wanted religion for the sake of art, but religion, in turn, wanted them to give up their art. Western artists did not have this dilemma because they believed that art, by developing man's faculties to their fullest capacity, approached religion; their religion was more anthropomorphic and humanistic. In Japan Norinaga's idea points in this direction: throughout his writings one sees no trace of the conflict, because his Shintoism was basically humanistic. The humanistic aspect of religion, however, eventually gave rise to scientific thinking, which, as time went on, came to drastically trim the power of both religion and art. Thus in the modern West and in contemporary Japan art and religion are in the same camp facing the common enemy of science. Now Westerners and Japanese alike are nostalgically looking back to the times of Zeami, Rikyū, and Bashō—the times when art and religion, not art and science nor religion and science, were in conflict. It is by no accident that today's Westerners, as well as the Japanese, seem to find the greatest appeal in those Japanese arts that originated in medieval Japanese culture.

Biographies

1—Tsurayuki

Ki no Tsurayuki is believed to have been born in 868 A.D. in an illustrious court nobleman's family which had produced a number of poets and scholars. As a child he must have been carefully tutored in Chinese and Japanese classics, for his later writings clearly reveal his solid knowledge of these. His talent in verse-writing was recognized early in life, too; records show that he participated in several important poetry contests before the year 893.

In 905 he became the Librarian of the Court. Later in the same year he was appointed a compiler of *The Collection of Ancient and Modern Poems*, alongside three distinguished poets of the day. His competent work shown in the creation of this first imperial anthology of Japanese verse all the more firmly established his reputation as a poet, critic, and scholar. From this time on he was assigned to various government offices, all of which paid high respect to his literary and scholarly talents.

In 930 Tsurayuki went to Tosa, a province in southern Shikoku, as its governor. After successfully carrying out his duties there for nearly five years, he was relieved of the governorship and returned to the Capital. His return journey is brilliantly described in *The Tosa Diary*, which he wrote in the character of a woman.

Prior to his departure to Tosa he had been commissioned by the Emperor to compile a new anthology of Japanese poetry. This he did during his stay in the province, and upon his return to the Capital he promptly made it public. This is *The Collection of Newly Selected Poems*.

After returning to the Capital he again served at the court in various capacities. As a government official, however, he never

237

rose to such high distinction as he did as a poet; this is attributed to the fact that he was not from the powerful Fujiwara family. The highest court rank Tsurayuki ever attained was the Lower Fourth. He died in 945 or 946.

Tsurayuki's poems still preserved total 1,057. Though the figure includes some works of dubious authorship, it clearly reflects the high acclaim his poetry enjoyed in his time. As many as 451 of these poems appear in various imperial anthologies; the compilers of *The Collection of Ancient and Modern Poems* took more poems from him than from any other poet.

Most representative of early Japanese court poetry, Tsurayuki's works have attracted many Western translators' attention. His poems are included in practically every anthology of classical Japanese literature in English translation. There are two complete translations of *The Tosa Diary*: Flora Best Harris, *Logs of a Japanese Journey from the Province of Tosa to the Capital* (Meadville, 1891), and William N. Porter, *The Tosa Diary* (London, 1912). An English translation of Tsurayuki's preface to *The Collection of Ancient and Modern Poems* is available in Frederick Victor Dickins, *Primitive and Medieval Japanese Texts* (Oxford, 1906).

2—Lady Murasaki

In spite of her high reputation as the author of *The Tale of Genji*, little is known about the facts of Lady Murasaki's life. Even her real name is not known, for Murasaki is merely her nickname taken after one of the heroines in her celebrated novel. It has been established, however, that her father was an eminent scholar in Chinese who at one time tutored the Empress in Tang poetry. From early in life Lady Murasaki received good training in Chinese, Japanese, and Buddhist classics as well as in the art of poetry and music.

In 999 Lady Murasaki married her long-time suitor, an official of respectable rank who was also a good poet. The following year she gave birth to a daughter, who was later to become a nurse to Emperor Go-Reizei. Her peaceful life, however, abruptly came

to an end with her husband's untimely death in 1001. It seems that she found her only solace in creative writing. *The Tale of Genji*, at least the main part of it, was written in those few years after her husband's death and before she entered the Empress' service in 1007.

Her life at the Empress' palace does not seem to have been an unhappy one; she received warm friendship and high respect from those who came to know her there. By her introspective nature, however, she was often inclined to see the melancholy side of life even at gay moments. Her *Diary*, beginning in 1008 and ending in 1010, is an interesting record of her life at this time. Her life thereafter is very much in the dark. She might have become a nun some time before her death.

Lady Murasaki's writings preserved today are *The Tale of Genji*, the *Diary*, and the *Poetical Works* ("Murasaki Shikibu Shū"). The translation of *The Tale of Genji* by Arthur Waley (6 vols., London, 1925–33) is almost an English classic now. The chapter under discussion here, "The Glow-Worm," appears in Volume III, the volume Waley calls *A Wreath of Cloud*. An English translation of the *Diary* is included in Annie Shepley Omori and Kochi Doi, *Diaries of Court Ladies of Old Japan* (Boston, 1920).

3—Yoshimoto

Nijō Yoshimoto (1320–88) was born in one of the most respected families of court nobility and received an education suitable for that high status. In the Imperial Succession Dispute of 1336 he stayed at the Northern Court in Kyoto and successively filled various distinguished posts in the government. He held the highest position, that of the Chief Advisor to the Emperor, for twenty years altogether. With his broad learning and brilliant literary talent, he was the central figure of the cultural circles at the court all this time.

His writings are voluminous and cover a wide range of topics. They include pieces on religious and secular ceremonies, ethics, grammar, falconry, and football. He was also a lyric poet of

considerable merit, and fifty-seven of his thirty-one syllable poems have been selected for various imperial anthologies. He also wrote treatises to state his ideas on lyric poetry.

It was in linked verse, however, that he made the most lasting contribution. He began writing linked verse early in his literary career and never stopped until his death. In collaboration with another poet he compiled the earliest collection of linked verse in 1356, himself contributing seventy-nine verses and a preface in Japanese. The collection, called *The Tsukuba Anthology* ("Tsukuba Shū"), received imperial recognition at its completion, an honor never granted to linked verse before. In 1372 Yoshimoto made public *The New Rules of Linked Verse* ("Renga Shinshiki"), which set standard rules for the poets of many generations to come. In addition he wrote some dozen works on the art of linked verse, touching on all the aspects of its composition and appreciation. The representative ones are *A Secret Treatise on the Principles of Linked Verse* ("Renri Hishō," 1349), *Conversations with a Man from Tsukuba* ("Tsukuba Mondō," 1372?), and *Ten Most Important Questions on Linked Verse* ("Jūmon Saihishō," 1383). Yoshimoto is often called the founder of linked verse, for it was through those works that linked verse was given a position among the major art forms of medieval Japan.

None of Yoshimoto's works has been translated into English. For that matter, translations of linked verse have been very few indeed. One of the most famous works of linked verse, however, is available in English: Kenneth Yasuda's *Minase Sangin Hyakuin: A Poem of One Hundred Links Composed by Three Poets at Minase* (Tokyo, 1956). The first half of it has also been rendered into English by Donald Keene and appears in his *Anthology of Japanese Literature*.

4—Zeami

Zeami Motokiyo (1363–1443) was the second Head Actor of the Kanze troupe, one of the oldest groups of professional Nō actors. Together with Kannami, his father and the first Head Actor, he

refined what had hitherto been a crude, primitive theatrical entertainment and created a highly sophisticated form of poetic drama. The Nō has since thrived throughout the centuries, down to this day, and Zeami seems to remain the foremost figure as an actor, playwright, and theorist of that art.

Carefully trained by his father from childhood, Zeami was an accomplished actor already at the age of twelve; he was good enough to perform before the contemporary ruler of Japan, Yoshimitsu, at that age. Yoshimitsu must have been very favorably impressed by the young actor, for he remained a good patron of him forever thereafter, until his death in 1408. Unfortunately, Yoshimitsu's successors did not give Zeami the same support, and despite all the evidence for the actor's greater artistic maturity, they invited him to their mansions far less frequently. In 1429, perhaps partly for a political reason, Zeami was banished from the court. Four years later he lost Motomasa, his eldest son and the third Head Actor of the troupe. And in 1434, now over seventy years of age, he was exiled to the northern island of Sado. Though apparently he was able to return to the Capital before his death, the great artist's last years must have been unhappy ones.

Zeami wrote a great number of Nō plays. The majority of plays in today's Nō repertoire are attributed to him. Many of his finer plays have been translated into English; most readily available are Arthur Waley, *The Nō Plays of Japan* (London, 1921), and Ezra Pound, *The Classic Noh Theatre of Japan* (New York, 1959). The present author has also published a small collection: *The Old Pine Tree and Other Noh Plays* (Lincoln, Neb., 1962).

Zeami's essays on the art of the Nō remained unknown until the twentieth century. Sixteen of them were discovered in 1909, and five more have been found since. There are several more essays attributed to him but not conclusively proved to be his. The representative essays and their approximate dates are: *The Flower of the Form* ("Fūshi Kaden," 1400–02), *Learning the Flower* ("Kashū," 1418), *The Way to the Highest Flower* ("Shikadō," 1420), *Writing of the Nō* ("Nōsakusho," 1423), *The Mirror of the Flower* ("Hana no Kagami," 1424), *The Nine*

Ranks ("Kyūi," 1428), *Gathering Jewels and Attaining the Flower* ("Shūgyoku Tokka," 1428), *Conversations on the Nō* ("Sarugaku Dangi," 1430), *Five Types of Nō Singing* ("Goong-yoku," 1430), and *The Flower of Sublime Simplicity* ("Kyaku-raika," 1433). Of these, *The Nine Ranks, The Way to the Highest Flower,* and two brief excerpts from *The Mirror of the Flower* appear in English translation in Ryusaku Tsunoda *et al.* (ed.), *The Sources of Japanese Tradition* (New York, 1958). Part of *The Flower of the Form* is rendered into English by Wilfred Whitehouse and Michitaro Shidehara in *Monumenta Nipponica,* XVIII (1928).

5—Sennō

Of numerous schools of flower arrangement now thriving in Japan, Ikenobō is the oldest in history. The name Ikenobō originally referred to a cluster of monks' cells at the Rokkaku Temple in Kyoto, but it came to designate a school of flower arrangement when the monks who resided there began specializing in that art in the fifteenth century. Among them a monk named Senkei was the most celebrated; it is recorded that when he held a demonstration one day in 1462 all art lovers in the Capital gathered there to admire his artistry. By the end of the century Ikenobō's reputation had been firmly established, as it had received recognition both from the Emperor and from the Shogunate.

Ikenobō Sennō (d. 1555?), the twenty-eighth headmaster of the school, was also a good artist and teacher. But he was more famous as the one who codified the various rules of flower arrangement existing at the time. His book on floral art, known as *Sennō's Book of Secrets* ("Sennō Kuden," 1542), has remained the most important piece of writing for Ikenobō artists throughout the centuries. According to its postscript, Sennō wrote the book at the request of a certain Buddhist monk in the nearby province of Ōmi. It is possible that he wrote more pieces like this, but they have all been lost.

Of late there have been an increasing number of books in

English on Japanese flower arrangement. On the Ikenobō school in particular there is Ikenobō Sen'ei's *Ikenobō School* (*Best of Ikebana*, III, Tokyo, 1962).

6—Rikyū

Born in the prosperous mercantile city of Sakai, where many tea devotees lived, Sen no Rikyū (1522–91) mastered the art of the tea ceremony early in life. It was the time when the tea ceremony was a favorite pastime of the ruling warrior class, and Rikyū soon gained the patronage of many a feudal lord. In his maturity his fame was so great that he was invited to become the Head Tea Master for Oda Nobunaga, a powerful war lord who had just unified Japan after a century of disorder. When Nobunaga died in 1582 Rikyū entered the service of his successor, Toyotomi Hideyoshi, in the same capacity.

Under the new lord, who was an enthusiastic lover of tea, Rikyū enjoyed immense power and prestige. Whenever Hideyoshi had guests at his castle, the Head Tea Master was there to entertain them. As the person closest to the supreme ruler of Japan, inevitably he became involved in the intricacies of state politics. The involvement at first brought him more power, but later it became the cause of his downfall. Under Hideyoshi's command, he performed harakiri and died at the age of seventy.

Rikyū wrote no treatise on the art of the tea ceremony. All we have today are his letters, which, except in a very few cases, offer little clue to his aesthetic ideas. He had, however, a number of devoted disciples, and some of them have recorded their master's words. To what extent these words are authentic will never be known, but at least we can learn what Rikyū's ideas were in the minds of his immediate disciples.

Of many books on the tea ceremony in English, Okakura Kakuzo's *The Book of Tea* (New York, 1906) was a pioneering work and is still an inspiring piece of writing on the spirit of the tea cult. On the historical and technical aspects A. L. Sadler's *The Japanese Tea Ceremony* (London, 1934) is the standard introduction.

7—Toraaki

Ōkura Toraaki (1597–1662) was born in the oldest family of Kyōgen actors and was trained to carry on the family distinction. He made his stage debut at the age of four and officially became a professional actor the following year. Not a born genius, he seems to have struggled hard to escape the shadow of his father, who was a celebrated actor. It is said that he was often seen clinging to a tree and shaking it as he desperately tried to achieve the right pitch of voice.

After his father's death in 1646, Toraaki became the Head Actor of the Ōkura Kyōgen troupe. In contrast to the newly rising rival actors of the Sagi family, who prided themselves in their free, impulsive style of acting, Toraaki strongly urged his colleagues and disciples to follow the orthodox style, to observe the old rules, and to act with restraint. Fearing that the traditional style of acting might totally disappear someday, he moreover undertook the toilsome work of recording the texts of Kyōgen plays for the first time in history. Those texts, preserved today, provide invaluable material for the study of Classical Japanese theater.

The same motive led Toraaki to write a guidebook of Kyōgen acting for his offspring who were to succeed him. The first version of *For My Young Successors* ("Waranbe Gusa") was written in 1651; however, Toraaki continued adding more material to it all through his later years. In 1660, when it was finally completed, the book had expanded to five volumes. Not entirely satisfied, he still went on to make minor revisions; the last addition was made only two months before his death.

A book of secrets to be read only by the heads of the Ōkura family, *For My Young Successors* was not known to the public for a number of years. It was not until 1944 that the book was published in a collotype edition. There is no English translation yet. As for Kyōgen plays themselves, Shio Sakanishi's *Kyogen: Comic Interludes of Japan* (Boston, 1938) is a handy collection.

8—Jigū

Nothing is known of Jigū's life, aside from what can be gathered from his own book, *The Remnants from the Western Sea*. As the book tells us, he studied the Heikyoku under Takayama Tan'ichi, who was a celebrated Heike musician around 1600 and who had a number of talented disciples. Jigū must have been one of the leading disciples, for, as the *Remnants* says, he was often invited to perform before highly illustrious figures of the time, including the second Shogun himself. Late in his career, however, he had the misfortune of losing his son; having no one to inherit the secrets of his artistic achievements, he set out to write the *Remnants*. The sea in the title refers to the Seto Inland Sea, where the hapless Heike clan fought their last battles.

The Remnants from the Western Sea* was published for the first time in 1956. There has been no English translation. William P. Malm's *Japanese Music and Musical Instruments* (Rutland and Tokyo, 1959) has a chapter on the Heikyoku.

9—Mitsuoki

Tosa Mitsuoki (1617–91) spent his boyhood in Sakai, but later moved to Kyoto with his father and rose to fame there as a young painter with a fresh, new style. His style, freer and more modern than that of the traditional Tosa school, evidently appealed to the taste of the time. In 1654 he was appointed the head of the Imperial Painting Office and held that post for the next twenty-seven years. In 1681 he retired and spent the rest of his life as a monk.

Mitsuoki painted a number of screen paintings and picture scrolls. He was especially skilled in genre painting and in flowers and birds. A screen depicting Matsushima and Itsukushima, a scroll on the origins of the Kitano Shrine, and a painting of a quail with autumn grass, for instance, are among his well-known

works. He is popularly known as one of the Three Great Masters of the Tosa school.

The Authoritative Summary of the Rules of Japanese Painting is the only book on the art of painting ever written by a Tosa painter. According to the postscript, Mitsuoki wrote down the principles of Tosa-style painting in that book so that they would not be lost to, or misinterpreted by, his successors. Because it contained the secrets of the ancient, illustrious school, the book was strictly forbidden to go out of the family. Somehow the secrets leaked out, however; only twenty-three years later there appeared a book written by a painter of the rival Kanō school containing almost all the important passages in the *Summary*, but without ever mentioning Mitsuoki's name. Ironically, the latter book became far more famous in the succeeding years, with the result that Mitsuoki's principles of painting came to be widely believed as those of the Kanō school.

The *Summary* has never been translated. Every book in English on Japanese painting has passages on the Tosa school, if not on Mitsuoki as one of its representative painters.

10—Bashō

Matsuo Bashō (1644–94), whose real name was Munefusa, was born in a low-ranking warrior's family at Ueno, a small town some eighty miles southeast of Kyoto. As a youth he waited on a young lord as a page, but shortly after the master's death in 1666 he left his home and embarked upon a wandering life. Many explanations have been given by later scholars as to the reason for this self-imposed exile, yet none has been proved satisfactory. Bashō seems to have spent a few years in Kyoto, probably trying to decide on his future; then in 1672 he came down to Edo, the present Tokyo, which was at that time a young rising city with many career opportunities.

Bashō had begun composing the Haiku before he was twenty and had attained some status as a local poet in his early twenties; in 1672, just before leaving for Edo, he had completed editing a book of Haiku contests for which he posed himself as the judge.

But his first years in Edo were not easy; at one time he even worked on a sewage construction project to help support himself. Yet his literary fame gradually rose and his name began to appear in various Haiku anthologies. In 1678 or thereabout he was firmly established as a Haiku master and started to take students. Two years later he moved into a permanent home for the first time, even though it was a small, modest hut; because it had a banana plant in the yard it was called the Bashō (banana plant) Hut, and the poet also took up Bashō as a pseudonym.

Bashō, however, was never cosily settled there; he spent more and more years traveling. In 1682 he traveled to the mountainous province of Kai, and two years later he made a long journey to his home province. In 1687, after a short trip to a Zen temple in Kashima, he undertook another long journey homeward, stopping here and there to see his disciples on the way; he did not return to Edo until the following year. In 1689 he made the longest journey of his life; he visited the northeastern parts of Japan, and the travel resulted in his celebrated masterpiece, *The Narrow Road of Oku* ("Oku no Hosomichi"). The next two years he spent wandering in Kyoto and its neighboring provinces, writing poetry and prose and teaching his disciples wherever he met them. Finally late in 1691 he returned to Edo, where he lived in a new hut with his nephew and some old friends. But Bashō had become too famous: many visitors kept him from a quiet, peaceful life, until at last he stopped seeing visitors altogether. He set out on his last journey in 1694; he died in Osaka, in the middle of that travel.

A most scrupulous versifier, Bashō composed only some 1,000 Haiku during his entire career. He contributed a considerable number of verses to various linked Haiku parties, too; *A Sack of Charcoal*, mentioned in the text, is the result of one of those undertakings. He was also an accomplished writer of prose and established a new genre, called the Haibun or the Haiku prose. Of his numerous short prose pieces, "The Unreal Dwelling" ("Genjū-an no Fu," 1690), "A Farewell to Kyoroku" ("Kyoroku Ribetsu no Ji," 1693), and "On Closing the Gate" ("Heikan no Setsu," 1693) are especially well known. Longer, and equally well-accomplished, are his diaries and travel journals: besides

247

The Narrow Road of Oku, mentioned above, they include *The Journal of a Forlorn Journey* ("Nozarashi Kikō," 1685), *The Journal of a Travel to Kashima* ("Kashima Kikō," 1687), *Little Notes in the Pannier* ("Oi no Kobumi," 1687–88), *The Journal of a Travel to Sarashina* ("Sarashina Kikō," 1688), and *The Saga Diary* ("Saga Nikki," 1691).

Many of Bashō's poems have been translated and appear in various anthologies as well as in books specifically on the Haiku. "The Unreal Dwelling" and part of *The Narrow Road of Oku* are in Keene's *Anthology of Japanese Literature*. Professor Keene has also translated *The Journal of a Travel to Sarashina* in the *Transactions of the Asiatic Society of Japan*, Third Series.

11—Yūshō

Little is known of Ojio Yūshō's life. He has been described as being a leading disciple of Fujita Yūkan, who in turn was a disciple of Shōkadō Shōjō. Of Shōjō a good deal is known: he was a Buddhist priest, connoisseur of art, and above all an expert calligrapher. He was the founder of a new style and had a number of students studying calligraphy under him.

The Secrets of Calligraphy is written in the form of a dialogue. As its postscript tells us, Yūshō was then of advanced age and of ill health, and he had retired to a remote place to lead the undisturbed life of a recluse. One of his pupils, Taki Yūden, who had had occasion to discuss the art of calligraphy with him before his retirement, collected old notes and published them for the benefit of those who could no longer apprentice themselves to Yūshō.

12—Chikamatsu

Chikamatsu Monzaemon (1652–1724), whose real name was Suginomori Nobumori, was born in a warrior's family and received good education in Japanese, Confucian, and Buddhist classics as a boy in Kyoto. He began writing plays for both the Kabuki and the puppet theater in the 1670's and, apparently,

he was almost immediately recognized as a talented playwright. He was particularly fortunate in having two great actors, Sakata Tōjūrō and Takemoto Gidayū, to perform his plays. In their hands his early plays attained an immense popularity. *Kagekiyo Victorious* ("Shusse Kagekiyo," 1686) and *Love Suicides at Sonezaki* ("Sonezaki Shinjū," 1703) are representative of his works in those days. From around the turn of the century Chikamatsu wrote more and more plays for the puppet theater, and after Tōjūrō's death in 1709 he almost completely gave up writing Kabuki plays. In 1706 or thereabout he had moved to Osaka, where Gidayū had his own Takemoto Theater. But Chikamatsu's greater masterpieces were to come after Gidayū's death. *The Battles of Coxinga* ("Kokusenya Kassen," 1715), a romantic war epic, broke all previous long-run records; it is said that the play was performed every day for seventeen months. Another work showing Chikamatsu's full maturity is *The Love Suicides at Amijima* ("Shinjū Ten no Amijima," 1720), which reportedly was based on a real incident of the time. His last work was *The Tethered Steed* ("Kanhasshū Tsunagiuma," 1724), completed shortly before his death.

Chikamatsu was a prolific writer. In addition to some thirty Kabuki plays, he wrote about seventy historical plays and twenty-four domestic plays for the puppet theater, and many more plays are traditionally attributed to him. Some of Chikamatsu's finer plays are available in English: Asataro Miyamori, *Masterpieces of Chikamatsu* (London, 1926), and Donald Keene, *Major Plays of Chikamatsu* (New York and London, 1961), the latter with a useful introduction to Chikamatsu's works. Donald H. Shively, *The Love Suicides at Amijima* (Cambridge, Mass., 1953), and Professor Keene's *The Battles of Coxinga* (London, 1951) are also good studies of Chikamatsu, centering on two of his greatest plays.

13—Norinaga

Motoori Norinaga (1730–1801) was born in a cotton dealer's family in Matsusaka, near Ise, and spent a happy boyhood there until his father's death in 1740. His mother, seeing his liking for

academic pursuits rather than for business, decided to make a doctor of him and sent him to Kyoto to learn medicine when he was twenty-two. While he was in the Capital, however, young Norinaga devoted much time to the reading of Japanese and Chinese classics under the guidance of some well-known scholars there. His determination to pursue the study of classics became firmer when, toward the end of his five-year stay in Kyoto, he came to know the works of a great contemporary Classicist, Kamo Mabuchi. Thus, though he returned to Matsusaka in 1757 and began practicing medicine there, Norinaga continued working on Japanese classics with even greater fervor than before. With Mabuchi's encouragement he soon embarked upon his life-work, an extensive study of *The Record of Ancient Matters*. A meticulous scholar, Norinaga tried to throw light on that classic from every conceivable angle—textual, linguistic, historical, literary, philosophical, religious—so much so that it took him nearly thirty-five years to complete the study. The result was a massive, forty-four volume work entitled *Studies in "The Record of Ancient Matters"* ("Kojiki Den," 1798), which now stands as a monument in the history of Classical scholarship in Japan.

While engaged in that colossal research project, energetic Norinaga still had time to pursue other lines of his scholarly interest as well. He wrote excellent textual studies on many classics of Japanese literature, including *The Collection of Ten Thousand Leaves* and *The Collection of Ancient and Modern Poems*. His study of *The Tale of Genji*, called *The Precious Little Comb* ("Tama no Ogushi," 1796), is especially interesting as it fully reveals his views on the nature of literature. His other works discussing the essentials of poetry include *The Small Boat Advancing through the Reeds* ("Ashiwake Obune," 1756?) and *Whispers in Favor of Ancient Poetry* ("Isonokami Sasamegoto," 1763). His classical scholarship was based on his solid knowledge of the early Japanese language, and he wrote some pioneering works in Japanese philology, too, such as *Chiding the Reed-Cutter* ("Kakaika," 1787) and *The Hail of Pearls* ("Tama Arare," 1792?). But permeating all his writings was his Shinto philosophy, which grew out of his study of *The Record of Ancient Matters*. Representative among his philosophical treatises and essays are

250

The Holy Spirit ("Naobi no Tama," 1771?), *Arrowroot* ("Kuzu-bana," 1780), *The Madman Fettered* ("Ken Kyōjin," 1785), *The Precious Comb Box* ("Tama Kushige," 1786), *The Righteous Words in the Age of the Gods* ("Kamiyo no Masagoto," 1789), *The Precious Basket* ("Tama Katsuma," 1794), *For Beginning Mountain-Climbers* ("Uiyamabumi," 1799), and *The Way of the Imperial Subject* ("Shindō," 1800). All told, Norinaga's writings amount to some 90 titles and 260 volumes.

Besides writing books, Norinaga also gave lectures throughout his life. He always had around him a small group of selected disciples, whom he tutored regularly in Japanese classics. On *The Tale of Genji,* for instance, he gave nine tutorial sessions a month for a period of eight years; thus we know what a detailed study of the novel his sessions must have been. Likewise, his lecture series on *The Collection of Ten Thousand Leaves* took him eleven or twelve years to complete. He did similar series on other classics; he also repeated some of the series several times in his life—twice on *The Collection of Ten Thousand Leaves* and three times on *The Tale of Genji.* He continued tutoring almost to the end of his life.

There are very few translations of Norinaga's works. Some sections of *The Precious Basket* appear in English in Volume XII (1885) of the *Transactions of the Asiatic Society of Japan* (translated by B. H. Chamberlain) and in F. J. Daniels (ed.), *Selections from Japanese Literature* (London, 1959). Brief excerpts from other works are available in *The Sources of Japanese Tradition.*

Sources

This section is primarily for those who read Japanese and who would wish to consult the sources in the original texts. The present author is responsible for the translation of all quotations from Japanese sources in this book.

In the notes below, the numerals at the left refer to page and then to line numbers in this book. The two italicized words following the numerals are the end of the quotation or phrase that is being annotated.

1

The texts of Tsurayuki's works referred to in the following notes are "*Kokin Waka Shū* Jo" (abbreviated as KWJ), *Tosa Nikki* (TN), and "*Shinsen Waka Jo*" (SWJ), as they appear in Hagitani Boku (ed.), *Tosa Nikki, Ki no Tsurayuki Zenshū (Nihon Koten Zensho,* Tokyo, 1950).

2, 4	*and figurative.*" "Appendix to Lyrical Ballads" (1802), N. C. Smith (ed)., *Wordsworth's Literary Criticism* (London, 1905), 41.
3, 12	*and hear.*" KWJ, 105.
3, 37	*a poem?" Ibid.,* 105.
4, 6	*such events.* Cf. KWJ, 107–08.
5, 10	*the scene.* TN, 80.
6, 7	*charming indeed.*" *Ibid.,* 97–98.
6, 32	*superficially stirred.*" KWJ, 109.
7, 14	*a jewel? Kokin Waka Shū,* no. 165.
7, 19	*my infatuation. Ibid.,* no. 226.
8, 1	*serious occasion.*" KWJ, 106–107.
8, 21	*good poetry.*" SWJ, 116.
9, 8	*thirty-one syllables.*" KWJ, 105–06.

9, 23 *congratulatory poetry." Ibid.,* 106.
10, 17 *its fragrance." Ibid.,* 109.
10, 32 *thousand years. Kokin Waka Shū,* no. 901.
11, 8 *or today. Ibid.,* no. 861.
11, 19 *fine silks."* KWJ, 109.
11, 29 *the ocean. Kokin Waka Shū,* no. 250 .
12, 20 *under blossoms.* KWJ, 109–110.
13, 5 *of Sorrow. Kokin Waka Shū,* no. 983.
13, 37 *have awakened. Ibid.,* no. 552.
14, 5 *a dream. Ibid.,* no. 553.
14, 24 *falling blossoms? Ibid.,* no. 88.
15, 20 *last summer? Ibid.,* no. 2.
15, 37 *in winter. Ibid.,* no. 573.
17, 32 *the future?"* TN, 86.
18, 27 *thirty-one syllables. Ibid.,* 95.
20, 21 *lovely appearance." Ibid.,* 94–95.
21, 12 *composing poems."* KWJ, 108.
21, 24 *a poem.* TN, 85.
22, 15 *their emotion. Ibid.,* 100–01.
22, 35 *of warriors."* KWJ, 105.
23, 10 *moral lessons."* SWJ, 116–17.

2

The text of *Genji Monogatari* used here is Yamagishi Tokuhei (ed.), *Genji Monogatari,* II *(Nihon Koten Bungaku Taikei,* XV, Tokyo, 1959). The page numbers below, unless noted otherwise, all refer to this text.

27, 9 *this world" Kagerō Nikki (Nihon Koten Bungaku Taikei,* XX, Tokyo, 1957), 109.
28, 10 *Kazoe's trap.* 430–31.
29, 31 *and laughed.* 431.
30, 33 *so, too?"* 431–32.
32, 21 *her inkwell."* 432.
32, 32 *said, laughing."* 432.
34, 9 *a tale.* 432–33.

3

Of Yoshimoto's essays on the *renga,* "Renri Hishō" (RH), "Tsukuba Mondō" (TM), and "Jūmon Saihishō" (JS) are included in Kidō Saizō (ed.), *Rengaronshū (Nihon Koten Bungaku Taikei,* LXVI, Tokyo, 1961). "Gekimōshō" (G) and "Kyūshū Mondō" (KM) have been reprinted in Okami Masao (ed.), *Yoshimoto Rengaronshū,* II (*Koten Bunko,* Tokyo, 1954). "Renga Jūyō" (RJ), edited by Mr. Okami, appears in Volume III of the same series (Tokyo, 1955).

38, 22	*people present."* KM, 189.
38, 27	*expert poet."* TM, 80.
38, 32	*of composition."* JS, 113.
38, 38	*is over.* Cf. KM, 189.
39, 12	*to moment."* RH, 38.
39, 14	*good poet.* Cf. RH, 45.
39, 24	*you nowhere."* JS, 114–15.
39, 35	*your contemporaries." Ibid.,* 112.
40, 10	*describe it."* RH, 40.
40, 18	*may be."* Takayama Sōzei, "Shoshin Kyūeishū." Cited in Ebara Taizō, *Haikai Seishin no Tankyū* (Osaka, 1944), 303–04.
40, 24	*verse, too."* TM, 80.
41, 20	*plum blossoms.* RH, 53–54.
41, 26	*among jewels." Ibid.,* 40.
41, 32	*they use." Ibid.,* 41.
41, 35	*and smooth.* Cf. JS, 111.
42, 2	*constantly use."* RH, 41.
42, 19	*good one.* JS, 111.
42, 30	*the blossoms."* RJ, 4.
43, 3	*your verse."* JS, 111.
43, 5	*by words." Ibid.,* 114.
43, 9	*the beginners."* RH, 40.
43, 16	*the spirit."* JS, 115.
43, 22	*linked verse."* RH, 40.
43, 26	*very careful." Ibid.,* 50.

44, 29 *the new.*" RJ, 4.
44, 30 *quaint word.* Cf. G, 4.
44, 33 *appear new.*" JS, 115.
45, 2 *speculative thinking.*" RH, 38.
45, 6 *antique object. Ibid.,* 38.
45, 25 *sport, too.* TM, 86.
47, 3 *the night.* "Renga Hidenshō," cited in *Rengaronshū,* 243.
47, 12 *my way.* "Shoshin Kyūeishū," *ibid.,* 252.
47, 29 *in bloom.* "Kyōchūshō," in *Zoku Gunsho Ruijū,* XVII, Part 2 (Tokyo, 1911), 1238.
48, 8 *evening dusk.* G, 27.
48, 24 *cherry-blossom time.*" RH, 50.
48, 29 *the moon.* G, 28.
49, 12 *fixed rule.*" RH, 49.
49, 18 *at all.*" *Ibid.,* 39.
49, 31 *grief-laden world.*" KM, 176.
49, 35 *closely linked.*" RJ, 5.
50, 13 *should change.*" JS, 113.
51, 1 *exclaim 'Indeed!' *" KM, 181.
51, 9 *and waters.*" RH, 43–44.
51, 16 *logical argument.*" G, 57.
51, 23 *look fresh.*" RJ, 8.
51, 25 *the world.*" TM, 81.
52, 9 *the fact.* Cf. *ibid.,* 81–82.
53, 2 *his mind. Ibid.,* 82–83.

4

The page references are to Nose Asaji, *Zeami Jūrokubushū Hyōshaku* (ZJH) (2 vols., rev. ed., Tokyo, 1958, 1960), Nishio Minoru (ed.), *Nōgakuronshū* (N) (*Nihon Koten Bungaku Taikei,* LXV, Tokyo, 1961), and Kawase Kazuma, *Tochū Zeami Nijūsanbushū* (TZN) (Tokyo, 1945). The latter two texts have been used only for those essays which are not included in the former.

55, 16 *the Nō.*" ZJH, I, 423.

56, 8	*may be." Ibid.,* I, 35.
56, 16	*who know." Ibid.,* I, 38.
56, 20	*your performance." Ibid.,* I, 35.
56, 35	*or weak." Ibid.,* I, 190.
57, 3	*object itself." Ibid.,* I, 192.
57, 11	*of forcefulness.* Cf. *ibid.,* I, 192–93.
57, 18	*the object." Ibid.,* I, 295.
57, 20	*nor weak." Ibid.,* I, 191.
57, 28	*of imitation." Ibid.,* I, 227.
58, 14	*his performance. Ibid.,* I, 48.
58, 30	*a monk.* Cf. *ibid.,* I, 56.
58, 33	*a woman.* Cf. N, 464.
58, 34	*a woman." Ibid.,* 465.
58, 36	*look right."* ZJH, I, 334.
59, 11	*accomplished artist." Ibid.,* I, 62.
59, 20	*are imitating." Ibid.,* I, 35.
59, 34	*its bill." Ibid.,* I, 478.
60, 18	*the spirit." Ibid.,* I, 362.
60, 21	*a crag." Ibid.,* I, 63.
60, 23	*dead tree." Ibid.,* I, 43.
60, 26	*beautiful blossoms.* Cf. *ibid.,* I, 32.
61, 19	*yūgen flowers." Ibid.,* I, 614.
61, 30	*of mutability."* TZN, 82.
62, 1	*one view."* ZJH, II, 134.
62, 8	*spring dawn? Ibid.,* II, 152.
62, 23	*its mate. Ibid.,* II, 152.
63, 2	*passed away." Ibid.,* II, 152.
63, 8	*deserted lover! Ibid.,* II, 153.
63, 25	*is not." Ibid.,* II, 140.
63, 31	*the root. Ibid.,* II, 153.
64, 17	*Mysterious Flower.* These ranks, together with Zeami's comments on them, appear in a short essay called "Kui," reprinted in ZJH, I, 547–83.
69, 4	*Mysterious Flower.* ZJH, I, 536.
69, 35	*the Nō." Ibid.,* II, 385.
70, 5	*insect's chirping."* N, 461.
70, 6	*that, too."* ZJH, I, 79.

70, 14	*poet, too.* Cf. *ibid.,* I, 8.
70, 16	*flowing stream.* Cf. *ibid.,* II, 89–90.
71, 9	*all laws."* N, 458.
71, 14	*upon him.* Cf. ZJH, II, 583–84.
71, 26	*for death." Ibid.,* II, 667.

5

The text of *Sennō Kuden* has been reprinted in *Zoku Gunsho Ruijū,* XIX, Part 2 (Tokyo, 1912). The page numbers below refer to this edition.

73, 20	*rural areas.* 41.
74, 1	*the rails." Makura no Sōshi (Nihon Koten Bungaku Taikei,* XIX, Tokyo, 1958), 58–59.
74, 21	*plant low." Senden Shō,* in *Gunsho Ruijū,* XIX, 644.
74, 26	*lettuce, serissa.* 45.
74, 32	*the leaves.* 43.
74, 33	*its leaves.* 44.
74, 34	*vice versa.* 44.
74, 34	*the water.* 44.
75, 2	*each other.* 44.
75, 3	*the vase.* 44.
75, 4	*too short."* 43.
75, 11	*the wall"* 44.
75, 15	*between them"* 44.
77, 5	*thick one."* 43.
77, 10	*look so."* 43.
77, 14	*the other.* 44
77, 17	*the shade.* 44.
77, 21	*the front.* 44.
77, 29	*the other."* 44.
77, 35	*the water."* 46.
78, 5	*the alcove."* 42–43.
78, 11	*the occasion.* 54–55.
78, 15	*or so.* 55.
78, 19	*the room.* 54.

78, 22	*in it.* 55.
79, 5	*similar occasions.* 44–45.
79, 10	*and earth.* 45.
79, 14	*"victory" plants.* 46.
79, 18	*in season.* 46.
79, 24	*iris, evergreens.* 46–47.
79, 32	*stone leek.* 47.
80, 31	*the time." Senden Shō,* 644.
81, 8	*plum blossom.* 45.
81, 13	*take over.* 46.
81, 22	*the water.* 43.
83, 11	*enlightenment, too.* 41–42.
86, 21	*strenuous self-discipline."* 47.
86, 27	*any art."* 47.

6

Many of the important essays on the art of the tea ceremony are collected in Volumes VIII and IX (edited by Kuwata Chūshin) of *Shinshū Chadō Zenshū* (SCZ) (9 vols., Tokyo, 1956). All quotations on the tea ceremony in this chapter are from this edition, unless noted otherwise.

88, 6	*that purpose."* "Nanbōroku," SCZ, IX, 3.
88, 25	*of men.* "Yamanoue Sōji Ki," SCZ, VIII, 127.
89, 2	*your soul?* "Nanbōroku," SCZ, IX, 194.
89, 24	*said, sadly.* "Nanbōroku," in a text adopted by Nishibori Ichizō in his *Nanbōroku no Kenkyū* (Tokyo, 1944), 192.
90, 7	*lower class."* "Yamanoue Sōji Ki," SCZ, VIII, 124.
90, 22	*unused utensils."* "Nanbōroku," SCZ, IX, 66.
90, 23	*be sparse." Ibid.,* 8.
90, 25	*simple way." Ibid.,* 47.
90, 29	*be light." Ibid.,* 6.
91, 5	*newly cleaned.* "Chōandō Ki," SCZ, IX, 282.
91, 11	*be served."* "Nanbōroku," SCZ, IX, 9.
91, 19	*Buddha's teaching." Ibid.,* 3.

91, 23	*tea ceremony." Ibid.,* 8.
92, 16	*his pocket. Ibid.,* 168–69.
92, 34	*autumn evening. Ibid.,* 12–13.
93, 5	*spring comes! Ibid.,* 13.
93, 12	*the weeds.* Copied by Toyotomi Hideyoshi on a poetry card. Cited by Kuwada Chūshin in his *Sen no Rikyū* (Tokyo, 1955), 189.
94, 28	*and modest."* "Jōō Wabi no Fumi," SCZ, VIII, 17.
94, 32	*your friends."* "Kobori Enshū Kakisute Bumi," SCZ, IX, 315.
95, 22	*it teaches.* "Kissa Zatsuwa," in *Zoku Gunsho Ruijū,* XIX, Part 2, 521.
95, 31	*than that."* "Nanbōroku," SCZ, IX, 155.
96, 7	*drink it.* Ibid., 194.
96, 16	*do it." Ibid.,* 6–7.
96, 27	*by itself." Ibid.,* 4.
96, 29	*the formalities." Ibid.,* 12.
96, 35	*the East."* "Yamanoue Sōji Ki," SCZ, VIII, 134.
97, 3	*and snow."* "Nanbōroku," in the Nishibori text, 185.
97, 6	*impure thought."* "Nanbōroku," SCZ, IX, 5.
97, 10	*his sight.* Cf. "Yamanoue Sōji Ki," SCZ, VIII, 125.
97, 14	*hanging slanted."* "Kimura Hitachi Ate Densho," cited in Nishibori's *Nanbōroku no Kenkyū,* 264.
98, 27	*bloomed out.* "Nanbōroku," SCZ, IX, 160.
100, 8	*of doubt.* Rikyū's letter to Priest Kōshuku, in Kuwada Chūshin (ed.), *Rikyū no Shokan* (Kyoto, 1961), 84.
100, 20	*of living.* "Yamanoue Sōji Ki," SCZ, VIII, 141.

7

The text used is Sasano Ken (ed.), *Waranbe Gusa* (Tokyo, 1962).

102, 9	*single performance."* 252.
102, 15	*of imitation."* 260.
102, 16	*this world."* 258.
102, 28	*in detail."* 310.
102, 37	*the stage."* 146.

103, 2	*the proper.* Cf. 135.
103, 11	*forever thereafter.* Cf. 138.
103, 18	*the stage."* 134–35.
103, 21	*as well.* Cf. 311.
103, 28	*the unreal."* 257.
104, 25	*they are.* 194.
104, 30	*never be.* 169.
104, 35	*this world.* 133.
105, 5	*your soul.* 301.
105, 33	*things true."* 257–58.
106, 1	*Comic Interlude."* 113.
106, 8	*Comic Interlude."* 133.
106, 27	*it new."* 132.
106, 31	*the new."* 133.
107, 5	*the low."* 258.
107, 15	*the people."* 255.
107, 23	*of comedy."* 255.
107, 25	*the road."* 256.
107, 26	*dramatic art.* Cf. 346.
107, 36	*a cripple.* 257.
108, 8	*with age."* 173.
108, 19	*proper attitude."* 256.
108, 23	*fundamental principle."* 302.
108, 28	*in pathos."* 302.
109, 15	*I do."* 260–61.
109, 35	*the outside."* 180.
110, 7	*the water?"* 270–71.
110, 13	*and effortlessly."* 295.
110, 22	*its shape.* 169.
110, 25	*the universe."* 53.
110, 28	*your soul."* 267.
110, 32	*thousand eyes."* 267.
111, 10	*pupils well."* 318.
111, 19	*our art.* 262.
111, 31	*formidable foe."* 53.
111, 34	*laughing aloud."* 61.
112, 2	*their guidance.* Cf. 424–26.
112, 20	*Comic Interlude."* 386.

8

The page references are to Tomikura Tokujirō (ed.), *Saikai Yoteki Shū* (Tokyo, 1956).

116, 17	*a hand.* 52–53.
116, 37	*Heike well."* 19.
117, 13	*Heike itself.* 19–20.
117, 23	*the text."* 81.
117, 32	*a metropolis.* Cf. 81.
118, 15	*religious life.* Cf. 82–84.
119, 22	*the theme."* 54.
119, 27	*performer's part.* Cf. 55.
120, 12	*its continuity.* Cf. 48.
120, 19	*the rocks.* Cf. 48–49.
120, 26	*the ground.* Cf. 49.
120, 31	*with water.* Cf. 48.
120, 36	*beautiful blossoms.* Cf. 50.
121, 1	*humid day.* Cf. 50–51.
121, 19	*of dew?* 51.
122, 1	*as well."* 57.
122, 20	*natural river.* Cf. 47–48.
122, 27	*own existence."* 85.
122, 31	*the man."* 85.
123, 5	*prayer anyway.* Cf. 22–23.
123, 14	*the angles.* Cf. 27.
123, 20	*the same.* Cf. 47.
123, 27	*individual artist.* Cf. 45–46.
124, 2	*its nest.* Cf. 37–38.
124, 5	*was right."* 25.
124, 10	*the peak.* 24.
124, 36	*of it.* Cf. 21–22.
125, 15	*the occasion.* Cf. 66.
125, 30	*an entertainment.* Cf. 31–32.
125, 37	*the water.* Cf. 34.
126, 3	*he can.* Cf. 36.
126, 8	*constantly trample.* Cf. 26.

126, 24 *by him.* Cf. 74–76.
126, 25 *his teacher."* 76.
126, 28 *his artistry."* 77.

9

The translations are based on the text of *Honchō Gahō Taiden*
as printed in Sakasaki Shizuka, *Nihonga no Seishin* (Tokyo,
1942).

130, 37 *my precepts."* 37.
131, 30 *in words."* 37.
132, 2 *of painting."* 58.
132, 21 *realize this.* 58.
132, 25 *its back.* 59.
132, 28 *have done.* 59.
132, 32 *a parakeet.* 59.
132, 34 *the life-size.* 59.
133, 15 *experienced artisan.* 61.
133, 18 *Muromachi period.* 59.
133, 21 *First Month.* 59.
133, 24 *life otherwise.* 60–61.
133, 35 *depicted individually."* 32.
134, 2 *are depicting."* 32.
134, 23 *Marvelous Work.* 34.
134, 34 *the shape."* 34.
135, 17 *desolate atmosphere."* 32.
135, 21 *so forth.* 34–35.
135, 34 *Divine Work."* 34.
137, 20 *the eyes.* 32–33.
139, 18 *Chinese paintings.* 37–38.
140, 35 *of lightness."* 36.
141, 5 *important principle."* 38.
141, 8 *the paper."* 38–39.
141, 13 *the brush."* 36–37.
141, 17 *and dead."* 36.
141, 20 *"is weak."* 38.
141, 24 *loose composition."* 57.

141, 27	*of painting.*" 57.
141, 29	*every branch.*" 57.
141, 32	*lowly style.*" 62.
142, 10	*manifest itself.* 37.
142, 28	*beyond description.* 32.
142, 37	*the model.*" 33.
143, 10	*the back.*" 33.
143, 15	*the painting.*" 46.
143, 21	*thin frost.*" 46.

10

The translations from Bashō's works are based on the texts printed in Ōtani Tokuzō and Nakamura Shunjō (eds.), *Bashō Kushū* (BK) (Tokyo, 1962), and Sugiura Shōichirō *et al.* (eds.), *Bashō Bunshū* (BB) (Tokyo, 1959). Many of the works by Bashō's disciples on the art of the Haiku are found in Imoto Nōichi (ed.), *Haironshū* (H) (*Nihon Koten Bungaku Taikei,* LXVI, Tokyo, 1961), *Shōmon Haiwa Bunshū* (SHB) (*Nihon Haisho Taikei,* IV, Tokyo, 1926), and *Bashō* (*Kokugo Kokubungaku Kenkyūshi Taisei,* XII, Tokyo, 1959).

146, 6	*our school.*" "Sanzōshi," H, 385.
147, 12	*poetic spirit.*" "Haikai Mondō," SHB, 414.
147, 16	*poetic spirit.*" "Sanzōshi," H, 397.
148, 8	*to nature.* "Oi no Kobumi," BB, 52.
148, 24	*common men.*" "Sanzōshi," H, 398.
149, 1	*a layman.* Cf. "Nozarashi Kikō," BB, 37–38; "Kashima Kikō," BB, 46; "Genjūan no Fu," BB, 180.
149, 22	*cypress tree.* "Asunarō," BB, 154.
149, 37	*heads together—.* "Kyoraishō," H, 376.
150, 22	*filthy ditch.*" "Heikan no Setsu," BB, 209.
150, 34	*a cuckoo.* "Saga Nikki," BB, 104.
151, 16	*his master. Ibid.,* 104.
151, 34	*adverse fate.*" "Nozarashi Kikō," BB, 36.
152, 3	*mulberry stick.* BK, 138.
152, 9	*grass seeds. Ibid.,* 233.
152, 25	*the hut.* "Inaka no Kuawase," BB, 288.

152, 29 *and lonesome." Ibid.,* 289.
153, 3 *the rocks.* BK, 102.
153, 6 *Milky Way. Ibid.,* 131.
153, 9 *Mogami River! Ibid.,* 72.
154, 21 *autumn wind.* "Kyoraishō," H, 377.
156, 2 *autumn frost—.* "Nozarashi Kikō," BB, 38.
156, 7 *of autumn.* "Oku no Hosomichi," BB, 93.
156, 25 *Lake Yogo.* "Kyoraishō," H, 376.
156, 36 *fish shop.* BK, 194.
158, 3 *personal self.* "Sanzōshi," H, 398–99.
158, 29 *another time. Ibid.,* 399.
159, 2 *of inspiration." Ibid.,* 399.
159, 4 *your mind." Ibid.,* 401.
159, 8 *that moment." Ibid.,* 399.
159, 12 *a pear." Ibid.,* 399–400.
160, 10 *the cool.* "Kikigaki Nanuka Gusa," *Bashō,* 281.
160, 19 *its sleep.* "Sanzōshi," H, 421.
160, 29 *in unison.*" "Kikigaki Nanuka Gusa," *Bashō,* 282.
160, 35 *be drawn.* "Kyoraishō," H, 369.
161, 12 *deepening night.* "Kikigaki Nanuka Gusa," *Bashō,* 280.
161, 25 *thatch-roofed temple.* "Sanchū Sangin Hyōgo," *Bashō Ichidaishū (Nihon Haisho Taikei,* I, Tokyo, 1926), 553.
162, 14 *ancient Buddhas.* BK, 175.
162, 17 *wistaria flowers—. Ibid.,* 59.
162, 20 *the rapids—. Ibid.,* 60.
162, 23 *buckwheat flowers—. Ibid.,* 139.
163, 6 *The daffodils. Ibid.,* 234.
163, 9 *faintly white. Ibid.,* 228.
163, 12 *autumn wind. Ibid.,* 136.
163, 15 *it is! Ibid.,* 194.
164, 14 *other three.*" "Sanzōshi," H, 384.
164, 20 *the veranda. Ibid.,* 384.
164, 24 *the Haiku." Ibid.,* 384.
164, 38 *year's end.* BK, 224.
165, 10 *the moon.* "Sanzōshi," H, 404.
165, 20 *unpoetic person.*" "Zoku Goron," SHB, 33.

165, 23	*ordinary sentiments."* "Sanzōshi," H, 439.
165, 35	*much lighter."* "Tabineron," SHB, 233.
165, 38	*in general."* BB, 500.
166, 2	*children do."* "Tabineron," SHB, 233.
166, 4	*sand-bed river."* "Betsuzashiki Jo," *Shōmon Haikai Zenshū (Nihon Haisho Taikei,* II, Tokyo, 1926), 529.
166, 12	*and night."* "Fugyoku Ate Ronsho," Ebara Taizō (ed.), *Kyoraishō, Sanzōshi, Tabineron* (Tokyo, 1939), 226.
166, 26	*cherry blossoms.* "Sanzōshi," H, 410.
167, 20	*fixed there."* "Kyoraishō," H, 310.
168, 7	*of Fushimi. Ibid.,* 325.
168, 23	*cake dish.* BK, 424.
169, 23	*comic poet.* "Fuyu no Hi," BK, 296.
170, 5	*autumn night.* "Sanzōshi," H, 423.
171, 2	*the Haiku."* "Genjūan no Ki," BB, 186.
171, 13	*poetic spirit."* "Seikyo no Ben," BB, 201.
171, 19	*my lifetime."* "Oi Nikki," *Shōmon Haikai Goshū (Nihon Haisho Taikei,* III, Tokyo, 1926), 13.
171, 23	*wild moor.* BK, 216.

11

The text of *Hitsudō Hiden Shō* is available in Kokusho Kankō Kai (ed.), *Nihon Shoga En,* I (Tokyo, 1914), which is the edition used here.

175, 2	*with another.* 168–69.
175, 18	*of Calligraphy.* 169.
176, 14	*human being."* 155.
176, 18	*or silver.* 169.
176, 33	*with life."* 163.
177, 1	*human body."* 167.
178, 8	*a spirit.* 168.
178, 20	*is spiritless.* 168.
179, 8	*is balance."* 152.
179, 14	*that kind."* 150.
179, 26	*shaved off."* 159.
180, 4	*of another.* 166.

180, 10	*of characters.* 180.
180, 32	*advanced student."* 150.
181, 8	*is better."* 154.
181, 19	*Cursive Style.* 164.
181, 30	*tranquil one.* 181.
182, 9	*calligrapher's strain."* 180.
182, 18	*strong one.* 181.
183, 2	*is better."* 159.
183, 4	*virtuosity, sincerity.* 181.
183, 14	*the paper."* 165.
183, 26	*by them."* 180.
183, 30	*for profit.* 169.
183, 32	*transgress them."* 180.
184, 9	*poor work."* 157.
184, 16	*various diseases.* 160–61.
184, 26	*conservative manner."* 163.
184, 28	*his heart."* 163–64.
184, 36	*habitually boastful."* 153.

12

The page numbers refer to the text of the Preface to *Naniwa Miyage* as reprinted in Shuzui Kenji and Ōkubo Tadakuni (eds.), *Chikamatsu Jōruri Shū*, Part 2 (*Nihon Koten Bungaku Taikei*, L, Tokyo, 1959).

188, 10	*the two.* 358–59.
189, 3	*it away.* 359.
190, 6	*feelings are."* 357.
190, 31	*puppet plays.* 356.
191, 11	*or feeling." Aristotle's Theory of Poetry and Fine Art* (London, 1907), 123.
193, 5	*is pitiful."* 358.

13

The volume and page numbers that appear below are those of *Zōho Motoori Norinaga Zenshū* (10 vols., Tokyo, 1926–27).

197, 1 *its borders."* "Kuzubana," V, 460.

197, 3 *something else.* Cf. *ibid.,* 461.

197, 22 *child's play."* "Tamakatsuma," VIII, 128.

198, 4 *use tools.* Cf. "Kuzubana," V, 476.

198, 11 *human beings.* Cf. "Tōmonroku," VI, 114–15.

198, 29 *his power."* "Tamakushige," VI, 14–15.

198, 32 *and insects.* Cf. "Naobi no Mitama," I, 63.

199, 19 *you are!"* "Kokinshū Tōkagami," VII, 243.

199, 23 *anything else.* Cf. "Shibun Yōryō," X, 247–48.

199, 27 *love affairs."* "Genji Monogatari Tama no Ogushi," VII, 503.

199, 35 *grief nowadays." Ibid.,* VII, 491.

200, 6 *broad terms." Ibid.,* VII, 491–92.

200, 12 *no aware. Ibid.,* VII, 491–92.

200, 14 *no aware.* Cf. "Shibun Yōryō," X, 273–74.

200, 18 *no aware.* Cf. *ibid.,* X, 273–74.

200, 24 *it should."* "Genji Monogatari Tama no Ogushi," VII, 491–92.

201, 11 *a tree."* "Isonokami Sasamegoto," VI, 529.

201, 18 *deeply suppressed. Ibid.,* VI, 529.

201, 28 *him solace."* "Shibun Yōryō," X, 268.

202, 1 *melancholy consoled." Ibid.,* X, 276.

202, 8 *his melancholy." Ibid.,* X, 319.

202, 18 *the time." Ibid.,* X, 275.

202, 29 *this account." Ibid.,* X, 287.

202, 33 *no aware." Ibid.,* X, 269.

203, 5 *no aware." Ibid.,* X, 273.

203, 13 *nor sorrow."* "Isonokami Sasamegoto," VI, 477–78.

203, 16 *no aware."* "Shibun Yōryō," X, 288.

203, 25 *want to." Ibid.,* X, 273–74.

203, 26 *his own."* "Genji Monogatari Tama no Ogushi," VII, 487.

203, 30 *does so.* Cf. "Shibun Yōryō," X, 283.

204, 4 *natural ones." Ibid.,* X, 306.

204, 11 *and unsightly."* "Ashiwake Obune," X, 167–68.

204, 14 *true hearts." Ibid.,* X, 167–68.

204, 19 *the mother's.* Cf. *ibid.,* X, 168.

204, 30 *lies dying?" Ibid.,* X, 168.

205, 6	*his life.* "Isonokami Sasamegoto," X, 201–02.
205, 12	*human heart.*" "Ashiwake Obune," X, 178–79.
205, 18	*no aware.*" "Shibun Yōryō," X, 306.
205, 24	*attractive way.*" "Ashiwake Obune," X, 179.
205, 31	*involve feelings.*" *Ibid.*, X, 162.
205, 37	*deep feelings.*" *Ibid.*, X, 162.
206, 4	*the parlor.*" "Shibun Yōryō," X, 316.
206, 5	*dusty heart.*" "Ashiwake Obune," X, 165.
206, 12	*popular songs.* Cf. "Isonokami Sasamegoto," VI, 467.
206, 24	*with time.*" "Ashiwake Obune," X, 151.
206, 35	*of poetry.*" *Ibid.*, X, 152.
207, 9	*own feelings.*" *Ibid.*, X, 172.
207, 19	*good order.*" *Ibid.*, X, 166.
207, 25	*of poetry.*" *Ibid.*, X, 165.
207, 27	*sound pleasant.*" "Sōanshū Tamahahaki," VI, 468.
207, 29	*and orderly.*" *Ibid.*, VI, 468.
208, 1	*conscious intention.*" "Ashiwake Obune," X, 175.
208, 4	*is shallow.* "Isonokami Sasamegoto," VI, 486–87.
208, 6	*moved heart.*" *Ibid.*, VI, 487.
208, 10	*and shabby.*" "Ashiwake Obune," X, 173.
208, 16	*same aim.*" "Shibun Yōryō," X, 310.
208, 21	*doing so.*" "Genji Monogatari Tama no Ogushi," VII, 492.
209, 3	*heart cleansed. Ibid.*, VII, 503.
209, 12	*is like.*" *Ibid.*, VII, 503.
209, 23	*a disaster.*" "Shibun Yōryō," X, 304.
210, 4	*read them. Ibid.*, X, 314.
210, 15	*high praise?*" "Ashiwake Obune," X, 163.
210, 19	*argument indeed.*" "Shibun Yōryō," X, 320.
210, 25	*no aware.*" *Ibid.*, X, 258.
210, 29	*aware bloom.*" "Genji Monogatari Tama no Ogushi," VII, 488.
211, 4	*evil thing.*" "Ashiwake Obune," X, 176.
211, 22	*feels consoled.*" "Genji Monogatari Tama no Ogushi," VII, 473.
211, 31	*various occasions.*" *Ibid.*, VII, 473.
211, 33	*are like.*" "Shibun Yōryō," X, 256.
211, 36	*his father.* "Isonokami Sasamegoto," X, 203.

212, 3 *in it."* "Ashiwake Obune," X, 163.
212, 6 *toward others.* "Shibun Yōryō," X, 257.
212, 18 *the gods."* "Uiyamabumi," IX, 482.
212, 29 *aims at." Ibid.,* IX, 494.

14

219, 11 *spoken to.* "Ashiwake Obune," *Zōho Motoori Nori-*
 naga Zenshū, X, 166–67.
220, 22 *written down."* "Shibun Yōryō," *ibid.,* X, 318.
220, 32 *of life."* "Genji Monogatari Tama no Ogushi," *ibid.,*
 VII, 473.
221, 23 *of novelty."* "Isonokami Sasamegoto," *ibid.,* X, 211.
225, 10 *Comic Interlude. Waranbe Gusa,* 308.
225, 32 *as well.* "Yamanoue Sōji Ki," *Shinshū Chadō Zenshū,*
 VIII, 128.
226, 11 *with melodies."* "Isonokami Sasamegoto," *Zōho Moto-*
 ori Norinaga Zenshū, VI, 469.
229, 30 *the bottom."* "Kokinshū Tōkagami," *ibid.,* VII, 237.
230, 24 *mountain road . . .* "Sanzōshi," *Haironshū,* 416.
232, 9 *the poems."* "Ashiwake Obune," *Zōho Motoori Nori-*
 naga Zenshū, X, 162.
232, 29 *the moon!"* "Kyoraishō," *Haironshū,* 314.
233, 22 *another matter."* "Nanbōroku," *Shinshū Chadō Zen-*
 shū, IX, 9.
233, 38 *at heart."* "Ashiwake Obune," *Zōho Motoori Norinaga*
 Zenshū, X, 175.

Index

271